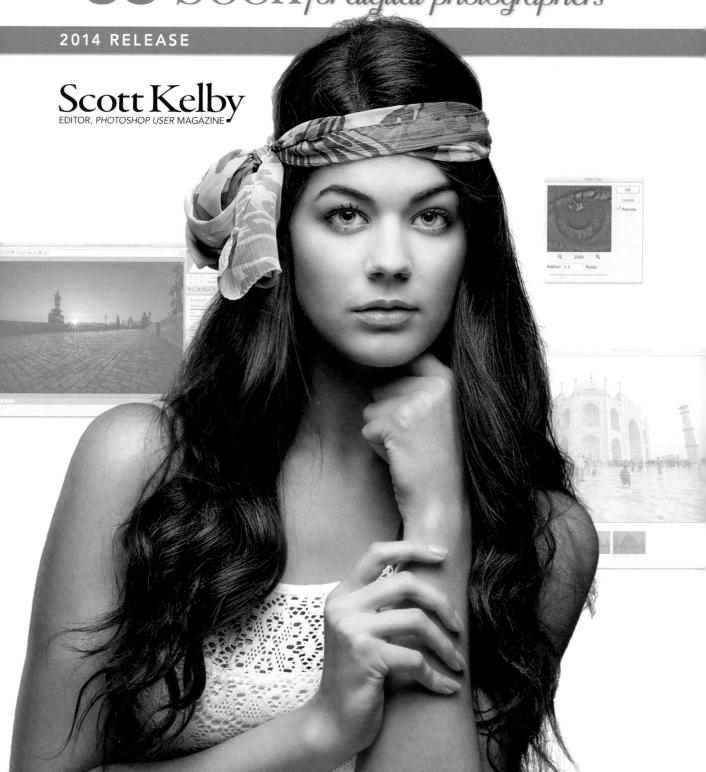

THE ADOBE PHOTOSHOP CC BOOK FOR DIGITAL PHOTOGRAPHERS 2014 RELEASE

The Adobe Photoshop CC Book for Digital Photographers Team

CREATIVE DIRECTOR Felix Nelson

MANAGING EDITOR Kim Doty

TECHNICAL EDITOR Cindy Snyder

ART DIRECTOR

Jessica Maldonado

COVER PHOTOS BY Scott Kelby Published by New Riders

©2015 by Scott Kelby

All rights reserved. No part of this book may be reproduced or transmitted in any form or by any means, electronic or mechanical, including photocopying, recording, or by any information storage and retrieval system, without written permission from the publisher, except for the inclusion of brief quotations in a review.

Composed in Avenir, Myriad Pro, and Helvetica by Kelby Media Group, Inc.

Trademarks

All terms mentioned in this book that are known to be trademarks or service marks have been appropriately capitalized. New Riders cannot attest to the accuracy of this information. Use of a term in this book should not be regarded as affecting the validity of any trademark or service mark.

Photoshop is a registered trademark of Adobe Systems, Inc. Macintosh is a registered trademark of Apple, Inc. Windows is a registered trademark of Microsoft Corp.

Warning and Disclaimer

This book is designed to provide information about Photoshop for digital photographers. Every effort has been made to make this book as complete and as accurate as possible, but no warranty of fitness is implied.

The information is provided on an as-is basis. The author and New Riders shall have neither the liability nor responsibility to any person or entity with respect to any loss or damages arising from the information contained in this book or from the use of the discs, electronic files, or programs that may accompany it.

THIS PRODUCT IS NOT ENDORSED OR SPONSORED BY ADOBE SYSTEMS INCORPORATED, PUBLISHER OF ADOBE PHOTOSHOP.

ISBN 13: 978-0-133-90085-9 ISBN 10: 0-13-390085-1

98765432

http://kelbyone.com www.newriders.com

This book is dedicated to my friend Erik Kuna, for working so hard, caring so much, and for doing it all for the right reasons.

ACKNOWLEDGMENTS

ve been writing books for 17 years now, and I still find that the thing that's the hardest for me to write in any book is writing the acknowledgments. It also, hands down, takes me longer than any other pages in the book. For me, I think the reason I take these acknowledgments so seriously is because it's when I get to put down on paper how truly grateful I am to be surrounded by such great friends, an incredible book team, and a family that truly makes my life a joy. That's why it's so hard. I also know why it takes so long—you type a lot slower with tears in your eyes.

To my remarkable wife, Kalebra: We've been married 25 years now, and you still continue to amaze me, and everyone around you. I've never met anyone more compassionate, more loving, more hilarious, and more genuinely beautiful, and I'm so blessed to be going through life with you, to have you as the mother of my children, my business partner, my private pilot, Chinese translator, and best friend. You truly are the type of woman love songs are written for, and as anyone who knows me will tell you, I am, without a doubt, the luckiest man alive to have you for my wife.

To my son, Jordan: It's every dad's dream to have a relationship with his son like I have with you, and I'm so proud of the bright, caring, creative young man you've become. I can't wait to see the amazing things life has in store for you, and I just want you to know that watching you grow into the person you are is one of my life's greatest joys.

To my precious little girl, Kira: You have been blessed in a very special way, because you are a little clone of your mom, which is the most wonderful thing I could have possibly wished for you. I see all her gifts reflected in your eyes, and though you're still too young to have any idea how blessed you are to have Kalebra as your mom, one day—just like Jordan—you will.

To my big brother Jeff, who has always been, and will always be, a hero to me. So much of who I am, and where I am, is because of your influence, guidance, caring, and love as I was growing up. Thank you for teaching me to always take the high road, for always knowing the right thing to say at the right time, and for having so much of our dad in you.

I'm incredibly fortunate to have part of the production of my books handled in-house by my own book team at Kelby Media Group, which is led by my friend and longtime Creative Director, Felix Nelson, who is hands down the most creative person I've ever met. He's surrounded by some of the most talented, amazing, ambitious, gifted, and downright brilliant people I've ever had the honor of working with, and thank God he had the foresight to hire Kim Doty, our Managing Editor, and the only reason why I haven't totally fallen onto the floor in the fetal position by the time a book is done. Kim is just an incredibly organized, upbeat, focused person who keeps me calm and on track, and no matter how tough the task ahead is, she always says the same thing, "Ah, piece of cake," and she convinces you that you can do it, and then you do it. I cannot begin to tell you how grateful I am to her for being my Editor, and to Felix for finding her. I guess great people just attract other great people.

Working with Kim is Cindy Snyder, who relentlessly tests all the stuff I write to make sure I didn't leave anything out, so you'll all be able to do the things I'm teaching (which with a Photoshop book is an absolute necessity). She's like a steel trap that nothing can get through if it doesn't work just like I said it would.

http://kelbyone.com

The look of the book comes from an amazing designer, a creative powerhouse, and someone whom I feel very, very lucky to have designing my books—Jessica Maldonado. She always adds that little something that just takes it up a notch, and I've built up such a trust for her ideas and intuition, which I why I just let her do her thing. Thanks Jess!

Huge thanks to my Executive Assistant Lynn Miller, who has only been working with me for a little while now, but she's absolutely awesome and runs a whole side of my business life and makes sure I'm where I'm supposed to be, working on what I'm supposed to be doing. She generally herds me like sheep to keep me focused so I have time to write books, spend time with my family, and have a life outside of work. So glad to have you on my team.

To my best buddy and book-publishing powerhouse, Dave Moser (also known as "the guiding light, force of nature, miracle birth, etc."), for always insisting that we raise the bar and make everything we do better than anything we've done before.

Thanks to everyone at New Riders and Peachpit, and in particular to my way cool Editor, Ted Waitt (who is one heck of a photographer and a vitally important part of everything I do in "Bookland"), my wonderful Publisher Nancy Aldrich-Ruenzel, marketing maven Scott Cowlin, marketing diva Sara Jane Todd, and the entire team at Pearson Education who go out of their way to make sure that we're always working in the best interest of my readers, that we're always trying to take things up a notch, and who work hard to make sure my work gets in as many people's hands as possible.

Thanks to my friends at Adobe: Winston Henderickson, Bryan O'Neil Hughes, Mala Sharma, Terry White, Jim Heiser, Julieanne Kost, Tom Hogarty, Scott Morris, Russell Preston Brown, Bryan Lamkin, and the amazing engineering team at Adobe (I don't know how you all do it). Gone but not forgotten: Barbara Rice, Jill Nakashima, Rye Livingston, Addy Roff, Jennifer Stern, Deb Whitman, Kevin Connor, John Nack, John Loiacono, Cari Gushiken, and Karen Gauthier.

Thanks to Matt Kloskowski for all his input and ideas for previous editions of the book. I'm very grateful to have his advice, and his friendship. I want to thank all the talented and gifted photographers who've taught me so much over the years, including: Moose Peterson, Joe McNally, Anne Cahill, Vincent Versace, Cliff Mautner, Dave Black, Bill Fortney, David Ziser, Helene Glassman, Kevin Ames, and Jim DiVitale.

Thanks to my mentors, whose wisdom and whip-cracking have helped me immeasurably, including John Graden, Jack Lee, Dave Gales, Judy Farmer, and Douglas Poole.

Most importantly, I want to thank God, and His Son Jesus Christ, for leading me to the woman of my dreams, for blessing us with two amazing children, for allowing me to make a living doing something I truly love, for always being there when I need Him, for blessing me with a wonderful, fulfilling, and happy life, and such a warm, loving family to share it with.

OTHER BOOKS BY SCOTT KELBY

Professional Portrait Retouching Techniques for Photographers Using Photoshop

The Digital Photography Book, parts 1, 2, 3, 4, and 5

Light It, Shoot It, Retouch It: Learn Step by Step How to Go from Empty Studio to Finished Image

Scott Kelby's 7-Point System for Adobe Photoshop CS3

It's a Jesus Thing: The Book for Wanna Be-lievers

The Adobe Photoshop Lightroom Book for Digital Photographers

Photoshop Down & Dirty Tricks

The Photoshop Elements Book for Digital Photographers

Professional Sports Photography Workflow

Photoshop for Lightroom Users

ABOUT THE AUTHOR

Scott Kelby

Scott is Editor, Publisher, and co-founder of Photoshop User magazine, co-host of The Grid, the weekly live videocast talk show for photographers, as well as producer of the top-rated weekly videocast series, Photoshop User TV.

He is President of the training, education, and publishing firm, KelbyOne, Inc., and was the founder of the National Association of Photoshop Professionals (NAPP).

Scott is a photographer, designer, and award-winning author of more than 60 books, including The Adobe Photoshop Lightroom 5 Book for Digital Photographers, Professional Portrait Retouching Techniques for Photographers Using Photoshop, Light It, Shoot It, Retouch It: Learn Step by Step How to Go from Empty Studio to Finished Image, The iPhone Book, The iPod Book, and The Digital Photography Book, parts 1, 2, 3, 4 $\&\,5.$

For the past four years, Scott has been honored with the distinction of being the #1 bestselling author of photography techniques books. His book, The Digital Photography Book, vol. 1, is now the best-selling book on digital photography in history.

His books have been translated into dozens of different languages, including Chinese, Russian, Spanish, Korean, Polish, Taiwanese, French, German, Italian, Japanese, Dutch, Swedish, Turkish, and Portuguese, among others, and he is a recipient of the prestigious ASP International Award, presented annually by the American Society of Photographers for "...contributions in a special or significant way to the ideals of Professional Photography as an art and a science."

Scott is Training Director for the Adobe Photoshop Seminar Tour and Conference Technical Chair for the Photoshop World Conference & Expo. He's featured in a series of Adobe Photoshop online courses at KelbyOne.com and has been training Adobe Photoshop users since 1993.

For more information on Scott, visit him at:

His daily blog: http://scottkelby.com

Google+: Scottgplus.com

Twitter: http://twitter.com@scottkelby Facebook: www.facebook.com/skelby

http://kelbyone.com CONTENTS

CHAPTER 1	
WWF Raw	
the essentials of camera raw	
Working with Camera Raw	002
Miss the JPEG Look?	
Try Applying a Camera Profile	
Using Camera Raw Like It's a Filter	
The Essential Adjustments: White Balance	
The Essential Adjustments #2: Exposure	
Letting Camera Raw Auto-Correct Your Photos	
Adding Punch to Your Images with Clarity	
Adjusting Contrast Using Curves	
Cropping and Straightening	
Seeing a Before/After in Camera Raw	
Photoshop Killer Tips	034
CHAPTER 2	036
Raw Justice	
camera raw—beyond the basics	
Double-Processing to Create	000
the Uncapturable	
Editing Multiple Photos at Once	
Sharpening in Camera Raw	04/
Automatically Fixing Lens Problems	052
Fixing Chromatic Aberrations (That Colored-Edge Fringe)	058
Edge Vignetting: How to Fix It and How to Add It for Effect	060
The Advantages of Adobe's DNG Format for RAW Photos	064
Adjusting or Changing Ranges of Color	. 066
Oh Hallelujah, It's a Regular Healing Brush! (Finally!)	
Finding Spots and Specks the Easy Way	
Calibrating for Your Particular Camera	
Reducing Noise in Noisy Photos	
Choosing How Your RAW Images	
Will Appear in Photoshop	
Photoshop Killer Tips	. 0/8

CONTENTS

http://kelbyone.com

CHAPTER 3	080
Attitude Adjustment camera raw's adjustment tools	
Dodging, Burning, and Adjusting Individual Areas of Your Photo	. 082
Retouching Portraits in Camera Raw	
Fixing Skies (and Other Stuff) with the Graduated Filter	
Applying Selective Color in Camera Raw	
Camera Raw's Radial Filter (Custom Vignettes & Spotlights)	
Fixing Color Problems (or Adding Effects) by "Painting" White Balance	
Reducing Noise in Just the Shadow Areas	
How to Get More Than 100% Out of Any Adjustment Brush Effect	
Photoshop Killer Tips	
Thotoshop Killer Tips	103
CHAPTER 4	106
Scream of the Crop how to resize and crop photos	
Basic Cropping for Photos	.108
Cropping to a Specific Size	
Creating Your Own Custom Crop Tools	
Sync Settings	
Custom Sizes for Photographers	. 119
Resizing Digital Camera Photos	
Smarter Image Upsizing (Even for Low-Res Images)	.124
Automated Saving and Resizing	. 126
Resizing for Poster-Sized Prints	.128
Straightening Crooked Photos	.130
Making Your Photos Smaller (Downsizing)	. 132
Resizing Just Parts of Your Image Using "Content-Aware" Scaling	. 135
Conditional Actions (At Last!)	
Photoshop Killer Tips.	.141

http://kelbyone.com CONTENTS

CHAPTER 5	144
Black & White now to create stunning b&w images	
Converting to Black and White Jsing Camera Raw	146
My Three-Click Method for Converting to B&W Once You're Already in Photoshop)	
Split Toning	
Duotones Made Crazy Easy	156
Quadtoning for Richer B&Ws	157
Creating Your Own One-Click Presets n Camera Raw	
f You're Really, Really Serious About B&W, 'hen Consider This Instead	160
Photoshop Killer Tips	
CHAPTER 6	162
We Are HDR creating HDR images	
Setting Up Your Camera to Shoot HDR	164
A Quick Tour of the HDR Pro Dialog	
Creating Realistic-Looking Images Jsing 32-Bit HDR	
Creating the Tone-Mapped HDR Look	
Creating a Blended HDR to Get the Best of Both Worlds	
Setting the HDR Look on a Single Image	
How to Get Rid of "Ghosting" Problems	
High Pass Sharpening for HDR Images	
HDR Finishing Techniques Vignetting, Sharpening & Soft Glow)	
Photoshop Killer Tips	

CONTENTS

http://kelbyone.com

CHAPTER 7 188
Little Problems fixing common problems
When Your Subject Is in the Shadows
Fixing Shots with a Dull Gray Sky
Using the Dodge and Burn Tools
Fixing Reflections in Glasses
Fixing Group Shotsthe Easy Way
Liquify Is Now Re-Editable (and It Has a Handy Tool!)209
Making Really Tricky Selections, Like Hair (and Some Cool Compositing Tricks, Too!)
Fixing Really Messed Up Wide-Angle Shots
Saving Blurry Pictures Using the Shake Reduction Filter
Stretching Stuff to Fit Using Content-Aware Scale
Removing Stuff Using Content-Aware Fill
Moving Stuff Without Leaving a Hole by Using Content-Aware Move
Photoshop Killer Tips

http://kelbyone.com CONTENTS

CHAPTER 8	244
Side Effects Special effects for photographers	
Desaturated Skin Look	246
High-ContrastPortrait Look	248
Dreamy Focus Effect for People and Landscapes	252
Panoramas Made Crazy Easy	254
Tilt Shift Effect Using the Blur Gallery)	
ris & Field Blur for How to Fake the 85mm f/1.4 Look)	262
Creating Dramatic Lighting	267
Photographic Toning Effects from Sepias to Split Tones)	272
Fashion Toning Using Photoshop's Color Lookup Adjustment Layer	274
Sculpting Using the Updated Liquify Filter	276
Lens Flare Look	280
Wet Streets and Cobblestones	282
Photoshop Killer Tips	284
CHAPTER 9	286
Sharpen Your Teeth sharpening techniques	
Sharpening Essentials	288
The Most Advanced Sharpening in Photoshop	295
Smarter Smart Sharpen	29
High Pass Sharpening	299
Output Sharpening in Camera Raw	30
Photoshop Killer Tips	302

CONTENTS

http://kelbyone.com

CHAPTER 10	304
Videodrome editing DSLR video in photoshop	
Four Things to Know Now About Creating Video in Photoshop	306
Opening Your Video Clips into Photoshop	
Your Basic Controls for Working with Video	
Editing (Trimming) Your Clips	
Working with Audio and Background Music	
Adding Transitions Between Clips and Fade Ins/Fade Outs	
Creating Lower Thirds (or Adding Logos)	
Applying Photoshop Filters and Adjustments	
Titles and Working with Text	
Using Blend Modes to Create "Looks"	
Our Start-to-Finish Project	
How to Create Scrolling Credits	
How to Apply One Effect to Your Entire Movie at Once	
Photoshop Killer Tips	
CHAPTER 11	352
Workflow my step-by-step workflow	
My Photoshop CC Photography Workflow	354
INDEX	363

Seven Things You'll Wish You Had Known Before Reading This Book

It's really important to me that you get a lot out of reading this book, and one way I can help is to get you to read these seven quick things about the book that you'll wish later you knew now. For example, it's here that I tell you about where to download something important, and if you skip over this, eventually you'll send me an email asking where it is, but by then you'll be really aggravated, and well... it's gonna get ugly. We can skip all that (and more), if you take two minutes now and read these seven quick things. I promise to make it worth your while.

(1) You don't have to read this book in order.

I designed this book so you can turn right to the technique you want to learn, and start there. I explain everything as I go, step-by-step, so if you want to learn how to remove dust spots from a RAW image, just turn to page 70, and in a couple of minutes, you'll know. I did write the book in a logical order for learning Photoshop, but don't let that tie your hands—jump right to whatever technique you want to learn—you can always go back, review, and try other stuff.

(2) Practice along with the same photos I used here in the book.

As you're going through the book, and you come to a technique like "Creating the Tone-Mapped HDR Look," you might not have an HDR-bracketed set of shots hanging around, so in those cases I usually made the images available for you to download, so you can follow along with the book. You can find them at http://kelbyone.com/books/cc14 (see, this is one of those things I was talking about that you'd miss if you skipped this and went right to Chapter 1).

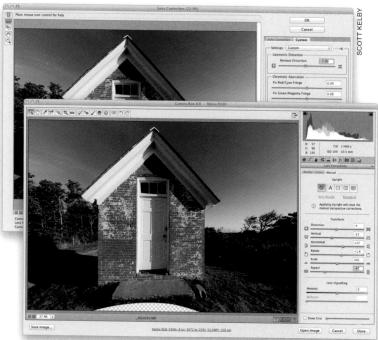

(3) The intro pages at the beginning of each chapter are not what they seem.

The chapter introductions are designed to give you a quick mental break between chapters, and honestly, they have little to do with what's in the chapter. In fact, they have little to do with anything, but writing these quirky chapter intros has become kind of a tradition of mine (I do this in all my books), so if you're one of those really "serious" types, I'm begging you—skip them and just go right into the chapter because they'll just get on your nerves. However, the short intros at the beginning of each individual project, up at the top of the page, are usually pretty important. If you skip over them, you might wind up missing stuff that isn't mentioned in the project itself. So, if you find yourself working on a project, and you're thinking to yourself, "Why are we doing this?" it's probably because you skipped over that intro. So, just make sure you read it first, and then go to Step One. It'll make a difference—I promise.

(4) There are things in Photoshop CC and in Camera Raw that do the exact same thing.

For example, there's a Lens Corrections panel in Camera Raw, and there's a Lens Correction filter in Photoshop, and they are almost identical. What this means to you is that some things are covered twice in the book. As you go through the book, and you start to think, "This sounds familiar...," now you know why. By the way, in my own workflow, if I can do the exact same task in Camera Raw or Photoshop, I always choose to do it in Camera Raw, because it's faster (there are no progress bars in Camera Raw) and it's non-destructive (so I can always change my mind later).

(5) I included a chapter on my CC workflow, but don't read it yet. At the end of this book I included a special chapter detailing my own Photoshop CC workflow, but please don't read it until you've read the rest of the book, because it assumes that you've read the book already, and understand the basic concepts, so it doesn't spell everything out (or it would be one really, really long

drawn-out chapter).

(6) Where's the Bridge stuff? Adobe hasn't updated Bridge for years now. Well, I guess that's not exactly true—they removed some stuff, but outside of that—that's pretty much it. Wait...wait...back in Photoshop CS6 they added a "Mini Bridge" to Photoshop so you can could access your images without leaving Photoshop. Oh. That's right—in Photohsop CC they even removed Mini Bridge. I'm thinking the future of Bridge is not bright, and since it hasn't really changed in years, I'm no longer including it here in the book, but if you're brand new to Photoshop, you don't use Lightroom and you think you might need Bridge, I did write two entire chapters just on Bridge and put them on the book's download site for you to download free. You'll find these at http:// kelbyone.com/books/cc14, along with another bonus chapter on printing (see, I care).

SCOTT KELBY

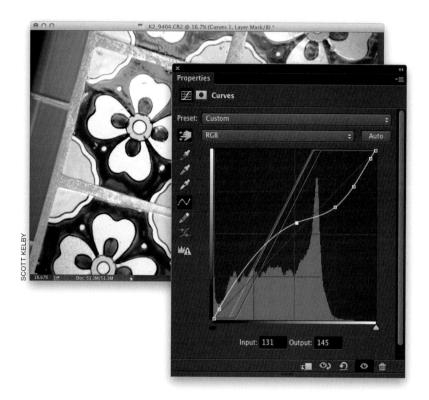

(7) Photography is evolving, Photoshop is evolving, and this book has to, too.

This is the second edition of this book that doesn't include a chapter on using Curves, and that's because today we use a different tool—Camera Raw (even if we don't shoot in RAW, because it works for JPEGs and TIFFs, too!). I spent years teaching Curves in books and in podcasts and here in this book, but honestly, today I really don't use Curves (and if I do, I use the Tone Curve in Camera Raw, which I do cover here in the book). In fact, I had a hard time finding any photographers I know still using Curves, which just shows how Photoshop has evolved over time. Although Curves isn't covered here in the book, I did provide a color correction chapter using Curves on the book's downloads page (ya know, just in case you want to go "old school"). You can find it at the web address just mentioned in #6.

(8) Each chapter includes my "Photoshop Killer Tips"!

Hey, I thought you said it was "Seven Things"? Well, consider this eighth a "bonus thing," because it's about another bonus I included in this edition of the book. At the end of every chapter is a special section I call "Photoshop Killer Tips" (named after the book of the same name I did a few years ago with Felix Nelson). These are those time-saving, job-saving, "man, I wish I had known that sooner" type tips. The ones that make you smile, nod, and then want to call all your friends and "tune them up" with your new status as Photoshop guru. These are in addition to all the other tips, which already appear throughout the chapters (you can never have enough tips, right? Remember: He who dies with the most tips, wins!). So, there you have it, seven (or so) things that you're now probably glad you took a couple minutes to read. Okay, the easy part is over-turn the page and let's get to work.

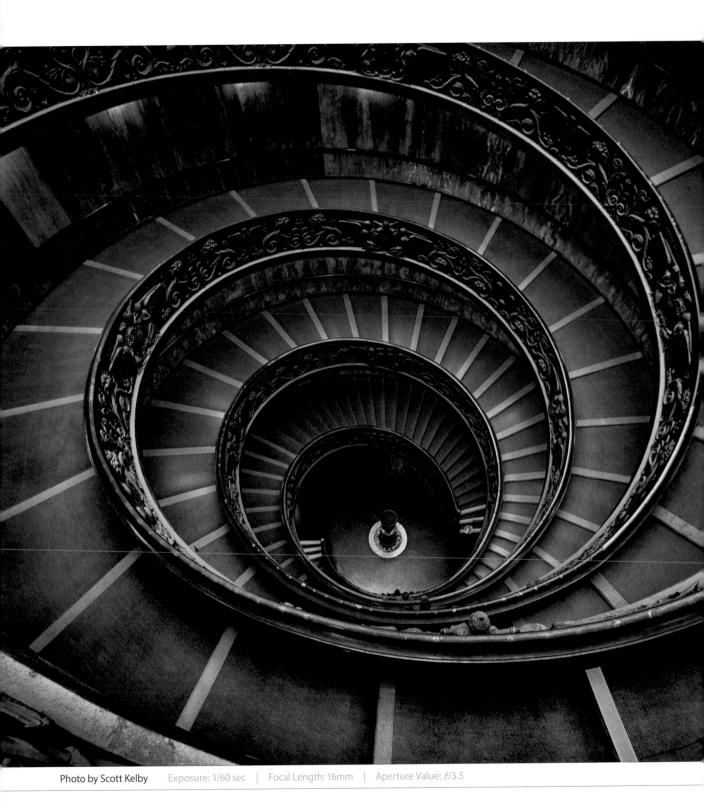

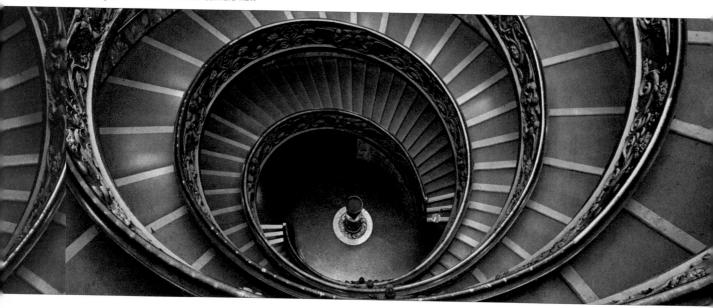

WWF Raw

the essentials of camera raw

Now, if you're reading the English-language version of this book, you probably instantly recognized the chapter title "WWF Raw" from the wildly popular American TV series Wasabi with Fries Raw (though in Germany, it's called Weinerschnitzel Mit Fischrogen Raw, and in Spain, it's called simply Lucha Falsa, which translated literally means "Lunch Feet"). Anyway, it has been a tradition of mine, going back about 60 books or so, to name the chapters after a movie title, song title, or TV show, and while "WWF Raw" may not be the ideal name for a chapter on Camera Raw essentials, it's certainly better than my second choice, "Raw Meat" (named after the 1972 movie starring Donald Pleasence. The sequel, Steak Tartare, was released straight to DVD in 1976, nearly 20 years before DVDs were even invented, which is quite remarkable for a movie whose French version wound up being called Boeuf Gâté Dans la Toilette, with

French actor Jean-Pierre Pommes Frites playing the lead role of Marcel, the dog-faced boy). Anyway, finding movies, TV shows, and song titles with the word "raw" in them isn't as easy as it looks, and since this book has not one, not two, not three, but...well, yes, actually it has three chapters on Camera Raw, I'm going to have to do some serious research to come up with something that tops "WWF Raw," but isn't "Raw Meat," and doesn't use the same name I used back in the CS4 edition of this book, which was "Raw Deal" (from the 1986 movie starring California Governor Arnold from Happy Days. See, that was a vague reference to the guy who played the diner owner in the '70s sitcom Happy Days, starring Harrison Ford and Marlon Brando). But what I really can't wait for is to see how the people who do the foreign translations of my books translate this intro. C'est magnifique, amigos!

Working with Camera Raw

Although Adobe Camera Raw was originally created to process photos taken in your camera's RAW format, you can also use it to process your JPEG and TIFF photos. A big advantage of using Camera Raw that many people don't realize is that it's just plain easier and faster to make your images look good using Camera Raw than with any other method. Camera Raw's controls are simple, they're instantaneous, and they're totally undoable, which makes it hard to beat. But first, you've got to open your images in Camera Raw for processing.

Opening RAW Images:

Since Camera Raw was designed to open RAW images, if you double-click on a RAW image (whether in Bridge or just in a folder on your computer), it will launch Photoshop and open that RAW image in Camera Raw (its full official name is Adobe Camera Raw, but here in the book, I'll just be calling it "Camera Raw" for short, because...well...that's what I call it). Note: If you double-click on what you know is a RAW image and it doesn't open in Camera Raw, make sure you have the latest version of Camera Raw—images from newly released cameras need the latest versions of Camera Raw to recognize their RAW files.

Opening JPEG & TIFF Images from Bridge:

If you want to open a JPEG or TIFF image from Bridge, it's easy: Right-click on it and, from the pop-up menu, choose **Open in Camera Raw.**

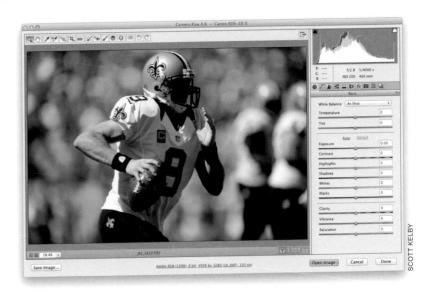

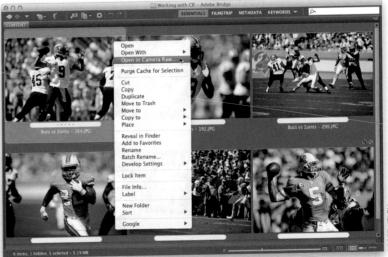

SCOTT KELBY

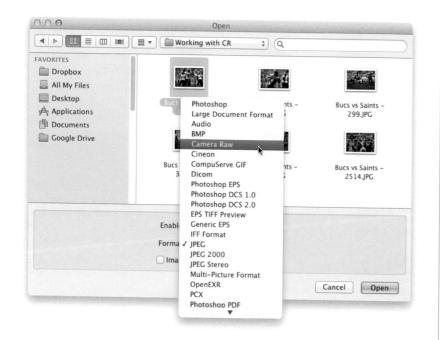

Opening JPEG & TIFF Images from Your Computer:

If you want to open a JPEG or TIFF image from your computer, then here's what you do: On a Mac, go under Photoshop's File menu and choose Open. When the Open dialog appears, click on your JPEG (or TIFF, but we'll use a JPEG as our example) image, and in the Format pop-up menu, it will say JPEG. You need to click-and-hold on that menu, and then choose Camera Raw, as shown here. Now, click the Open button, and your JPEG image will open in Camera Raw. In Windows, just go under Photoshop's File menu and choose **Open As**, then navigate your way to that JPEG or TIFF image, change the pop-up menu near the bottom right to Camera Raw, and click Open.

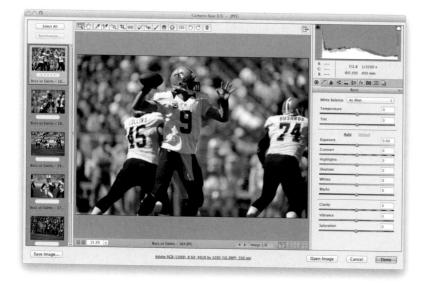

Opening Multiple Images:

You can open multiple RAW photos in Camera Raw by selecting them first (either in Bridge or in a folder on your computer), then just double-clicking on any one of them, and they'll all open in Camera Raw and appear in a filmstrip along the left side of the Camera Raw window (as seen here). If the photos are JPEGs or TIFFs, in Bridge, select 'em first, then press Command-R (PC: Ctrl-R). You won't be able to open multiple JPEGs or TIFFs from a Mac Finder or Windows Explorer window; you'll need to use Bridge to open them (just use the Path Bar in Bridge to navigate to where those images are located).

Editing JPEG & TIFF Images in Camera Raw:

One thing about editing JPEGs and TIFFs in Camera Raw: When you make adjustments to a JPEG or TIFF and you click the Open Image button, it opens your image in Photoshop (as you'd expect). However, if you just want to save the changes you made in Camera Raw without opening the photo in Photoshop, then click the Done button instead (as shown here), and your changes will be saved. But there is a big distinction between editing JPEG or TIFF images and editing a RAW image. If you click the Done button, you're actually affecting the real pixels of the original JPEG or TIFF, whereas, if this were a RAW image, you wouldn't be (which is another big advantage of shooting in RAW). If you click the Open Image button, and open your JPEG or TIFF in Photoshop, you're opening and editing the real image, as well. Just so you know.

The Two Camera Raws:

Here's another thing you'll need to know: there are actually two Camera Raws—one in Photoshop, and a separate one in Bridge. The advantage of having two Camera Raws comes into play when you're processing (or saving) a lot of RAW photos—you can have them processing in Bridge's version of Camera Raw, while you're working on something else in Photoshop. If you find yourself using Bridge's Camera Raw most often, then you'll probably want to press Command-K (PC: Ctrl-K) to bring up Bridge's Preferences, click on General on the left, and then turn on the checkbox for Double-Click Edits Camera Raw Settings in Bridge (as shown here). Now, double-clicking on a photo opens RAW photos in Bridge's Camera Raw, rather than Photoshop's.

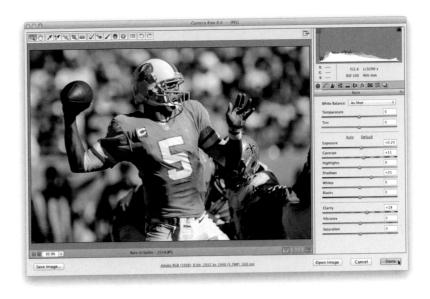

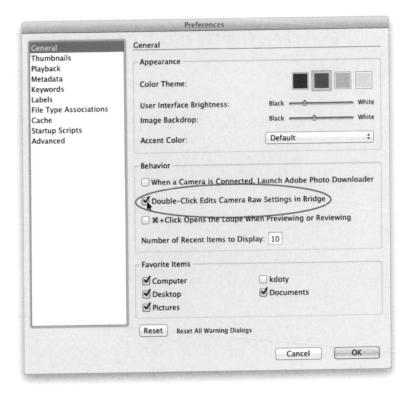

If you've ever wondered why RAW images look good on your camera's LCD, but look flat when you open them in Camera Raw, it's because what you see on your LCD is a JPEG preview (even though you're shooting in RAW), and your camera automatically adds color correction, sharpening, etc., to them. When you shoot in RAW, you're telling the camera, "Turn all that color enhancement and sharpening off—just leave it untouched, and I'll process it myself." But, if you'd like that JPEG-processed look as a starting place for your RAW photo editing, camera profiles can get you close.

Miss the JPEG Look? Try Applying a Camera Profile

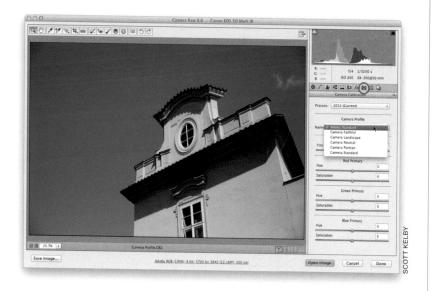

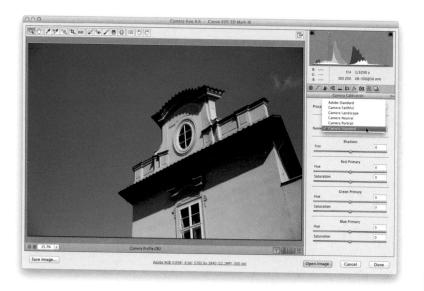

Step One:

Click on the Camera Calibration icon (the third icon from the right) near the top of the Panel area, and in the Camera Profile section, click-and-hold on the Name popup menu, and you'll see a list of camera profiles available for your particular camera (it reads the embedded EXIF data, so it knows which brand of camera you use). For example, if you shoot Canon, you'll see a list of the in-camera picture styles (shown here) you could have applied to your image if you had taken the shot in JPEG mode (if you shoot in RAW, Camera Raw ignores those in-camera profiles, as explained above). If you shoot Nikon, you'll see a slightly different list, but it does the same type of thing.

Step Two:

The default profile will be Adobe Standard. Now, ask yourself this: "Does the word 'Standard' ever mean 'Kick Butt?'" Not usually, which is why I suggest you try out the different profiles in this list and see which ones you like. At the very least, I would change it to Camera Standard, which I think usually gives you a better starting place (as seen here).

Step Three:

Depending on the individual photo you're editing, Camera Standard might not be the right choice, but as the photographer, this is a call you have to make (in other words, it's up to you to choose which one looks best to you). I usually wind up using either Camera Standard or Camera Landscape for images taken with a Canon camera, because I think Landscape looks the most like the JPEGs I see on the back of my camera. But again, if you're not shooting Canon, Landscape might not be one of the available choices (Nikons have eight picture styles and Canons have five). If you don't shoot Canon or Nikon, or one of a handful of other cameras, then you'll only have Adobe Standard, and possibly Camera Standard, to choose from, but you can create your own custom profiles using Adobe's free DNG Profile Editor utility, available from Adobe at http:// kel.by/1trwAbm.

Step Four:

Here's a before/after with only one thing done to this photo: I chose Camera Landscape (as shown in the pop-up menu in Step Three). Again, this is designed to replicate the color looks you could have chosen in the camera, so if you want to have Camera Raw give you a similar look as a starting point, give this a try. Also, since Camera Raw allows you to open more than one image at a time (in fact, you can open hundreds at a time), you could open a few hundred images, then click the Select All button that will appear at the top-left corner of the window, change the camera profile for the first-selected image, and then all the other images will have that same profile automatically applied. Now, you can just click the Done button.

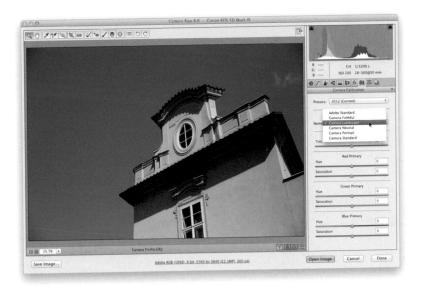

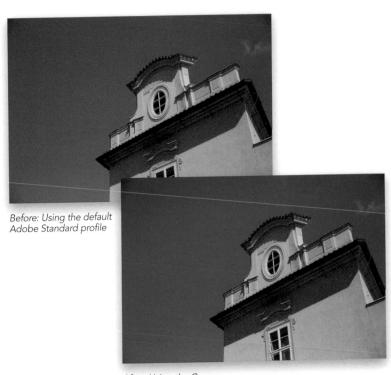

After: Using the Camera Landscape profile

Okay, I'm starting off with this particular feature because the ability to reopen any currently open image in Camera Raw had been at the top of my Photoshop wish list for years. Before this was possible, if you had an image open in Photoshop and you wanted to re-edit it in Camera Raw, you had to save the image and close it. Then, you'd have to go to the Open dialog, find the image on your computer, change the Format to Camera Raw and then open it. Now, it's finally just a one-click process (like applying any other filter).

Using Camera Raw Like It's a Filter

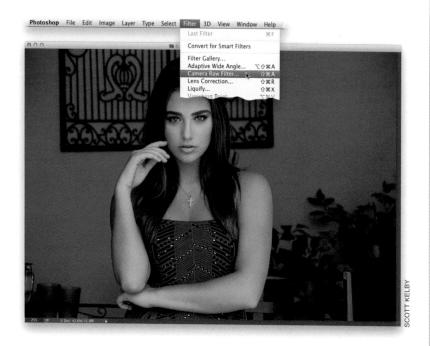

Step One:

When you have an image already open in Photoshop and want to edit it in Camera Raw, just go under the Filter menu and choose **Camera Raw Filter** (as shown here).

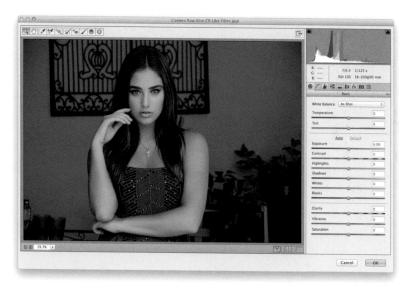

Step Two:

The Camera Raw window opens, and now you can make any changes you'd like. When you're done, just click OK, and you're back in Photoshop with your Camera Raw changes applied. Just a heads up: if your image is already open in Photoshop, even if it was shot in RAW format on your camera, it's no longer a RAW photo at this point, so it doesn't go back and reopen the RAW version—it takes the 8- or 16-bit photo you have already open in Photoshop and it opens that in Camera Raw. This isn't a bad thing, and works as expected, but I just thought I'd address it in case you were wondering.

The Essential Adjustments: White Balance

If you've ever taken a photo indoors, chances are it came out with kind of a yellowish tint. Unless you took the shot in an office, and then it probably had a green tint. If you just took a shot of somebody in the shade, the photo probably had a blue tint. Those are white balance problems, and if we properly set our white balance in the camera, we won't see these color problems (the photos will just look normal), but since most of us shoot with our cameras set to Auto White Balance, we're going to run into them. Luckily, we can fix them pretty easily.

Step One:

The white balance is usually the very first thing I adjust in my own Camera Raw workflow, because getting the white balance right will eliminate 99% of your color problems right off the bat. At the top of the Basic panel (on the right side of the Camera Raw window), are the White Balance controls. If you look to the right of the words "White Balance," you'll see a pop-up menu (shown circled here in red), and by default it shows you the "As Shot" white balance (you're seeing the white balance you had set in your camera when you took the shot). I had been shooting indoors under regular indoor lighting, so my white balance had been set to Tungsten, but then I went into the studio and didn't change my white balance, so the first few shots came out with a bluish tint (as seen here—yeech!) and that's why the white balance is way, way off.

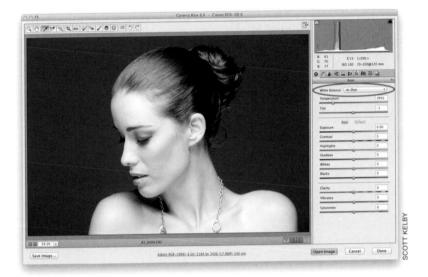

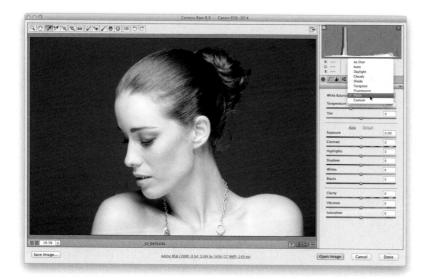

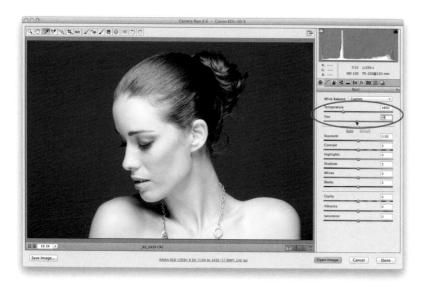

Step Two:

There are three ways to change the white balance in your photo, and the first is to simply choose one of the built-in White Balance presets. Fairly often, that's all you need to do to color correct your image. Just click on the White Balance pop-up menu, and you'll see a list of white balance settings you could have chosen in the camera. Just choose the preset that most closely matches what the lighting situation was when you originally took the photo (for example, if you took the shot in the shade of a tree, you'd choose the Shade preset). Here I tried each preset and Flash seemed to look best—it removed the bluish tint. (Note: This is the one main area where the processing of RAW and JPEG or TIFF images differs. You'll only get this full list of white balance presets with RAW images. With JPEGs or TIFFs, your only choice is As Shot or Auto white balance.)

Step Three:

The second method is to use the Temperature and Tint sliders (found right below the White Balance preset menu). The bars behind the sliders are color coded so you can see which way to drag to get which kind of color tint. What I like to do is use the built-in presets to get close (as a starting point), and then if my color is just a little too blue or too yellow, I drag in the opposite direction. So, in this example, the Flash preset was close, but made it a little too yellow, so I dragged the Temperature slider a little bit toward blue and the Tint slider a tiny bit toward green.

Step Four:

Just a couple of other quick things about manually setting your white balance using the Temperature and Tint sliders: If you move a slider and decide you didn't want to move it after all, just double-click directly on the little slider "nub" itself, and it will reset to its previous location. By the way, I generally just adjust the Temperature slider, and rarely have to touch the Tint slider. Also, to reset the white balance to where it was when you opened the image, just choose As Shot from the White Balance pop-up menu (as seen here).

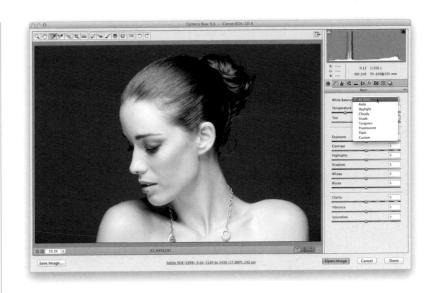

Step Five:

The third method is my personal favorite, and the method I use the most often, and that is setting the white balance using the White Balance tool (I). This is perhaps the most accurate because it takes a white balance reading from the photo itself. You just click on the White Balance tool in the toolbar at the top left (it's circled in red here), and then click it on something in your photo that's supposed to be a light gray (that's right—you properly set the white balance by clicking on something that's light gray). So, take the tool and click it once on the background near her shoulder in the bottom right (as shown here) and it sets the white balance for you. If you don't like how it looks, then just click on a different light gray area.

TIP: Quick White Balance Reset

To quickly reset your white balance to the As Shot setting, just double-click on the White Balance tool up in the toolbar.

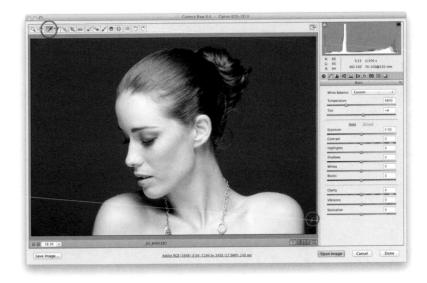

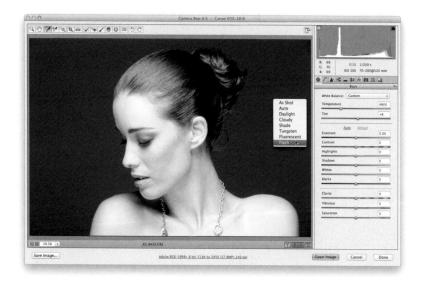

Before: The As Shot white balance has a bluish tint

After: With one click of the White Balance tool, everything comes together

Step Six:

Now, here's the thing: although this can give you a perfectly accurate white balance, it doesn't mean that it will look good. White balance is a creative decision, and the most important thing is that your photo looks good to you. So don't get caught up in that "I don't like the way the white balance looks, but I know it's accurate" thing that sucks some people inset your white balance so it looks right to you. You are the bottom line. You're the photographer. It's your photo, so make it look its best. Accurate is not another word for good. By the way, you can just Rightclick on your image to access the White Balance pop-up menu (as shown here).

Step Seven:

Here's a before/after so you can see what a difference setting a proper white balance makes (by the way, you can see a quick before/after of your white balance edit by pressing the letter **P** on your keyboard to toggle the preview on/off).

TIP: Using the Gray Card

To help you find that neutral light gray color in your images, I've included an 18% gray card in the back of this book (it's perforated, so you can tear it out). Once your lighting is set, just have your subject hold it while you take one shot. Then, open that image in Camera Raw, and click the White Balance tool on the card in your image to instantly set your white balance. Now, apply that same white balance to all the other shots taken under that same light (more on how to do that coming up in the next chapter).

The Essential Adjustments #2: Exposure

The next thing I fix (after adjusting the white balance) is the photo's exposure. Now, some might argue that this is the most essential adjustment of them all, but if your photo looks way too blue, nobody will notice if the photo's underexposed by a third of a stop, so I fix the white balance first, then I worry about exposure. However, exposure in Camera Raw isn't just the Exposure slider. It's actually five sliders: Exposure (midtones), Blacks (deep shadows), Shadows (regular shadows), Highlights (well-named), and Whites (extreme highlights).

Step One:

I recommend (and so does Adobe) starting with the top tonal slider in the Basic panel (Exposure) and working your way down through the other sliders in order, which is a different workflow than in previous versions of Camera Raw, where it didn't matter too much which slider you moved when. However, since CS6, it works best if you start by getting the Exposure (midtones) set first, and then if things look kind of washed out, adding some Contrast. This photo, well, it's a mess. Taken in harsh, unflattering light, it needs some serious Camera Raw help.

Step Two:

Start by adjusting the Exposure slider. This photo is way overexposed, so drag it to the left to darken the midtones and the overall exposure. Here, I dragged it over to –1.70 (it looks a lot better already), but the image is still kind of flat looking, and that's why your next step should be to adjust the contrast (by the way, although you can drag the Contrast slider to the left to make things less contrasty, I can't remember an occasion where I wanted my image to look more flat, so I don't drag to the left. Ever. But, hey, that's just me).

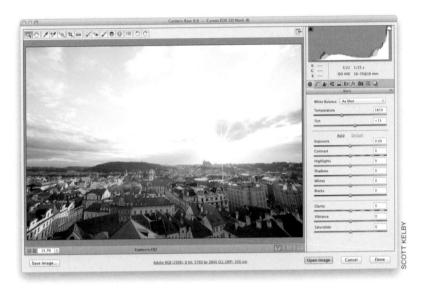

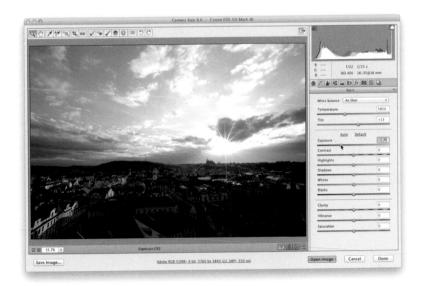

Step Three:

Increase the contrast using the Contrast slider, which makes the bright areas brighter and the dark areas darker (here, I dragged it to the right to +30, which helped deal with the flat, lowcontrast look). These two steps-adjusting the Exposure and then the Contrast slider (if necessary)—should be your starting points every time. This topdown approach helps, because the other sliders build off this exposure foundation, and it will keep you from having to constantly keep tweaking slider after slider. So, think of these two as the foundation of your exposure, and the rest are kind of optional based on the image you're working on.

Step Four:

Before we go any further, increasing our contrast to where we wanted it created a clipping problem, meaning we are clipping off our highlights (part of our photo got so bright that it won't have any detail in that area at all. It's blown out. If all that sounds bad, well, that's 'cause it is). Luckily, Camera Raw will give you a warning if you're clipping, in the upper-right corner of the histogram. See that triangle? That's the highlight clipping warning (although I just call it "the white triangle of death"). Now, if you do see a white triangle, don't freak out. First, go up and click directly on that white triangle and the areas that are clipping will appear in red (look in the sky, here). We do this to find out if what's clipping is an area of important detail, or if it's like a tiny highlight on a chrome bumper or something meaningless in the background of your image.

Step Five:

If that red highlight shows over an area you feel has important detail (we're not concerned with detail in the sky here, but we can try to get a little back in those clouds), go to the Highlights slider and drag it to the left until the red areas disappear (here, I dragged the Highlights slider to the left to –11). So, I look to the Highlights slider to recover clipped highlights first, and then if that doesn't do the trick, I try lowering the Exposure amount, but I rarely have to do that.

TIP: The Color Warning Triangles

If you see a red, yellow, magenta, etc., color warning triangle (rather than white), it's not great, but it's not nearly as bad as white. It means you're clipping just that one color channel (and there's still detail in the other channels).

Step Six:

The next slider down, Shadows, is another one you only use if there's a problem (just like the Highlights slider), and in this case, the problem is we can't see much detail in the bottom-right corner of the photo. That's when you reach for the Shadows slider—drag it to the right to brighten the shadows (like I did here, where I dragged it over to +34) and look how you can now see the buildings in the foreground better.

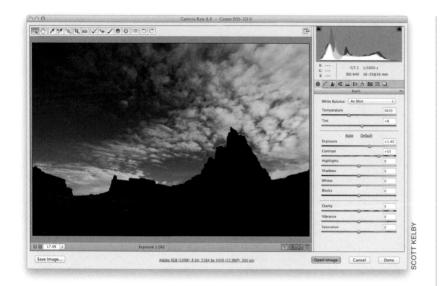

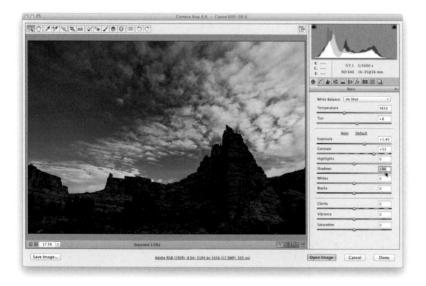

Step Seven:

Before we leave the Shadows slider. we need to switch to another image for just a moment (we'll come back to the other image shortly), because I want to point out that one of the most common times you'll use the Shadows slider is when your subject is backlit like this one, where the sky is pretty well exposed, but the foreground is really dark. When I was standing there, of course my eye compensated perfectly for the two vastly different exposures, but our cameras still aren't as sophisticated as the human eye, so we get shots that look like this. Start by bumping up the Exposure, and then the Contrast (the Shadows slider will work much better when you tweak these first).

Step Eight:

Now, drag the Shadows slider way over to the right to open up those rocks and the foreground, so the whole image looks more balanced (here, I dragged over to +86). Now we can jump back to our original image.

Step Nine:

The last two essential exposure sliders are the Whites and Blacks. If you're used to working with Levels in Photoshop, you'll totally get these, because they're like setting your highlight and shadow points (or your white and black points). Most of the time, if I use the Whites slider (which controls the brightest highlights), I find myself dragging it to the right to make sure the whites are nice and bright white (and not light gray), but in this instance, I was using the Whites slider to pull the whites back a bit (to help hide the fact that it was shot in harsh, direct daylight), so I dragged it to the left (to darken the whites) to around -78. I also increased the deepest shadows by dragging the Blacks slider to the left just a little bit (here, I dragged over to -8). I still use this slider if, near the end of the editing process, I think the color needs more oomph, as this helps the colors look saturated and less washed out. Here's a before/after, but I did add two last finishing touches, which were to increase the Clarity a little (more on this coming up on page 20) and I increased the Vibrance amount a bit. Again, I recommend doing all of this in a top-to-bottom order, but just understand that not every image will need an adjustment to the Highlights and Shadows—only mess with those if you have a problem in those areas. Otherwise, skip 'em.

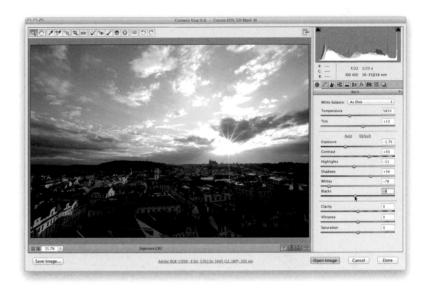

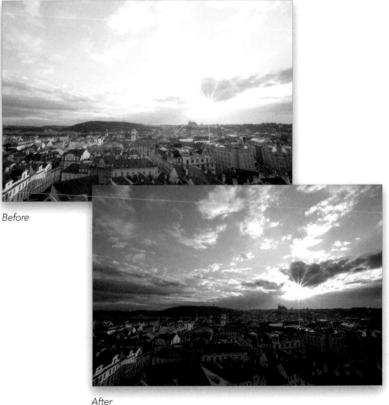

If you're not quite comfortable with manually adjusting each image, Camera Raw does come with a one-click Auto function, which takes a stab at correcting the overall exposure of your image (including contrast, highlights, shadows, etc.), and at this point in Camera Raw's evolution, it's really not that bad. If you like the results, you can set up Camera Raw's preferences so every photo, upon opening in Camera Raw, will be auto-adjusted using that same feature. You also now have the option to add individual Auto corrections, and we'll take a look at how to do that, too.

Letting Camera Raw Auto-Correct Your Photos

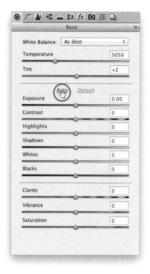

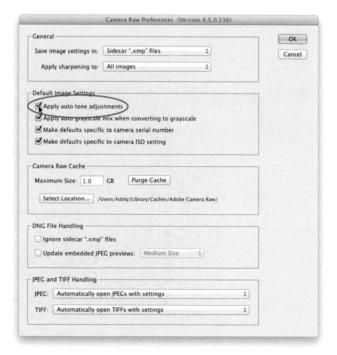

Step One:

Once you have an image open in Camera Raw, you can have Camera Raw take a stab at setting the overall exposure (using the controls in the Basic panel) for you by clicking on the Auto button (shown circled in red here). In older versions of Camera Raw, this Auto correction feature was...well...let's just say it was less than stellar, but it's gotten much better since then, and now it does a somewhat decent job (especially if you're stuck and not sure what to do), so click on it and see how it looks. If it doesn't look good, no sweat—just press Command-Z (PC: Ctrl-Z) to Undo.

Step Two:

You can set up Camera Raw so it automatically performs an Auto Tone adjustment each time you open a photo—just click on the Preferences icon up in Camera Raw's toolbar (it's the third icon from the right), and when the dialog appears, turn on the checkbox for Apply Auto Tone Adjustments (shown circled here), then click OK. Now, Camera Raw will evaluate each image and try to correct it. If you don't like its tonal corrections, then you can just click on the Default button, which appears to the right of the Auto button (the Auto button will be grayed out because it has already been applied).

Step Three:

While the Auto button can do a pretty good job at making a proper exposure, sometimes it's absolutely dreadful. Say you have an image that's intentionally kinda dark, like a low-key image or when you shot someone on a black background. When you click on the Auto button, it tries to make it a daylight shot and it's just a disaster. Here, though, it made it a bit bright, but it's not too bad.

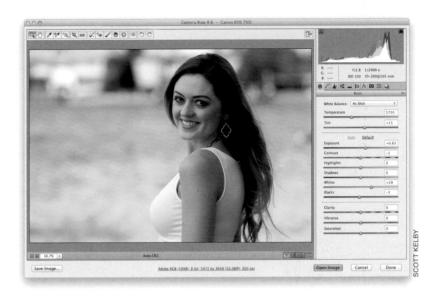

Step Four:

Now, here's the problem: when you hit Auto, it's applying Auto Shadows, Auto Highlights, Auto everything. But, what Adobe added here in Camera Raw (well, hid here; this one's buried) is the option to add individual Auto corrections, like Auto Temperature and Auto Tint, and a way for you to set the white point and black point automatically. So, it's kinda like an Auto White Balance and an Auto Levels, but they're all separate. For example, you can add a separate Auto correction for Tint and a separate one for Temperature. You don't have to do them both; you can do one or the other. Same thing with Whites and Blacks. I've set this back to the default, here, so we can try this out.

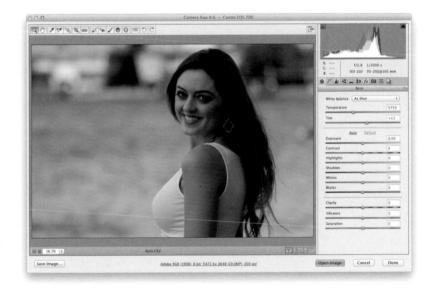

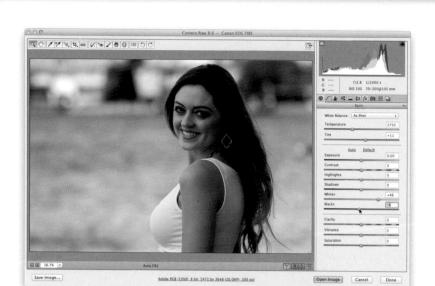

So, let's start with the Whites and Blacks. All you have to do is press-and-hold the Shift key, double-click on the Whites slider knob, and it sets the white point for you. Done. Set. Do the same with the Blacks slider. Boom—it sets the blacks. Look at the difference with just those two; it does a nice job.

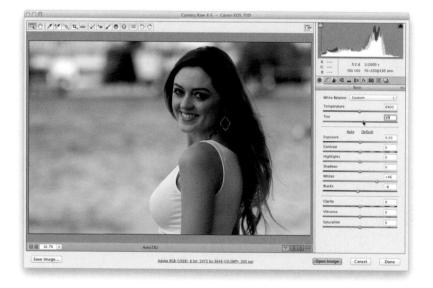

Step Six:

If you want Auto White Balance, just go up, press-and-hold the Shift key, and double-click on the Temperature slider knob. If you need to adjust the Tint, do the same there. If it does something you don't like, release the Shift key, double-click on the knob, and it will return to the default. So, you can't ever mess things up. I think this is a very hidden, but very powerful little tool here.

Adding Punch to Your Images with Clarity

This is one of my favorite features in Camera Raw, and whenever I show it in a class, it never fails to get "Oooohs" and "Ahhhhs." I think it's because it's just one simple slider, yet it does so much to add "snap" to your image. The Clarity slider (which is well-named) basically increases the midtone contrast in a way that gives your photo more punch and impact, without actually sharpening the image. I add lots of Clarity anytime I want to enhance the texture in an image, and it works great on everything from landscapes to cityscapes, from travel photos to portraits of men—anything where emphasizing texture would look good.

Step One:

The Clarity slider is found in the bottom section of the Basic panel in Camera Raw, right above the Vibrance and Saturation sliders. (Although its official name is Clarity, I heard that at one point Adobe engineers considered naming it "Punch" instead, as they felt using it added punch to the image.) To clearly see the effects of Clarity, first zoom in to a 100% view by double-clicking on the Zoom tool up in the toolbar (it looks like a magnifying glass). In the example shown here, I only zoomed to 17.5% so you could see more of the image.

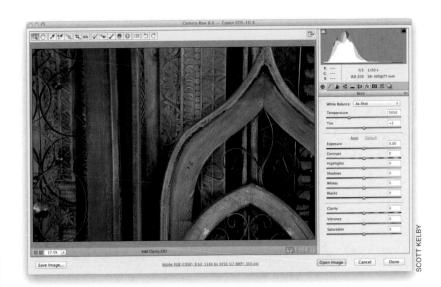

Step Two:

Using the Clarity control couldn't be easier—drag the slider to the right to increase the amount of punch (midtone contrast) in your image (compare the top and bottom images shown here). Here, I dragged it over to +100, which is something you really couldn't get away with in earlier versions of Camera Raw (you'd get horrible halos around everything), but now you can crank that puppy up and it looks awesome! Any image I edit where I want to emphasize the texture (landscapes, cityscapes, sports photos, etc.) gets between +25 and +50 Clarity, but now you can crank it up even higher in most cases (as seen here).

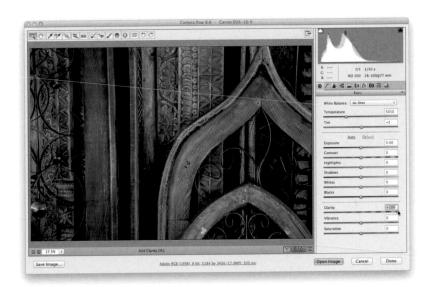

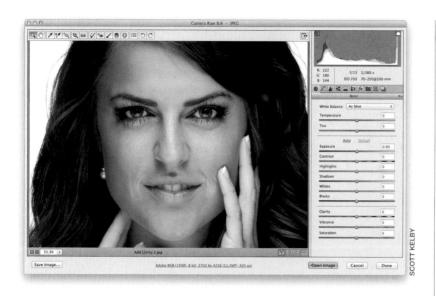

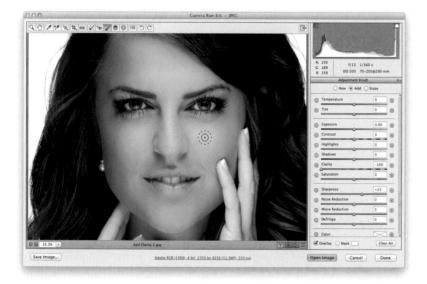

Of course, there are subjects where you don't want to emphasize texture (like women and children), and in those cases, I don't apply any positive Clarity. However, you can also use the Clarity control in reverse—to soften skin. This is called adding negative Clarity, meaning you can apply less than 0 (zero) to reduce the midtone contrast, which gives you a softening effect, but you don't want to apply it to the entire image, so you'd use the Adjustment Brush to apply it (more on the Adjustment Brush in Chapter 3). Here's an original image without any negative Clarity applied.

Step Four:

Here, I've taken the Adjustment Brush (again, lots on how to use this in Chapter 3), and I set the Clarity all the way to the left, to -100, for super-soft skin softening. To balance all that softness, I also increased the Sharpness amount to +25 (more on this soon, too), and then I painted over just her skin, being careful to avoid any areas that should stay nice and sharp, like her eyes, eyebrows, nostrils, lips, hair, and the edges of her face. Take a look at how much softer our subject's skin looks now. Now, if you need to soften up some skin really quickly, and you're not super-fussy about how it looks, negative Clarity can do the trick.

Adjusting Contrast Using Curves

The much-improved Contrast slider in Camera Raw will still only take you so far, but luckily there's Curves, which is a powerful ally in your fight against flat-looking photos. While I've got you here, there's another feature from regular Photoshop that made its way into Camera Raw: the ability to edit individual R, G, and B channels with Curves. Okay, I don't use this feature, but somebody could really have some fun with it (for cross-processing effects, if nothing else).

Step One:

After you've done all your exposure adjustments in the Basic panel, and you feel you need more contrast (hey, it's possible), it's time to head for the Tone Curve panel (click on the second icon from the left, near the top of the Panel area, shown circled here in red). There are two different types of curves available here: the Point curve, and the Parametric curve. We'll start with the Point curve, so click on the Point tab at the top of the panel. Here's what the photo shown here looks like with no added contrast in the Point curve (notice that the Curve pop-up menu above the curve is set to Linear, which is a flat, unadjusted curve). Note: In earlier versions of Camera Raw, RAW images had the default curve set to Medium Contrast (since your camera didn't add any contrast), but now, just like when you shoot in JPEG, no additional contrast will be added by default.

Step Two:

If you want more contrast, choose **Strong Contrast** from the Curve pop-up menu
(as shown here), and you can see how
much more contrast this photo now has,
compared with Step One. The difference
is the Strong Contrast settings create a
steeper curve, and the steeper the curve,
the more contrast it creates.

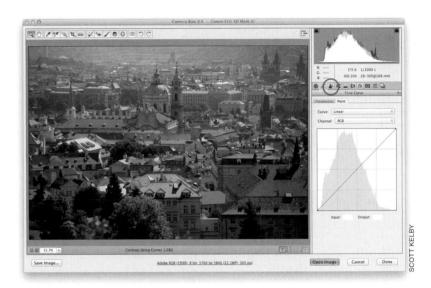

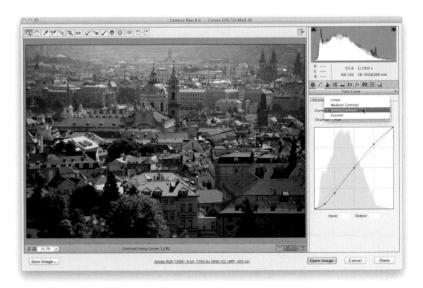

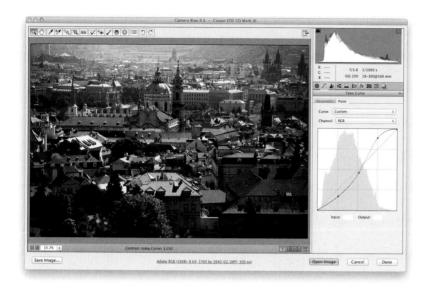

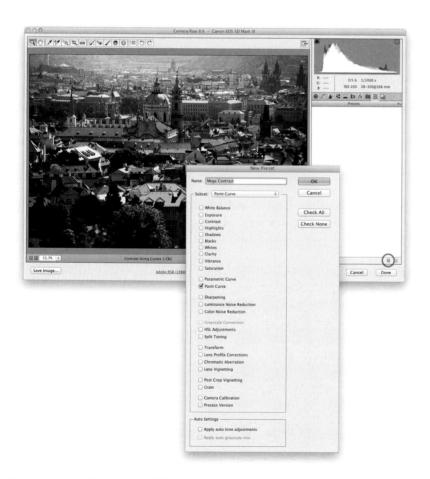

If you're familiar with Photoshop's Curves and want to create your own custom curve, start by choosing any one of the preset curves, then either click-and-drag the adjustment points on the curve or use the **Arrow keys** to move them (I think it's easier to click on a point, then use the Up and Down Arrow keys on your keyboard to move that part of the curve up or down). If you'd prefer to start from scratch, choose Linear from the Curve pop-up menu, which gives you a flat curve. To add adjustment points, just click along the curve. To remove a point, just click-and-drag it right off the curve (drag it off quickly, like you're pulling off a Band-Aid).

Step Four:

If you create a curve that you'd like to be able to apply again to other photos, you can save this curve as a preset. To do that, click on the Presets icon (the second icon from the right) near the top of the Panel area to bring up the Presets panel. Next, click on the New Preset icon (which looks just like Photoshop's Create a New Layer icon) at the bottom of the panel. This brings up the New Preset dialog (shown here). If you just want to save this curve setting, from the Subset pop-up menu near the top, choose Point Curve, and it turns off the checkboxes for all the other settings available as presets, and leaves only the Point Curve checkbox turned on (as shown here). Give your preset a name (I named mine "Mega Contrast") and click OK.

If you're not comfortable with adjusting the Point curve, try the Parametric curve, which lets you craft your curve using sliders that adjust the curve for you. Click on the Parametric tab, and you'll see four sliders, which control the four different areas of the curve, but before you start "sliding," know that the adjustments you make here are added to anything you did in the Point tab (if you did anything there first—I reset the Point tab's Curve popup menu to Linear here).

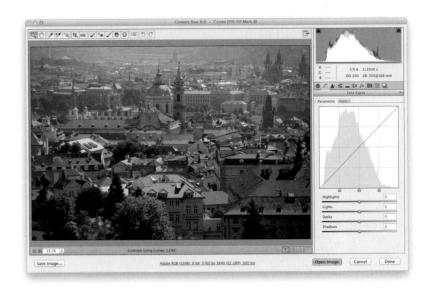

Step Six:

The Highlights slider controls the highlights area of the curve (the top of the curve), and dragging it to the right arcs the curve upward, making the highlights brighter. Right below that is the Lights slider, which covers the next lower range of tones (the area between the midtones and the highlights). Dragging this slider to the right makes this part of the curve steeper, and increases the upper midtones. The Darks and Shadows sliders do pretty much the same thing for the lower midtones and deep shadow areas. But remember, dragging to the right opens up those areas, so to create contrast, you'd drag both of those to the left instead. Here, to create some really punchy contrast, I dragged both the Highlights and Lights sliders to the right, and the Darks and Shadows sliders to the left.

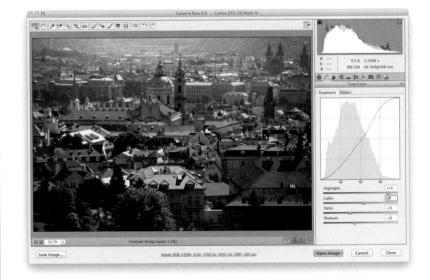

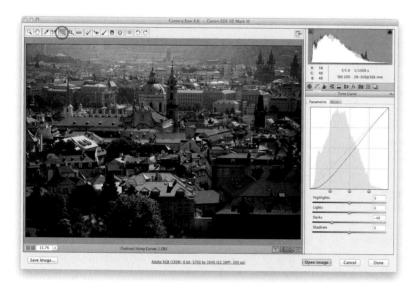

Step Seven:

Another advantage of the Parametric curve is that you can use the region divider controls (under the curve) to choose how wide a range each of the four sliders covers. So, if you move the far-right region divider to the right, it expands the area controlled by the Lights slider. Now the Highlights slider has less impact, flattening the upper part of the curve, so the contrast is decreased. If I drag that same region divider control back to the left instead (shown here), it expands the Highlights slider's area, which steepens the curve and increases contrast.

Step Eight:

If all of this makes you a bit squeamish, have I got a tool for you: it's called the Targeted Adjustment tool (or TAT for short) and you'll find it up in the toolbar at the top of the window (it's the fifth tool from the left, shown circled here). Just move the tool over the part of the image you want to adjust, then drag upward to lighten that area, or downward to darken it (this just moves the part of the curve that represents that part of the image). A lot of photographers love the TAT, so make sure you give it a try, because it makes getting that one area you want brighter (or darker) easier. Now, there is one caveat (I've been waiting to use that word for a while), and that is: it doesn't just adjust that one area of your photoit adjusts the curve itself. So, depending on the image, other areas may get lighter/ darker, too, so just keep an eye on that while you're adjusting. In the example shown here, I clicked-and-dragged upward to brighten the white building a little more, and the curve adjusted to make that happen automatically.

Step Nine:

Before we finish up with curves, there's another feature in Camera Raw we'll look at, and that's the ability to tweak the individual RGB curves in the Point curve. Although this works great for creating cross-processing effects (which we'll cover in a moment), you'll probably wind up using it most for fixing tough white balance problems (like a color cast that just won't go away). You choose which channel you want to adjust by going to the Point tab, and then choosing the individual channel from the Channel pop-up menu (as shown here, where I'm choosing Blue to help me remove a color cast from the background and her skin—the background is supposed to be solid gray, and her skin isn't supposed to be bluish).

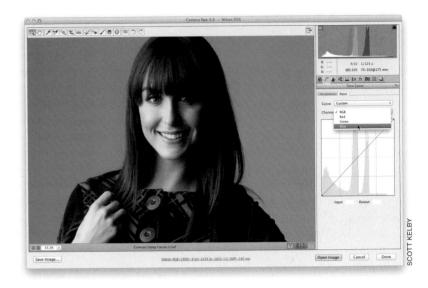

Step 10:

So, now that you have just the Blue channel selected (notice that the Curve readout is now tinted blue, as well, as a visual cue to you that you're adjusting just this one channel), how do you know which part of the curve to adjust? You can get Camera Raw to tell you exactly which part to adjust. Move your cursor over the background area you want to affect, press-and-hold the Command (PC: Ctrl) key, and your cursor temporarily changes into the Eyedropper tool. Click once on your image and it adds a point to the curve that corresponds to the area you want to adjust. Now, click on that curve point and drag at a 45° angle down toward the bottom-right corner, and it removes the blue from the background (as seen here).

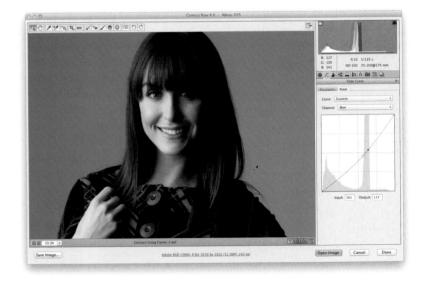

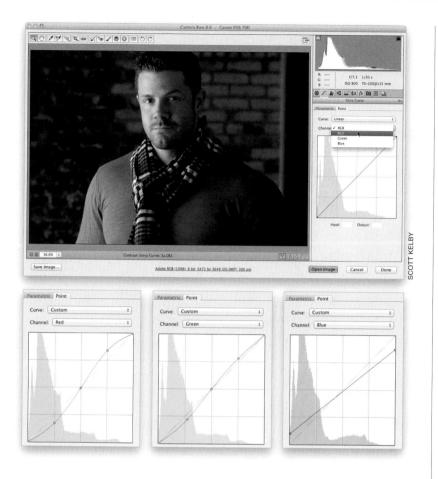

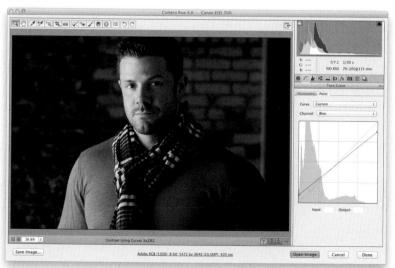

Step 11:

If you want to use these RGB curves to create a cross-processing effect (a classic darkroom technique from the film days, but still popular today, especially in fashion photography), it's actually fairly easy. There are dozens of different combinations, but here's one I like: Start by choosing **Red** in the Point tab's Channel pop-up menu, and create kind of a steep S-curve shape by clicking three times along the diagonal curve (once in the center, once at the next grid line above, and once below), so they're evenly spaced along the line. Now, leave the center point where it is, drag the top point straight upward, and drag the bottom point straight down to create the curve you see here at the far left. Then, switch to the Green channel and make another three-point S-curve, but one that's not as steep (as seen here, in the center). Lastly, go to the Blue channel, don't add any points, and just drag the bottom-left point straight upward along the left edge (as seen here at right) and drag the top-right point down along the right edge.

Step 12:

Of course, based on the particular image you use, you might have to tweak these settings a bit (usually, it's the amount you drag in the Blue channel, but again, it depends on the photo you're applying it to). If you come up with a setting you like, don't forget to save it as a preset in the Preset panel (just like you did with your Mega Contrast curve earlier).

Cropping and Straightening

There's a distinct advantage to cropping your photo here in Camera Raw, rather than in Photoshop itself, and that is you can return to Camera Raw later and bring back the uncropped version of the image. This even holds true for JPEG and TIFF photos, as long as you haven't overwritten the original JPEG or TIFF file. To avoid overwriting, when you save the JPEG or TIFF in Photoshop, just change the filename (that way the original stays intact). With RAW images, you don't have to worry about that, because it doesn't let you overwrite the original.

Step One:

The Crop tool (C) is the sixth tool from the left in the toolbar. By default, you click-and-drag it out around the area you want to keep, and like in Photoshop, you have access to a list of preset cropping ratios. To get them, click-and-hold on the Crop tool and a pop-up menu will appear (as shown here). The Normal setting gives you the standard drag-itwhere-you-want-it cropping. However, if you choose one of the cropping presets, then your cropping is constrained to a specific ratio. For example, choose the 2 to 3 ratio, click-and-drag it out, and you'll see that it keeps the same aspect ratio as your original uncropped photo.

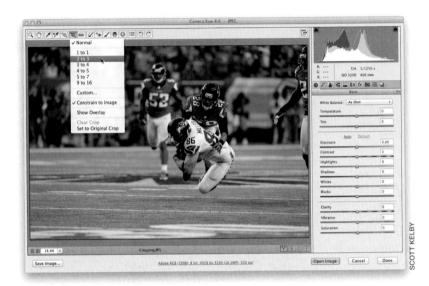

Step Two:

Here's the 2-to-3-ratio cropping border dragged out over my image. The area to be cropped away appears dimmed, and the clear area inside the border is how your final cropped photo will appear. If you want to see the cropped version before you leave Camera Raw, just switch to another tool in the toolbar. (Note: If you draw a set size cropping border and want to switch orientation, click on the bottom-right corner and drag down and to the left to switch from wide to tall, or up and to the right to switch from tall to wide.)

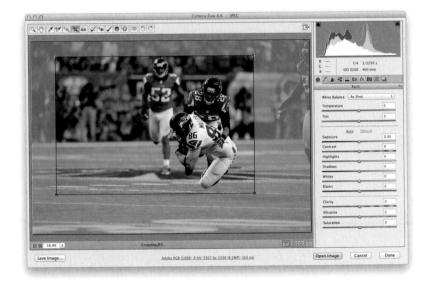

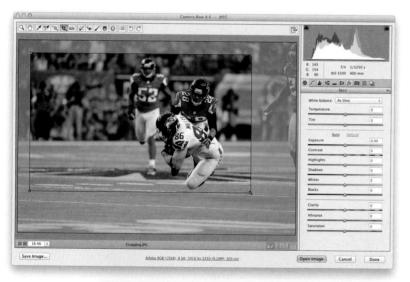

If you re-open your cropped photo again in Camera Raw, you'll see the cropped version. To bring back the cropping border, just click on the Crop tool. To remove the cropping altogether, press the **Esc** or **Delete (PC: Backspace) key** on your keyboard (or choose **Clear Crop** from the Crop tool's pop-up menu). If you want an aspect ratio that isn't in the presets (like 3 to 5, for example), choose **Custom** from the Crop tool's pop-up menu to bring up the dialog you see here. Just enter your aspect ratio, click OK, and it will now appear in the pop-up menu.

Step Four:

Here, we're going to create a custom crop so our photo winds up having a 3 to 5 aspect ratio, so type in your custom size, click OK, click-and-drag out the cropping border, and the area inside it will be a 3-to-5 ratio. Click on any other tool in the toolbar or press **Return (PC: Enter)**, and you'll see the final cropped image. If you click the Open Image button, the image is cropped to your specs and opened in Photoshop. If, instead, you click the Done button, Camera Raw closes and your photo is untouched, but it keeps your cropping border in place for the future.

If you save a cropped JPEG or TIFF photo out of Camera Raw (by clicking the Done button), the only way to bring back those cropped areas is to reopen the photo in Camera Raw. However, if you click the Save Image button and you choose **Photoshop** from the Format pop-up menu (as shown), a new option will appear called Preserve Cropped Pixels. If you turn on that checkbox before you click Save, when you open this cropped photo in Photoshop, it will appear to be cropped, but the photo will be on a separate layer (not flattened on the Background layer). So the cropped area is still there—it just extends off the visible image area. You can bring that cropped area back by clicking-and-dragging your photo within the image area (try it-use the Move tool [V] to clickand-drag your photo to the right or left and you'll see what I mean).

Step Six:

If you have a number of similar photos you need to crop the same way, you're going to love this: First, select all the photos you want to crop in Camera Raw (either in Bridge or on your computer), then open them all in Camera Raw. When you open multiple photos, they appear in a vertical filmstrip along the left side of Camera Raw (as shown here). Click on the Select All button (it's above the filmstrip) and then crop the currently selected photo as you'd like. As you apply your cropping, look at the filmstrip and you'll see all the thumbnails update with their new cropping instructions. A tiny Crop icon will also appear in the bottom-left corner of each thumbnail, letting you know that these photos have been cropped in Camera Raw.

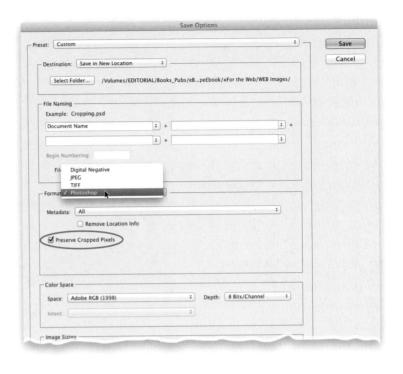

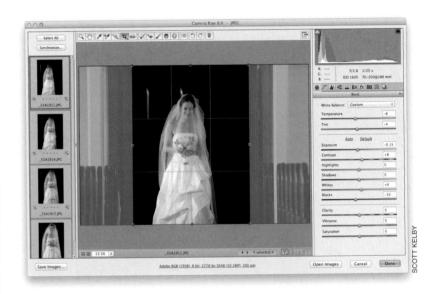

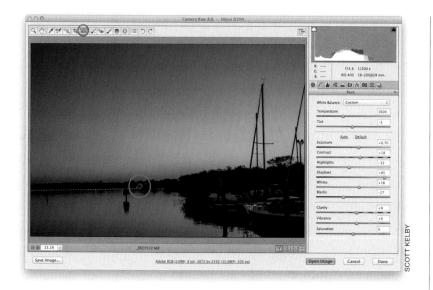

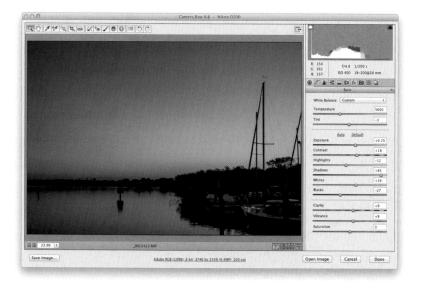

Step Seven:

Another form of cropping is actually straightening your photos using the Straighten tool. It's a close cousin of the Crop tool because what it does is essentially rotates your cropping border, so when you open the photo, it's straight. In the Camera Raw toolbar, choose the Straighten tool (it's immediately to the right of the Crop tool and shown circled here in red). Now, click-and-drag it along the horizon line in your photo (as shown here. You can also double-click on the tool itself, or double-click on the image). When you release the mouse button, a cropping border appears and that border is automatically rotated to the exact amount needed to straighten the photo (as shown in Step Eight).

Step Eight:

You won't actually see the straightened photo until you switch tools, press Return (PC: Enter), or open the photo in Photoshop (which means, if you click Save Image or Done, Camera Raw closes, and the straightening information is saved along with the file. So if you open this file again in Camera Raw, you'll see the straightened version, and you won't really know it was ever crooked). If you click Open Image instead, the straightened photo opens in Photoshop. Again, if this is a RAW photo (or if it's a JPEG or TIFF and you clicked the Done button), you can always return to Camera Raw and remove this cropping border to get the original uncropped photo back.

TIP: Canceling Your Straightening
If you want to cancel your straightening,
just press the **Esc key** on your keyboard,
and the straightening border will go away.

Seeing a Before/After in Camera Raw

Before Photoshop CC, Camera Raw's ability to show you a before/after preview of your changes was clunky at best, and totally confusing at worst, mostly because toggling on/off the Preview checkbox didn't show you a full before/after of your image, it only turned on/off the changes you made in the current panel. Luckily, in CC, they borrowed a feature from Lightroom and gave us before/after previews that have a lot of options and make sense.

Step One:

If you've made some adjustments, and want to see what your image looked like before you made them (the "before" image), just press the P key on your keyboard. This is probably the Before view I use the most in my own workflow. To return to your After image, press P again. If you'd like to see a side-by-side Before/ After view, either click on the Before/After preview icon (circled here in red) or press the Q key to get the view you see here, with the Before image on the left, and the After image, with the tweaks you applied (here, I applied a duotone look using the technique found on page 156) on the right. Note: Each time you press Q, it toggles to a different preview view.

Step Two:

One thing I don't like about this sideby-side view is that while it works great on tall, vertical images, for wide orientation images like this, the previews are really small. Luckily, you can fix that: once you're in this view, just press Command-+ (plus sign; PC: Ctrl-+) to zoom in on your image like you see here. Each time you press that shortcut, it zooms in tighter. Once you're zoomed in tight, you can reposition your image by simply clicking on either image (your cursor changes to the Hand tool) and dragging the image any way you want. To zoom back out, press Command-- (minus sign; PC: Ctrl--) until you're zoomed out enough.

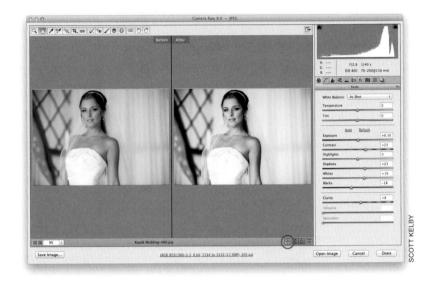

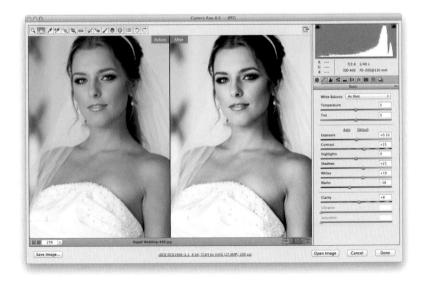

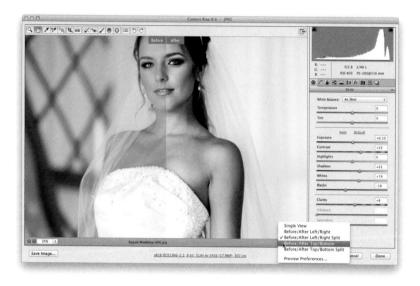

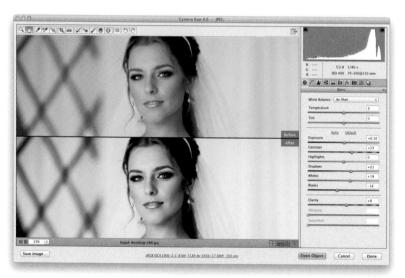

Another preview option is a split-screen that shows the left half of the image as the Before and the right half as the After (as seen here). Once you're in this mode. you can literally swap sides, so the After is on the left and the Before is on the right (so instead of a Before/After, you have an After/Before). To do that, click on the icon to the right of the Before/After icon (it's shown circled in red here, at the bottom) below the bottom-right corner of your image preview, and it swaps the two. If you click the next icon to the right of it, it copies the current settings to the Before image. The final icon (on the far right), lets you toggle on/off the changes made in just the current panel (like the old way previews worked in Camera Raw). By the way, if you click-and-hold on the first icon (the one that looks like the letter "Y"), a pop-up menu appears (seen here) that lets you choose the different before/ after previews by name.

Step Four:

If you press Q again, it toggles you to the Before/After Top/Bottom preview (as seen here, which looks kinda creepy, since her color head is growing out of her black & white head). If you press Q one last time, you get a top/bottom split view. Anyway, besides all this, you have a reasonable amount of control over how all this is displayed by going to that pop-up menu we saw back in Step Three and choosing Preview Preferences to bring up the dialog you see here below. The first column lets you hide (by turning off) any of the preview mode checkboxes you don't care about (I only use the left/right sideby-side myself). In the second column, you get to choose whether you want to see a solid line divider between your before/ after previews, and if you want to see the words Before and After onscreen.

Photoshop Killer Tips

Skipping the Camera Raw Window Altogether

If you've already applied a set of tweaks to a RAW photo, you probably don't need the Camera Raw editing window opening every time you open the file. So, just pressand-hold the Shift key when you doubleclick on the RAW file in Bridge, and the image will open in Photoshop, with the last set of edits already applied, skipping the Camera Raw window altogether. If you didn't apply any tweaks in Camera Raw, it just opens with the Camera Raw defaults applied. Either way, it's a big time saver.

Handy Shortcuts for Blend Modes

Most people wind up using the same handful of layer blend modes—Multiply, Screen, Overlay, Hard Light, and Soft Light. If those sound like your favorites, you can save yourself some time by jumping directly to the one you want using a simple keyboard shortcut. For example, to jump directly to Screen mode, you'd press Option-Shift-S (PC: Alt-Shift-S), for Multiply mode, you'd press Option-Shift-M (PC: Alt-Shift-M), and so on. To run through the different shortcuts, just try different letters on your keyboard.

Seeing Image Size

The size of your photo (and other information) is displayed below the Preview area of Camera Raw (in blue underlined text that looks like a web link). When you drag out a cropping border, the size info for the photo automatically updates to display the dimensions of the currently selected crop area.

Don't Get Fooled by the Default Button

If you've edited your image in Camera Raw, and then you decide you want to start over, clicking the Default button in the Basic panel (it's to the left of the Auto button) won't return your image to how it looked when you opened it. Instead, to get back to the original way your image looked when you first opened it in Camera Raw, go to the Camera Raw flyout menu and choose Camera Raw Defaults. You can also press-and-hold the Option (PC: Alt) key, and the Cancel button will change to a Reset button.

Deleting Multiple Images While Editing in Camera Raw

If you have more than one image open in Camera Raw, you can mark any of them you want to be deleted by selecting them (in the filmstrip on the left side of Camera Raw), then pressing the Delete key on your keyboard. A red "X" will appear on those images. When you're done in Camera Raw, click on the Done button, and those images marked to be deleted will be moved to the Trash (PC: Recycle Bin) automatically. To remove the mark for deletion, just select them and press the Delete key again.

Cool Raw Retouching Trick

There's a pretty common retouching technique in Photoshop for reducing hot spots (shiny areas on a subject's face), which uses the Healing Brush to completely remove the hot spot, then under the Edit menu, you choose Fade Healing Brush, and lower the Opacity there. A little hint of the hot spot comes back, so it looks more like a

Spot Removal Type: Heal Size 4 Feather 100 Opacity 76

highlight than a shine (it actually works really well). You can do something similar in Camera Raw when using the Spot Removal tool (set to Heal) by removing the hot spot (or freckle, or wrinkle) and then using the Opacity slider in the Spot Removal options panel.

Get a Larger Preview Area

If you have multiple images open in Camera Raw, and need more room to see the preview of the image you're currently working on, just double-click right on that little divider that separates the filmstrip from the Preview area, and the filmstrip tucks

in over to the left, out of the way, giving you a larger preview. To bring it back, just double-click on that divider again (it's now over on the far-left side of the Camera Raw window) and it pops back out.

Rate Your Images in Camera Raw You don't have to be in Bridge to add or change star ratings. If you've got multiple images open, you can do it right in

Photoshop Killer Tips

Camera Raw. Just press **Command-1, -2,** -3 (PC: Ctrl-1, -2, -3), and so on, to add star ratings (up to five stars). You can also just click directly on the five little dots that appear below the thumbnails in the filmstrip on the left.

Rule-of-Thirds Cropping

This one Adobe borrowed from Camera Raw's sister program Photoshop Lightroom, because (like in Lightroom) you can have the "Rule-of-Thirds" grid appear over your cropping border anytime by just clicking-and-holding on the Crop tool ian the toolbar, then choosing **Show Overlay**.

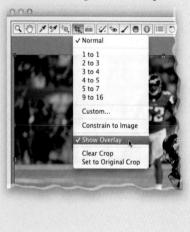

Jump to Full Screen Mode in Camera Raw

If you want to see your image in Camera Raw as large as possible, just press the **F key**, and Camera Raw expands to Full Screen mode, with the window filling your monitor, giving you a larger look at your image.

Shortcut for Viewing Sharpening The best zoom magnification to view

your sharpening in Camera Raw is a 100% view, and the quickest way to get there is to just double-click the Zoom tool.

Don't Know Where to Start When Editing an Image? Try Auto Levels or Curves

Adobe greatly improved the results of the Auto button found in the Levels and Curves adjustment layer settings in the Properties panel, as well as in the Levels and Curves adjustment dialogs. It often actually makes a pretty decent starting point for editing your image, especially if you have a tricky image and you're not sure where to start.

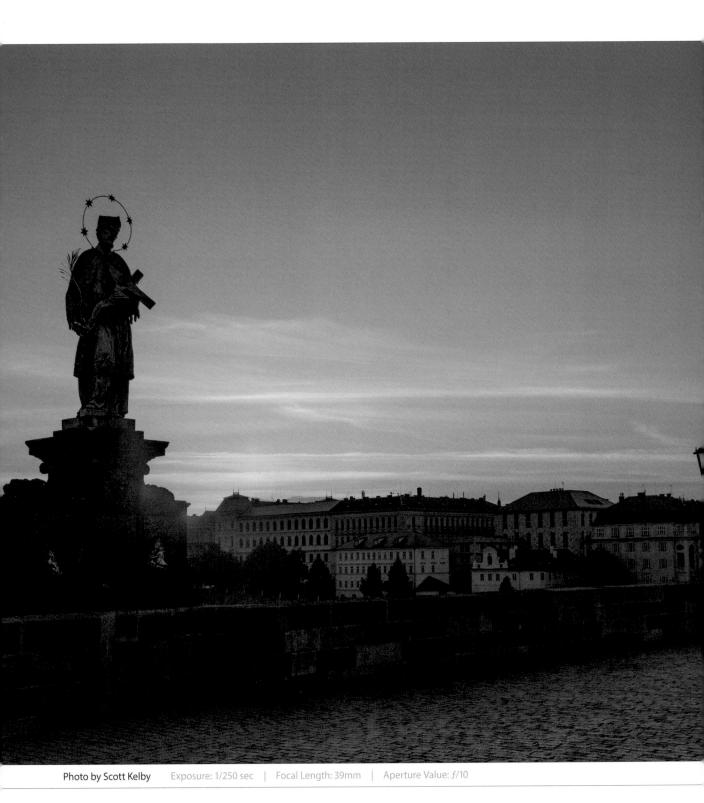

Chapter 2 Camera Raw—Beyond the Basics

Raw Justice

camera raw—beyond the basics

When I searched The Internet Movie Database (IMDb) for movies or TV shows containing the word "Raw," I was pleasantly surprised to find out just how many choices I actually had. However, I went with the 1994 movie Raw Justice, but I don't want you to think for one minute that I was influenced in any way by the fact that the star of the movie was Pamela Anderson. That would be incredibly shallow of me. Like any serious movie buff, I was drawn to this movie by what drew most of the audience to this movie: actor Robert Hays (who could forget his role in 2007's Nicky's Birthday Camera or the Michael Tuchner-directed film Trenchcoat). Of course, the fact that Stacey Keach was in the movie was just the icing on the cake, but everybody knows the real draw of this flick clearly was Hays. However, what I found most puzzling was this: in the movie poster, Pamela Anderson totally dominates the poster with a large,

full-color, 3/4-length pose of her wearing a skimpy black dress, thigh-high boots, and holding a pistol at her side. yet the other actors appear only as tiny black-and-white. backscreened headshots. I have to admit, this really puzzles me, because while Pamela Anderson is a fine actress one of the best, in fact—I feel, on some level, they were trying to fool you into watching a movie thinking it was about Pamela Anderson's acting, when in fact it was really about the acting eye candy that is Hays. This is called "bait and switch" (though you probably are more familiar with the terms "tuck and roll" or perhaps "Bartles & Jaymes"). Anyway, I think, while "Raw Justice" makes a great title for a chapter on going beyond the basics of Camera Raw, there is no real justice in that this finely crafted classic of modern cinematography wound up going straight to DVD.

Double-Processing to Create the Uncapturable

As good as digital cameras have become these days, when it comes to exposure, the human eye totally kicks their butt. That's why we shoot so many photos where our subject is backlit, because with our naked eye we can see the subject just fine (our eye adjusts). But when we open the photo, the subject is basically in silhouette. Or how about sunsets, where we have to choose which part of the scene to expose for—the ground or the sky—because our camera can't expose for both? Well, here's how to use Camera Raw to overcome this exposure limitation:

Step One:

Open the photo you want to doubleprocess. In this example, the camera properly exposed for the sky in the background, so the bridge in the foreground is a silhouette. Of course, our goal is to create something more like what our eye sees, but our camera can't—a photo where both the bridge and the sky are each exposed properly. Plus, by doubleprocessing (editing the same RAW photo twice), we can choose one set of edits for the sky and another for the bridge, to create just what we want.

Step Two:

Let's start by making the bridge visible. Drag the Shadows slider all the way to the right, and then bump up the Exposure slider, as well (here, I've dragged it over to +0.50). The bridge looks kind of "flat" contrast-wise, so bump up the Contrast a bit, too (let's go to +64). Lastly, since this is a brick bridge, and we want to accentuate its texture, let's crank the Clarity up to around +43, and then make the little bit of color that's there more vibrant by increasing the Vibrance to around +35. Now, press-and-hold the Shift key, and the Open button changes to Open Object (as seen here). Click it.

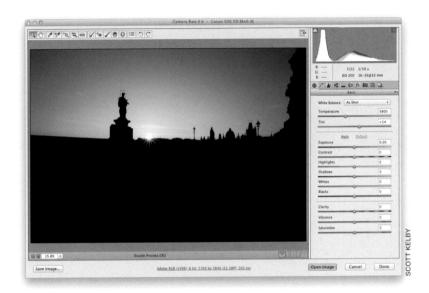

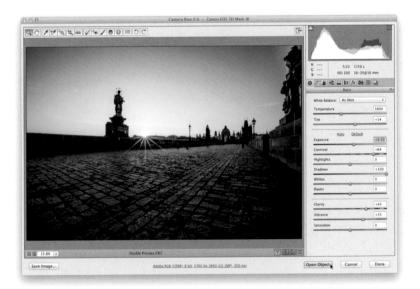

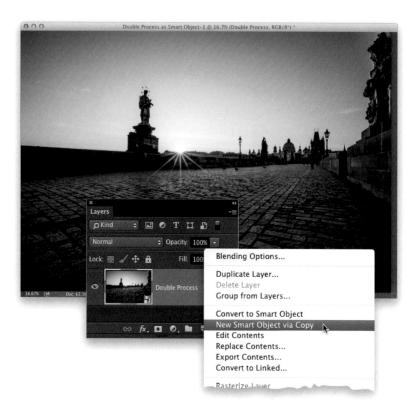

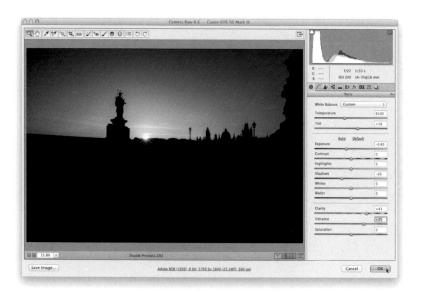

Clicking Open Object makes your image open in Photoshop as a smart object (you'll see the layer thumbnail has a little page icon in the bottom-right corner). Now we need a second version of this image, because the sky looks a bit too light in this version. In our second version of this RAW file, we'll focus on just the sky. If you were to duplicate the layer by dragging it onto the Create a New Layer icon, the double-processing wouldn't work. That's because the duplicate layer would be tied to the original layer, so any changes you made to the duplicate would also automatically be applied to the original layer. We need to be able to edit these two layers separately from each other. Basically, we need to break the link between the two layers. To do that, go to the Layers panel, Right-click on the layer, and from the pop-up menu that appears, choose New Smart Object via Copy. This gives you a duplicate layer, but breaks the link to the original layer.

Step Four:

Now, double-click directly on this duplicate layer's thumbnail and it opens this duplicate in Camera Raw. Here, you're going to expose for the sky, without any regard for how the bridge looks (it will turn really dark, but who cares—you've already got a version with it properly exposed on its own separate layer, right?). So, first click the Default link to reset the sliders to 0, then drag the Exposure slider way over to the left (I went to -0.65), and drag the Shadows slider to -26 to help darken the sky. I also dragged the Temperature and Tint sliders a little to the right to warm the color of the sky, and lastly, I left the Clarity and Vibrance set to what they were. Once the sky looks good, click OK.

You now have two versions of your photo, each on a different layer—the brighter one exposed for the bridge in the foreground on the bottom layer, and the darker sky version on the layer directly on top of it—and they are perfectly aligned, one on top of the other. This is why we call it "double-processing," because you have two versions of the same image, each processed differently. Now what we need to do is combine these two different layers (with different exposures) into one single image that combines the best of both. It'll be easier if we have the image with the properly exposed bridge as our top layer, so click on that layer and drag it above the darker sky layer (as seen here). We'll combine the images with a layer mask, but rather than painstakingly painting it, we can cheat and use the Quick Selection tool (W). So, get it from the Toolbox and paint over the bridge, statues, and buildings, and it selects them for you in just a few seconds (as shown here).

Step Six:

Go to the Layers panel and click on the Add Layer Mask icon at the bottom of the panel (shown circled here in red). This converts your selection into a layer mask, which hides the light sky and reveals the new darker sky layer in its place (as seen here).

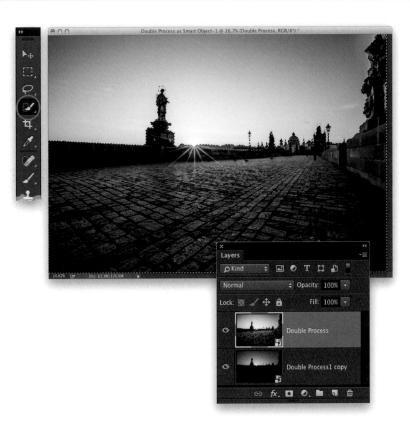

Step Seven:

Now, you're going to lower the Opacity of this top layer (the brighter bridge layer), so it blends in a little better with the darker sky layer. Here, I've lowered it to 80%, and the colors match much better.

TIP: Always Opening Your Images as Smart Objects

If you always want your RAW-processed images to open as smart objects, click on the workflow options link at the bottom of the Camera Raw dialog (the blue text below the Preview area), and when the dialog appears, turn on the Open in Photoshop as Smart Objects checkbox.

Step Eight:

Now, we have a pretty common problem to deal with here: along the edge, where the brighter bridge meets the darker sky, there's a little bit of a white fringe happening (I zoomed in here to 100%, so you can see it better). Luckily, that's fairly easy to fix, without having to take a tiny brush and paint all along that edge (which is how we used to do it, and we still sometimes do that for a little touch-up, but this isn't a little touch-up).

Step Nine:

We're going to shift the edge of our mask a few pixels, so you don't see that white edge fringe any longer, and we'll let Photoshop do all the heavy lifting. Go under the Select menu and choose Refine Mask. This brings up the Refine Mask dialog you see here. First, to make seeing this white edge easier, from the View pop-up menu up top, choose On Black and now it really stands out, so you can see it clearly for what you're going to do next. In the Edge Detection section, turn on the Smart Radius checkbox and drag the Radius slider to the right until the white edge is almost gone (I dragged to 3.1). Then, under Adjust Edge, drag the Shift Edge slider to the left (as shown here) until the white edge disappears (as you see here, where I dragged to -25), then click OK. See, that was fairly easy. Again, if after doing this, you still notice a white pixel or two here or there, just take a very small brush, set it to 50% Opacity up in the Options Bar, and simply paint over it to hide it.

Step 10:

Now, let's finish this baby off. Go to the Layers panel and, from the flyout menu at the top right, choose **Flatten Image** to flatten the image down to one layer. Then, I would do something to make the image a little more vibrant (and applying an effect to the combined image helps unify the look). So, go under the Filter menu and choose **Camera Raw Filter** to reopen the image in Camera Raw.

Step 11:

Just increase the Vibrance setting to give the image a more vibrant, unified look (I increased it to +45), and click OK. You can see a before/after of our double-processed image below.

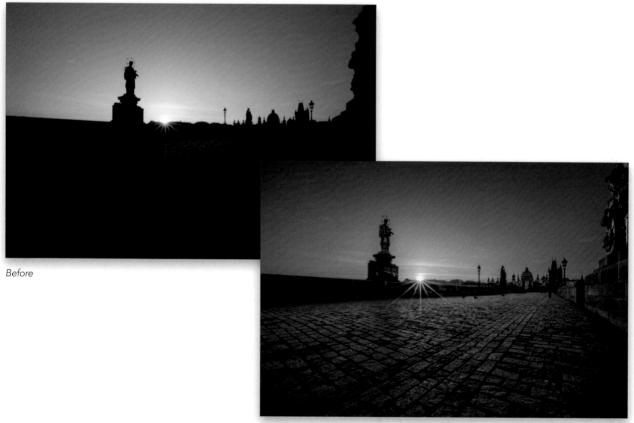

After

Editing Multiple Photos at Once

One of the biggest advantages of using Camera Raw is that it enables you to apply changes to one photo, and then easily apply those exact same changes to a bunch of other similar photos taken in the same approximate setting. It's a form of built-in automation, and it can save you an incredible amount of time when editing your shoots.

Step One:

The key to making this work is that the photos you edit all are shot in similar lighting conditions, or all have some similar problem. In this case, our photos are too red and a little underexposed. In Bridge, start by selecting the images you want to edit (click on one, press-and-hold the Command [PC: Ctrl] key, then click on all the others). If they're RAW images, just double-click on any one of them and they open in Camera Raw, but if they're JPEG or TIFF images, you'll need to select them, and then click on the Open in Camera Raw icon at the top of the window.

Step Two:

When the images open in Camera Raw, you'll see a filmstrip along the left side of the window with all the images you selected. Now, there are two ways to do this and, while neither one is wrong, I think the second method is faster (which you'll see in a moment). We'll start with the first: Click on an image in the filmstrip, then make any adjustments you want to make this one image look good (I tweaked the Temperature, Exposure, Contrast, Highlights, Whites, Blacks, and Clarity to fix the white balance, brighten it, and make it more contrasty).

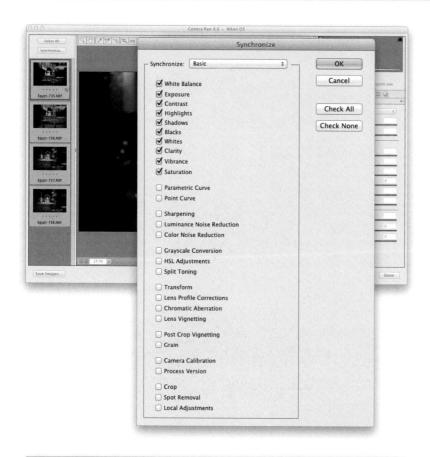

Once you've got one of the photos looking good, click the Select All button up at the top of the filmstrip to select all the photos (even though it selects the rest of the photos, you'll notice that the image you edited is actually the "most selected" image, with a highlight border around it). Now click the Synchronize button (it's right below the Select All button) to bring up the Synchronize dialog (seen here). It shows you a list of all the things you could copy from this "most selected" photo and apply to the rest of the selected photos. Choose Basic from the pop-up menu at the top, and it unchecks all the other stuff, and leaves just the Basic panel checkboxes turned on.

Step Four:

When you click the OK button, it applies the Basic panel settings from the "most selected" photo to all the rest of the selected photos (if you look in the filmstrip, you'll see that all the photos have had those settings adjusted). Okay, so why don't I like this method? Although it does work, it takes too many clicks, and decisions, and checkboxes, which is why I prefer the second method.

TIP: Editing Only Select Photos
If you only want certain photos to be
affected, and not all the ones open
in Camera Raw, then in the filmstrip,
Command-click (PC: Ctrl-click) on only
the photos you want affected and click
the Synchronize button.

In the second method, as soon as Camera Raw opens, click the Select All button to select all your images, then go ahead and make your changes. As you make the changes to your "most selected" photo, all the others are updated with your new settings almost instantly, so you don't have to remember which settings you applied—when you move one slider, all the images get the same treatment, so you don't need the Synchronize dialog at all. Try out both methods and see which one you like, but if you feel the need for speed, you'll probably like the second one much better.

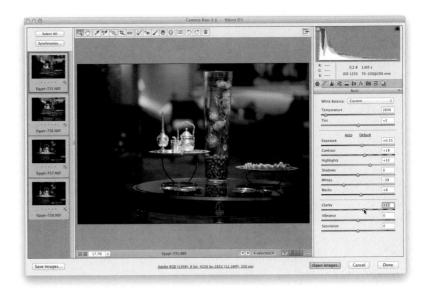

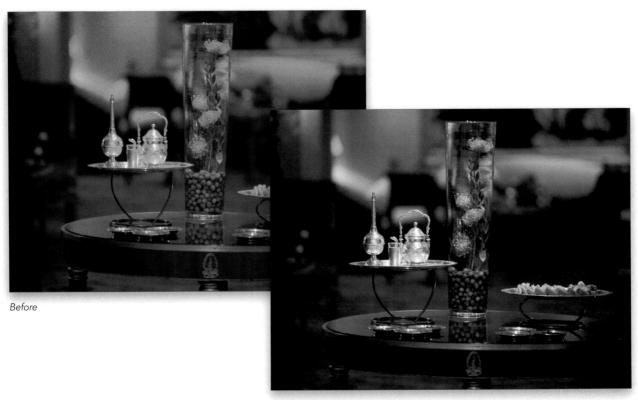

After

If you shoot in JPEG, your digital camera applies sharpening to your photo right in the camera itself, so no sharpening is automatically applied by Camera Raw. But if you shoot in RAW, you're telling your camera to ignore that sharpening, and that's why, when you bring a RAW image into Camera Raw, by default, it applies some sharpening, called "capture sharpening." In my workflow, I sharpen twice: once here in Camera Raw, and once more right before I output my final image from Photoshop (called "output sharpening"). Here's how to apply capture sharpening in Camera Raw:

Sharpening in Camera Raw

Step One:

When you open a RAW image in Camera Raw, by default, it applies a small amount of sharpening to your photo (not the JPEGs or TIFFs, only RAW images). You can adjust this amount (or turn it off altogether, if you like) by clicking on the Detail icon (it's the third icon from the left) at the top of the Panel area, or using the keyboard shortcut Command-Option-3 (PC: Ctrl-Alt-3). At the top of this panel is the Sharpening section, where by a quick glance you can see that sharpening has already been applied to your photo. If you don't want any sharpening applied at this stage (it's a personal preference), then simply click-and-drag the Amount slider all the way to the left to lower the amount of sharpening to 0 (zero), and the sharpening is removed.

Step Two:

If you want to turn off this automatic, by default sharpening (so capture sharpening is only applied if you go and manually add it yourself), first set the Sharpening Amount slider to 0 (zero), then go to the Camera Raw flyout menu and choose Save New Camera Raw Defaults (as shown here). Now, RAW images taken with that camera will not be automatically sharpened.

Before we charge into sharpening, there's one more thing you'll want to know: if you don't actually want sharpening applied, but you'd still like to see what the sharpened image would look like, you can sharpen just the preview, and not the actual file. Just press Command-K (PC: Ctrl-K) while Camera Raw is open, and in the Camera Raw Preferences dialog, choose Preview Images Only from the Apply Sharpening To pop-up menu (as shown here), and then click OK to save this as your default. Now the sharpening only affects the preview you see here in Camera Raw, but when you choose to open the file in Photoshop, the sharpening is not applied.

Step Four:

If you've been using Camera Raw for a while now, you probably remember back to older versions of Photoshop where you had to view your image at 100% to really see any effects of the sharpening. They pretty much fixed that back in CS5, so it's not as necessary to be at a 100% size view, but it still seems to me to render the most accurate view of the sharpening. The guickest way to jump to that 100% view is to double-click directly on the Zoom tool in the toolbar (shown circled here). (Note: You'll see a message about zooming to 100% at the bottom of the Detail panel, but it'll disappear after you zoom in to 100%.)

Dipping into the realm of the painfully obvious, dragging the Amount slider to the right increases the amount of sharpening. Compare the image shown here, with the one in Step Four (where the Sharpening Amount was set to 0), and you can see how much sharper the image now appears, where I dragged it to 100.

Step Six:

The next slider down is the Radius slider, which determines how far out the sharpening is applied from the edges being sharpened in your photo. This pretty much works like the Radius slider in Photoshop's Unsharp Mask filter, which is probably why the default is 1 (because that's probably where we'll leave it most of the time). I use less than a Radius of 1 if the photo I'm processing is only going to be used on a website, in video editing, or somewhere where it's going to be at a very small size or resolution. I only use a Radius of more than 1 when: (1) the image is visibly blurry, (2) it has lots of detail (like this photo, where I pushed the Radius to 1.2), so it can take some serious sharpening, or (3) the image needs some "emergency" sharpening. If you decide to increase the Radius amount above 1 (unlike the Unsharp Mask filter, you can only go as high as 3 here), just be careful, because if you go too much above 1, your photo can start to look fake, oversharpened, or even noisy, so be careful out there (in the next step, I set it back to 1).

Step Seven:

The next slider down is the Detail slider, which determines how much of the edge areas are affected by sharpening. You'll apply lower amounts of Detail if your photo is slightly blurred, and higher amounts if you really want to bring out texture and detail (which is why this slider is aptly named). So, how much Detail you apply depends on the subject you're sharpening. With an image like this one, with lots of metal and texture it's an ideal candidate for a high amount of Detail (as are most landscapes, cityscapes, motorcycle shots—stuff with lots of edges), so I dragged the slider to the right (all the way to 78), until the detail really came out.

Step Eight:

I'm going to change photos to show you the Masking slider. This one's easier to understand, and for many people, I think it will become invaluable. Here's why: When you apply sharpening, it gets applied to the entire image evenly. But what if you have an image where there are areas you'd like sharpened, but other softer areas that you'd like left alone (like the photo here, where you want to keep her skin soft, but have her eyes, lips, etc., sharpened)? If we weren't in Camera Raw, you could apply the Unsharp Mask filter to a duplicate layer, add a layer mask, and paint away (cover) those softer areas, right? Well, that's kind of what the Masking slider here in Camera Raw does—as you drag it to the right, it reduces the amount of sharpening on non-edge areas. The default Masking setting of 0 (zero) applies sharpening to the entire image. As you drag to the right, the non-edge areas are masked (protected) from being sharpened.

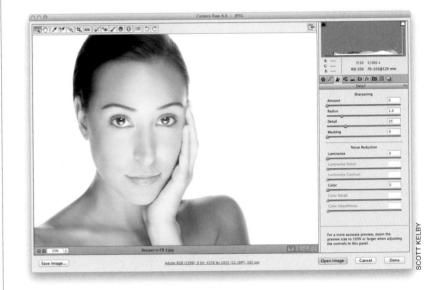

Step Nine:

All four sliders in the Sharpening section of the Detail panel let you have a live preview of what the sharpening is affecting—just press-and-hold the Option (PC: Alt) key as you drag; your screen will turn grayscale, and the areas that the slider you're dragging will affect appear as edge areas in the Preview area. This is particularly helpful in understanding the Masking slider, so press-and-hold the Option key and drag the Masking slider to the right. When Masking is set to 0, the screen turns solid white (because sharpening is being evenly applied to everything). As you drag to the right, in the preview (shown here), the parts that are no longer being sharpened turn black (those areas are masked). Any areas you see in white are the only parts of the photo receiving sharpening (perfect for sharpening women, because it avoids sharpening their skin, but sharpens the things you want sharp, like the eyes, hair, eyebrows, lips, edges of her face, and so on). Below is a before/after of our manhole cover shot, with these settings-Amount: 110, Radius: 1, Detail: 78, Masking: 0.

After

Automatically Fixing Lens Problems

Earlier versions of Camera Raw have had lens correction features, but Camera Raw can now automatically apply corrections for common lens problems (like barrel or/and pin-cushion distortion, or edge vignetting). It does this by reading the embedded camera data (so it knows which camera and lens you used), and it applies a profile to fix the problem. It's amazingly fast, and it takes just one checkbox, but what if there is no profile for your camera/lens, or there's no EXIF data for your image (maybe you scanned it), or if you don't like the profile (it was too little or too much)? You're about to learn all of that.

Step One:

Open the image with a lens problem in Camera Raw. Now, if you've been using Photoshop for a while, you already know there's a Lens Correction filter found under Photoshop's Filter menu, and they've updated that with pretty much the same features as the Camera Raw version, but it's better to do the correction here because: (1) it's non-destructive, and (2) it's faster. So I always fix lens problems here, rather than using the Photoshop filter.

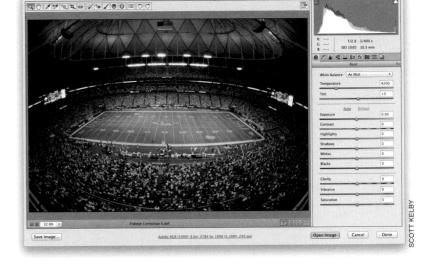

Step Two:

Click on the Lens Corrections icon (the fifth icon from the right at the top of the Panel area) and on the Profile tab, turn on the Enable Lens Profile Corrections checkbox. Now, chances are that you're done. Boom. It's fixed. That's because, as I said above, it looks at the camera data embedded in the shot to find out which camera and lens you used, then it searches its internal database for a profile of that lens, and it immediately fixes the photo (as seen here). If it can't find a profile, it lets you know at the bottom of the panel (as seen in the next step). Also, I usually have to back down the amount of correction just a bit with fisheye lenses by dragging the Distortion slider a little bit to the left (as seen here).

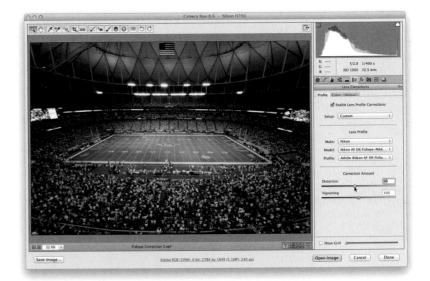

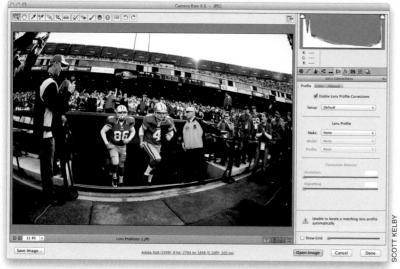

Q0/90 X m 2 to 2 8 0 = 0 C Adobe RC8 (1998): 8 bit: 2784 by 1848 (5.1MP): 300 m

Step Three:

So, what happens in a case like this, where you open a photo and it can't find a profile automatically, or the image doesn't have any embedded EXIF data (for example, if you're trying to fix a scanned image, or an image you copiedand-pasted from another document)? Take a look at the photo here. Camera Raw couldn't find a profile for it, so in the Lens Profile section, the Make is set to None and the Model and Profile pop-up menus are grayed out. What this really means is that you have to help it out by telling it what equipment you used to take the photo (if you know), or you'll have to make your best guess (if you don't).

Step Four:

This was taken with a Nikon, so from the Make field I chose Nikon, and as soon as I did, it did the rest-it found a lens match and fixed the photo. Now, it's not always 100% sure it has the right lens match, so it gives you a list of lenses it thinks might be right. You can click on the Model pop-up menu, and you'll see a list of lenses it thinks it could be (as seen here). You can try out any of the other lenses listed there and see if it gives you a better result than the one that it chose for you (it does a surprisingly good job, so I usually wind up using the one it chose, but every once in a while I find a lens in that list I like better, even though sometimes I know it's not the actual lens I used). Here, I actually used the 10.5mm fisheye lens, so I chose that from the pop-up menu and then adusted the Distortion a bit.

Here's another image. This one was taken with a wide-angle lens, and you can immediately see the problem: the building is leaning back (it's larger at the bottom and narrower at the top). Now, while I'm going to take you through the different automatic fixes for this problem, using Creative Cloud's Upright feature, in this case, I'm going to take things farther than I normally would, but the final result of the Upright feature is pretty amazing. Start by going to the Lens Corrections panel, click on the Profile tab, and turn on the Enable Lens Profile Corrections checkbox (the Upright feature works better with this turned on first). The auto profile correction is very subtle in this case.

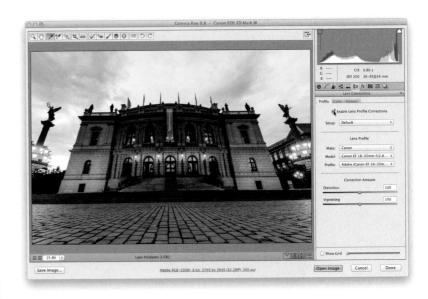

Step Six:

Let's apply the auto Upright correction by clicking on the Manual tab, then clicking on the Auto button (it's the second button from the left under Upright and shown circled here in red), and it tries to straighten the perspective of the building (as seen here). This takes the three different auto Upright options (you'll learn about each in a moment), and it applies a balanced version of each. In this case, it's certainly a step in the right direction, but it's not quite there.

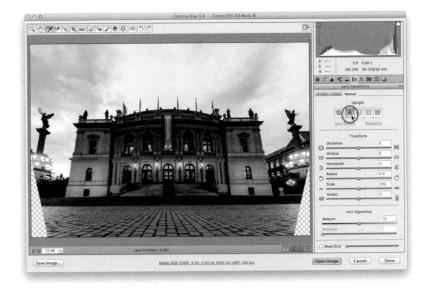

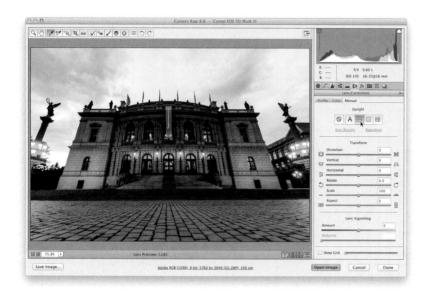

Step Seven:

Now, let's try each of the three individual Upright options and see how they affect the image. The first is just a Level adjustment (the third button from the left) and this is what I'd click if it were a regular image where the only problem was a crooked horizon line. It looks for a straight line somewhere in your photo and tries to straighten it out. In this case, it did very little, but depending on the photo, it can definitely save time and trouble.

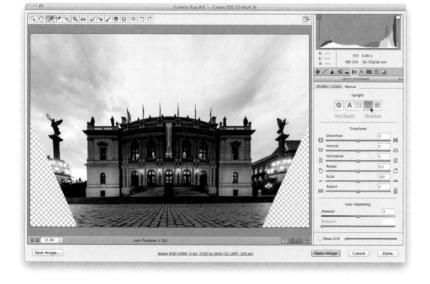

Step Eight:

Next, let's try the Vertical option (the second button from the right) and it changes the perspective of the image (as shown here). Of course, you'd have to crop the image down a bit (pretty standard for perspective corrections of any kind).

Step Nine:

The last option, Full (the button on the right), applies a level, horizontal, and vertical correction, and it changed the perspective a little more than just the Vertical option did. Now, there certainly are a few problems—the image looks a bit stretched and bloated and it needs to be cropped down, although we'll lose the sides of the image. All easy fixes. Just drag the Distortion slider a little to the right to fix the bowing, and then drag the Aspect slider a little to the left to fix the stretching.

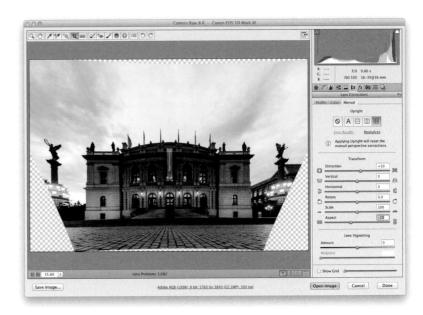

Step 10:

To crop the image, while you're still in Camera Raw, drag out the Crop tool (C) and, by default, it snaps to the point where you can crop the image without having any missing areas (like at the rightside corners). If you want to extend it further, click on the Crop tool in the toolbar and, from the pop-up menu that appears, choose Constrain to Image to deselect it. You can now click-and-drag the cropping border where you'd like. Press the Return (PC: Enter) key to lock in your crop. You can see the Before/After on the next page.

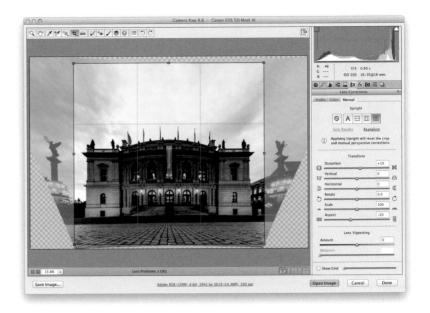

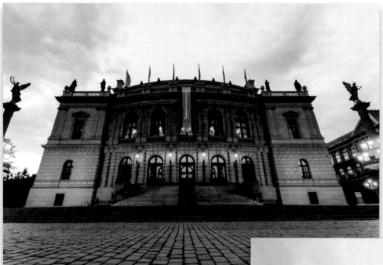

Before

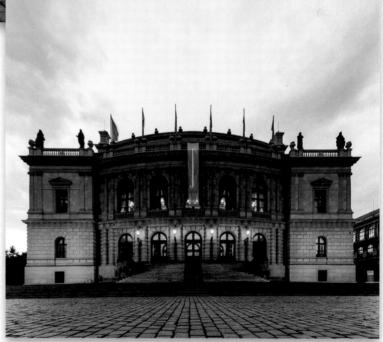

After: Here's the final image after the Upright corrections and cropping

Fixing Chromatic Aberrations (That Colored-Edge Fringe)

Chromatic aberration is a fancy name for that thin line of colored fringe that sometimes appears around the edges of objects in photos. Sometimes the fringe is red, sometimes green, sometimes purple, blue, etc., but all the time it's bad, so we might as well get rid of it. Luckily, Camera Raw has a built-in fix that does a pretty good job.

Step One:

Open a photo that has signs of chromatic aberrations. If they're going to appear, they're usually right along an edge in the image that has lots of contrast (like along the edges of these structures).

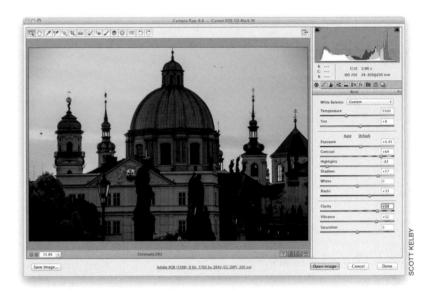

Step Two:

Press Z to get the Zoom tool and zoom in on an area where you think (or see) the fringe might be fairly obvious (here, I've zoomed in on the dome in the middle, and you can see thin red and green lines along the edge of the dome). To remove this, start by clicking on the Lens Corrections icon (the sixth icon from the left) at the top of the Panel area, then click on the Color tab (in the center) to make the Chromatic Aberration controls visible.

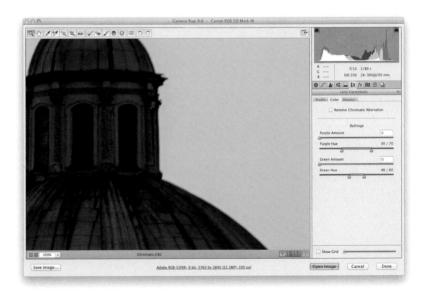

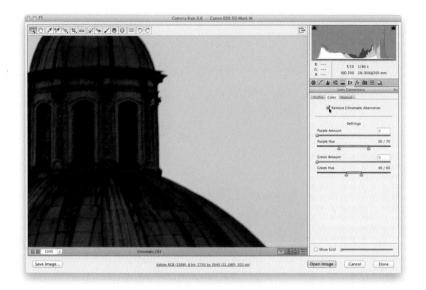

In most cases, all you'll have to do is turn on the Remove Chromatic Aberration checkbox (as shown here) and you're done—Photoshop removes the color fringe based on your lens' make and model, which it learns from the metadata embedded into the image at the moment you took the shot. However, if for some reason the image still needs more correction (the checkbox alone didn't do the trick), then you can try getting rid of the fringe manually using the sliders in the Defringe section below the checkbox (just so you can see how this works, go ahead and turn off the Remove Chromatic Aberration checkbox).

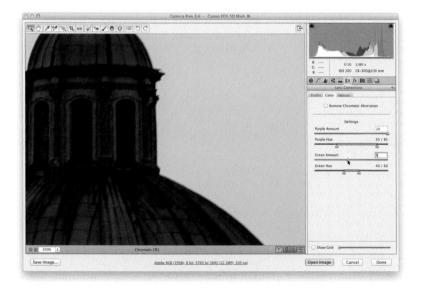

Step Four:

We'll start by trying to remove the red line by dragging the right Purple Hue slider knob to the right until you see it's gone. In this case, it removed it nicely. You can do the same thing for the green aberration—drag the Green Amount slider to the right first (like you see here), and if anything is left over, drag the Green Hue slider to dial in just the right hue, until it's completely gone. Again, I rarely have to go beyond turning on the Remove Chromatic Aberration checkbox, but at least now if it doesn't do the job for you, you'll know what to do instead.

Edge Vignetting: How to Fix It and How to Add It for Effect

If you're looking at a photo and the corners of the photo appear darker, that's lens vignetting. Generally, I look at it this way: If it's just the corners, and they're just a little bit dark, that's a problem and I fix it. However, sometimes I want to focus the viewer's attention on a particular area, so I create a vignette, but I expand it significantly beyond the corners, so it looks like an intentional soft spotlight effect. Here's how to fix (or create) vignettes:

Step One:

Here, you can see the dark areas in the corners (that's the bad vignetting). This is normally caused by the camera's lens, so don't blame yourself (unless you bought a really cheap lens—then feel free to give yourself as much grief as you can bear). To remove this vignetting from the corners, start by clicking on the Lens Corrections icon (the sixth icon from the left) at the top of the Panel area. In the Profile tab, turn on the Enable Lens Profile Corrections checkbox and Photoshop tries to remove the edge vignetting based on your lens' make and model (it learns this from your image's EXIF data. See page 52 for more on this). If the image still needs correcting, try the Vignetting slider under Correction Amount.

Step Two:

If the automatic way just isn't working, do it manually by clicking on the Manual tab. In the Lens Vignetting section, click on the Amount slider and drag it to the right until the vignetting in the corners disappears. Once you move the Amount slider, the Midpoint slider beneath it becomes available. It determines how wide the vignetting repair extends into your photo, so drag it to the left to expand the lightening farther toward the center of your photo.

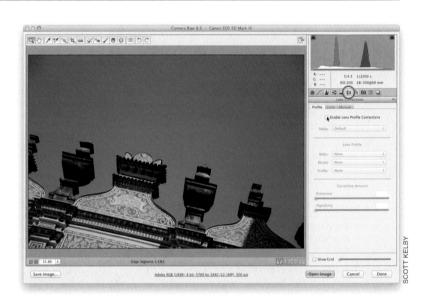

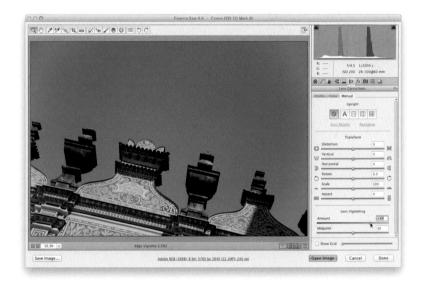

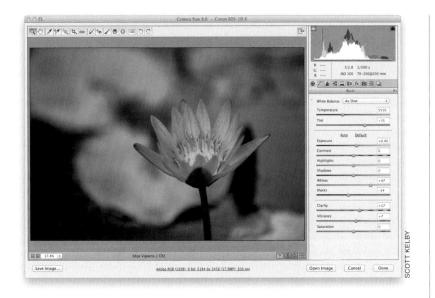

Now for the opposite: adding vignetting to focus attention (by the way, in the "Special Effects for Photographers" chapter, I also show you how to get the same effect outside of Camera Raw). For this, we'll switch to a different photo.

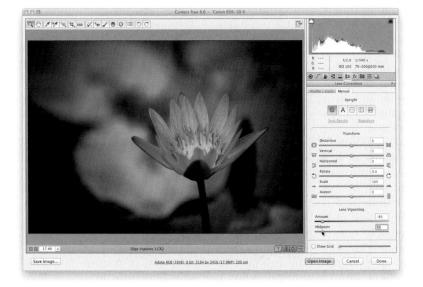

Step Four:

This time, in the Lens Vignetting section, you're going to drag the Amount slider to the left, and as you drag left, you'll start to see vignetting appear in the corners of your photo. But since it's just in the corners, it looks like the bad kind of vignetting, not the good kind, so you'll need to make the vignetting look more like a soft spotlight falling on your subject. Drag the Midpoint slider quite a bit to the left, which increases the size of the vignetting and creates a soft, pleasing effect that is very popular in portraiture, or anywhere you want to draw attention to your subject. That's it—how to get rid of 'em and how to add 'em. Two for the price of one!

Step Five:

So far, adding the vignette has been pretty easy—you just drag a couple of sliders, right? But where you'll run into a problem is when you crop a photo, because you're also cropping the vignetting effect away, as well (after all, it's an edge effect, and now the edges are in a different place, and Camera Raw doesn't automatically redraw your vignette at the newly cropped size). So, start by applying a regular edge vignette (as shown here).

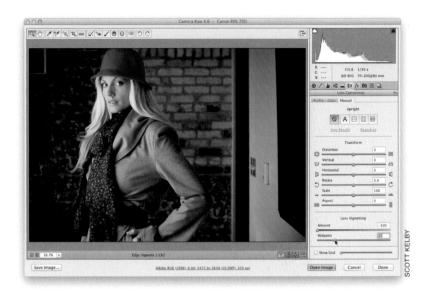

Step Six:

Now, let's get the Crop tool **(C)** from the toolbar, crop that photo in pretty tight, and you can see what the problem is—the vignette effect we just added is pretty much gone (the dark edges were cropped away).

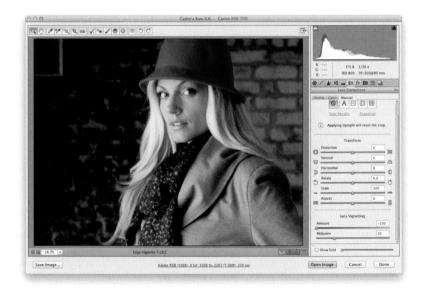

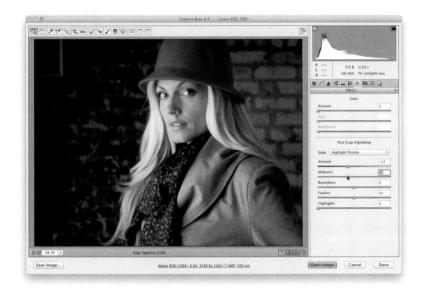

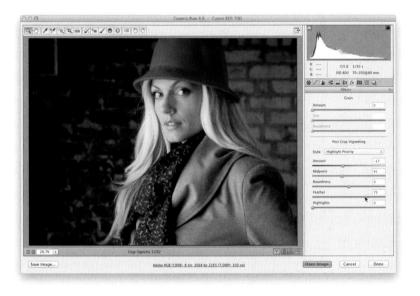

Step Seven:

Let's go add a post-crop vignette by clicking on the Effects icon (the fourth icon from the right) at the top of the Panel area and, under Post Crop Vignetting, dragging the Amount slider to the left to darken the edges, then using the Midpoint slider to choose how far into your image this vignetting will extend (as seen here). Now, at the top of the Post Crop Vignetting section is a pop-up menu with three different types of vignetting: Highlight Priority (which I think far and away looks the best, and the most like the original vignetting we applied back in Step Five), which tries to maintain the highlight details as the edges are darkened; Color Priority tries to maintain the color while the edges are darkened (it's okay, but not great); and Paint Overlay is an old method from CS4 that almost everybody hated (apparently somebody liked it, because it's still there). I would stay away from this one altogether.

Step Eight:

Below the Midpoint slider is the Roundness slider that gives you control over the roundness of the vignetting (lower the Feather amount to 0, so you can get a better idea of what the Roundness slider does). The farther to the right you drag, the rounder the shape gets, and when you drag to the left, it actually becomes more like a large, rounded-corner rectangle. The Feather slider determines how soft that oval you created with the Roundness slider becomes. I like it really soft, so it looks more like a spotlight, so I usually drag this slider quite a bit over to the right (here I dragged it over to 73, but I wouldn't hesitate to go higher, depending on how it looks on the photo).

The Advantages of Adobe's DNG Format for RAW Photos

Adobe created DNG (an open archival format for RAW photos) because, at this point in time, each camera manufacturer has its own proprietary RAW file format. If, one day, one or more manufacturers abandon their proprietary format for something new (like Kodak did with their Photo CD format), will we still be able to open our RAW photos? With DNG, it's not proprietary—Adobe made it an open archival format, ensuring that your negatives can be opened in the future, but besides that, DNG brings another couple of advantages, as well.

Step One:

There are three advantages to converting your RAW files to Adobe DNG: (1) DNG files are generally about 20% smaller. (2) DNG files don't need an XMP sidecar file to store Camera Raw edits, metadata, and keywords—the info's embedded into the DNG file, so you only have one file to keep track of. And, (3) DNG is an open format, so you'll be able to open them in the future (as I mentioned in the intro above). If you have a RAW image open in Camera Raw, you can save it as an Adobe DNG by clicking the Save Image button (as shown here) to bring up the Save Options dialog (seen in the next step). Note: There's really no advantage to saving TIFF or JPEG files as DNGs, so I only convert RAW photos.

Step Two:

When the Save Options dialog appears, in the middle of the dialog, from the Format pop-up menu, choose **Digital Negative** (shown here). Once you choose Digital Negative, a new set of options appears at the bottom of the dialog (seen in Step Three).

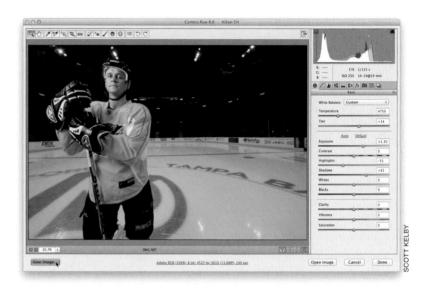

The Embed Fast Load Data checkbox uses a smaller embedded RAW preview that makes switching between images faster (I turn this feature on). Below that is a somewhat controversial option, but if used in the right way, I think it's okay. It uses a JPEG-like lossy compression (meaning there is a loss in quality), but the trade-off (just like in JPEG) is that your file sizes are dramatically smaller (about 25% of the size of a full, uncompressed RAW file). So, if there's a loss of quality, why would you use this? Well, I wouldn't use it for my Picks (the best images from a shoot—ones I might print, or a client might see), but what about the hundreds the client rejected or you don't like? Those might (it's your call) be candidates to be compressed to save drive space. It's something to consider. If you do want to do it, turn on that checkbox, then choose (from its popup menu) which option is most important to you: saving the same physical dimensions (pixel size) or file size (megapixels). Once you've made your choices, click OK, and you've got a DNG.

TIP: Setting Your DNG Preferences With Camera Raw open, press Command-K (PC: Ctrl-K) to bring up Camera Raw's Preferences dialog. There are two preferences in the DNG File Handling section: Choose Ignore Sidecar ".xmp" Files only if you use a different RAW processing application (other than Camera Raw or Lightroom), and you want Camera Raw to ignore any XMP files created by that application. If you turn on the Update Embedded JPEG Previews checkbox (and choose your preferred preview size from the pop-up menu), then any changes you make to the DNG will be applied to the preview, as well.

Adjusting or Changing Ranges of Color

In the next chapter, you're going to learn how to paint an adjustment over any part of your image, but sometimes you need to affect an entire area (like you need the entire sky bluer, or the sand warmer, or a piece of clothing to be an entirely different color). In those cases, where you're adjusting large areas, it's usually quicker to use the HSL adjustments, which not only let you change color, but also let you change the saturation and the lightness of the color. It's more powerful, and handier than you might think.

Step One:

Here's the original image of some washed-out buildings. What I'd like to do is tweak their color so they really stand out. You tweak individual colors, or ranges of color, in the HSL/Grayscale panel, so click on its icon at the top of the Panel area (it's the fourth one from the left—circled here in red). Now, click on the Saturation tab (as shown here) to bring up the Saturation sliders (which control the intensity of the colors).

Step Two:

We'll start by bringing some richness and depth back into the green building on the right. You can just drag the Greens slider to the right, and it will get greener (the color will get more intense), but most of the time, the color your eye sees (green, in this case) is made up of more than just that color. So, rather than guessing, and messing with the individual sliders I recommend grabbing the Targeted Adjustment tool (T; or TAT, for short) from the toolbar up top (it's the fifth tool from the left), then clicking it on the building, and dragging straight upward. As you do this, it knows which sliders control that area, and it moves them for you (in this case, it moved the Greens slider a lot, but it also moved the Yellows slider quite a bit, and the Oranges slider a little, too). Since the other buildings also have these colors, it made their colors more vivid, as well.

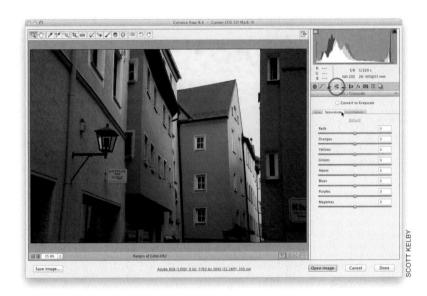

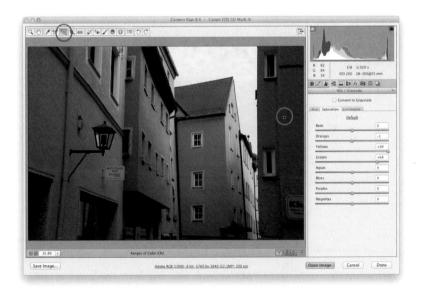

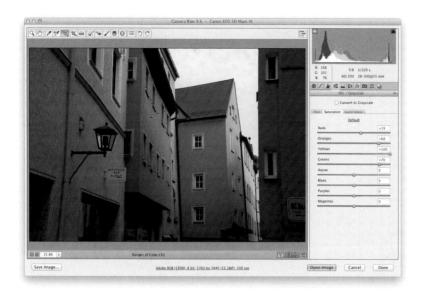

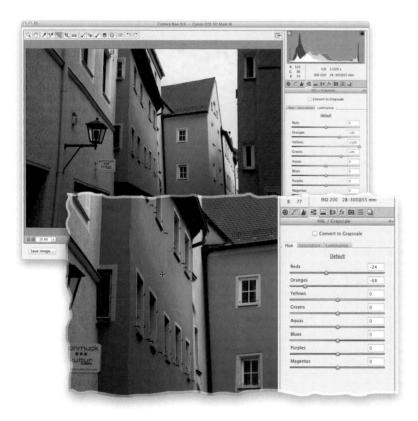

By the way, dragging upward with the TAT increases the saturation amounts, and dragging downward decreases them. Just so you know. Okay, now that the greens and yellows are looking better, let's work on the reds and oranges. So, take the TAT, click it on the orangey building in the middle, and drag straight upward to increase the color saturation (intensity) of those reds and oranges. Go look at the sliders, and you'll see it moved the Reds and Oranges sliders (so that color was mostly made up of red and orange, although it made slight adjustments to the Yellows and Greens, too), but beyond that, the TAT knows the right percentage of each, which is why using it gives you such an advantage (in fact, I don't use these HSL sliders without using the TAT).

Step Four:

If you think the colors look too dark, then all you have to do is click on the Luminance tab (it controls how bright the colors appear), click on a dark area of yellow, and drag upward (as shown here, where I clicked on the yellow building on the left), and now the colors are a little brighter (compare it with what you see in Step Three). If your colors were too bright, you'd drag downward. So, that's how it works for tweaking Saturation and Luminance. However, if you want to actually change a color (and not just tweak the existing color), then click on the Hue tab. The controls are the same: click your TAT on the orange building and drag downward to change the color (as I did here in the inset). Again, you could always drag the sliders around, and eventually you'd find out which slider controls which part of the image, but I think you can see why Adobe invented the TAT—to make our lives in this panel easier.

Oh Hallelujah, It's a Regular Healing Brush! (Finally!)

One thing we always had to go to Photoshop for was to use the Healing Brush. Sure, if you wanted to remove a spot or a blemish, you could use Camera Raw's Spot Removal tool, but since it did "circular" healing, even though you had "healing power," you couldn't paint a stroke to remove a wrinkle, or a dark circle, or a power line, or, well, much of anything other than a spot. All you could do was draw more circles. Well, finally (finally!), we have a tool that lets us paint a stroke and heal those problems away (but, of course, it's for more than just wrinkles. It's for all the stuff you used to have to jump over to Photoshop to remove).

Step One:

Here's the image we want to retouch. Our subject has a dark circle on the left, under his eye, that we want to remove (something we definitely would not have been able to do easily in previous versions of Camera Raw), as well as some small blemishes. Get the Spot Removal tool (B) from the toolbar up top (shown circled here in red). By the way, I think they totally should rename this tool now that it works more like the Healing Brush, and it does more than just remove spots.

Step Two:

Double-click on the Zoom tool in the toolbar to jump to a 100% view, so we can see an up-close view of the area where we want to remove the dark circle. Now, take the Spot Removal tool and just paint a stroke over the dark circle you want to remove and, as you do, you'll see an outline showing the area you're healing as you paint.

TIP: More Realistic Retouching

If you need to remove a guy's wrinkles, and you remove them completely, it will probably look a bit unrealistic, but you can adjust the Opacity slider (in the panel on the right) to bring back a tiny bit of the original wrinkle. So, you're actually reducing the wrinkles, rather than totally removing them.

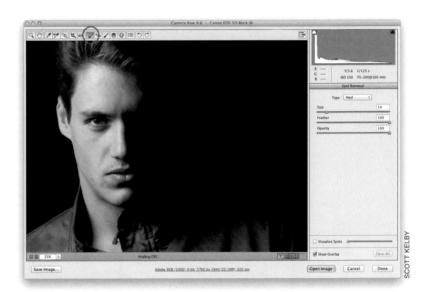

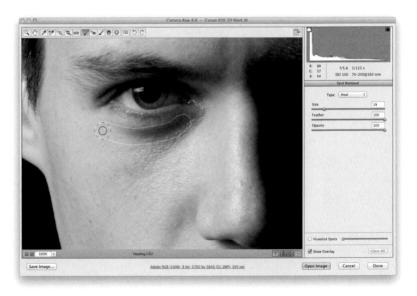

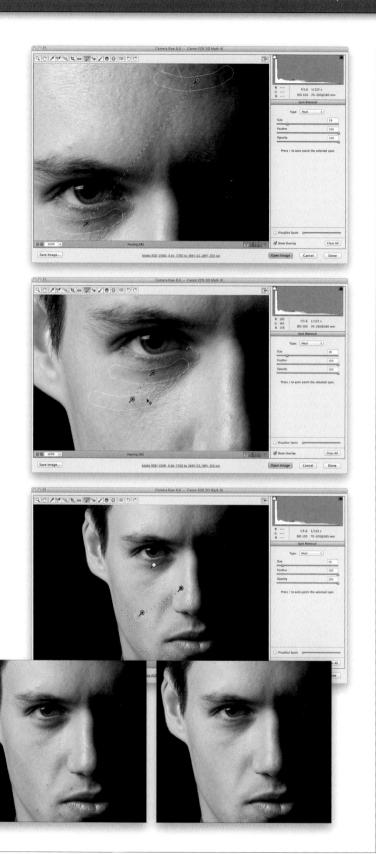

When you finish your stroke, you'll see two outlined areas: (1) the area inside the red-dotted line is the area you're healing, and (2) the area inside the green-dotted line is the area that the Spot Removal tool chose to sample the texture it's going to use to make your retouch. Usually this sample area is pretty close to the area you're trying to fix, but sometimes it does what it did here—it chooses an area far enough away that it doesn't actually create a perfect match (in this case, the direction and type of skin found on the forehead are a lot different than the skin texture and direction under his eye). That's okay, we can easily make the Spot Removal tool choose a different area to sample from.

Step Four:

Take your cursor, click inside the green sample area, and just drag it somewhere else on your subject's face that's a better match (here, I dragged it below and to the left of the area we painted over). Once you drag it over a new area, let go of the mouse button for just a moment and it draws a preview of how this sample area looks (that way, you can see if moving it actually helped or not). If it doesn't look good, just drag the green sample area somewhere else and let go of the mouse button again for a quick preview of how it looks now.

Step Five:

Once the eye looks better, go around the face and click on the blemishes to remove them. When you release the mouse button, a second circle appears to show you the area the tool chose to sample from. If you need to move it, just click-and-drag it. That's pretty much all there is to it.

Finding Spots and Specks the Easy Way

There is nothing worse than printing a nice big image, and then seeing all sorts of sensor dust, spots, and specks in your image. If you shoot landscapes or travel shots, it is so hard to see these spots in a blue or grayish sky, and if you shoot in a studio on seamless paper, it's just as bad (maybe worse). I guess I should say: it used to be bad. Now, it's absolutely a breeze, thanks to a feature in Camera Raw that makes every little spot and speck really stand out so you can remove them fast!

Step One:

In this image, you can see some spots and specks in the sky. I can see five or six pretty clearly, but it's the spots that you can't see clearly at this size that "Getchal"

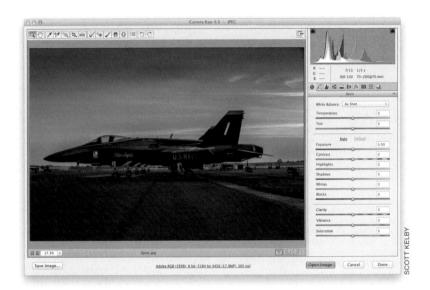

Step Two:

Click on the Spot Removal tool up in the toolbar (**B**; it's shown here circled in red), and at the bottom of its panel, there's a checkbox for Visualize Spots. Turn that checkbox on and it gives you an inverted view of your image. Now, slowly drag the Visualize Spots slider to the right and, as you do, the spots will start to clearly appear (I didn't drag too far with this image, but you can sure see the spots there). Next, just take the Spot Removal tool and, right on the image (with the Visualize Spots option still on), click once right over each spot to remove them until they're all gone.

Some cameras seem to have their own "color signature," and by that I mean that every photo seems to be a little too red, or every photo is a little too green, etc. You just know, when you open a photo from that camera, that you're going to have to deal with the slight color cast it adds. Well, if that's the case, you can compensate for that in Camera Raw, and then set that color adjustment as the default for that particular camera. That way, any time you open a photo from that camera, it will automatically compensate for that color.

Calibrating for Your Particular Camera

Step One:

To calibrate Camera Raw so it fixes a persistent color cast added by your camera, open a typical photo taken with that camera in Camera Raw, and then click on the Camera Calibration icon (it looks like a camera and is the third icon from the right at the top of the Panel area). So, let's say that the shadow areas in every photo from your camera appear slightly too red. In the Camera Calibration panel, drag the Red Primary Saturation slider to the left, lowering the amount of red in the entire photo. If the red simply isn't the right shade of red (maybe it's too hot and you just want to tone it down a bit), drag the Red Primary Hue slider until the red color looks better to you (dragging to the right makes the reds more orange).

Step Two:

To have Camera Raw automatically apply this calibration each time a photo from that particular camera is opened in Camera Raw, go to Camera Raw's flyout menu (in the top right of the panel), and choose **Save New Camera Raw Defaults** (as shown here). Now, when you open a photo from that camera (Camera Raw reads the EXIF data so it knows which camera each shot comes from), it will apply that calibration. *Note:* You can adjust your blues and greens in the same way.

Reducing Noise in Noisy Photos

This is, hands down, not only one of the most-requested features by photographers, but one of the best since the upgrade in CS5. Now, if you're thinking, "But Scott, didn't Photoshop and Camera Raw both have built-in noise reduction before CS5?" Yes, yes they did. And did it stink? Yes, yes it did. But, does the current noise reduction rock? Oh yeah! What makes it so amazing is that it removes the noise without greatly reducing the sharpness, detail, and color saturation. Plus, it applies the noise reduction to the RAW image itself (unlike most noise plug-ins).

Step One:

Open your noisy image in Camera Raw (the Noise Reduction feature works best on RAW images, but you can also use it on JPEGs and TIFFs, as well). The image shown here was shot at a high ISO using a Nikon D3S, which didn't do a very good job in this low-light situation, so you can see a lot of color noise (those red, green, and blue spots) and luminance noise (the grainy looking gray spots).

Step Two:

Sometimes it's hard to see the noise until you really zoom in tight, so zoom into at least 100%, and there it is, lurking in the shadows (that's where noise hangs out the most). Click on the Detail icon (it's the third icon from the left at the top of the Panel area) to access the Noise Reduction controls. I usually get rid of the color noise first, because that makes it easier to see the luminance noise (which comes next). Here's a good rule of thumb to go by when removing color noise: start with the Color slider over at 0 (as shown here) and then slowly drag it to the right until the moment the color noise is gone. Note: A bit of color noise reduction is automatically applied to RAW images the Color slider is set to 25. But, for JPEGs or TIFFs, the Color slider is set to 0.

So, click-and-drag the Color slider to the right, but remember, you'll still see some noise (that's the luminance noise, which we'll deal with next), so what you're looking for here is just for the red, green, and blue color spots to go away. Chances are that you won't have to drag very far at all—just until that color noise all turns gray. If you have to push the Color slider pretty far to the right, you might start to lose some detail, and in that case, you can drag the Color Detail slider to the right a bit, though honestly, I rarely have to do this for color noise.

Step Four:

Now that the color noise is gone, all that's left is the luminance noise, and you'll want to use a similar process: just drag the Luminance slider to the right, and keep dragging until the visible noise disappears (as seen here). You'll generally have to drag this one farther to the right than you did with the Color slider, but that's normal. There are two things that tend to happen when you have to push this slider really far to the right: you lose sharpness (detail) and contrast. Just increase the Luminance Detail slider if things start to get too soft (but I tend not to drag this one too far and will generally bump up the Sharpening Amount at the top of the panel to bring back original detail), and if things start looking flat, add the missing contrast back in using the Luminance Contrast slider (I don't mind cranking this one up a bit, except when I'm working on a portrait, because the flesh tones start to look icky). You probably won't have to touch either one all that often, but it's nice to know they're there if you need them.

Step Five:

The last slider, the Color Smoothness slider, was added in Creative Cloud. It works with the Color Detail slider, and you use it to make sure the colors don't shift. Dragging it to the right ensures your colors stay intact (but, don't go too high or the colors can end up desaturating), and dragging it to the left ensures the colors blend more. So, if you know the colors need to be right on (like for a web catalog), drag to the right, but if the color's looking a little chunky, drag it to the left. Here's the final image, zoomed back out, and you can see the noise has been pretty much eliminated, but even with the default settings (if you're fixing a RAW image), you're usually able to keep a lot of the original sharpness and detail. A zoomed-in before/after of the noise reduction we applied here is shown below.

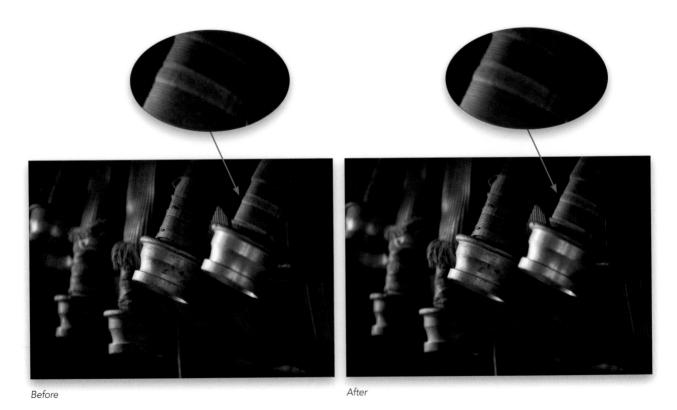

After you're done editing your image in Camera Raw, your next stop is probably Photoshop, right? Well, you get to choose "how" your image comes over, and by that I mean you get to choose the size (physical dimensions), the color space, bit depth (8 or 16 bits/channel), and stuff like that. But, if you've been searching for a preferences button for these, you'll be searching a while, 'cause Adobe did their best to hide them. Here's how to find them, and set them your way:

Choosing How Your RAW Images Will Appear in Photoshop

Step One:

If you look directly below your image, you'll see a line of underlined blue text, like a web link (it's circled in red here). The text itself looks like EXIF camera data. There's nothing really here to let you know that this is actually where you click to bring up the dialog for choosing your preferences for how your photo is going to look when it opens in Photoshop. If that wasn't stealthy enough for ya, Adobe didn't name these "Preferences." They call them "Workflow Options" just to throw you off the scent. Anyway, now that you know that's what's really under there, go ahead and click that button/ link/thingy.

Step Two:

This brings up the Workflow Options dialog (seen here). Near the top, you get to choose which color space you want your image to open with from the Space pop-up menu (seen here). You generally want to choose the color space that matches what you've chosen in Photoshop for your color space. So, if you have your Photoshop color space set to Adobe RGB (1998) or sRGB, then you'd want to choose the same color space here (or you'll have a profile mismatch). For most folks, this is an easy choice—just have it match what your Photoshop color space is set to.

To the right of the Space pop-up menu, you can choose what bit depth you want your photo to open as (either 8 or 16 bits/ channel). The choice is yours (just so you know, most of the time I work in 8-bit mode, unless I see some banding in the sky or some other problem, in which case I'll go back to Camera Raw and reopen it as 16-bit, but that happens pretty rarely). Right under that, you have the option of messing with the Image Sizing. I say this is an option because if you leave that Resize to Fit checkbox turned off, it doesn't resize your image—it just opens the image in its native (original) size. However, if you need to make it smaller, or fit a particular width, height, pixel dimension, and so on, you can choose one of those options from the pop-up menu and then type in the size and/or resolution you want.

Step Four:

Below that is your Output Sharpening, which is sharpening that is applied before your image is opened in Photoshop. Personally, I don't turn this feature on at this stage of the game. I sharpen manually later on using the Unsharp Mask filter. However, if you do want to add some sharpening right from the get-go, turn on the checkbox, then choose the final destination for this image (whether it will be seen just on a screen, like on a webpage, or whether instead it will be printed on glossy or matte paper). Then, you get to choose the level of sharpening from the Amount pop-up menu. By the way, in my experience the Low setting should be named "None;" the Standard (medium) setting should be "Low;" and the High setting should be named "Medium, but just barely." At the bottom of the dialog is a checkbox to have your image appear in Photoshop as an editable smart object (meaning, you can double-click on its thumbnail and it will reopen the original RAW file right back here in Camera Raw for re-editing).

Step Five:

If you find yourself switching between a couple of different settings (for example, let's say you print some of your images, and you use Adobe RGB [1998] at 16 bits/channel at the image's native size with sharpening set to High, but then the rest you post to your online portfolio, so for those you use sRGB at 8 bits/channel at 1,200 pixels on the long edge with Standard sharpening), luckily you don't have to type all that in each time you switch. You can have all those settings just one click away by creating a Workflow preset. Start by entering all the settings you want, then go under the Preset pop-up menu at the top of the dialog and choose **New** Workflow Preset, as shown here. A little naming dialog will appear (shown here in the inset) where you can type in a name, then click OK.

Step Six:

Now, your newly created Workflow preset will appear in the Presets menu, and when you choose it, it enters all those settings for you. You can create as many presets as you'd like, so any recurring settings are just one click away. When you're done, click OK and now those settings are your new default settings, so when you click Open Image in the Camera Raw window, all your photos processed in Camera Raw will open in Photoshop using those settings (and they'll stay like that until you change 'em).

Photoshop Killer Tips

Don't Use the Reduce Noise Filter in Photoshop

There are two different places you can reduce noise in Photoshop: The Noise Reduction controls in Camera Raw rock, however the Reduce Noise filter in Photoshop (under the Filter menu, under Noise)

does not. We used to joke that the sliders weren't connected to anything, and if they were, it was a blur filter. My advice—only use the Noise Reduction in the Detail panel of Camera Raw, and avoid the other altogether.

Rotating Your Images

Finally, a shortcut that makes perfect sense: To rotate your image to the left, press **L**; to rotate to the right, press **R**. The nice thing is, once you learn one, you'll never forget the other.

Making Camera Raw Full Screen

To have Camera Raw expand to fill your entire screen, click the Full Screen mode icon at the top of the window or just press the **F key**.

Avoiding Noise Problems

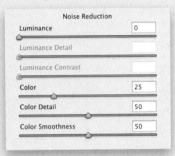

If there's noise in your photo, chances are it's in the shadow areas, so keep this in mind when you're editing your images. If you open up the shadows a lot (using the Shadows slider, Blacks, or in some cases, even the Exposure slider), any noise that was already in the image is going to become magnified. If you can't avoid opening up those shadows, just make sure you use Camera Raw's Noise Reduction to reduce the visible amount.

Tip for Wacom Tablet Users Who Use Their Tablet in Their Lap

Back in CS4, Adobe introduced Fluid Canvas Rotation, which lets tablet users who work with their tablet in their lap rotate the screen to match the current angle of their tablet (you turn this on by clicking on the Hand tool, choosing the Rotate View tool, and then clicking-and-dragging that within your image to

rotate the canvas). There was only one problem, though: when you rotated the canvas, it rotated your brushes, too (which wouldn't happen in real life). Luckily, now when your canvas rotates, your brushes stay intact.

Get Automatic Auto Corrections

The Auto correction one-click fix feature got dramatically better in previous versions of Photoshop. So, now it's to the point where the Auto button is pretty decent. Not great, not amazing, but decent. Anyway, if you want to have Camera Raw automatically apply an Auto correction to every photo you open (to get a better starting point for your editing), then click on the Preferences icon in Camera Raw's toolbar (it's the third icon from the right), and in the Default Image Settings section, turn on the Apply Auto Tone Adjustments checkbox. Now, every image will get an automatic correction as soon as it's opened.

Default Image Settings

Apply auto tone adjustments

Apply auto grayscale mix when converting to grayscale

Make defaults specific to camera serial number

Make defaults specific to camera ISO setting

Shortcut for Changing UI Color Back in Photoshop CS6, Adobe intro-

duced the new "dark" color scheme (replacing the old light gray look that had been Photoshop's look since Photoshop 1.0). But, if you want a lighter or darker version of Photoshop's user interface, you can press **Shift-F1** to make the interface one shade darker or **Shift-F2** to make it one shade brighter (you can press it more than once, depending on how light/dark your current interface is set). Also, if you're using a laptop, depending on how you have your laptop's preferences

Photoshop Killer Tips

set, to make this shortcut work you might have to add the Fn key (so, Fn-Shift-F1 or Fn-Shift-F2).

Assigning a Color Profile to Your RAW Image

If you shoot in RAW, your camera doesn't embed a color profile in the image (like it does with JPEG and TIFF images). You assign a color profile in Camera Raw, and if you're using Camera Raw for all your editing, and then you're just saving your file as a JPEG for emailing or posting to the web, you're going to want to assign a color profile that keeps the colors looking like you saw in Photoshop. You do this by clicking on the blue link beneath the Preview area in Camera Raw. This

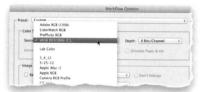

brings up the Workflow Options dialog, where you choose which color profile gets embedded into your image (you choose it from the Space pop-up menu). If you're emailing the image, or posting it on the web, choose **sRGB** as your color space—that way it pretty much maintains the colors that you saw while you were in Camera Raw (if you left it at ProPhoto RGB, or even Adobe RGB [1998], the colors on the web, or in the email, will probably look drab and washed out).

Get a Histogram for the Most Important Part of Your Photo

If you're editing a portrait in Camera Raw, the most important part is, of course, your subject, but the histogram in Camera Raw shows you a readout for the entire image (so if you shot your subject on a white background, the histogram isn't going to be much help in determining if the skin tone is correct). To get around this, grab the Crop tool (C), and drag out a cropping border tight right around your subject's face (but don't actually crop the image). With the cropping border in place, if you look at the histogram (in the top right of the window), it shows you a readout for just what's inside the cropping border—your subject's face. Very handy!

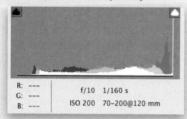

The Hidden Trash Can

If you're wondering why you've never seen the Trash icon in Camera Raw (where you can click to delete files), it's because it only appears when you have multiple images open there (it appears at the end

of the toolbar). Click on it, and it marks your selected image(s) for deletion. Click the Done button, and it deletes that image (well, it moves it to the Trash on a Mac, or Recycle Bin on a PC).

Finding Your Best Images Fast

I mentioned in the last chapter that if you have multiple images open in Camera Raw, you can assign star ratings and labels to photos just as if you were in Bridge (you even use the same shortcuts). But, a little-known tip is that if you press-and-hold the Option (PC: Alt) key, the Select All button at the top of the filmstrip on the left

changes into the Select Rated button. Click it, and any images that have either a star rating or a label will be instantly selected for you, letting you get to your best images fast.

Right-Click to Choose Your Zoom If you Right-click directly on your image in Camera Raw's Preview area, a pop-up menu with different zoom percentages appears.

Chapter 3 Camera Raw's Adjustment Tools

Attitude Adjustment camera raw's adjustment tools

When I went searching for songs with the word "adjustment" in them, I quickly found Aerosmith's "Attitude Adjustment," which would make this an easy choice for me as an Aerosmith fan, but there's no real way for you to know if the title I'm referencing up there is actually the one by Aerosmith, or if I secretly went with another song with the exact same title by hip hop artists Trick Trick and Jazze Pha. In iTunes, this song was marked with the Explicit label, so I thought I'd better listen to the free 90-second preview first, because I wanted to make sure I didn't pick a song whose free preview was too explicit, but while listening to that preview, something very unexpected happened to me that I haven't gotten over to this very day. The sad truth is that I couldn't understand a word they were saying. I even played it back a couple of times, and I was waiting for naughty words to jump out at me, but I could barely make out anything

they said. It just sounded like a bunch of noise. This can only mean one thing—I'm old. I remember playing songs for my parents when I was younger, and I remember my mom saying, "I can't understand a word they're saying" and she had that irritated look that only old people who can't understand a word they're hearing can get. But this time it was me. Me—that young, cool guy (stop giggling) experiencing my first "old people" moment. I was sad. I just sat there for a moment in stunned silence, and then I said "F&*\$ S#!& A@# M*%\$#%" and in no time flat, my wife stuck her head in the room and said, "Are you writing rap lyrics again?" At that moment, I felt young again. I jumped up out of my chair, but then I grabbed my back and yelled "F*%\$#% R%^\$!" My wife then said, "I can't understand a word you're saying." Peace out!

Dodging, Burning, and Adjusting Individual Areas of Your Photo

One of my favorite features in Camera Raw is the ability to make non-destructive adjustments to individual areas of your photos (Adobe calls this "localized corrections"). The way they've added this feature is pretty darn clever, and while it's different than using a brush in Photoshop, there are some aspects of it that I bet you'll like better. We'll start with dodging and burning, but we'll add more options in as we go.

Step One:

This photo has two areas that need completely different adjustments: (1) the sky needs to be darker with more vibrant colors, and (2) the planes need to be brighter and punchier. So, get the Adjustment Brush from up in the toolbar (it's shown circled here in red) or just press the letter **K** on your keyboard. However, I recommend that you do all the regular edits to your photo in the Basic panel first (exposure, contrast, etc.), just like normal, before you grab the brush.

Step Two:

Once you click on the brush, an Adjustment Brush panel appears on the right side of the window, with most of the same sliders you have in the Basic panel (except for Vibrance), along with some extra ones (like Sharpness, Noise Reduction, and Moire Reduction). Let's start by darkening the sky. With the Adjustment Brush, you (1) choose what kind of adjustment you want first, then (2) you start painting, and then (3) you tweak the amount of your adjustment after the fact. So, start by clicking on the - (minus sign) button to the left of the Exposure slider, which resets all the sliders to 0 and lowers the Exposure (the midtones control) to -0.50, which is a decent starting place.

At the bottom of the Adjustment Brush panel, there is a really amazing Adjustment Brush feature called "Auto Mask," which helps to keep you from accidentally painting on things you don't want to paint on (so it's great around the edges of things). But, when you're painting over something like a big sky, it actually slows things down because it keeps trying to find an edge. So, I leave the Auto Mask checkbox turned off for stuff like this, and here, I'll just avoid getting close to the edges of the planes (for now, anyway). Go ahead and paint over the sky (with Auto Mask turned off), but of course, avoid getting too close to the planes just stick to open areas of sky (as seen here). Notice how the sky gets darker as you paint?

Step Four:

Once you've painted in most of the sky (but avoided the edges of the planes), now you can tweak how dark it is. Try lowering the Exposure to –1.00 (as shown here) and the area you painted over gets a lot darker. This is what I meant by "you tweak it after the fact." Also, you see that green pin in the top left of the image? That represents this one adjustment (you can have more than one, which is why you need a way to keep track of them. More on this coming up).

TIP: Deleting Adjustments

If you want to delete any adjustment you've made, click on the adjustment's pin to select that adjustment (the center of the pin turns black), then press the Delete (PC: Backspace) key on your keyboard.

Step Five:

Okay, now that "glow" around the tops of the planes and tails where we haven't painted is starting to get on my nerves, so let's deal with that before we tweak our settings any more. When we're getting near the tops and tails is when you want to turn Auto Mask back on (shown here). That way, you can paint right up against them, filling in all those areas, without accidentally painting over the planes. The key to using Auto Mask is simple—don't let that little + (plus sign) inside the inner circle of your brush stray over onto the planes, because that's what determines what gets affected (if that + crosses over onto a tail, it starts painting over the tail). It's okay if the outer circle crosses right over the planes—just not that + (see how the brush here is extending over onto the tail, but it's not getting darker? That's Auto Mask at work).

Step Six:

So, how do you know if you've really painted over the entire area you wanted to adjust? How do you know whether you've missed a spot? Well, if you turn on the Mask checkbox at the bottom of the panel, it puts a tint over the area you painted (as seen here, where I changed my tint color to red by clicking on the color swatch to the right of the checkbox), so you can see if you missed anything. If you don't want this on all the time, just press the letter \mathbf{Y} on your keyboard to toggle it on and off. You can also hover your cursor over any inactive pin (and it will temporarily show the masked area for that pin. Now that you know where you painted, you can go back and paint over any areas you missed.

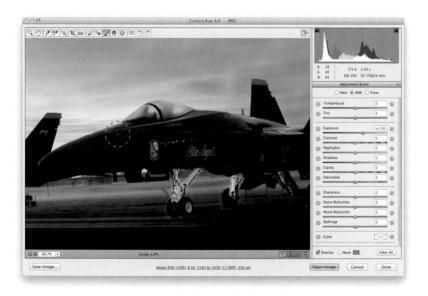

Step Seven:

Now, let's unlock a little more of the Adjustment Brush's power by adjusting more sliders. That's right, once you've painted over (masked) an area, you can adjust any of the other sliders and they affect just the area you painted over (here, they'll just affect the sky). Starting at the top, let's drag the Tint slider to the right, toward magenta, to make the sky color more interesting (I dragged it over to +30), then let's make it even darker by lowering the Exposure amount to -1.15. Now, head down to Saturation and crank that up a bit (I took it up to +60), and that flat dawn sky gets much more vibrant (as seen here). Yeah, that's just like I remember it (wink). The ability to paint over one area, and stack up a number of adjustments on just that area, is what gives this tool so much power.

Step Eight:

Next, let's work on the planes (the Blue Angels' F/A-18 Hornets). First, click the New radio button at the top of the panel, so we can paint over a new area (otherwise, the planes would get the same settings we used on the sky). Then, click the + button to the right of Exposure twice to reset all the other sliders to 0 and bump up the Exposure amount to +1.00 (twice the one-click amount). Now, with Auto Mask turned on, paint over the planes (as shown here), which lightens those areas because you increased the Exposure amount by quite a bit. Also, notice there are now two pins, and the sky's pin is now white (although it's not visible here because I zoomed in), letting you know it's no longer active. If you wanted to adjust the sky again, you'd click on its pin, and all the sky settings would come back.

Step Nine:

Finish painting over the rest of the planes, and then let's add some more "juice" to them by increasing the Exposure amount a bit more (here, I dragged it over to +1.50), then open the shadow areas by dragging the Shadows slider a little to the right (here, I went to +10), and then let's add some punch by adding Clarity (drag it over to around +17). Now the planes are really starting to pop, but you can see that I let the little + in the middle of the brush extend off the bottom of the first plane's wheels a bit, and it started to brighten the tarmac (concrete runway) below them, which looks bad. So, we'll have to deal with that next.

TIP: Choosing What to Edit

If you have multiple pins and you drag a slider, Camera Raw will adjust whichever pin is currently active (the green-and-black one). To choose which adjustment you want to edit, click on the pin to select it, then make your changes.

Step 10:

If you make a mistake, or need to erase something that spilled over, just pressand-hold the Option (PC: Alt) key and the brush switches to Erase mode. Now, just paint the area where you spilled over and it erases the spillover (as shown here; I also erased the adjustment from the last two planes because it made them a bit too bright). You can also switch to Erase mode by clicking on the Erase radio button at the top of the Adjustment Brush panel. When you switch this way, you get to choose the Size, Feather, Flow, and Density of the Erase brush (more on this in just a moment), so it's at least good to click on the radio button, choose your preferred brush size, then from that point on, just press-and-hold the Option key to get it when you need it.

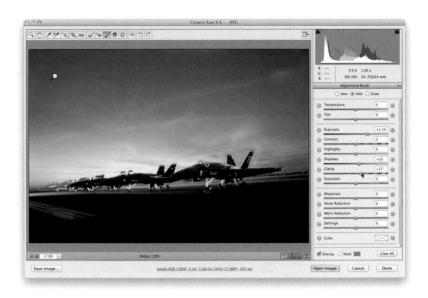

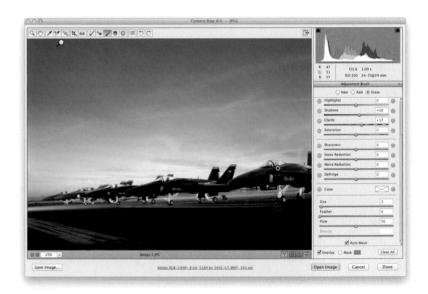

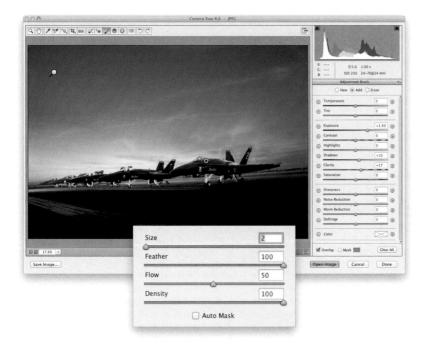

Step 11:

Here are a couple of other things about the Adjustment Brush you'll want to know: The Feather slider controls how soft the brush edges are—the higher the number, the softer the brush (I paint with a soft brush about 90% of the time). For a hardedged brush, set the Feather slider to 0. The default brush settings are designed to have it build up as you paint, so if you paint over an area and it's not dark enough, paint another stroke over it. This build-up amount is controlled by the Flow and Density sliders at the bottom of the panel. The Density slider kind of simulates the way Photoshop's airbrush capabilities work with its Brush tools, but the effect is so subtle here that I don't ever change it from its default setting of 100. The Flow slider controls the amount of paint that comes out of the brush (I leave the Flow set at 100 most of the time these days, but if I decide I want to "build up," then I lower it to 50). Below is a before/after, which shows how useful dodging and burning with the Adjustment Brush can be.

After

Retouching Portraits in Camera Raw

One of the main things we've always had to go to Photoshop for was retouching portraits, but now, by using the Spot Removal tool, along with the Adjustment Brush, we can do a lot of simple retouching jobs right here in Camera Raw, where they're completely non-destructive and surprisingly flexible.

Step One:

In the portrait shown here (which I shot on stage during my Light It, Shoot It, Retouch It tour, we want to make three retouches: (1) we want to remove any blemishes and soften her skin, (2) we want to lighten the whites of her eyes, brighten her eyes in general, and add contrast, and (3) we want to sharpen her eyes, eyebrows, and eyelashes.

Step Two:

We'll start with removing blemishes. First, zoom in on her face, then get the Spot Removal tool (B) from the toolbar up top (it's shown circled here in red) and set your brush Size to where it's just slightly larger than the blemish you want to remove. Now, move your cursor over the blemish and just click. Don't paint a stroke or anything—just click once and it's gone. If the removal doesn't look quite right, it just means that Camera Raw chose a bad place to sample clean skin from to make its repair. So, click on the green sample circle and drag it to a nearby area and it redoes the retouch (as shown here). Now, remove the rest of the blemishes with just a single click each, adjusting the position of their green sample circles, if necessary.

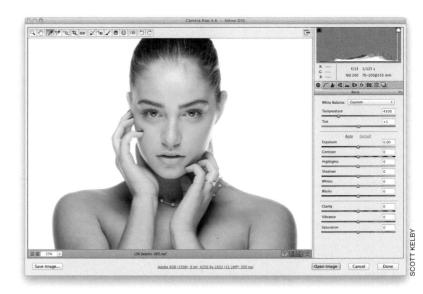

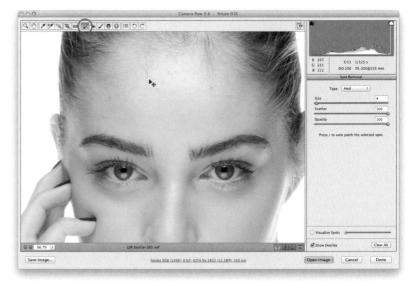

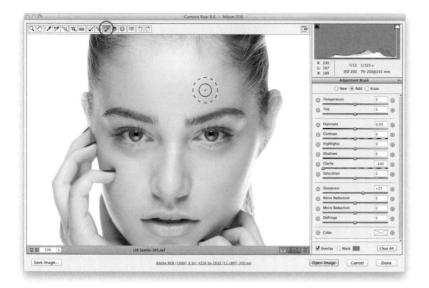

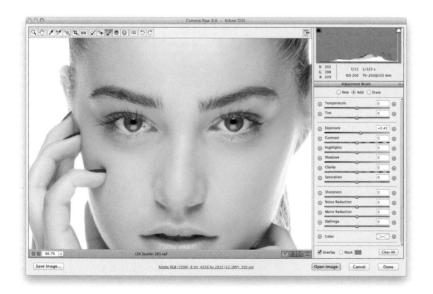

Next, let's do some skin softening. Click on the Adjustment Brush (shown circled here) in the toolbar, then click the - (minus sign) button to the left of Clarity four times to set the Clarity amount at -100 (this is called "negative clarity" by people who love to give everything a name). Now, increase the Sharpness slider to +25 and you're ready to go. Increase the size of your brush (by using either the Size slider or the Right Bracket key on your keyboard), and then paint over her skin to soften it (as shown here), but be careful to avoid any areas that should stay sharp and retain lots of detail, like her eyebrows, eyelids, lips, nostrils, hair, etc. While you're painting, you might not feel like it's really doing that much, but press the **P key** to togale the preview on/off, and you'll see that it's doing a lot more than you might think. Of course, once you're done painting, if you think you've applied too much softening, just raise the Clarity (try -75 or -50).

Step Four:

Let's work on the eyes next. Click the New radio button at the top of the panel (to work on a new area), then reset the Clarity and Sharpness sliders to 0 by double-clicking directly on the slider knobs. Now, drag the Exposure slider a little to the right, decrease the size of your brush, then paint over the whites of her eyes (as shown here). Once that looks good, click the New radio button again and zero out the sliders, so we can work on adding contrast and brightness to her irises.

Step Five:

To add more contrast, we're really going to crank up the Contrast slider (here, I dragged it over to +73), but to brighten and enhance the texture of the irises a bit at the same time, increase the Exposure to +85 and the Clarity to +18, then paint directly over the irises, and see how much better they look! Lastly, let's sharpen the eyes, eyelashes, and eyebrows. Click the New button once again, reset all the sliders to 0 (just click the + [plus sign] button to the right of Sharpness and it resets them all and moves Sharpness up to +25). Now, paint over her pupils and irises (but not out all the way to the edge of the iris), then paint over her eyelashes and eyebrows to help make them look sharper and crisper, completing the retouch (a before/after is shown below).

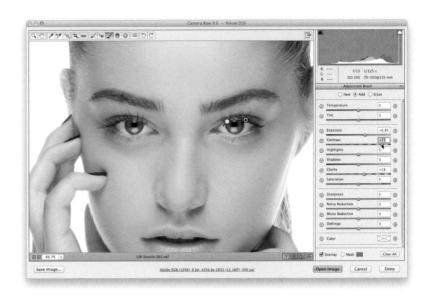

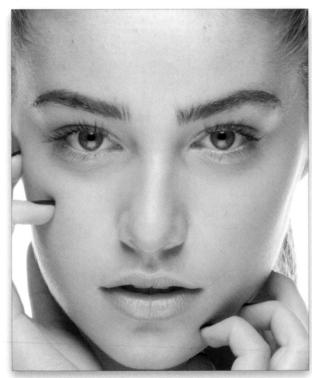

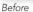

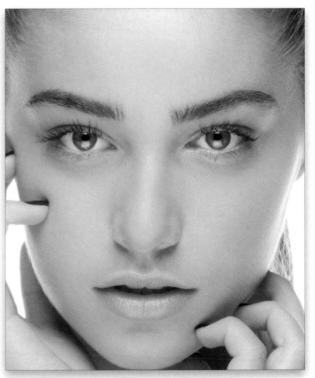

After

The Graduated Filter (which acts more like a tool) lets you recreate the look of a traditional neutral density gradient filter (these are glass or plastic filters that are dark on the top and then graduate down to fully transparent). They're popular with landscape photographers because you're either going to get a photo with a perfectly exposed foreground, or a perfectly exposed sky, but not both. However, with the way Adobe implemented this feature, you can use it for much more than just neutral density gradient effects (although that probably will still be its number one use).

Fixing Skies (and Other Stuff) with the Graduated Filter

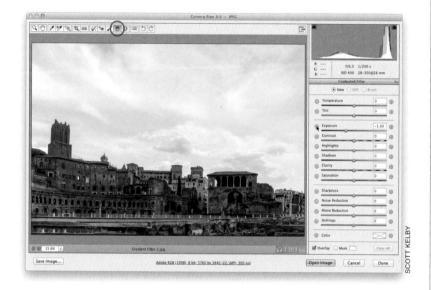

Step One:

Start by selecting the Graduated Filter tool (**G**) up in the toolbar (it's shown circled in red here). When you click on it, its options panel appears (shown here) with a set of effects you can apply that are similar to the ones you can apply using the Adjustment Brush. Here we're going to replicate the look of a traditional neutral density gradient filter and darken the sky. Start by dragging the Exposure slider to the left, or just click on the – (minus sign) button two times to get to –1.00 (as shown here).

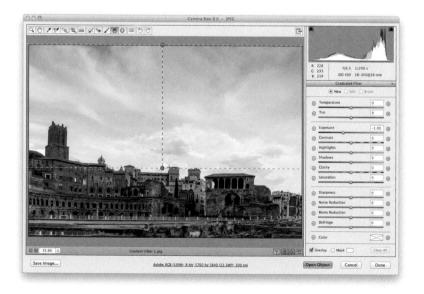

Step Two:

Press-and-hold the Shift key (to keep your gradient straight), click at the top center of your image, and drag straight down until you reach the top of the buildings (as shown here). Generally, you want to stop dragging the gradient before it reaches the horizon line, or it will start to darken your properly exposed foreground. You can see the darkening effect it has on the sky and the photo already looks more balanced. *Note:* Just let go of the Shift key to drag the gradient in any direction.

The green pin shows the top of your gradient; the red pin shows the bottom. In this case, we'd like the sky a little darker still, so drag the Exposure slider to the left a bit to darken the midtones in the sky. What's nice about this tool is, like the Adjustment Brush, once we've dragged out the Graduated Filter, we can add other effects to that same area. So, if you'd like the sky to be bluer, you can click on the Color swatch, and when the Color Picker appears, click on a blue color to complete your effect.

TIP: Gradient Tips

You can reposition your gradient after the fact—just click-and-drag downward on the line connecting the green and red pins to move the whole gradient down. Click-and-drag either pin to rotate your gradient after it's in place. You can also have more than one gradient (click on the New radio button at the top of the panel) and to delete a gradient, just click on it and press the Delete (PC: Backspace) key.

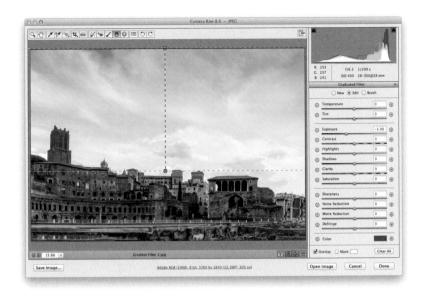

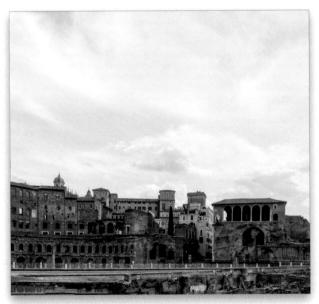

After

There are some really nice special effects you can apply from right within Camera Raw itself, and some of these are easier to achieve here than they are by going into the rest of Photoshop and doing it all with layers and masks. Here is a special effect that is popular in portrait and wedding photography: drawing attention by turning everything black and white, but leaving one key object in full color (and while we photographers cringe at the sight of it, clients absolutely love it).

Applying Selective Color in Camera Raw

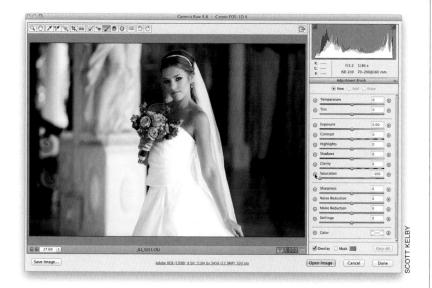

Step One:

For this effect (where we make one part of the image stand out by leaving it in color, while the rest of the image is black and white [I know it's cheesy, you know it's cheesy, but, again, clients love it]), we want to set up the Adjustment Brush so it paints in black and white. Start by getting the Adjustment Brush (K), then in the Adjustment Brush options panel, click on the – (minus sign) button to the left of Saturation four times to reset all the other sliders to 0 and set the Saturation to –100. That way, whatever you paint over becomes black and white.

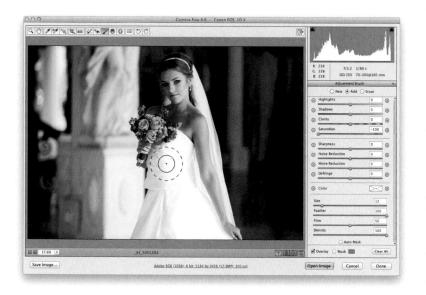

Step Two:

In just a moment, we're going to paint over most of the image, and this will go a lot faster if you turn off the Auto Mask checkbox near the bottom of the panel (so it's not trying to detect edges as you paint). Once that's off, make your brush nice and big (drag the Size slider to the right or press the **Right Bracket key**), and paint over most of the image, but make sure you don't get too close to the area right around the bouquet, as shown here, where I left about a ½" area untouched all around the bouquet.

Now you'll need to do two things: (1) make your brush size smaller, and (2) turn on the Auto Mask checkbox. The Auto Mask feature is really what makes this all work, because it will automatically make sure you don't accidentally make the object in your image that you want to remain color, black and white, as long as you follow one simple rule: don't let that little plus-sign crosshair in the center of the brush touch the thing you want to stay in color (in our case, it's the bouquet of flowers). Everything that little crosshair touches turns black and white (because we lowered the Saturation to -100), so your job is to paint close to the flowers, but don't let that crosshair actually touch the flowers. It doesn't matter if the edges of the brush (the round rings) extend over onto the flowers (in fact, they'll have to, to get in really close), but just don't let that little crosshair touch, and you'll be fine. This works amazingly well (you just have to try it for yourself and you'll see).

Step Four:

Here, we've painted right up close to the bouquet and yet the flowers and even the green stems are still in color because we were careful not to let that crosshair stray over onto them.

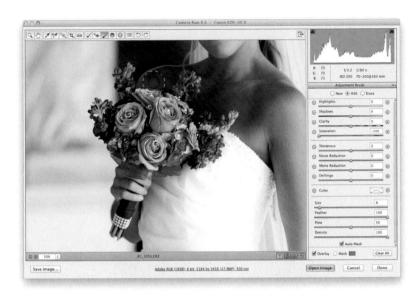

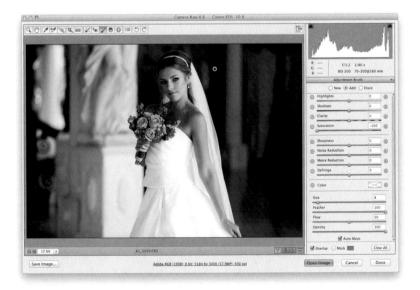

You've been able to add edge vignettes (where the outside edge around your image is darkened) for a while now, but the problem had always been your subject had to be right in the center, since it darkened evenly around the outside edges. Now, with the Radial Filter, you can control placement of your vignette, so it's right where you want it, and you can have multiple sources of light, so you can also use it as a spotlight effect or to re-light your image after the fact.

Camera Raw's Radial Filter (Custom Vignettes & Spotlights)

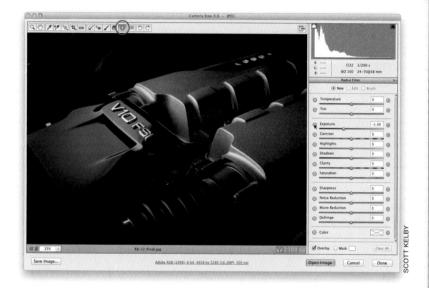

Step One:

Here, we want to focus the viewer's attention on the car's engine specs (using dramatic lighting) rather than the outside edges of the image. So, click on the Radial Filter tool (J) up in the toolbar (it's shown circled here in red). Since we want to darken the outside edges, click the – (minus sign) button to the left of the Exposure slider a couple times, so when we use the tool it will be easy to see the effect (we can always change the amount later).

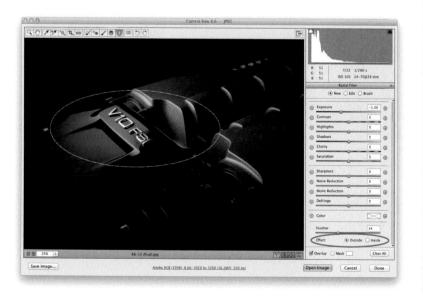

Step Two:

At the bottom of the this panel, you'll see an Effect option, which lets you choose whether it's the area inside the circle that gets affected or the area outside. In this case, we want what's inside to remain unchanged and everything outside it to be darker, so click the Outside radio button. Now, click-and-drag out the tool in the basic direction you want your oval (or circular) pool of light to appear. Here, I dragged it out over the center of the area I want to affect.

TIP: Repositioning as You Drag As you're dragging out your oval, you can reposition it as you're dragging by pressing-and-holding the **Spacebar**. Try it. It's really handy.

Once your oval is in place, you can rotate it by moving your cursor outside the green overlay and clicking-and-dragging in the direction you want to go. To resize the oval, just click on any one of the little handles on the edges, and drag out or in. To move the oval, just click anywhere inside the overlay and drag it where you want it. While we're here, let's make the area outside of the "lit" area darker. Drag the Exposure slider to the left until it reads –1.75 (as seen here).

TIP: Two Handy Keyboard Shortcuts
Pressing the letter **V** hides the green overlay oval from view (press V again to get it
back; you'll see I turned it off in the next
step), and pressing the letter **X** swaps the
Effect from Outside to Inside (so, instead
of the outside being dark in this case, it
makes the center dark and everything
outside the oval unchanged).

Step Four:

The nice thing about this filter is that you can do more than just adjust Exposure. For example, drag the Contrast slider over to the right (as I did here to +34) and this makes that outside area more contrasty. If it wasn't already so gray (it is an engine after all), you could lower the Saturation and then everything outside the oval would not only be darker, but black and white (or vice versa if you increased the Saturation). Now, I mentioned in the intro on the previous page that you could add multiple filters on the same image and that you could use it to effectively re-light an image. So, let's do that next.

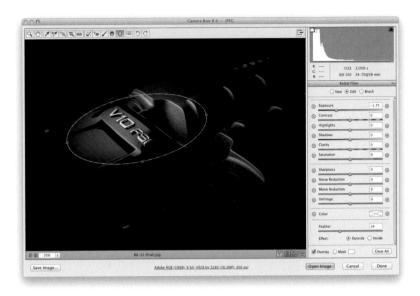

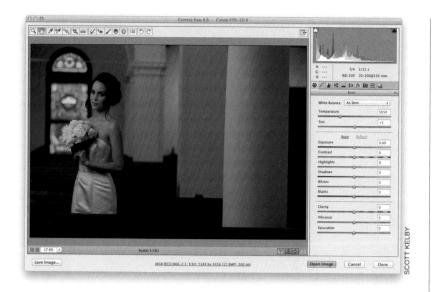

Step Five:

Here we're going to re-light this image using the Radial Filter. The viewer's eye is drawn to the brightest part of the image first, but unfortunately, in this shot, the light on our subject is not as bright as the light coming through the stained glass window next to her, which draws your eye away from her face. The light on our subject is at least directional, nice, and soft—it's just not quite bright enough.

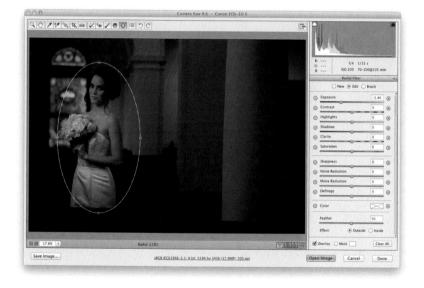

Step Six:

We'll start the same way we did the last one—by selecting the Radial Filter tool and dragging out an oval in the direction we want it. In this case, I want her to remain the same, but I want the area around her much darker. So, make sure the Outside Effect radio button is selected and drag the Exposure slider way over to the left to darken the area outside the oval (here I dragged it to –1.40).

TIP: Removing Ovals

If you want to remove an oval you've created, either just click on it and hit the **Delete (PC: Backspace) key**, or move your cursor over the center point of the oval, press-and-hold the **Option (PC: Alt) key**, and your cursor will turn into a pair of scissors. Now, just click on the center point of the oval to delete it. Also, just as a general rule, when you have this scissor tool, don't run. Sorry, I couldn't help myself.

Step Seven:

To add another oval, click the New radio button at the top of the Panel area (so Camera Raw knows you want to create a new pool of light), then at the bottom of the panel, switch the Effect to Inside (or use the shortcut I mentioned earlier: X). Now, we're going to use this oval to light her bouquet, which is getting a bit lost. So, drag out a small oval over her bouquet, but this time, you'll brighten this area by dragging the Exposure slider to the right a bit (as I did here, where I dragged to +1.10).

Step Eight:

We need another of the exact same oval to light her face a bit better. Rather than starting from scratch, we'll duplicate the second oval. Press-and-hold Command-Option (PC: Ctrl-Alt) and when your cursor changes into two small arrows, click-and-drag on the center of your second oval, release your mouse button and those keys, and a third oval (a duplicate of your second one) appears. Place it right on her face (as shown here) and rotate and resize it as necessary. Increase the Exposure a little (here, I set it to +1.35), and you could try increasing the Shadows to open up detail there (as I did here, where I increased it to +14). Remember, you can use any of the sliders in the panel.

TIP: Controlling the Edge Blending
The softness of the transition between
the center of your oval and the area being
affected by the sliders is controlled by the
Feather amount and, at a setting of 100,
you get the softest, smoothest blending
between the two. If you lower the Feather
amount, the transition area becomes
smaller and, of course, if you drag it to
zero, it becomes a downright hard edge.
Never had a use for that. Ever.

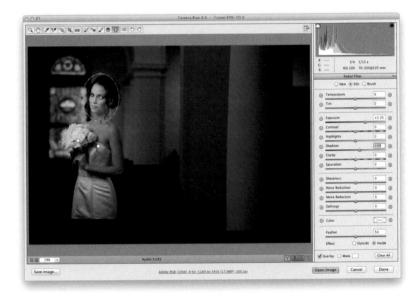

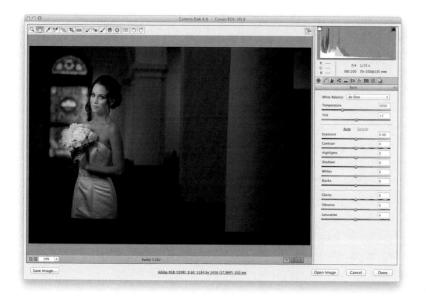

Step Nine:

One more thing to think about: What we've mostly done here is darken the area around our subject (well, except for those two small areas we brightened). But, if we want to make her brighter overall, we'll need to go back to the Basic panel and drag the Exposure slider to the right (I didn't need to here). This would make her brighter, but also make the entire photo brighter at the same time. So, if the edges of the image then look too bright, you can go back to the Radial Filter tool, click on the first oval you made, and decrease (darken) the Exposure slider some more (that will only affect the area around her). I'm showing the before image below, as well, so you can see how dramatically we've re-lit the image using the Radial Filter.

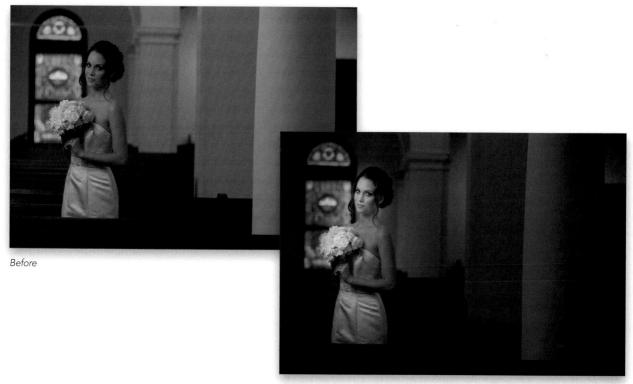

After

Fixing Color Problems (or Adding Effects) by "Painting" White Balance

Camera Raw lets us paint with white balance, and of all the things that have been added to Camera Raw over the years, believe it or not, this is one of the ones you'll probably wind up using the most. It's pretty common to have a natural light photo where part of the photo is in shadows, which usually means the parts in daylight have one color, and the parts in shadows are usually bluish (especially if you use Auto White Balance, which most of us do, because it works pretty well for most situations). Here's how to paint with white balance to make all the color in your image consistent:

Step One:

Here's a location portrait, where our subject has a nice warm skin tone (partially because I put an orange gel over the off-camera flash), but take a look at the background behind her—the buildings are in the shade and that makes them look blue (like it was taken at dawn), even though it was taken at sunset. If I try to warm up the white balance, she is going to turn really yellow. Luckily, now we can adjust the white balance in just one area.

Step Two:

Get the Adjustment Brush (K), click on the + (plus sign) button to the right of Temperature (this resets all the other sliders to 0 and sets the Temperature to +25), and start painting over these bluish background areas (as shown here). Once you've painted over them, you can adjust the Temperature slider (drag to the right to warm up the color and make this area less blue, as I did here, or to the left if the default setting of +25 makes things too warm). This is the beauty of using the Adjustment Brush for this—once you paint over the bluish area, you can "dial in" just the right amount of white balance correction by dragging the slider after you've painted. Now the buildings look more neutral, especially the mirrored building in the top right. I also increased the Highlights a bit to finish it up.

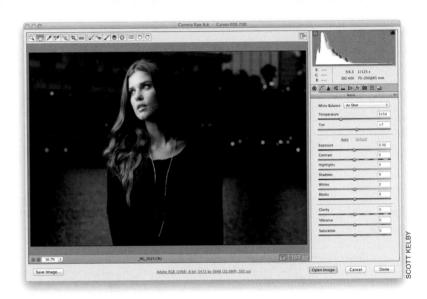

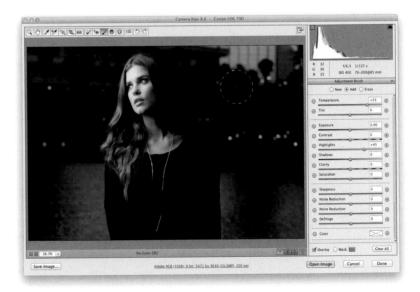

If you shoot at a high ISO (like 800 or above), you're going to see some noise in your image (depending on your camera's make and model, of course), but the area where it's going to show up the most is in the shadow areas (that's where noise tends to be its worst, by far). Worse yet, if you have to brighten the shadow areas, then you're really going to see the noise big time. Well, as good as Camera Raw's noise reduction works, like any noise reduction, the trade-off is it makes your photo a bit softer (it kind of blurs the noise away). This technique lets you paint noise reduction just where you need it, so the rest of the image stays sharp.

Reducing Noise in Just the Shadow Areas

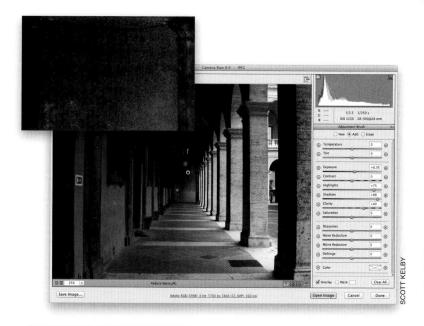

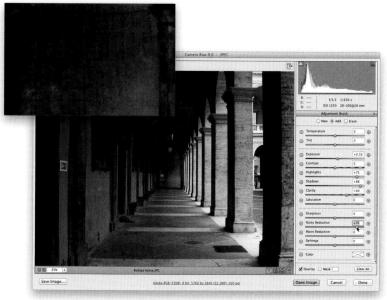

Step One:

We'll start by brightening up the wall at the end of this walkway. This shot was taken at ISO 1250, so when we brighten up that area, it's going to exaggerate any noise in those shadow areas big time, but at least now we can do something about it. Start by getting the Adjustment Brush (K), click on the + (plus sign) button to the right of Shadows (this resets all the other sliders to 0), then drag the Shadows slider to around +88, and paint over that brown wall in the back. Even after that, it's still too dark, so try brightening the Highlights by dragging that slider over to +75 and increase the Exposure to +0.35. Lastly, drag the Clarity slider over to +40 (to enhance the texture). It definitely looks better now (well, to me anyway), but if you look at the inset, you now see lots of noise that was once hidden in those shadows.

Step Two:

Now, zoom in to 100%, so you can really see the noise in these shadow areas, and drag the Noise Reduction slider to the right as you keep an eye on the amount of noise in your image. Keep dragging until you find that sweet spot, where the noise has been reduced but these shadow areas haven't gotten too blurry (remember, it's noise reduction, not noise removal). This noise reduction only affects that wall area where you painted, and the rest of the image keeps its original sharpness.

How to Get More Than 100% Out of Any Adjustment Brush Effect

Let's say you feel like a particular part of your photo needs more Clarity, so you've set the Clarity slider to 100 and painted over that part of your image. You look at that area and think, "Even though I painted with the slider at 100%, I still need more!" (Basically, you need your amp to go to 11.:) Here's what to do:

Step One:

Here's the image we want to work on, and our goal is to bring out extra detail in the headlamps of the car. So, go ahead and get the Adjustment Brush (K), click on the + (plus sign) button to the right of the Clarity slider (to reset all the other sliders to 0), and then drag just that Clarity slider way over to +100. Next, fully paint over just the two circular headlamps. Now, if you think they still need more detail to really make them "pop," but you've already painted with your Clarity maxed out at +100, what do you do? You can't drag the slider over to +200 or anything like that, right?

Step Two:

All you need to do is press **Command-Option** (**PC: Ctrl-Alt**) and click-and-drag on the edit pin to make another copy of the adjustment (so you have two pins on this area now: the original pin where you applied 100% Clarity, and now a second pin with another 100% Clarity on top of that). Basically, you've got 200% Clarity applied on those headlamps. Of course, this doesn't just work for Clarity—it works for any of the sliders here in the Adjustment Brush panel.

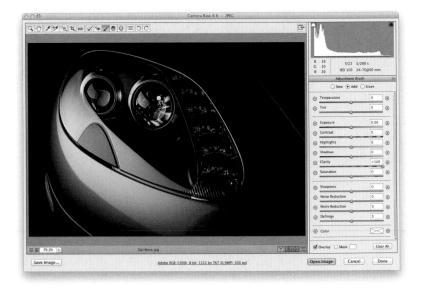

Photoshop Killer Tips

Painting a Gaussian Blur

Okay, technically it's not a Gaussian blur, but in Camera Raw, you can paint with a blur effect by lowering the Sharpness amount (in the Adjustment Brush panel) below 0 (actually, I'd go all the way to –100 to get more of a Gaussian-type blur

look). This is handy if you want to add a blur to a background for the look of a more shallow depth of field, or one of the 100 other reasons you'd want to blur something in your photo.

Why There Are Two Cursors

When you use the Adjustment Brush, you'll see there are two brush cursors displayed at the same time, one inside the other. The smaller one shows the size of the brush you've selected; the larger (dotted-line circle) shows the size of the feathering (softening) you've applied to the brush.

How to Set the Color to None

Once you pick a color using the Adjustment Brush's Color Picker, it's not really obvious how to reset the color to None (no color). The trick is to click on the Color swatch (in the middle of the Adjustment Brush options panel) to reopen the Color Picker, then drag the Saturation slider down to 0. Now, you'll see the X over the Color swatch, letting you know it's set to None.

How to See Just One of Your Layers
Just Option-Click (PC: Alt-click) on the
Eye icon beside the layer you want to see,
and all the others are hidden from view.
Even though all the other layers are hidden,
you can scroll through them by pressingand-holding the Option (PC: Alt) key, and
then using the Left and Right Bracket
keys to move up/down the stack of layers.
Want to bring them all back? Just Optionclick on that Eye icon again.

Painting Straight Lines

If you want to paint a straight line using the Adjustment Brush, you can use the same trick we use with Photoshop's Brush tool: just click once where you want the line to start, press-and-hold the Shift key, then click once where you want the straight line to end, and the Adjustment Brush will draw a perfectly straight line between the two. Really handy when working on hard edges, like the edge of a building where it meets the sky.

Save a "Jump Back" Spot

If you're familiar with Photoshop's History panel, and how you can make a snapshot at any stage of your editing, so you can jump back to that look with just one click, well...good news: you can do that in Camera Raw, too! You can save a snapshot while you're in any panel by pressing Command-Shift-S (PC: Ctrl-Shift-S). Then you can jump back to how the image looked when you took that snapshot by clicking on it in the Snapshots panel.

Photoshop Killer Tips

Starting Over from Scratch

If you've added a bunch of adjustments using the Adjustment Brush, and you realize you just want to start over from scratch, you don't have to click on each one of the edit pins and hit the Delete

(PC: Backspace) key. Instead, click on the Clear All button in the bottom-right corner of the Adjustment Brush options panel.

Changing Brush Size with Your Mouse

If you Right-click-and-hold with the Adjustment Brush in Camera Raw, you'll see a little two-headed arrow appear in the middle of your brush. This lets you know you can drag side-to-side to change the size of your Adjustment Brush (drag left to make it smaller and right to make it bigger).

Seeing Paint as You Paint

Normally, when you paint with the Adjustment Brush, you see the adjustment (so if you're darkening an area, as you paint, that area gets darker), but if you're doing a subtle adjustment, it might be kind of hard to see what you're actually painting (and if you're spilling over into an area you don't want darkened). If that's the case, try this: turn on the Mask checkbox (at the bottom of the Adjustment Brush panel). Now, when you paint, it paints in white (the default mask color, which you can change by clicking on the color swatch to the right of the checkbox), so you can see exactly the area you're affecting. When you're done, just press the Y key to turn the Mask checkbox off. This one's worth a try.

Add Your Own Color Swatches

When you click on the Color swatch in the Adjustment Brush panel, you see that there are five color swatches in the bottom-right corner of the Color Picker.

They're there for you to save your mostused colors, so they're one click away. To add a color to the swatches, first choose the color you want from the color gradient, then press-and-hold the Option (PC: Alt) key and when you move your cursor over any of those five color swatches, it will change into a paint bucket. Click that little bucket on any one of the swatches, and it changes the swatch to your currently selected color.

Hiding the Edit Pins

To temporarily hide the edit pins that appear when you use the Adjustment Brush, just press the **V key** on your keyboard (it toggles the pins' visibility on/off).

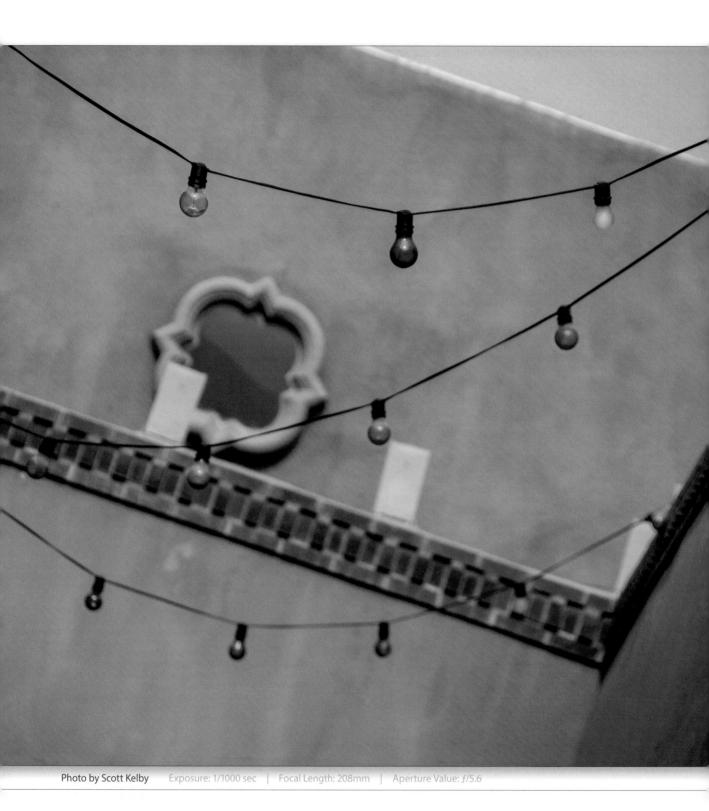

Chapter 4 How to Resize and Crop Photos

Scream of the Crop how to resize and crop photos

I love the title of this chapter—it's the name of an album from the band Soulfarm (tell me that Soulfarm wouldn't make a great name for a horror movie!). Anyway, I also found a band named Cash Crop, which would make a great title, too, but when I looked at their album, every song was marked with the Explicit warning. I listened to a 90-second preview of the first track (which was featured in the original motion picture soundtrack for the movie Sorority Row), and I immediately knew what kind of the music they did. Naughty, naughty music. Anyway, while I was listening, and wincing from time to time as F-bombs exploded all around me, I realized that someone at the iTunes Store must have the full-time job of listening to each song and choosing the 90-second preview. I imagine, at this point, that person has to be 100% completely numb to hearing things like the F-bomb, the S-missile, and the B-grenade (which means

they could totally do a stint as Joe Pesci's nanny). But, I digress. The "Scream of the Crop" title (which would make a great title for a movie about evil corn) is almost ideal for this chapter, except for the fact that this chapter also includes resizing. So, I thought, what the heck, and searched for "resize" and found a song called "Undo Resize" by electronic ambient artist DJ Yanatz Ft. The Designers, and it literally is an 8:31 long background music track with two European-sounding women whispering the names of menu commands from Adobe products. Stuff like "Select All," "Fill," "Distort," "Snap to Grid," and so on. I am not making this up (I listened to the free 90-second preview). It was only 99¢, which was a bargain for 8+ minutes of menu commands set to music. Normally, this many minutes of menu commands set to music would be more like, I dunno, \$1.29 or so.

Basic Cropping for Photos

Adobe completely overhauled cropping in Photoshop CS6, and it was a big improvement (it was long overdue, since aside from a few minor enhancements, cropping had been essentially unchanged since Photoshop 1.0). Here, we'll cover the basic garden-variety cropping (and a new way of cropping), but since there are many different ways to crop a photo in Photoshop (and different reasons why you'd use one over another), we'll cover them all. If you're a Lightroom user, you'll be right at home with this cropping, because it works more like Lightroom's cropping.

Step One:

Press the letter C to get the Crop tool and you instantly see the first improvement over previous versions of the tool: you don't have to drag the cropping border out over your photo—it's automatically added around your image for you (yay!). Now, just grab one of the corner or side handles and start dragging inward to start cropping (as shown here) and it crops in toward the center of the image (the area to be cropped away will appear dimmed). If you want to keep the image proportions the same in your crop (I usually do), just press-and-hold the Shift key while you drag any of the cropping handles. Also, you can reposition your image within the border by clickingand-dragging on it.

Step Two:

The Rule of Thirds overlay grid that you see in Step One doesn't appear over your photo until you actually drag one of the cropping handles. If you see a different overlay, just click on the Overlay Options icon in the Options Bar (it's to the right of the Straighten tool) and you'll get a popup menu of the different overlays you can choose (if you're not sure which one you want, you can cycle through them by pressing the letter O). There are also three overlay settings in the menu: Always Show Overlay (once you start cropping, it's visible even when you're not cropping), Never Show Overlay, and Auto Show Overlay (my favorite—it only appears when you're actually cropping).

While you have the cropping border in place, if you need to rotate your photo, just move your cursor anywhere outside the border. When you do this, the cursor will change into a double-headed arrow. Just click, hold, and drag up (or down) and the image will rotate in the direction you choose (rather than the cropping border). This makes the process much easier (especially when you're trying to straighten a horizon line or a building). A little pop-up appears, too, with the angle of rotation (it's shown circled here in red).

Step Four:

If you decide you want to return to the old way of rotating your crop (where the border rotates, rather than your image), click on the Set Additional Crop Options icon (it looks like a gear) in the Options Bar and turn on the Use Classic Mode checkbox (also known as "old school" or "ancient cropping" by today's hipster croppers), and then you're back to the old method. However, I really recommend giving this newer way a tryit takes a little getting used to, but once you do, you'll really find it useful. While we're in this options menu, when you're not in Classic mode, you have two options available here: (1) to turn off having your crop centered automatically (it's on by default), and we'll talk about the next one on the next page (it's a little more involved).

Step Five:

That other option (2) is more powerful than it sounds, because it pretty much brings one of the most popular cropping features of Lightroom over here to Photoshop. In Lightroom, it's called Lights Out cropping, and when you use this, it blacks out everything surrounding your crop area, so as you drag a cropping handle, you see exactly what the final image will look like without any distractions. If you click on the Set Additional Crop Options icon, you can toggle this on/off with the Show Cropped Area checkbox, but honestly it's quicker just to press the letter H on your keyboard (it's easy to remember— H for hide the distracting stuff; click on a cropping handle first or it'll switch to the Hand tool). Want to take it up a notch? Once you've hidden the extra stuff, hit the Tab key on your keyboard and everything else (the Toolbox, panels, Options Bar, etc.) hides temporarily, too. The other options here only kick in if you do have that dimmed cropped away area visible (called the Crop Shield), and you can make it lighter or darker by changing the Opacity amount, or you can turn it off altogether by turning off the Enable Crop Shield checkbox.

Step Six:

If you want to save some time, there's a list of preset standard cropping sizes in the pop-up menu at the left end of the Options Bar (seen here). Just choose the crop ratio you'd like (here, I chose a square 1:1 ratio), and your crop border automatically resizes to that size or ratio (as shown here).

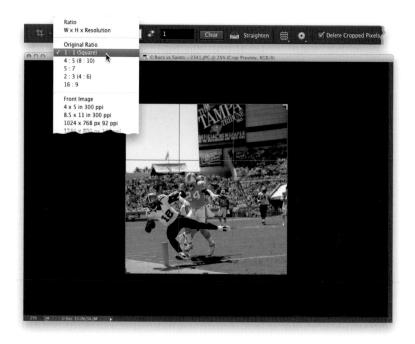

Step Seven:

If you decide at some point you don't want to crop the image at all, you can either press the **Esc key** on your keyboard, click on the "No!" symbol in the Options Bar (as shown here), or just click on a different tool in the Toolbox, which will bring up a dialog asking if you want to crop the image or not.

TIP: Flipping Your Crop Horizontal/Vertical

Want to flip the cropping border after you've clicked-and-dragged it out, so you can crop your wide photos with a tall crop that maintains the same aspect ratio (or vice versa)? Just press the letter **X** on your keyboard.

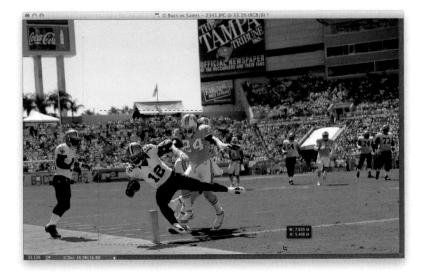

Step Eight:

So far, we've looked at the standard way of cropping—click on the tool and then drag the handles where you want thembut you can also use the freestyle way of cropping (like in previous versions of Photoshop) by taking the Crop tool itself and just clicking-and-dragging over the area you want to crop (as shown here). Don't let it freak you out that there's a cropping border already in place—just click-and-drag it out, and when you release the mouse button, it will display your new cropping border. Of course, now you can tweak the handles just like before. If you go back and look at the original image in Step One, you'll see how much we've already cropped away (it's quite a bit).

Step Nine:

You can also add canvas area around your image using the Crop tool. One quick thing to check first: if you want a white background for your canvas area (and my guess is, most times you will), then before you even click on the Crop tool, press the letter **D** on your keyboard to set your Background color to white. Then, once you click on the Crop tool, make sure Ratio is selected in the popup menu at the left end of the Options Bar and you click the Clear button to clear the Width and Height fields, otherwise the cropping border will be constrained to the aspect ratio of your image (in this case, we want the bottom section to be deeper than the sides and top). Now, grab a cropping handle and drag the border outward to add canvas area. Here, I clicked on the top-left cropping handle and dragged up and to the left (at a 45° angle), and it expanded the top and left side areas around my image.

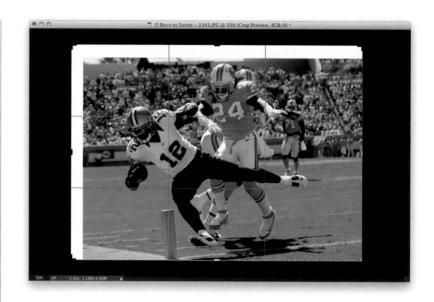

Step 10:

Here, I dragged the right side out and then dragged the bottom-center handle down quite a bit to add a fine art poster mat look around my image.

TIP: Skip Holding the Shift Key
You already know that to keep your
cropping proportional, you press-andhold the Shift key, right? Here's how to
skip having to hold that key ever again,
yet still keep it proportional: close any
open images, grab the Crop tool, and
then choose **Original Ratio** from the
pop-up menu at the left end of the
Options Bar. Now, it's your default
setting. How cool is that?

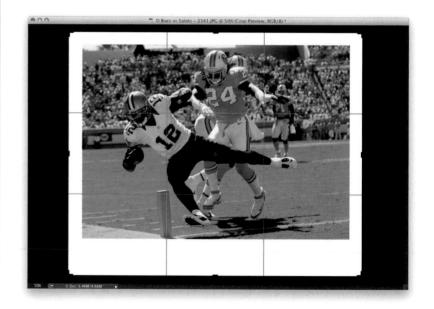

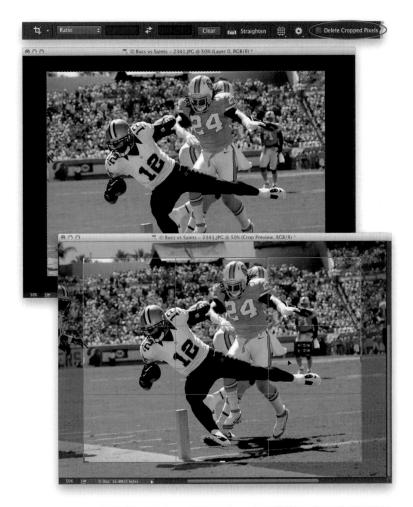

Step 11:

Before you actually commit to cropping your image, you have a decision to make. Luckily, it's probably a decision you'll make once, based on how you like to do things, so you won't have to make it every time. You get to decide if the part of your image that gets cropped away from view is: (a) gone forever, or (b) just hidden from view and, if necessary, can be brought back. You choose this by turning on/off the Delete Cropped Pixels checkbox up in the Options Bar (shown circled here in red). With it turned on, when you crop, the stuff outside the border is cropped away (and you get a smaller file size). If you turn if off, it keeps those areas in the file, even though you can't see them (well, not until you click on the Crop tool again and click-and-drag the cropping border back out). If you need the photo a specific size, but aren't happy with the way your first crop looks, you can move the image around with the Move tool (V), or click on the cropping border while the Crop tool is active, then click on the image and move it.

Step 12:

Once you have the cropping border right where you want it, press the **Return (PC: Enter) key** to crop your image. The final cropped image is shown here, where we cropped off the signs on the top and the field on the bottom, the cameraman and player on the far left, and the crowd and players on the right.

Cropping to a Specific Size

If you're using one of the standard size or cropping ratio presets that appear in the Crop tool's pop-up menu, then you're set. However, there are only a few common sizes in that pop-up menu, so you're going to need to know (a) how to create custom sizes, and (b) how to save that custom size to the pop-up menu, so you don't have to build it from scratch again next time. Plus, I'm going to show you another way to crop an image that, well, I'm not proud of, but I know a lot of photographers that do it this way. (Now, I'm not saying that I've done it that way, but...well...I've done it that way. More times than I care to admit.)

Step One:

Here's the image I want to print as a wide 20x16" print (a very common size today, even though it's based on the size of traditional film, not digital images, so you have to crop just to make it fit). Start by clicking on the Crop tool (C) in the Toolbox, then from the pop-up menu at the left end of the Options Bar, choose **W** x **H** x **Resolution** (as shown here).

Step Two:

This adds a Resolution field to the Options Bar next to the Width and Height fields. Type in the custom size you want (in this case, 20x16" at a resolution of 240 ppi, which is pretty ideal for most color inkjet printing) and it resizes automatically. If you think you'll be using this size again (and chances are, you will), click on the pop-up menu and choose New Crop Preset, name it, click OK, and it adds this new size to that pop-up menu, so you don't have to recreate it every time. You can click-and-drag the photo left/right to get the part of it you want to appear inside the cropping border. Now press the Return (PC: Enter) key and it crops your image to that size.

Okay, here's that (ahem) other method: Go under the File menu and choose **New** (or press **Command-N [PC: Ctrl-N]**). When the New dialog appears, enter 20 inches by 16 inches, and enter 240 for Resolution, then click OK to create a new blank document in the exact size and resolution you need (as seen here).

TIP: Cropping to Another Photo's Size

If you already have a photo that is the exact size and resolution that you'd like to apply to other images, you can use its settings as the crop dimensions. First, open the photo you'd like to resize, and then open your ideal-size-and-resolution photo. Get the Crop tool, and then from the pop-up menu at the left end of the Options Bar, choose Front Image. Photoshop will automatically input that photo's dimensions into the Crop tool's Width, Height, and Resolution fields. All you have to do is click back on the other image, and you'll see a cropping border that shares the exact same specs as your ideal-size photo.

Step Four:

Now, get the Move tool (V), click on the image you want cropped to that size, and drag it onto that new blank document. While you still have the Move tool, click-and-drag the image around within the window so it's cropped the way you want it, then press Command-E (PC: Ctrl-E) to merge this layer with the Background layer, and you're set. As you can see, they both kind of do the exact same thing, so which one's right? The one you like best.

Creating Your Own Custom Crop Tools

Although it's more of an advanced technique, creating your own custom tools isn't complicated. In fact, once you set them up, they will save you time and money. We're going to create what are called "tool presets." These tool presets are a series of tools (in this case, Crop tools) with all our option settings already in place, so we can create a 5x7", 6x4", or whatever size Crop tool we want. Then, when we want to crop to 5x7", all we have to do is grab the 5x7" Crop tool preset. Here's how:

Step One:

Press the letter **C** to switch to the Crop tool, and then go under the Window menu and choose **Tool Presets** to bring up the Tool Presets panel. You'll find that five Crop tool presets are already there. (Make sure that the Current Tool Only checkbox is turned on at the bottom of the panel, so you'll see only the Crop tool's presets, and not the presets for every tool.)

Step Two:

Go up to the Options Bar and, with the pop-up menu set to **Ratio**, enter the dimensions for the first tool you want to create (in this example, we'll create a Crop tool that crops to a wallet-size image). In the Width field, enter 2 in, then press the **Tab key** to jump to the Height field, enter 2.5 in, and press Return (PC: Enter). *Note*: If you want to include the resolution in your tool preset, from the pop-up menu, choose **W** x **H** x **Resolution**. Enter your height, width, and resolution in the fields to the right of the pop-up menu, and click OK.

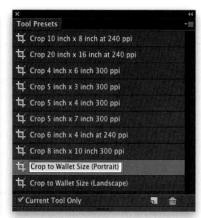

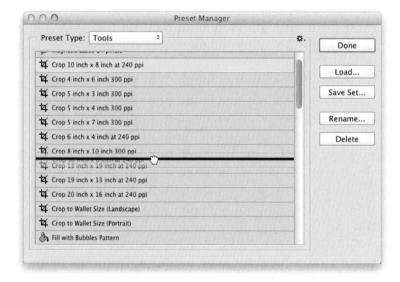

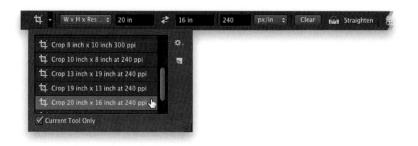

In the Tool Presets panel, click on the Create New Tool Preset icon at the bottom of the panel (to the left of the Trash icon). This brings up the New Tool Preset dialog, in which you can name your new preset. Name it, click OK, and the new tool is added to the Tool Presets panel. Continue this process of typing in new dimensions in the Crop tool's Options Bar and clicking on the Create New Tool Preset icon until you've created custom Crop tools for the sizes you use most. Make sure the name is descriptive (for example, add "Portrait" or "Landscape"). If you need to change the name of a preset, just double-click directly on its name in the panel, and then type in a new name.

Step Four:

Chances are your custom Crop tool presets won't be in the order you want them, so go under the Edit menu, under Presets, and choose **Preset Manager**. In the resulting dialog, choose **Tools** from the Preset Type pop-up menu, and scroll down until you see the Crop tools you created. Now just click-and-drag them to wherever you want them to appear in the list, and then click Done.

Step Five:

Now you can close the Tool Presets panel because there's an easier way to access your presets: With the Crop tool selected, just click on the Crop icon on the left end of the Options Bar. A tool preset picker will appear. Click on a preset, and your cropping border will be fixed to the exact dimensions you chose for that tool.

Sync Settings

Imagine being able to sit down at a friend's or co-worker's computer to do some Photoshop work and, within seconds, you have all your own brushes, swatches, actions, patterns, and more, so it's just like working in your version of Photoshop, your way. Or, wouldn't it be nice to have your laptop's and your desktop's settings exactly alike? You can do just that by syncing your important settings with the Creative Cloud, so they're always just one click away (plus, now you have a copy of your important settings backed up to the cloud, so if your hard drive dies or your computer gets lost or stolen, you can quickly get back up and running).

Step One:

Start by going under the Photoshop (PC: Edit) menu, under Preferences, and choosing **Sync Settings** (as shown here) to go directly to the preference settings for syncing (also shown here). By default, it assumes you want all your stuff synced, but if you'd prefer to not have one or more of the options synced, set the What To Sync pop-up menu to **Custom**, and just turn off those checkboxes.

Step Two:

If the date of your Last Sync was quite a while ago (time flies when you're not syncing), you can go under the Photoshop (PC: Edit) menu, under your Adobe ID, and choose **Upload Settings** and it will update your Creative Cloud settings with your current ones (it only updates any settings you've changed since your last sync). Okay, so how do you use all of this on a different computer? Well, you start in the Help menu, where you choose **Manage My Account**, sign in to your Creative Cloud account, and then go back under your Adobe ID and choose **Download Settings**.

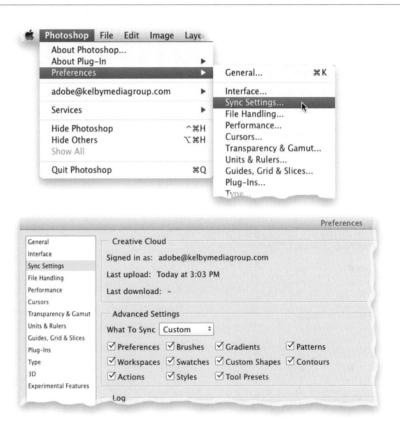

Photoshop's dialog for creating new documents has a pop-up menu with a list of preset sizes. You're probably thinking, "Hey, there's a 4x6", 5x7", and 8x10"—I'm set." The problem is there's no way to switch the resolution of these presets (so the Portrait, 4x6 will always be a 300 ppi document). That's why creating your own custom new document sizes is so important. Here's how:

Custom Sizes for Photographers

New Name: Untitled-1 OK Preset: Custom # Cancel Save Preset... Width: 7 Inches \$ Delete Preset. Height: 5 Inches \$ Resolution: 212 Pixels/Inch + Color Mode: RGB Color \$ 8 bit \$ + Image Size: Background Contents: White 4.50M Advanced Color Profile: Working RGB: Adobe RGB (1998) Pixel Aspect Ratio: Square Pixels **‡**

Step One:

Go under the File menu and choose **New** (or press **Command-N** [**PC: Ctrl-N**]). When the New dialog appears, click on the Preset pop-up menu to reveal the list of preset types, and choose **Photo**. Then click on the Size pop-up menu to see the preset sizes, which include 2x3", 4x6", 5x7", and 8x10" in both portrait and landscape orientation. The only problem with these is that their resolution is set to 300 ppi by default. So, if you want a different size preset at less than 300 ppi, you'll need to create and save your own.

Step Two:

For example, let's say that you want a 5x7" set to landscape (that's 7" wide by 5" tall). First, choose Photo from the Preset popup menu, then choose Landscape, 5x7 from the Size pop-up menu. Choose your desired Color Mode (below Resolution) and Color Profile (under Advanced), and then enter a Resolution (I entered 212 ppi, which is enough for me to have my image printed on a high-end printing press). Once your settings are in place, click on the Save Preset button.

This brings up the New Document Preset dialog. In the Preset Name field, enter your new resolution at the end of the size. You can turn on/off the checkboxes for which parameters you want saved, but I use the default setting to include everything (better safe than sorry, I guess).

Step Four:

Click OK and your new custom preset will appear in the New dialog's Preset pop-up menu. You only have to go through this once. Photoshop will remember your custom settings, and they will appear in this Preset pop-up menu from now on.

Step Five:

If you decide you want to delete a preset, it's simple—just open the New dialog, choose the preset you want to delete from the Preset pop-up menu, and then click the Delete Preset button. A warning dialog will appear asking you to confirm the delete. Click Yes, and it's gone!

If you're used to resizing scans, you'll find that resizing images from digital cameras is a bit different, primarily because scanners create high-res scans (usually 300 ppi or more), but the default settings for many digital cameras produce an image that is large in physical dimensions, but lower in pixels-per-inch (usually 72 ppi). The trick is to decrease the physical size of your digital camera image (and increase its resolution) without losing any of its quality. Here's the trick:

Resizing Digital Camera Photos

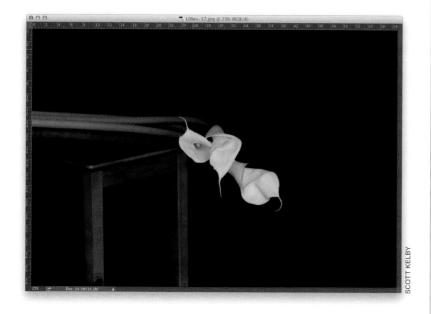

Step One:

Open the digital camera image that you want to resize. Press **Command-R (PC: Ctrl-R)** to make Photoshop's rulers visible. As you can see from the rulers, the photo is about 59" wide by 39" high.

Step Two:

Go under the Image menu and choose Image Size (or press Command-Option-I [PC: Ctrl-Alt-I]) to bring up the Image Size dialog. As you can see here, the Resolution setting is 72 ppi. A resolution of 72 ppi is considered "low resolution" and is ideal for photos that will only be viewed onscreen (such as web graphics, slide shows, and so on), but it's too low to get high-quality results from a color inkjet printer, color laser printer, or for use on a printing press.

If we plan to output this photo to any printing device, it's pretty clear that we'll need to increase the resolution to get good results. I wish we could just type in the resolution we'd like it to be in the Resolution field (such as 200 or 240 ppi), but unfortunately this "resampling" makes our low-res photo appear soft (blurry) and pixelated. That's why we need to turn off the Resample checkbox (it's on by default). That way, when we type in a Resolution setting that we need, Photoshop automatically adjusts the Width and Height of the image down in the exact same proportion. As your Width and Height come down (with Resample turned off), your Resolution goes up. Best of all, there's absolutely no loss of quality. Pretty cool!

Step Four:

Here I've turned off Resample and I entered 240 in the Resolution field for output to a color inkjet printer. (I know, you probably think you need a lot more resolution, but you don't. In fact, I never print with a resolution higher than 240 ppi.) This resized my image to nearly 12x18" so it's just about perfect for printing to my Epson Stylus Photo R2880 printer, which makes up to 13x19"-sized prints—perfect!

Step Five:

Here, I've lowered the Resolution setting to 180 ppi. (Again, you don't need nearly as much resolution as you'd think, but 180 ppi is pretty much about as low as you should go when printing to a color inkjet printer.) As you can see, the Width of my image is now almost 24" and the Height is now almost 16". Best of all, we did it without damaging a single pixel, because we were able to turn off Resample, which normally, with things like scans, we couldn't do.

Step Six:

When you click OK, you won't see the image window change at all—it will appear at the exact same size onscreen but look at the rulers. You can see that it's now almost 16" high by almost 24" wide. Resizing using this technique does three big things: (1) it gets your physical dimensions down to size (the photo now fits easily on a 16x24" sheet); (2) it increases the resolution enough so you can output this image on a color inkjet printer; and (3) you haven't softened, blurred, or pixelated the image in any way—the quality remains the same—all because you turned off Resample. Note: Do not turn off Resample for images that you scan on a scanner—they start as highres images in the first place. Turning Resample off like this is only for low-res photos taken with a digital camera.

Smarter Image Upsizing (Even for Low-Res Images)

Another thing I love that Adobe's engineers do in each new version of Photoshop is that they go back and make existing features even better. In Creative Cloud, they came up with a new option for upsizing images (making them larger using the Image Size dialog) with a new mathematical algorithm for upsizing your image while maintaining more detail and sharpness than ever before (and this includes better results from upsizing a low-res 72 ppi image).

Step One:

Here's a low-resolution 72-ppi image we want to resize to a high-enough resolution to make a print of it. Go under the Image menu and choose Image Size to bring up the Image Size dialog (by the way, the Image Size dialog is resizable). You can see our image has a resolution of just 72 pixels per inch (or ppi, for short). Make sure the Resample checkbox is turned on and then choose Preserve Details (Enlargement) from the Resample pop-up menu. When you do this, a Reduce Noise slider appears beneath the menu that might come in handy if you notice that the noise gets increased along with the size of your photo (but using it adds a little blurring, so use it gingerly). By the way, you can compare different sizing methods by pressing Option-1-Option-7 (PC: Alt-1-Alt-7) to toggle through the different Resample options.

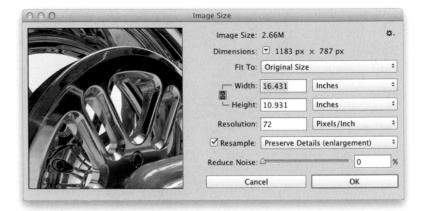

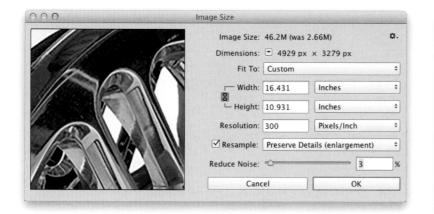

Step Two:

Now, in the Resolution field, enter the new resolution you want. Here, we'll enter 300 ppi (if you don't want to change the resolution, you can just type in new physical dimensions instead, a resize percentage, or both). The preview window shows you how the image is going to look at its new size or resolution. That's it! In the Before and After shown below, you can see how much more detail and sharpness is now maintained after the upsize. One last thing: if you resize to some particular sizes a lot, you can save your own custom size presets. Just go under the Fit To popup menu and choose **Save Preset**.

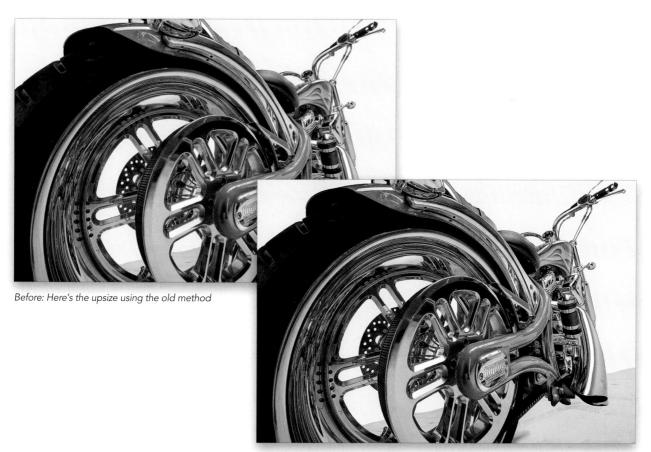

After: Here's the new method. Much better!

Automated Saving and Resizing

If you have a bunch of images that you need resized, or converted from TIFFs to JPEGs (or from PSDs to JPEGs, for that matter), then you will love the built-in Image Processor. It's kind of hidden in a place you might not expect it (under the Scripts menu), but don't let that throw you—this is a really handy, and really easy-to-use, totally automated tool that can save you tons of time.

Step One:

Go under the File menu, under Scripts, and choose **Image Processor**. By the way, if you're working in Adobe Bridge (rather than Photoshop), you can Command-click (PC: Ctrl-click) on all the photos you want to apply the Image Processor to, then go under the Tools menu, under Photoshop, and choose Image Processor. That way, when the Image Processor opens, it already has those photos pegged for processing. Sweet!

Step Two:

When the Image Processor dialog opens, the first thing you have to do is choose the folder of photos you want it to "do its thing" to by clicking on the Select Folder button, then navigating to the folder you want and clicking Choose (PC: OK). If you already have some photos open in Photoshop, you can click on the Use Open Images radio button (or if you chose Image Processor from Bridge, the Select Folder button won't be there at all—instead it will list how many photos you have selected in Bridge). Then, in the second section, decide whether you want the new copies to be saved in the same folder or copied into a different folder. No big whoop (that's a technical term).

The third section is where the fun begins. This is where you decide how many copies of your original you're going to wind up with, and in what format. If you turn on the checkboxes for Save as JPEG, Save as PSD, and Save as TIFF, you're going to create three new copies of each photo. If you turn on the Resize to Fit checkboxes (and enter a size in the Width and Height fields), your copies will be resized, too (in the example shown here, I chose a small JPEG of each file, then a larger TIFF, so in my folder I'd find one small JPEG and one larger TIFF for every file in my original folder).

Step Four:

In the fourth section, if you've created an action that you want applied to your copies, you can also have that happen automatically. Just turn on the Run Action checkbox, then from the pop-up menus, choose which action you want to run. If you want to automatically embed your copyright info into these copies, type your info in the Copyright Info field. Lastly, there's a checkbox that lets you decide whether to include an ICC profile in each image or not (of course, I'm going to try to convince you to include the profile, because I included how to set up color management in Photoshop in the bonus Print chapter found on the book's companion webpage). Click the Run button, sit back, and let it "do its thing," and before you know it, you'll have nice, clean copies aplenty.

Resizing for Poster-Sized Prints

So, since you saw earlier how much resolution you need to have to create a decent-sized print, how do photographers get those huge poster-sized prints without having super-high-megapixel cameras? It's easy—they upsize the images in Photoshop, and the good news is that unless you need to resize your image by more than 300%, you can do this all right in Photoshop without having to buy a separate resizing plug-in (but if you need more than a 300% size increase, that's where those plug-ins, like OnOne Software's Perfect Resize, really pay off).

Step One:

Open the photo you want to resize, then go under the Image menu and choose Image Size or press Command-Option-I (PC: Ctrl-Alt-I). When the Image Size dialog appears, to the right of the Width field, you'll see a pop-up menu where Inches is chosen. Click on that menu and choose Percent (as shown here). Both the Width and Height will change to Percent, because they're linked together by default. Then, turn on the Resample checkbox at the bottom.

Step Two:

Now, type in either 200% or 300% (although there is some debate about this, it seems to work best if you move up/down in 100% increments) in the Width field (again, since they're linked, the Height field will automatically change to the same number).

At the bottom of the dialog is a pop-up menu that decides which algorithm is used to upsize your photo. The default is Automatic, and I use that for most everyday resizing stuff, but when it comes to jumping in big increments, like 200% or 300%, I switch to **Bicubic Smoother** (which Adobe says is "best for enlargement"), as shown here.

Step Four:

Vincent Versace breaks this rule. According to Vincent's research, the key to his resizing technique is to not use the sampling method Adobe recommends (Bicubic Smoother), but instead to choose Bicubic Sharper, which he feels provides better results. So, which one is the right one for you? Try both on the same image (that's right—just do a test print), and see if you can see a visible difference. Here's the final image resized to around 25x16" (you can see the size in the rulers by pressing Command-R [PC: Ctrl-R]).

Straightening Crooked Photos

Adobe has been tweaking the way we straighten images for the past few versions of Photoshop. It now has the fastest and easiest way yet, and it's built right into the Crop tool's options.

Step One:

Open the photo that needs straightening, click on the Crop tool **(C)** in the Toolbox, and then click on the Straighten tool up in the Options Bar.

Step Two:

Now, find something in your photo that's supposed to be straight or relatively straight (the ledge, in this example). Click-and-drag the Straighten tool horizontally along this straight edge in your photo, starting from the left and extending to the right (as shown here).

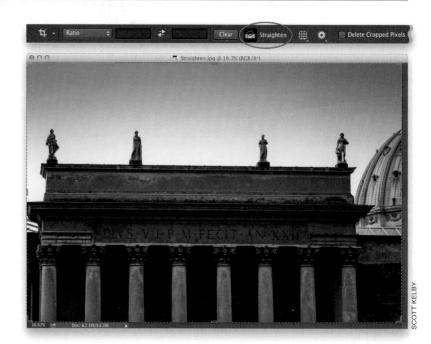

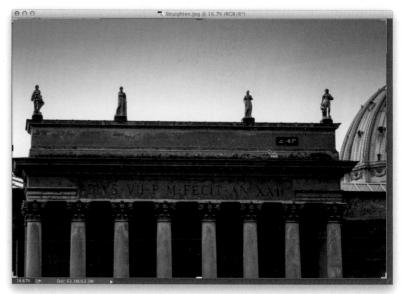

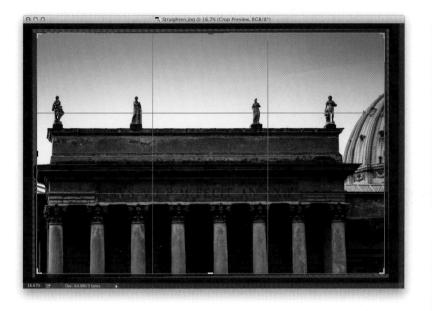

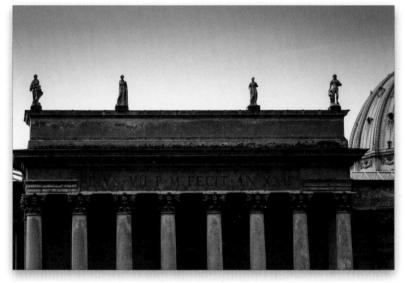

When you release the mouse button, your photo rotates the exact amount to perfectly straighten the photo. One nice feature here is that it automatically resizes the cropping border, so that when you lock in your crop, you don't have any gray gaps in the corners (if you ignore the cropping border, and look at the whole image now, see those triangular gray areas? Those would be white if Photoshop didn't crop in like this). Now, just press the Return (PC: Enter) key to lock in your straightening, and it straightens and crops the image down to just what you see inside the cropping border (the final straightened image is shown here below).

Making Your **Photos Smaller** (Downsizing)

There's a different set of rules we use for maintaining as much quality as possible when making an image smaller, and there are a few different ways to do just that (we'll cover the two main ones here). Luckily, maintaining image quality is much easier when sizing down than when scaling up (in fact, photos often look dramatically better—and sharper—when scaled down, especially if you follow these guidelines).

Downsizing photos where the resolution is already 300 ppi:

Although earlier we discussed how to change image size if your digital camera gives you 72-ppi images with large physical dimensions (like 24x42" deep), what do you do if your camera gives you 300ppi images at smaller physical dimensions (like 12x8" at 300 ppi)? Basically, you turn on the Resample checkbox (in the Image Size dialog under the Image menu), then simply type in the desired size (in this example, we want a 6x4" final image size), and click OK (don't change the Resolution setting, just click OK). The image will be scaled down to size, and the resolution will remain at 300 ppi. IMPORTANT: When you scale down using this method, it's likely that the image will soften a little bit, so after scaling, you'll want to apply the Unsharp Mask filter to bring back any sharpness lost in the resizing (go to Chapter 9 to see what settings to use).

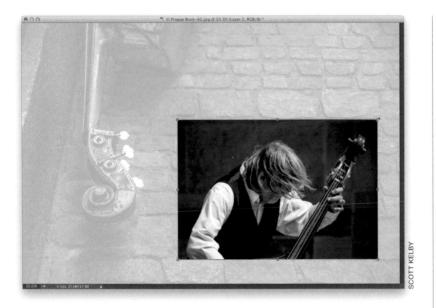

Making one photo smaller without shrinking the whole document: If you're working with more than one image in the same document, you'll resize a bit differently. To scale down a photo on a layer (like this photo of a cellist, which is on its own layer), first click on that photo's layer in the Layers panel, then press Command-T (PC: Ctrl-T) to bring up Free Transform (it puts little handles around your image on that layer, kind of like what the Crop tool does). Press-and-hold the Shift key (to keep the photo proportional), grab a corner handle, and drag inward (here, I've grabbed the top-right corner handle and dragged inward to shrink the image). When the size looks good, press Return (PC: Enter). If the image looks softer after resizing it, apply the Unsharp Mask filter (again, see Chapter 9 for settings) to bring that sharpness back.

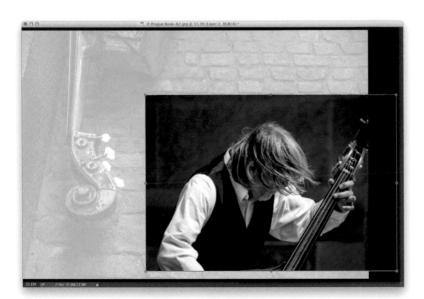

TIP: Reaching the Free Transform Handles

If you drag an image from one open document to another (like I did here, where I dragged the original cellist photo over onto the photo of the cello on the street), there's a pretty good chance you'll have to resize the dragged image, so it fits within your other image. And, if the image is larger (as in this case), when you bring up Free Transform, you won't be able to reach the resizing handles (they'll extend right off the edges of the document). Luckily, there's a trick to reaching those handles: just press Command-0 (PC: Ctrl-0), and your window will automatically resize so you can reach all the handles—no matter how far outside your image area they once were. Two things: (1) This only works once you have Free Transform active, and (2) it's Command-0—that's the number zero. not the letter O.

Resizing problems when dragging between documents:

This one gets a lot of people, because at first glance it just doesn't make sense. You have two documents open, and they look approximately the same size (as seen here, at top), but when you drag the stained glass photo onto the blank document, the stained glass photo appears really small (as seen below). Why? Although the documents appear to be the same size, they're not. The stained glass photo is a low-resolution, 72-ppi (pixels per inch) image, but the blank document is a high-resolution, 300-ppi image. The tip-off that you're not really seeing them at the same size is found in each photo's title bar. Here, the stained glass image is displayed at 100%, but the Untitled-1 document is displayed at only 25% (so, it's much larger than it appears). The key is that when you're dragging images between documents, they need to be the same size and resolution.

Want to save time the next time you're scanning prints? Try gang scanning (fitting as many photos on your flatbed scanner as you can and scanning them as one big single image), and then you can have Photoshop automatically straighten each individual image and place it into its own separate document. You do this by going under the File menu, under Automate, and choosing **Crop and Straighten Photos**. No dialog will appear. Instead, Photoshop will look for straight edges in your photos, straighten the photos, and copy each into its own separate document.

We've all run into situations where our image is a little smaller than the area where we need it to fit. For example, if you resize a digital camera image so it fits within a traditional 8x10" image area, you'll have extra space either above or below your image (or both). That's where Content-Aware Scaling comes in—
it lets you resize one part of your image, while keeping the important parts intact (basically, it analyzes the image and stretches, or shrinks, parts of the image it thinks aren't as important). Here's how to use it:

Resizing Just Parts of Your Image Using "Content-Aware" Scaling

Step One:

Create a new document at 8x10" and 240 ppi. Open a digital camera image, get the Move tool (V), and drag-anddrop it onto the new document, then press Command-T (PC: Ctrl-T) to bring up Free Transform (if you can't see all the handles, press Command-0 [zero; PC: Ctrl-0]). Press-and-hold the Shift key, then grab a corner point and drag inward to scale the image down, so it fits within the 8x10" area (as shown here on top), and press Return (PC: Enter). Now, in the image on top, there's white space above and below the photo. If you want it to fill the 8x10 space, you could use Free Transform to stretch the image to do so, but you'd get a stretched version of the jet (seen at bottom). This is where Content-Aware Scale comes in.

Step Two:

Go under the Edit menu and choose Content-Aware Scale (or press Command-Option-Shift-C [PC: Ctrl-Alt-Shift-C]). Grab the top handle, drag straight upward, and notice that it stretches the sky upward, but pretty much leaves the jet intact. Grab the bottom handle and drag downward, and it again stretches the sky. When you've dragged far enough, press Return (PC: Enter) to lock in your change. (Note: The button that looks like a person in the Options Bar tells Content-Aware Scale that there are people in the photo, so it tries to avoid stretching anything with a skin tone.)

Step Three:

There are two more controls you need to know about: First, if you try Content-Aware Scale and it stretches your subject more than you want, get the Lasso tool (L) and draw a selection around your subject (as shown here), then go under the Select menu and choose Save Selection. When the Save Selection dialog appears, just click OK and press Command-D (PC: Ctrl-D) to Deselect. Then bring up Content-Aware Scale again, but this time, go up in the Options Bar and choose your selection from the Protect pop-up menu (as shown here) to tell Photoshop where your subject is. Now you can drag up or down to fill the empty space with the least possible stretching.

Step Four:

There's also an Amount control up in the Options Bar, which determines how much stretching protection is provided. At its default of 100%, it's protecting as much as possible. At 50%, it's a mix of protected resizing and regular Free Transform, and for some photos that works best. The nice thing is the Amount control is live, so as long as your handles are still in place, you can lower the Amount and see live onscreen how it affects your resizing.

Conditional Actions (At Last!)

Actions are basically tape recordings that live inside of Photoshop and you can use them to automate boring, repetitive tasks. Actions have been in Photoshop for many years now and ever since they were added, users have been asking for the ability to have conditional actions (meaning, a step in the recording where you can insert a condition, like "if this particular thing exists, then do this instead"). For example, if you wanted to have one action that properly resizes both your wide and your tall images for your online portfolio, you'd want your action to be "conditional" (if it's wide, run this action; if it's tall, run this one instead).

Step One:

Start by opening a wide image, and then go under the Window menu and choose **Actions** to bring up the Actions panel. Click on the Create New Action icon at the bottom of the panel (it looks like the Create a New Layer icon in the Layers panel and is circled in red here) and, when the New Action dialog appears, name your new action "Wide Portfolio," then click the Record button.

Step Two:

Now it's recording what you're doing, so go under the Image menu, choose Image Size, and resize your image, so it's about 1200 pixels wide by 800 pixels tall, and then click OK. Next, press the square Stop Recording icon at the bottom of the Actions panel to stop recording (as shown here). Okay, that's one action done.

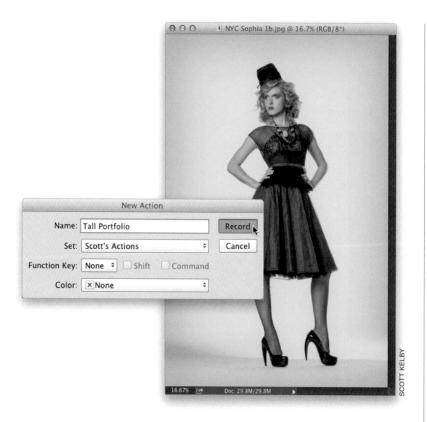

Next, open a tall image and do the same thing, but name this action "Tall Portfolio" and, in the Image Size dialog, make this one 532 pixels wide by 800 pixels tall. Click OK, then click the Stop Recording icon. Now we have our two actions, so we can use those to make our conditional action in the next step.

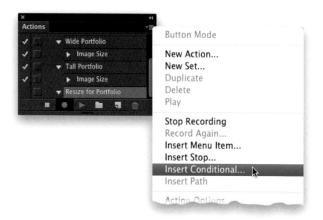

Conditional Action If Current ✓ Document Is Landscape OK Document Is Square Then Play Action \$ Cancel Document Mode Is RGB Document Mode Is CMYK Else Play Action \$ Document Mode Is Grayscale Document Profile Is sRGB Document Depth Is 8 Bits Per Pixel Document Depth Is 16 Bits Per Pixel Document Depth Is 32 Bits Per Pixel Document Has Unsaved Changes Document Has A Selection

Step Four:

Click on the Create New Action icon, once again, name this one "Resize for Portfolio," and click the Record button. Now, go right to the Actions panel's flyout menu and choose **Insert Conditional** (as shown here). This is where we tell Photoshop which action to run if it opens a wide image and which one to run if it opens a tall image. So, no matter what their orientation, they'll wind up being 800 pixels tall, so they look uniform side-by-side in our portfolio. You'll see that you have a bunch of different conditions to choose from in the Conditional Action dialog (also shown here).

Step Five:

For our project, here, from the If Current (meaning, the currently open document) pop-up menu, we're going to chose **Document Is Landscape**, and if that's the case, from the Then Play Action pop-up menu, choose the **Wide Portfolio** action you made earlier. Finally, from the Else Play Action pop-up menu, choose **Tall Portfolio**. Click OK, and then click the Stop Recording icon at the bottom of the Actions panel.

Step Six:

Now, to apply this conditional action to a folder full of images, go under the File menu, under Automate, and choose Batch (we use Batch to process an entire folder of images at one time automatically). When the dialog appears, in the Play section at the top left, choose the Resize for Portfolio conditional action you just created in the previous step from the Action pop-up menu. Then, choose the folder you want to run this action on (click the Choose button in the Source section), choose Save and Close from the Destination pop-up menu (or if you want them to be resized and saved in a different folder, choose Folder and then pick the folder you want them to be moved into after you've resized them), and then click the OK button at the top right.

Step Seven:

Once the batch runs, even though the folder had both wide and tall images, you'll see that the height of all the images is exactly the same. Again, this is just one use for conditional actions, but now you know how to create them (they're pretty easy, right?), and now that you know, you can start creating smarter actions.

	Conditional Action		
If Current:	Document Is Landscape		ОК
Then Play Action:	Wide Portfolio	•	Cancel
Else Play Action:	Tall Portfolio	‡	

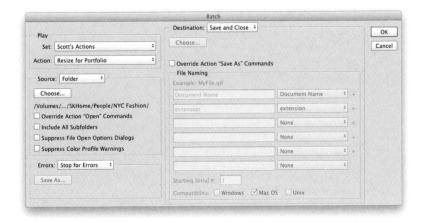

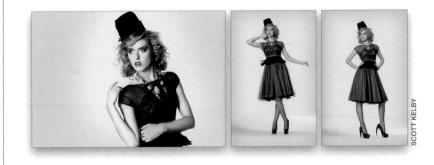

Instant Background Layer Unlocking

This is one of those little tips that just makes you smile. To instantly turn your Background layer into a regular layer without having a dialog pop up first, just click-and-drag the little lock icon to the right of the word "Background" straight into the trash (thanks to Adobe's Julieanne Kost for sharing this one).

Get Your Channel Shortcuts Back
Back in CS3, and all earlier versions of
Photoshop, you could look at the individual color channels for a photo by pressing
Command-1, Command-2, Command-3,
and so on (on a PC, you'd use Ctrl-1, Ctrl-2,
etc., instead). In CS4, they changed the
shortcuts, which totally bummed out a lot of
longtime users, but you have the option of
bringing those glory days of channel shortcuts back to the pre-CS4 era. Go under the
Edit menu, choose Keyboard Shortcuts,
then near the top of the dialog, turn on the
Use Legacy Channel Shortcuts checkbox.

Set Defaults in Layer Styles

You can set your own custom defaults for layer styles like Drop Shadow or Glow. All you have to do is create a new layer in the Layers panel by clicking on the Create a New Layer icon, then choose the layer style you want from the Add a Layer Style icon's pop-up menu (like Outer Glow, for example). In the Layer Style dialog, enter your own settings (like changing the glow from yeech yellow to white, or black, or anything but yeech yellow), then click

on the Make Default button near the bottom of the dialog. To return to the factory default (yeech) settings, click the Reset to Default button.

How to Know if You Used the "Blend If" Sliders on a Layer

Photoshop now adds an icon on the right of any layer where you've adjusted the Blend If sliders in the Blending Options of the Layer Style dialog. The icon looks

like two little overlapping squares, but it's

more than an icon—it's a button. Doubleclick on it and it brings up the Blend If sliders in the Layer Style dialog.

Layer Mask from Layer Transparency Here's a nice time saver: you can make

the transparent areas of any layer into a mask in just one step: go under the Layer menu, under Layer Mask, and choose

From Transparency.

One Click to Close All Your Tabs
If you're using the Tabs feature (all your

documents open as tabs), then you'll definitely want to know this tip: to close all your open tabs at once, just Right-click on any tab and choose **Close All**.

Seeing Your Final Crop in Camera Raw

When you crop a photo in Camera Raw, you can see the final cropped image without having to open the image in

Photoshop. Once your cropping border is in place, just change tools and you'll see the cropped version (in some previous versions, the cropped away area was still visible; it was just dimmed).

Save 16-Bit to JPEG

Back in CS4, if you worked with 16-bit photos, when you went to the Save dialog to save your photo, there was no option to save your image as a JPEG, because JPEGs have to be in 8-bit mode, so you'd have to close the dialog, convert to 8-bit, then go and Save again. That has changed and JPEG is now a choice, but what it does is makes a copy of the file, which it converts to 8-bit, and saves that instead. This leaves your 16-bit image still open onscreen and unsaved, so keep that in mind. If you want to save the 16-bit version separately, you'll need to save it as a PSD or TIFF like before. For me, once I know it has saved an 8-bit JPEG, I don't need the 16bit version any longer, so I close the image and click the Don't Save button, but again, that's just me.

Lens Corrections Grid

If you're using Camara Raw's Lens Corrections panel to do things like straighten buildings or flatten rounded horizon lines, press the letter **V** on your keyboard, and an alignment grid appears over your image to help you line things up. To hide it again, press V again.

Assign a Keyboard Shortcut to the Color Picker

You can assign a keyboard shortcut to bring up the Foreground (or Background) Color Picker (this is handier than it sounds). Go under the Edit menu, under Keyboard Shortcuts, and from the Shortcuts For pop-up menu, choose Tools. Then scroll down near the bottom, and you'll see Foreground Color Picker and Background Color Picker. Click on whichever one you want, and type in the shortcut you want. I have to tell you up front: most of the good shortcuts are already taken (in fact, almost all combinations of shortcuts are already taken), but my buddy Dave Cross came up with a good idea. He doesn't use the Pen tool all that much, so he used the letter P (for Picker). When you enter "P," it's going to warn you that it's already being used for something else, and if you

click the Accept and Go to Conflict button at the bottom left, it assigns P to the Color Picker you chose, and then sends you to the Pen tool to choose a new shortcut. If you don't need to assign one to the Pen tool (you don't use it much either), then just leave it blank and click OK.

Visual Way to Change Your Brush Size and Softness

This is incredibly handy, because you can actually see and control the exact size and amount of softness for your current brush tip. Press-and-hold Option-Ctrl (PC: Alt-Ctrl) then click-and-drag (PC: Right-click-and-drag) up/down to control the softness/hardness of the brush, and left/right to control the size.

Working with Tabbed Documents
When working with multiple documents
while using the Tabs features, to see any
tabbed image, just click on its tab at the
top of the image window or press **Ctrl- Tab** to cycle through them one by one. To
turn tabbing off, go under the Photoshop

(PC: Edit) menu, under Preferences, and choose **Interface**, then turn off the Open Documents as Tabs checkbox. Also, you'll probably want to turn off the Enable Floating Document Window Docking checkbox, too, or it will dock your single open image.

Setting Up Your Workspace
Photoshop comes with a number of
built-in workspace layouts for different
tasks with just the panels visible Adobe
thought you'd need. You can find them
by clicking on the pop-up menu at the
right end of the Options Bar. To create your own custom workspace layout,
just click-and-drag the panels where you
want them. To nest a panel (so they appear one in front of another), drag one
panel over the other. When you see a
blue outline appear, release the mouse
button and it nests. More panels can be
found under the Window menu. Once

your panels are set up where you want them, go under the Window menu, under Workspace, and choose **New Workspace**, to save your layout so it's always one click away (it will appear in the pop-up menu). Also, if you use a workspace and change a panel's location, it remembers. That's okay, but you'd think that clicking on your workspace would return things to normal. It doesn't. Instead, you have to go into that pop-up menu and choose **Reset [your workspace name]**.

Getting Sharp Edges on Your Stroke Layer Effect

If you've applied a large stroke using the Stroke layer effect (under the Edit menu) or Stroke layer style (by clicking on the Add a Layer Style icon at the bottom of the Layers panel and choosing Stroke from the pop-up menu), you've probably already noticed that the edges start to get rounded, and the bigger you make the stroke, the rounder they get. So, what's the trick to nice, sharp straight edges? Just switch the Stroke position or location to Inside.

White Balance Quick Fix

If you have an image whose white balance is way off, and you didn't shoot it in RAW, try this: go under the Image menu, under Adjustments, and choose **Match Color**. When the Match Color dialog appears, just turn on the Neutralize checkbox in the Image Options section. It works better than you'd think for most white balance problems (plus, you can write an action to do all that for you).

Change Ruler Increments

If you want to quickly change the unit of measure in your ruler (say, from pixels to inches or from centimeters to millimeters), just Right-click anywhere inside the Rulers and choose your new unit of measurement from the pop-up menu that appears.

Using "Scrubby Sliders"

Anytime you see a numerical field in Photoshop (like the Opacity field in the Layers panel, for example), you can change the setting without typing in a number, or dragging the tiny slider. Instead. click directly on the word "Opacity" and drag left (to lower the opacity) or right (to increase it). This is very fast, and totally addictive, and if you're not using it yet, you've got to try it. There's no faster way to make quick changes (also, press-and-hold the Shift key while using it, and it goes even faster).

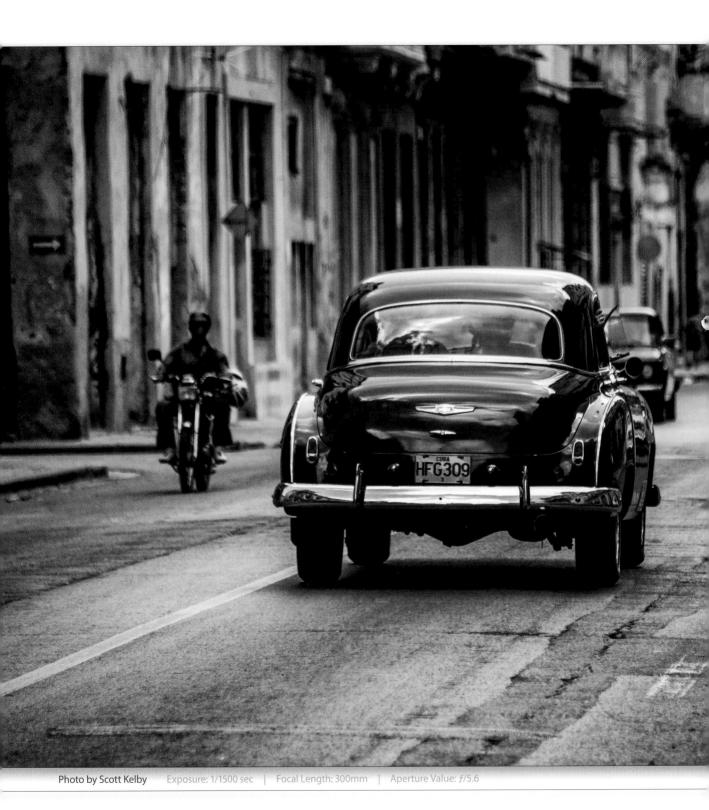

Chapter 5 How to Create Stunning B&W Images

Black & White

how to create stunning b&w images

I know what you're thinking: "He's given up on the whole movie name/song title/TV show thing." But, actually, the "Black & White" you see above is from the song by the 1970s hit machine Three Dog Night. (Remember the song: "The ink is black. The page is white. Together we learn to read and write"? I can't believe with captivating lyrics like that, these guys aren't still crankin' out the hits.) Anyway, back in the CS4 intro for this chapter, I wrote that I had toyed with the idea of using the song "Black Widow" by Mötley Crüe, but I chose not to for a very legitimate (yet, secret until now) reason: I couldn't figure out how to add those two little dots above the letter "u" in Crüe, so I went with Elvis Costello's "Black and White World" instead (it was an easy choice, as it contains no crazy dots above any letters). I have to admit, I am a bit embarrassed that I didn't know what those little dots are called, so I did a Google search for this

phrase: "two little dots above the letter U." It returned six search results, including a Facebook group called (and I'm not making this up): "It is a crime to write über without the Umlaut." At that moment I realized two things: (1) it's called an umlaut, and (2) people get totally psychotic about things like a missing umlaut. This is probably why, in the printed version of my CS4 book, not only did my editor Kim add the umlaut above the "u" for me, but she also added an umlaut over the "o" in Mötley. You're thinking, "Wow, she's good!" and she totally is, but I know her dirty little secret. She only knew there was a problem there to fix because she's a huge "big hair bands from the '80s" fan. If, instead, she had been a fan of Sheena Easton or Garth Brooks back then, you know and I know she would have changed it to read "Motley Crew," just like she referred to the song "Walk This Way" as being performed by Arrow Smith. (Kidding, Kim. Just a joke. really!)

Converting to Black and White Using Camera Raw

Although Photoshop has its own Black & White conversion adjustment layer, I never, ever use it, but that's only because it totally stinks (I don't know any pros who use it). I think you can create a much better black-and-white conversion using Camera Raw, and it's much faster and looks infinitely better. Well, that is as long as you don't get suckered into using the HSL/Grayscale panel in Camera Raw, which is nothing more than the Black & White adjustment layer hiding in Camera Raw, trying to sucker in some poor unsuspecting soul.

Step One:

We'll start by opening a color image in Camera Raw (as seen here). Converting from color to black and white is simple just click on the HSL/Grayscale icon (the fourth one from the left) at the top of the Panel area, and then turn on the Convert to Grayscale checkbox at the top of the panel (as seen here). That's all you want to do here (trust me). By the way, I did two little fixes to the photo unrelated to the B&W conversion: (1) I clicked on the Lens Corrections icon and, on the Profile tab, turned on the Enable Lens Profile Corrections checkbox, and (2) on the Manual tab. I used the Rotate slider to straighten it (as shown here).

Step Two:

Once you click on that Convert to Grayscale checkbox, it gives you an incredibly flat conversion (like you see here), and you might be tempted to drag those color sliders around, until you realize that since the photo is already converted to black and white, you're kind of dragging around in the dark. So, the best advice I can give you is to get out of this panel just as fast as you can. It's the only hope for making this flat-looking grayscale image blossom into a beautiful butterfly of a B&W image (come on, I at least get five points for the butterfly metaphor).

When you talk to photographers about great B&Ws, you'll always hear them talk about high-contrast B&Ws, so you already know what you need to do-you need to add lots of contrast. That basically means making the whites whiter and the blacks blacker. So, start in the Basic panel. Normally, you'd adjust the Exposure slider to start things off, but in this case, the image looks okay in the midtones (actually, the image is all midtones), so if you wanted, you could drag a little to the left to darken it, but I'm just leaving it set as-is. However, this flat-looking image needs lots of contrast, so let's drag the Contrast slider way over to the right (here, I dragged to +53). That looks a little better, but we've got more to do!

Step Four:

Now, let's set our white and black points. Start by dragging the Whites slider as far to the right as you can without clipping the highlights (in other words, drag until you see the white triangle in the top right of the histogram appear [that's the highlight clipping warning], then back it off just a tiny bit, until it turns black again). Here, I dragged it over to +63. Now, drag the Blacks slider to the left until it really starts to look nice and contrasty (as shown here, where I dragged to -39). Okay, it's starting to look a lot better, but we're not quite there yet.

Step Five:

The underside of the triangle and some of the figures are kind of dark, so drag the Shadows slider to the right to lighten those areas a bit (I dragged to +53). Then, increase the Clarity amount quite a bit, which adds midtone contrast and makes the image more punchy and a little brighter, too (here, I pushed it over to +35). Also, the column on the left looks really white, so let's pull back those highlights by dragging the Highlights slider to the left (here, I dragged to -63). I also pulled back the Whites a little to keep them from clipping. Now, if you feel like it could still be more contrasty (I do), then go to the Tone Curve panel and choose Strong Contrast from the Curve pop-up menu at the top of the Point tab (as shown here on the right). If that's too much contrast, try Medium Contrast instead.

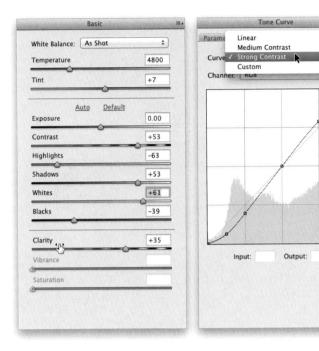

Step Six:

There is one problem that is unique to this particular photo—the column on the left still looks a little washed out, so get the Adjustment Brush **(K)**, click on the – (minus sign) button to the left of Highlights (to reset the sliders to 0), and then decrease the Highlights a bit. Now, decrease the Shadows some, as well, and then paint over the column (as shown here). A before/after is shown on the next page. Pretty striking difference, eh?

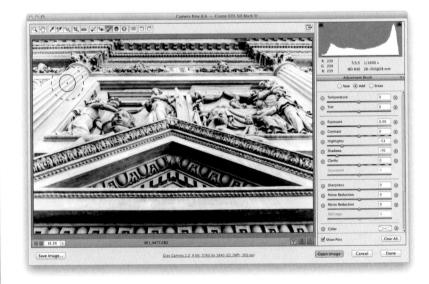

After

My Three-Click Method for Converting to B&W (Once You're Already in Photoshop)

Some of the best techniques unfold when you least expect it, and this technique is a perfect example. I was working on a completely different technique when I stumbled upon this and I fell in love, and now you're only three clicks away from a nice, crisp, high-contrast B&W image (once you're already in Photoshop. Otherwise, I would do it in Camera Raw, because you have more control). Plus, I'll show you how you can tweak your conversion, along with a variation, with just a couple more clicks. It's a B&W clicking lovefest.

Step One:

Open the color photo you want to convert into a high-contrast B&W image. You start by pressing the letter **D** to set your Foreground color to black, and then in the Adjustments panel, click on the Gradient Map icon (it looks like a horizontal gradient—it's shown circled in red here).

Step Two:

Once you click that icon, the Gradient Map options appear in the Properties panel, but you don't have to do anything there. Not a bad B&W conversion, eh? Believe it or not, just the simple act of applying this black-to-white gradient map will almost always give you a much better conversion than choosing Grayscale from the Image menu's Mode submenu, and I feel it's generally even better than both the default and Auto settings in the Black & White adjustment dialog. However, we can add another click or two and take this conversion up a big notch.

Now you're going to add some contrast the easy way. Click on the Levels adjustment layer icon in the Adjustments panel (it's the second icon in the top row). Here's the good news: when the Levels options appear in the Properties panel, you're not actually going to adjust the Levels. All you need to do is change the layer blend mode of this adjustment layer from Normal to Soft Light (at the top of the Layers panel, as seen here) and look how much more contrasty, and just generally yummy, this photo looks now. If choosing Soft Light for the particular photo you're working on doesn't add enough contrast, then try Overlay mode instead (it's more contrasty). Okay, that's it—three clicks and you're done. Now, if you're feeling "clicky," there is a way to tweak your conversion if you really feel like it (not necessary usually, but in case you want to, I'll show ya).

Step Four:

In the Layers panel, click on the Gradient Map adjustment layer (the middle layer) to make it active. Now, click directly on the gradient in the Properties panel, which brings up the Gradient Editor dialog. Once it appears, click once directly in the center, right below the gradient ramp (as shown circled here) to add a color stop (it looks like a little house) right below your gradient. Don't click OK yet. At this point, your image will look really dark, but that's okay—we're not done yet.

Step Five:

Double-click directly on that color stop you just created and Photoshop's Color Picker appears (seen here). Click-anddrag your cursor all the way over to the left side of the Color Picker, right up against the edge (as shown here), and pick a medium gray color. As you slide up and down that left side, let go of the mouse button and look at your photo. You'll see the midtones changing as you drag, and you can stop at any point where the image looks good to you. Once you find a spot that looks good (in our case, one in the center), click OK to close the Color Picker (don't close the Gradient Editor, just the Color Picker at this point, because there's another tweak you can do. Of course, this is all optional [you could have stopped back at Step Three], but now we have some extra editing power if we want it).

Step Six:

Once you're back at the Gradient Editor, and your color stop is now gray, you can drag that middle gray stop around to adjust the tone of your image (as shown here). What's weird is you drag the opposite way that the gradient shows. For example, to darken the photo, you drag to the right, toward the white end of the gradient, and to lighten the photo, you drag left toward the dark end. Freaky, I know. One other thing: unlike almost every other slider in all of Photoshop, as you drag that color stop, you do not get a live preview of what's happeningyou have to release the mouse button and then it shows you the results of your dragging. Click OK, and you're done.

Step Seven:

Here's a quick variation you can try that's just one more click: go to the Layers panel and lower the Opacity of your Gradient Map adjustment layer to 80% (as shown here). This bleeds back in a little of the color, and gives a really nice subtle "wash" effect (compare this slightly-colored photo with the full-color photo in Step One, and you'll see what I mean. It's kinda nice, isn't it?). A before and after is shown below, but it's just the three-click version (not all the other tweaking we added after the fact).

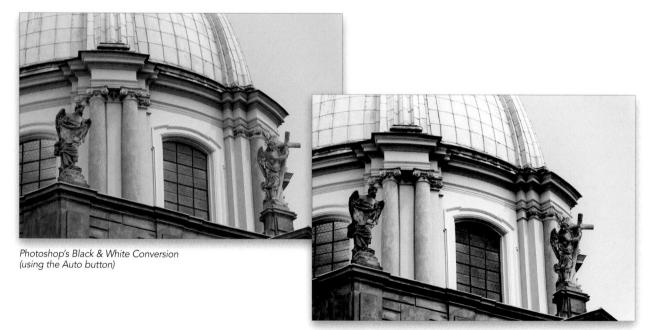

Scott's "Three-Click Method" (using just the three clicks, not the extra tweaking)

Split Toning

Split toning is a traditional darkroom special effect where you apply one tint to your photo's highlights, and one tint to your photo's shadow areas, and you even can control the saturation of each tint and the balance between the two for some interesting effects. Although split-toning effects can be applied to both color and B&W photos, you probably see it most often applied to a B&W image, so here we'll start by converting the photo to black and white, then apply the split-tone effect.

Step One:

Start by converting your full-color image to black and white by clicking on the HSL/ Grayscale icon (the fourth icon from the left) at the top of the Panel area and then just turning on the Convert to Grayscale checkbox at the top of the panel (see page 146 for one of my favorite methods for converting to black and white). Note: The only adjustments I made in the Basic panel, before I turned on the checkbox, were to increase the Exposure a little and reduce the Highlights (they were clipping).

Step Two:

Now, click on the Split Toning icon (the fifth icon from the left) at the top of the Panel area. At this point, dragging either the Highlights or Shadows Hue slider does absolutely nothing because, by default, the Saturation sliders are set to 0. So, do yourself a favor and drag the Highlights Saturation slider over to around 25, so at least you can see what it looks like while you're dragging the Hue slider. As soon as you do this, you'll see the default tint color for Hue (which is kind of pinkish).

TIP: Seeing Your Colors

To temporarily see your hues at their full 100% saturation, just press-and-hold the Option (PC: Alt) key, then click-and-drag a Hue slider. It helps when picking your colors, if you don't feel like taking my advice and increasing the saturation (like I mentioned at the end of Step Two).

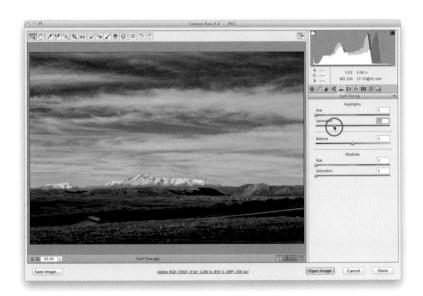

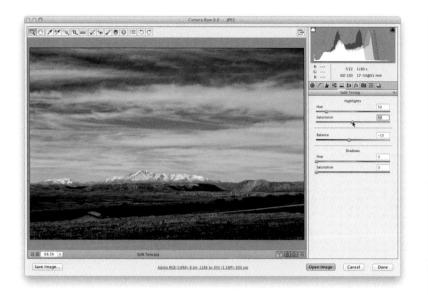

Now that you can see what's going on, click-and-drag the Highlights Hue slider until you find a highlight hue you like. For this image, I'm using a Hue setting of 50, and I also increased the Highlights Saturation amount to around 50 to make the tint a bit heavier.

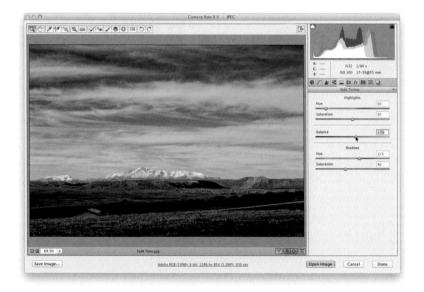

Step Four:

Let's add a teal tint to the shadows (a fairly popular spilt-tone combination) by dragging the Shadows Saturation slider to 40 (so you can see the shadows hue), then drag the Shadows Hue slider over to 215, and now you see that teal tint in the shadow areas. There is one more control—a Balance slider, which lets you control whether your split tone favors your highlight or shadow color. Just drag left, then back right, and you'll instantly see what this slider does (here, I dragged the Balance slider over to the right to +10, and you can see that the split tone now has more yellow in the highlight areas). If you do find a split-toning combination you like (hey, it could happen), I'd definitely jump to page 159 to find out how to turn that into a one-click preset, so you don't have to go through all this every time you want a quick split-tone effect.

Duotones Made Crazy Easy

Don't let the fact that this technique fits neatly on one page make you think it's not a rocking technique, because this is the best and fastest duotone technique I've ever used (and it's the only one I use in my own workflow). I used to do a more complicated version, but then my buddy Terry White showed me a technique he learned from one of his buddies whose duotones he adored, and well...now I'm passing it on to you. It's very easy, but man does it work like a charm.

Step One:

Start by converting your color image to black and white by clicking on the HSL/Grayscale icon (the fourth icon from the left) at the top of the Panel area and then turning on the Convert to Grayscale checkbox at the top of the panel (see page 146 for one of my favorite methods for converting to black and white). *Note:* Before coverting it, I decreased the Exposure, Hightlights, and Shadows, increased the Contrast, Whites, and Blacks, and added some Clarity in the Basic panel.

Step Two:

Now, click on the Split Toning icon at the top of the Panel area (it's the fifth icon from the left), and then, in the Shadows section, increase the Saturation amount to 25 as a starting point. Next, just drag the Shadows Hue slider until you have a nice sepia-tone hue (I generally use something around 28). If you think it's too intense, lower the Saturation and you're done. That's right—completely ignore the Highlights controls altogether, and you'll love the results you get (ignore the powerful pull of the Highlights sliders. I know you feel on some level that they will make things better, but you are already holding the magical key to great duotones. Don't blow it!). That's it—that's the whole ball of wax (I told you it was easy, but don't let that fool you. Try printing one of these and you'll see what I mean). Mmmm. Duotone.

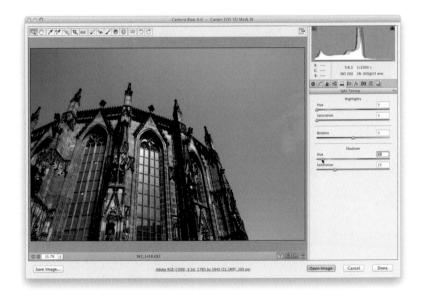

If you've ever wondered how the pros get those deep, rich-looking B&W photos, you might be surprised to learn that what you were looking at weren't just regular B&W photos, instead they were quadtones or tritones—B&W photos made up of three or four different grays and/or brown colors to make what appears to be a B&W photo, but with much greater depth. For years, Photoshop had a bunch of very slick presets buried somewhere on your computer, but luckily, now they're just one click away.

Quadtoning for Richer B&Ws

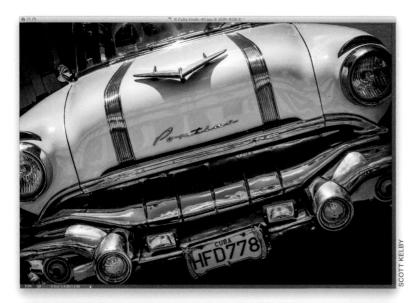

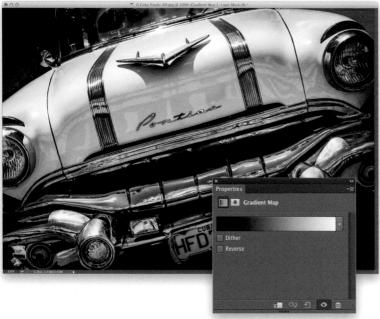

Step One:

Open the photo you want to apply your quadtoning effect to (the term quadtoning just means the final photo will use four different inks mixed together to achieve the effect. Tritones use three inks, and do I really have to mention how many duotones use?). Quadtoning effects seem to look best with (but are not limited to) two kinds of photos: (1) landscapes, and (2) people. But, here, we're going to apply it to an image of an old car.

Step Two:

To create a quadtone, you'll have to convert to Grayscale mode first, but by now you know what a flat-looking B&W photo that creates, so instead try this (from a few pages ago): Press the letter **D** to set your Foreground and Background colors to their defaults of black and white, then click on the Gradient Map icon in the Adjustments panel. When the Gradient Map options appear in the Properties panel, you don't need to make any changes. Now, you can convert this image to Grayscale mode by going under the Image menu, under Mode, and choosing Grayscale. It will ask you if you want to flatten your layers, so click the Flatten button. (It will also ask you if you want to discard the color info. Click Discard.)

Once your photo is in Grayscale mode, the Duotone menu item (which has been grayed out and unchoosable until now) is now open for business (if you're in 8-bit mode). So, go under the Image menu, under Mode, and choose **Duotone**. When the Duotone Options dialog appears (shown here), the default setting is for a one-color Monotone (a cruel joke perpetrated by Adobe engineers), but that's no big deal, because we're going to use the built-in presets from the pop-up menu at the top. Here, you'll literally find 137 presets (only 116 on a PC; I counted). Now, you'd think they'd be organized by duotones first, tritones, then quadtones, right? Nopethat makes too much sense (in fact, I'm not sure they're in any order at all).

Step Four:

I thought I'd give you a few of my favorites to get you started: One I use often is named "BI 541 513 5773" (the BI stands for black, and the three sets of numbers are the PMS numbers of the three other Pantone colors used to make the quadtone). How about a nice duotone? It uses black and it adds a reddish brown to the mix. It's called "478 brown (100%) bl 4," and depending on the photo, it can work really well (you'll be surprised at how different these same quadtones, tritones, and duotones will look when applied to different photos). There's a nice tritone that uses black and two grays, named "Bl WmGray 7 WmGray 2." We'll wrap things up with another nice duotone this one's named "Warm Gray 11 bl 2," and gives you the duotone effect shown here. Well, there you have it-four of my favorites (and don't forget, when you're done, convert back to RGB mode for color inkjet printing).

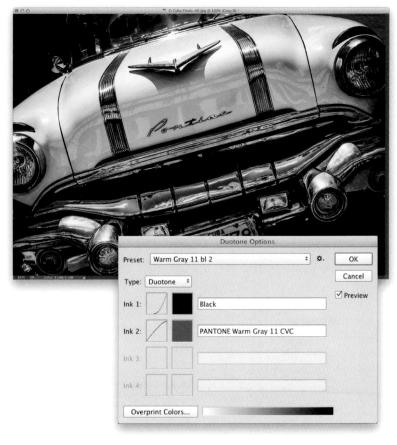

Now that we created split tones and duotones, this is the perfect time to start making your own one-click presets. That way, the next time you open a photo that you want to have that same effect, you don't have to go through all those steps (converting it to black and white, tweaking it, then applying the Split Toning settings), you can just click one button and all those settings are applied at once, giving you an instant one-click effect anytime. Of course, these presets aren't just for split tones and duotones—make one anytime you want to reuse any settings from Camera Raw.

Creating Your Own One-Click Presets in Camera Raw

Step One:

Since we just created that duotone effect in Camera Raw, we'll go ahead and use that to create a one-click preset there. Just remember—anytime you come up with a look you like, you can save it as a preset. To create a preset, you click on the Presets icon (it's the second icon from the right at the top of the Panel area), and then click on the New Preset icon (shown circled here in red) to bring up the New Preset dialog (seen here). Now, just turn on the checkboxes for the adjustments you want copied to your preset (as I did here), give your preset a name, and then click the OK button.

Step Two:

Once you've saved the preset, it appears in the Presets list (since there's only one preset here, I'm not sure it qualifies as a list at this point, but you get the idea, right?). To apply it is really a one-click process—just open a different photo, go to the Presets panel, and click on the preset (as shown here), and all those settings are applied. Keep in mind, though, because the exposure is different for every photo, if you save a preset where you had to tweak the exposure a lot, that same exposure will be applied anytime you apply this preset. That's why you might want to save just the split-tone/duotone settings and not all the exposure stuff, too.

If You're Really, Really Serious About B&W, Then Consider This Instead

I saved this for the last page, because I wanted to share all my favorite techniques for doing B&W using just Photoshop's tools, and although I still use those techniques from time to time, it would be pretty disingenuous of me if I didn't tell you what I do most of the time, which is: I use Silver Efex Pro 2, a black-and-white plug-in that is part of the Google Nik Collection. Almost all the pros I know use it as well, and it's absolutely brilliant (and super-easy to use). You can download the free 15-day trial copy from www.google.com/nikcollection and see for yourself. Here's how I use it:

Step One:

Once you install Silver Efex Pro 2, open the image you want to convert from color to B&W, then go under Photoshop's Filter menu, under Nik Collection, and choose Silver Efex Pro 2. When the window opens, it gives you the default conversion (which isn't bad all by itself), and a host of controls on the right side (but honestly, I literally never touch those controls).

Step Two:

The magic of this plug-in is its B&W (and duotone) presets. They're listed along the left side of the window, complete with a small preview of how the effect will look, but here's where I always start: on their High Structure preset. Eight times out of 10, that's the one I choose, because it has its own high-contrast, sharpened look that is wonderful for so many images. However, if I'm converting a portrait, I'll often wind up using a different preset, because High Structure can be too intense when your subject is a person. So, I click on the top preset in the list, and then click on each preset below it until I find one that looks good to me, then I click OK in the bottomright corner and I'm done. That's all I do. It's fast, easy, and it looks fantastic. That's just what I want.

Why the Fill Dialog Shows Up Sometimes, but Not Others

If you have a flattened image (so, it's just a Background layer), and you make a selection and press the Delete (PC: Backspace) key, the Fill dialog appears (Content-Aware is selected in the Use pop-up menu, by default). But there are times when hitting Delete won't bring up the Fill dialog. Instead, if you have a multi-layered document, it will delete whatever is inside the selection on your current layer, making it transparent. (That's either, "Yikes!" or "Great!" depending on how you look at it.) Also, if you have only one single layer (that is not a Background layer), you'll again delete anything inside your selection and make it transparent. So, to bring up the Fill dialog in those instances, just use Shift-Delete (PC: Shift-Backspace) instead.

Move an Object Between Documents and Have It Appear in the Exact Same Place

If you have something on a layer in one document, and you want the object to appear in the exact same place in another open document, here's what you do: First, press-and-hold the Command (PC: Ctrl) key, go to the Layers panel, and click on the layer's thumbnail to put a selection around your object. Then, press Command-C (PC: Ctrl-C) to Copy that object into memory. Switch to the other document, then go

under the Edit menu, under Paste Special, and choose **Paste in Place**. Now it will appear in the exact same position in the

other document (provided, of course, the other document is the same size and resolution). This also works with selected areas—not just layers.

Doing a Smooth Zoom In

Another way to zoom in on your image is to click-and-hold the Zoom tool (the magnifying glass icon) on the spot where you want to zoom, and it smoothly zooms in right on that spot. The only downside is that it does it so smoothly, it's actually slow. It does look cool, but again, it's slow. That's why clicking with the tool and dragging to the right works so much better (although it's not nearly as cool to show to your friends as the "slow zoom").

Removing Red Eye

If you have a photo that has someone with the dreaded red-eye problem, it's a 15-second fix. Use the Zoom tool (Z) to zoom in tight on the eye, then get the Red Eye tool from the Toolbox (it's under the Spot Healing Brush, or press Shift-J until you have it). Click it once on the red area of the eye, and in just a second or two, the red is gone. If your first try doesn't select all the red, increase the Pupil Size up in the Options Bar. If the retouch doesn't look dark enough (the pupil looks gray, rather than black), just

increase the Darken Amount up in the Options Bar.

Dragged-and-Dropped Images Don't Have to Appear as Smart Objects

You can drag-and-drop images from Bridge right into open documents (and if there isn't a document open, it'll open as a new document), but by default it

always drags in as a smart object. If you'd rather it didn't, press Command-K (PC: Ctrl-K) to bring up Photoshop's Preferences, click on General on the left, then turn off the checkbox for Always Create Smart Objects When Placing in the Options section.

Chapter 6 Creating HDR Images

We Are HDR creating HDR images

Tell me this isn't the perfect name for a chapter on HDR. The band is named hdr, their album is called We Are Hdr, and there's a song on the album called, "We Are HDR." This was destiny, my friends. Now, I have to admit, I have no idea if the HDR they are referring to actually stands for the type of HDR (High Dynamic Range) imaging we're talking about in this chapter, but on some level, I like to think it does (although it probably stands for something more like "Heavy Donut Raid" or "Her Darn Rottweiler" or maybe "Hi, Don Rickles"). Anyway, if there's a topic that gets photographers really riled up, it's HDR (Highly Decaffeinated Roast), so I don't really want to take us down that rabbit hole. Now, as you'll learn, there are two types of HDR (Hardee's Delicious Ribs): The good one, where you expand the dynamic range of the photo, getting a greater range of tone and light than today's digital cameras can

create, which gives you an image that's closer to what the human eye captures. And the evil HDR (House Developers' Revolt), which makes your images look like a movie still from a Harry Potter movie. Now, I know as you read this, you're thinking, "Oh, I would want that first thing" and at this point, I totally believe that's what you think you want. But here's the thing: there's one slider in Photoshop's Merge to HDR Pro dialog that lets you go from real to surreal pretty much by just sliding it one way or the other. And I know that, at some point, when nobody's looking, you're going to drag toward the fantasy side, and then—BAM!—you're hooked, and before long, you're tone mapping everything from your wedding photos to baby photos, and you're friends and family will sit you down and try to help wean you off the "hard stuff," but the lure of surreal HDR (Hallucinogenic Deli Relish) is just too strong. Don't say I didn't warn you.

Setting Up Your Camera to Shoot HDR

For the HDR (High Dynamic Range) technique to work, you have to "shoot for HDR" (in other words, you have to set up your camera to shoot multiple exposure-bracketed shots that can be combined in Photoshop to create a single HDR image that combines the full tonal range of all those bracketed images). Here, I'm going to show you how to set up your DSLR camera to shoot three- and five-stop brackets, so all you have to do is hold the shutter button and it will do the rest.

Step One:

When you're shooting for HDR, you're going to be shooting multiple bracketed exposures of the exact same scene, so ideally you'd be shooting on a tripod so that the images perfectly align with each other in Photoshop. (Note: Because HDR processing is likely to increase any visible noise in your image, if you're on a tripod, use the lowest, cleanest native ISO on your camera, which is 100 ISO on most Canon and Sony DSLRs, or 200 ISO on many Nikon DSLRs, depending on the model.) Now, that being said, if you don't have a tripod, or you're in a situation where you can't use one, you can shoot hand-held, and let Photoshop auto-align the images and remove any ghosting caused by hand-holding. Just make sure you're shooting in a well-lit area, so your shutter speed will be fast enough that your images won't come out blurry (but you generally get the best results on a tripod).

Step Two:

We shoot HDRs in aperture priority mode (A on Nikon and Sony cameras; Av on Canon cameras), so basically we choose the f-stop and then the camera automatically varies the shutter speed to create the bracket exposures. I recommend choosing an f-stop with a lot of depth so everything's in focus throughout, like f/8 or f/11 (areas that are blurry, like backgrounds shots at f/2.8 or f/4 look kind of funky and obvious in HDR images, so I try to stick with f-stops with more depth).

We'll need to set up our camera to automatically bracket our exposures so we have a minimum of one normal exposure, one shot that is 2 stops underexposed (too dark), and one that is 2 stops overexposed (too bright). Some cameras let you choose to make just those three shots (these offer 2 stop bracketing), but some others require you to shoot five bracketed shots, each 1 stop apart, in which case you can use all five shots to create your HDR (check your camera manual to find out how to turn on exposure bracketing because it's different for every DSLR make and model).

Step Four:

The goal here is to press-and-hold the shutter button one time, and then have the camera take all three (or five) bracketed shots for you. To make this happen, just switch your camera to continuous high-speed shooting mode (also called burst mode). Also, if you're using a tripod, you should probably be using a cable release or a wireless shutter release so you don't move the camera while pressing the shutter button.

A Quick Tour of the HDR Pro Dialog

We combine our bracketed shots into one single HDR image in the Merge to HDR Pro dialog (seen below), and I thought to get us started I'd just quickly take you through what each section does (and which sliders you can pretty much ignore). Don't let all those sliders and stuff intimidate you—this is actually pretty easy stuff. Also, even though this combines our bracketed images into one image, we always do some finishing work in Camera Raw after the fact, which is one reason we ignore some of the lesser-powered, but same-named, sliders here.

Presets and Ghosting:

At the top right at the dialog, there's a Preset pop-up menu, and you might be tempted to choose one of those presets until you actually try a few (yes, they're that bad). Right under that is the Remove Ghosts checkbox, and you'd only turn this on if you hand-held your bracketed shots (it tries to remove any ghosted parts of your images caused by movement when you took the shot. It actually does a remarkably good job, but only turn it on if you actually see ghosting). Below that, the standard Mode setting is 16-bit (a higherquality mode than the normal 8-bit works best here), and only use the Local Adaption mode at this point (the other choices are holdovers from the "bad HDR" of CS4 and earlier, Yecch!)

Edge Glow:

In the Edge Glow section, the Radius slider controls the size of the white glow that appears around the edges of large objects, and the Strength slider controls how strong that white glow is. The farther you drag the Strength slider to the right, the more obnoxious, er...l mean pronounced, that white glow becomes. It's a delicate balancing act using these two sliders to get a look that doesn't have really distracting white glows. I've also found that, for the most part, setting the Radius at a higher number (like 150 or higher) and the Strength at a lower number (around 0.50 or less) gives the best results. The Edge Softening checkbox takes the harshness out of the effect, and I use it often.

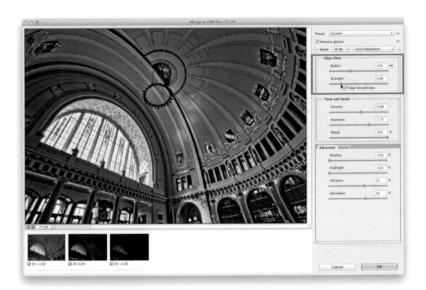

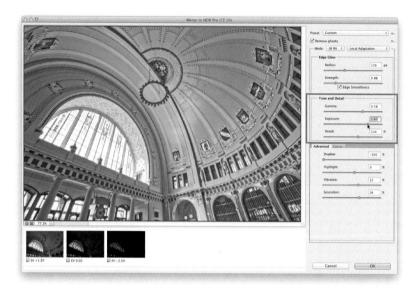

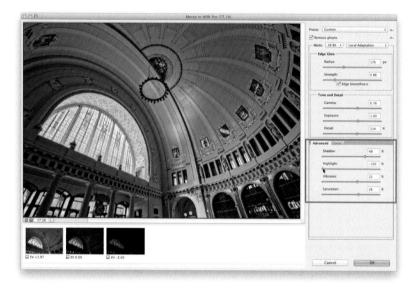

Tone and Detail:

The next section down is Tone and Detail, and honestly I don't ever mess with the Gamma or Exposure sliders— I save adjusting those for when I'm in Camera Raw after I've made the HDR image. The Gamma slider controls the midtones: if you drag the slider to the left, it darkens the midtones; drag it to the right and it brightens them. The Exposure slider controls the overall exposure, much like the Exposure slider in Camera Raw (dragging to the left darkens the overall image; dragging to the right brightens it). The next slider is the Detail slider, which kind of acts like the Clarity slider in Camera Raw (it adds something similar to midtone contrast). Think of this as the "Make it look like HDR" slider—cranking this one way up helps to create the hyperreal tonemapped artistic look.

Advanced and Curves:

Now, on to the Advanced tab (even though these settings aren't really advanced). The top slider is like a very subtle version of Camera Raw's Shadows slider. It really doesn't do all that much, even at 100%, so I usually skip it. Highlight controls the highlights (duh), and I do use this one when some areas (like windows in a church, or clouds in the sky) have turned gray. Dragging slightly to the right makes them white again (it's not nearly as good as Camera Raw's Highlights slider). You could use the Vibrance slider if your colors seem a little dull, or the Saturation slider if you want to take your image to "Harry Potter land," but again, the versions here in HDR Pro don't have nearly as much power as the same sliders in Camera Raw. so I don't use them at all. Ever. Lastly, there is no Contrast slider here, so to add contrast, click on the Curve tab to reveal a point curve like the one in Camera Raw (see page 22). Okay, that's a quick look, but you're about to learn a whole lot more, so let's get to it!

Creating Realistic-Looking Images Using 32-Bit HDR

There are basically two types of HDR images: There are the heavily tone-mapped versions that have kind of a surreal, somewhat Harry Potter fantasy look to them (made popular by a French software program called Photomatix). Then, there are HDR images that are designed from the outset to look like realistic images, but that take advantage of the expanded dynamic range you can capture by combining multiple images with different exposures. So, it's closer to what the eye sees, but it still definitely has its own "look." Here's how to create the latter—the more realistic-looking HDR.

Step One:

In Bridge, select your bracketed images, then go up to the Tools menu, under Photoshop, and choose **Merge** to HDR Pro. This brings up your image in the standard Merge to HDR Pro dialog, which is fine for creating the hyperreal tone-mapped look, but for realistic HDRs, I think you get much better results by instead switching HDR Pro to 32-bit mode. So, from the Mode pop-up menu near the top-right corner of the dialog, choose **32 Bit**.

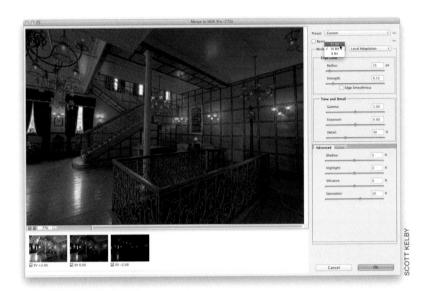

Step Two:

When you choose 32 Bit, all of the sliders are hidden and replaced with the Set White Point Preview histogram. All you have to do here is make sure the Complete Toning in Adobe Camera Raw checkbox is turned on and click one button, the Tone in ACR button in the lower right-hand corner of the dialog (this just means that once the bracketed images are combined into one HDR image, Photoshop will open that image directly in Camera Raw for tweaking).

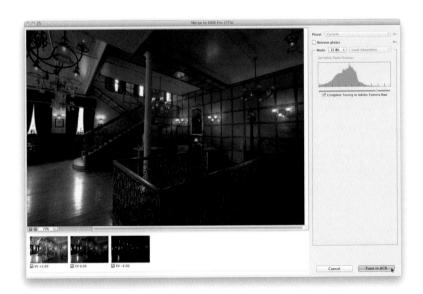

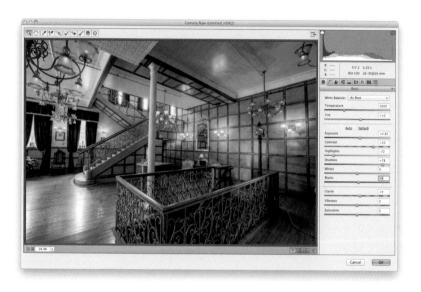

When your single HDR image opens in Camera Raw (already looking better than the flat-looking image you saw in the HDR 32-bit window), you can now do all your standard stuff to make the image look good. Here, I increased the Exposure a bit because it was too dark overall, I increased the Contrast, which I always do. and I opened up the Shadows a bunch to see more detail. I also added a little bit of Clarity to bring out the texture in the wood, and pulled back the Highlights so the windows weren't so blown out. Note: Generally, the Exposure slider has a 10stop range (from -5 to +5), but when you do this 32-bit version, it now has a 20stop range (from -10 to +10). I still haven't had an image where I ever use that extra range, but just so you know.

Step Four:

When you're done in Camera Raw, click the OK button and it opens your HDR image in Photoshop. However, you're still in 32-bit mode, so there's not much you can actually do in Photoshop until you convert it to 16-bit or Photoshop's usual 8-bit mode. To do that, go under the Image menu, under Mode, and choose 8 Bits/Channel. This brings up a dialog asking if you want to merge your layers. You want to click Merge (flattening the image). This brings up a small version of the regular HDR toning controls (and now your image looks weird). To get your image looking right again, from the Method pop-up menu in the dialog, choose Exposure and Gamma. Just doing this brings back the regular look. Now, don't touch anything else here. just click OK and your image becomes a regular 8-bit Photoshop image, and you can now do any additional tweaking you want to do (like sharpening or finishing moves, as shown on page 184).

Creating the Tone-Mapped HDR Look

In this project, we're going to create that heavily tone-mapped hyperreal look (this particular look isn't for everybody, which is why I started with the realistic HDR technique first). If, instead, you want a hybrid, kind of a half-HDR/half-real, jump to page 174, 'cause here we're setting the amp on 11! (A not-so-subtle reference to the movie *This Is Spinal Tap.*) This is a really quick and easy effect—just a few clicks and you're done (great for people with attention spans like mine, who want it done now without a lot of fuss)—but I'm just warning you now, this is the full-on, "I'm in a Harry Potter fantasy world" style of HDR you're about to learn. Just so you know.

Step One:

Here, I selected three bracketed shots in Bridge (one that's the normal exposure, one that's 2 stops underexposed, and one that's 2 stops overexposed), then went up under the Tools menu, under Photoshop, and chose **Merge to HDR Pro**. After a few moments, the Merge to HDR Pro dialog appears (as shown here; I'm being pretty gratuitous when I say "a few moments," because I timed it and, on my laptop, it took 19 seconds). Anyway, it merges these three images into one single HDR image that looks pretty bad, because it's using the default 16-bit settings, which should be named simply "Bad" for clarity's sake.

Step Two:

When HDR Pro came out, I made a lot of fun of the presets that came with it because I couldn't find a single image that they didn't look awful on. So, I set out to create a preset of my own that worked pretty consistently for most of the images I tried it on. It took a while, but I came up with one, and Adobe liked it enough that they included it in Photoshop. It's named "Scott5," so choose that from the Preset pop-up menu, then turn on the checkbox for Edge Smoothness, which takes a lot of the harshness out of the effect (I created that preset before Adobe added Edge Smoothness, so I always turn it on). If you want a little extra "juice" in your HDR image, drag the Strength slider to the right just a smidgen, as shown here where I dragged from the Scott5 default of 0.47 up to 0.67.

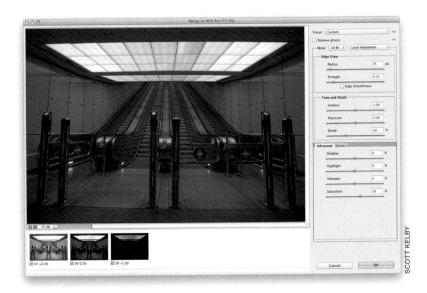

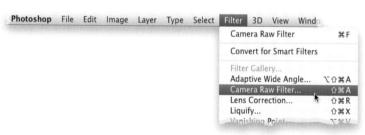

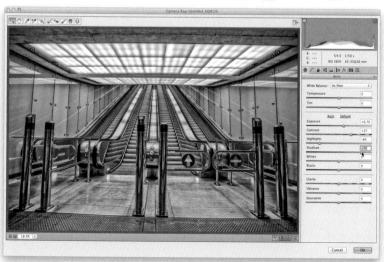

With this preset, there are really only two sliders that I ever need to tweak and. they're both pretty subtle compared to their Camera Raw counterparts with the same names. They are: (1) the Shadow slider (if you drag it to the right, it lightens the darkest areas of your photo, but just barely. It's kinda lame), and (2) the Highlight slider. For indoor shots, I always think of this slider as controlling window light, or any lights visible in the room (like the ones you see here in the ceiling—they get brighter as I drag the Highlight slider to the right, as shown here). For example, if you took an HDR photo in a church or a house, the Highlight slider would control how bright your windows look-the farther you drag to the right, the brighter the windows become. Honestly, I usually don't touch anything else, so just click OK to process the HDR and open in it Photoshop (but we're not done, yet).

TIP: Presets Can Look Very Different on Different Photos

How any preset looks is totally dependent on which image you apply it to, so while one might look great on one photo, it can look dreadful on the next. Hey, it is what it is.

Step Four:

To do our final tweaks, go under the Filter menu and choose **Camera Raw Filter**, and it brings up the standard Camera Raw window. This particular image was pretty dark overall, so to make it brighter I dragged the Exposure slider to the right to +0.70. I also generally increase the Contrast quite a bit (I do this for almost every photo, not just HDR images), and since the lights were so bright in this image, I pulled the Highlights back a bit. Lastly, to open the Shadows a bit on those chrome areas, I dragged the Shadows slider to the right to +70 (as shown here). Don't click OK quite yet.

(Continued)

Step Five:

We've got some lens distortion problems, here. Look back at Step Foursee how the left side of the image is bowing inward and leaning to the right? We need to fix that. Click on the Lens Corrections icon (the sixth icon from the left) at the top of the Panel area. Then, on the Manual tab, click on the "A" button under Upright and it tries to auto-fix the problem. It actually does a pretty decent job (it's incredibly handy, but when it doesn't work-don't worry-you'll know, because in those cases, its fix is worse than the original problem). While clicking the "A" button did straighten out the poles and walls, look at the floor. It's kind of bowing still (it's higher on the left than it is on the right), and the ceiling is bowing a bit, too. We can fix that, as well.

Step Six:

To get rid of this barrel distortion problem, while still on the Manual tab, drag the Distortion slider to the right until the lines on the floor and ceiling are straight and level, and the bowing is gone (here, I had to drag it to +15 before the bowing went away). One last lens problem: the whole scene looks like it's tipping a bit to the right (take a look at the floor and you'll see what I mean), but rotating the image until the floor looks straight just makes the ceiling look even more crooked. This is a horizontal perspective problem, and to fix this, just drag the Horizontal slider to the left to -5 and it fixes that perspective problem. However, now you see gaps at the top, bottom, and sides of the frame (caused by doing those lens corrections) that will need to be cropped off before we get to the final image. When you apply Camera Raw as a filter like this, it doesn't allow you to crop like it normally does in Camera Raw, so just click the OK button to return to Photoshop and we'll crop it there.

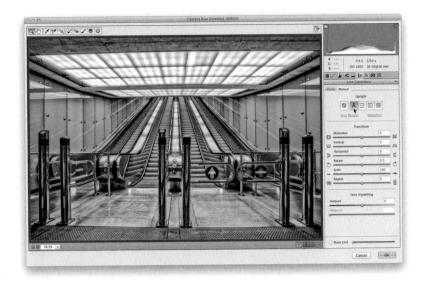

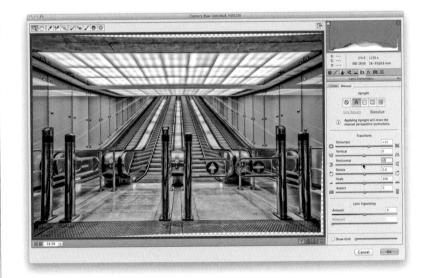

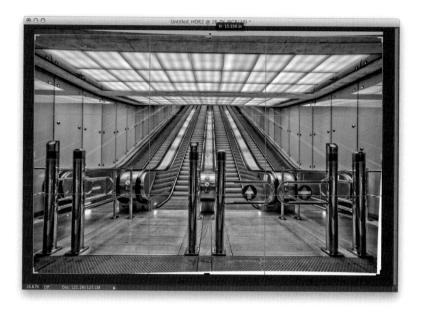

Step Seven:

Press ${\bf C}$ to get the Crop tool from the Toolbar, and then crop the image inward at the top and bottom to crop off those gaps. When it looks good to you, press the Return (PC: Enter) key to lock in your crop. The before (normal) image is shown below left, and our HDR tonemapped after image is shown to the right. Even though I'm showing you the final image at this point below, I would take this one step further, since it's a tone-mapped look, and add the finishing moves I go through starting on page 184 later in this chapter. It's just three quick and easy little things, but they make a difference.

The original normal-exposure image

The HDR image after applying the tone-mapped effect, tweaking it in Camera Raw, and fixing the lens correction problems

Here's how it looks after adding the finishing moves on page 184

Creating a Blended HDR to Get the Best of Both Worlds

There are great things about HDR (it's amazing how it brings out details and enhances texture in things like wood, tile, metal, etc.), but there are a lot of things that look awful in HDR (trees start to look plastic, white clouds get drop shadows and start to turn black, etc.). So, what if you could create a hybrid, where you get the best things from HDR blended with the best things from a normal single image? Well, this is how to get the best of both worlds by blending the original with the HDR, and best of all, you have full control over how they blend.

Step One:

Select your images in Bridge, then go under the Tools menu, under Photoshop, and choose **Merge to HDR Pro**. When the Merge to HDR Pro dialog appears, go ahead and choose the Scott5 preset from the Preset pop-up menu at the top right of the dialog. Then, turn on the Edge Smoothness checkbox (as seen here) to reduce some of the harsh edges.

Storation N S

Step Two:

We want this image to be super-HDR'd at this point (don't worry, we'll fix this later), so crank up the Strength slider a bit to +0.61, then down at the bottom, on the Advanced tab, let's open up the shadows as much as possible by dragging the Shadow slider all the way over to the right to +100, and then increase the Highlight setting a bit to make them nice and white (in the ceiling), but without blowing them out. You really want that Harry Potter fantasy look here, but stay away from the Vibrance and Saturation sliders or you may see Harry himself appear with an onscreen warning that you've gone too far. Now, click OK to open that HDR'dto-death photo in Photoshop.

Now go back to Bridge, choose the normal exposure of the three (or five, or seven—whatever you shot) images (the shot that looks regular), and doubleclick on it so it opens in Camera Raw. You really don't have to do anything to the image unless it looks kinda messed up (so if it's too dark, or something's blown out, or whatever, you can fix that now if you want—it's your call). In this case, I just left the default settings and didn't mess with anything. Go ahead and open this single normal-exposure image in Photoshop.

Step Four:

When this regular image appears onscreen, you now have two images open in Photoshop (the HDR and the regular one; both are seen here). Press Command-A (PC: Ctrl-A) to select the entire regular image, then press Command-C (PC: Ctrl-C) to Copy that image into memory. Now, switch to the HDR image and press Command-V (PC: Ctrl-V) to Paste the normal-exposure image directly on top of the HDR image.

(Continued)

Step Five:

If you shot these bracketed shots on a tripod, there's a pretty good chance that when you paste this regular image on top of the HDR image they will be perfectly aligned with one another. Just toggle the top layer on/off from view a couple of times (by clicking on the Eye icon to the left of the image thumbnail in the Layers panel), and you'll see if they're perfectly lined up (they have to be perfectly lined up for this technique to work). If you handheld your shots, there's a better than average chance they are not lined up perfectly, so if they're not perfectly lined up, in the Layers panel, Command-click (PC: Ctrl-click) on the unselected layer to select them both. Then, go under the Edit menu and choose Auto-Align Layers. When the dialog appears (shown here), make sure the Auto radio button is selected, then just click OK. Don't mess with anything else—just click OK and it does its thing.

Step Six:

Now that your images are aligned, you'll have to crop your image in just a tiny bit (using the Crop tool **[C]**) because when Auto-Align does its thing, it leaves little gaps along the edges where it had to nudge things to make it align perfectly. Once it's cropped, go to the Layers panel again and click on the top layer to make it the active layer.

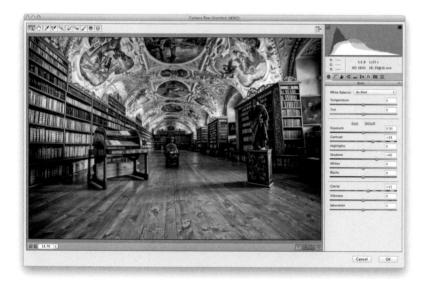

Step Seven:

So, to quickly recap: we've got the regular-exposure image on the top layer (named Layer 1), the HDR image on the bottom layer (named Layer 0 now), and they're perfectly aligned with one another. Now it's blending time. Make sure your top layer in the Layers panel is the active one, then simply lower the Opacity slider on this normal layer to let some of the HDR layer below it start to blend in. Here, I lowered it to 65%, so it's mostly normal image but with 35% of the HDR image showing through. It's a blend of the two but mostly the regular image, so we get the nice detail in the wood on the floor and some added detail throughout, but without any of the "funky" HDR stuff. If you think you want more detail, try 50%. If you want less of the HDR look, try 80% it's totally your call.

Step Eight:

I usually finish things off by flattening the layers (press Command-E [PC: Ctrl-E]), then going under the Filter menu, choosing Camera Raw Filter, and tweaking the image a bit. Here, I increased the Contrast a little (to +28), bumped up the Shadows (to +40), and increased the Clarity a little (to +15), and then I went to the Effects panel and added Post-Crop Vignetting by dragging the Amount slider to -11. That's it.

TIP: Cherry-Picking the HDR

Here, we simply lowered the Opacity of the top layer to let the entire HDR image bleed through a bit, but another strategy is to leave the Opacity at 100% and add a layer mask instead. Then, just paint in black with a soft-edged brush over the areas you want to have more of an HDR look (like the floor, bookcases, or ceiling). Lower the Opacity of the brush itself (up in the Options Bar) to 50% before you start painting, so the effect is more subtle.

Getting the HDR Look on a Single Image

If you didn't take bracketed images in your camera, but you still want that HDR look, you can pretty much do the entire thing right in Camera Raw by pushing a few sliders to the max. Here's how it's done:

Step One:

Here's the original single-image exposure, and it's the perfect kind of image to apply an HDR look to. There's a wide tonal gap between the bright light coming in from the windows and the dark shadows in the rest of the image; plus, things with lots of texture and detail tend to look great as HDR images, and if they look great as HDR, they'll look great with an HDR effect applied, even though we're applying it to a single image. Start by opening the image in Camera Raw. Here's the basic recipe we follow: crank up the Shadows all the way, crush down the Highlights all the way, add lots of Contrast (all the way), max out the Clarity. To finish off: add some sharpening and maybe a dark edge vignette. Okay, let's try it.

Step Two:

Drag the Contrast slider all the way to the right (to +100). Then, drag the Shadows slider all the way to the right, which tends to make the image look washed out. So, then, drag the Clarity slider to +100. If it wasn't already blown-out outside the windows (or if your room has visible lights), it probably is now, so we always drag the Highlights slider all the way to the left (to -100). So, it's Contrast, Shadows, and Clarity to +100, and Highlights to -100. That's the recipe (save it as a preset in the Presets panel and then it's a one-click effect, right?). And, of course, you could also add the standard finishing effects (on page 184), like vignetting and a soft glow.

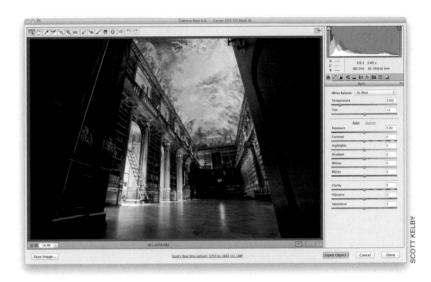

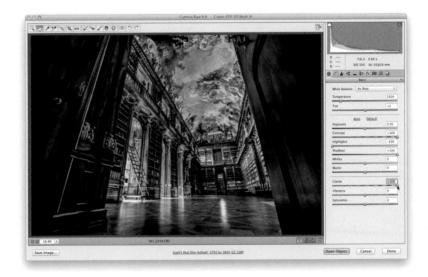

The original normal-exposure image

Using just Camera Raw to create the HDR look

The original normal-exposure image

Using just Camera Raw to create the HDR look

The original normal-exposure image

Using just Camera Raw to create the HDR look (with the Highlights at around -60)

How to Get Rid of "Ghosting" Problems

If anything was moving slightly in the scene you were photographing (like water in a lake, or tree branches in the wind, or people walking by, etc.), you'll have a ghosting problem, where that object is either blurry (at best), or you'll actually see a transparent ghost of that part of the image (hence the name), or half a person, and so on. In this hand-held photo, there are people moving in the scene and that usually means we'll have some ghosting, but in most cases, fixing that is just one-click away. Or maybe two. Either one or two clicks. Max.

Step One:

Select your images in Bridge, then go under the Tools menu, under Photoshop, and choose Merge to HDR Pro to open the HDR bracketed images. You can just use the Default setting (which by the way, almost never looks good), but just so it doesn't look too terrible, turn on the Edge Smoothness checkbox and maybe raise the Detail slider to around 90 (as seen in the next step). Unfortunately for this shot, you can't keep tourists from moving (well, not without duct tape) and, if you look to the left side, you can see lots of ghosting of people, especially on the guy in the yellow hoodie. You can see what looks like multiple semi-transparent versions of him in the foreground (which is why it's called ghosting).

Step Two:

Luckily, fixing this is pretty darn easy: turn on the Remove Ghosts checkbox at the top right of the dialog (shown circled here in red). HDR Pro tries to deal with the ghosting by looking for things that are common to all your exposures to lock onto, and it does a pretty amazing job of it most of the time. If you look at the bottom of the screen you'll see thumbnails of the images that made up your single HDR image, and you'll see a green highlight around one of them. That's the photo it chose as the basis for its ghost removal. It's much improved, right? But it's not perfect (note the blurring in his leg).

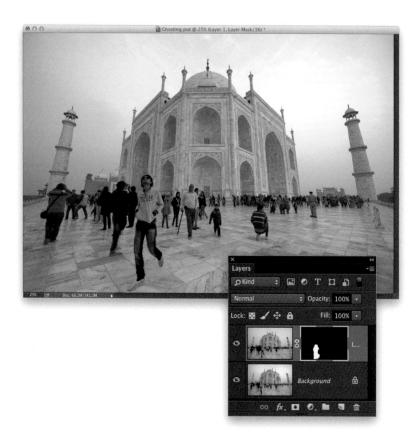

So, what do you do if HDR Pro makes the wrong guess? (By the way, this is more common when using JPEG images than RAW images.) If this happens, you get to help out by choosing which of your bracketed photos you think it should lock onto by clicking through each of those thumbnails in the filmstrip at the bottom of the dialog. If you look back in Step Two, you'll see that it originally chose the thumbnail on the far left. Just click through all five images and see if any of them do a better job of removing the ghosting. Here, I clicked on the second image from the left and it looks much better. (Note: If you shot a multi-photo exposure of something, like waves rushing to the shore, you can actually choose which individual wave you want visible using this same technique, so it's not just for ghosting.)

Step Four:

Now, what would you do if the Remove Ghosts checkbox just didn't work at all and you still had lots of ghosting? Then you'd use a similar trick to the one you learned in "Creating a Blended HDR" earlier in this chapter. You'd create the regular HDR image first. Then, you'd copy-andpaste the original on top, Option-click (PC: Alt-click) on the Add Layer Mask icon at the bottom of the Layers panel to hide this original image behind a black mask, get the Brush tool (B), and choose a small, soft-edged brush. Set your Foreground color to white and paint over the person that is ghosting, and as you paint, it paints the original person from the single still image back in (it works really well, actually). If the person you just pasted in looks "too normal," then start over, but before you copy-and-paste the original on top, apply the single-image HDR look from page 178 to the image first. That way, it will look more HDR when you paint him in.

High Pass Sharpening for HDR Images

Although I cover High Pass sharpening in the sharpening chapter, I thought it was important to include it here as its own project, because High Pass sharpening has kind of become synonymous with HDR editing. High Pass sharpening is sometimes called "extreme sharpening," and that's a really good description of what it is. Here, I'm going to show you how to apply it, how to control it afterward, and an optional method that I use myself quite a bit.

Step One:

Once you've finished creating your HDR image using Merge to HDR Pro, and it's open in Photoshop, start by pressing **Command-J (PC: Ctrl-J)** to duplicate the Background layer. Then, go under the Filter menu, under Other, and choose **High Pass** (as shown here).

Step Two:

When the High Pass filter dialog appears, drag the Radius slider all the way to the left so that everything turns solid gray. Now, drag the slider to the right until you can just start to see the color peek through the solid gray (as shown here)—the farther you drag, the more intense the effect will be (here, as an example, I dragged to 9 pixels, and you can see lots of edge detail starting to appear). When you're done, click OK.

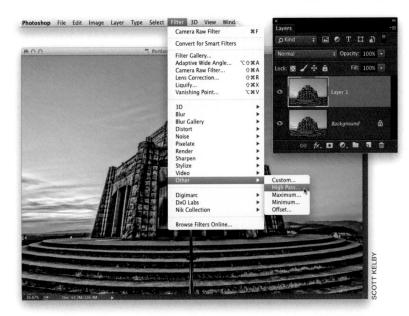

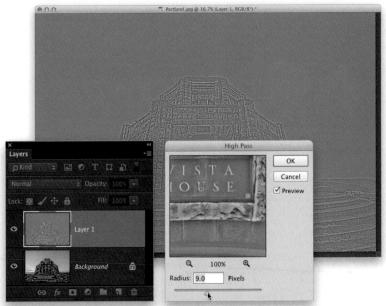

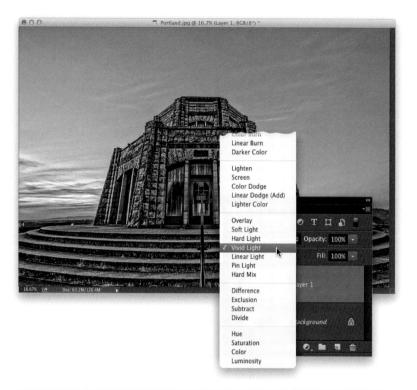

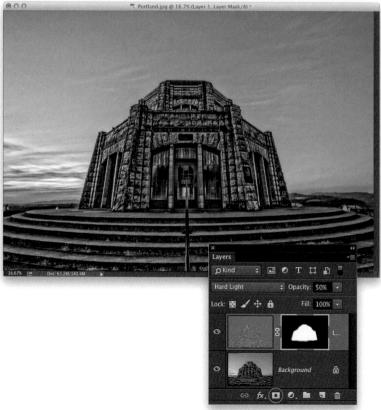

To bring the sharpening into the image, go to the top of the Layers panel and change the duplicate layer's blend mode from Normal to one of these three modes: (1) for medium sharpening, choose Soft Light; (2) for heavy sharpening, choose Overlay; or (3) for just insane sharpening, choose Hard Light (as shown here). If the sharpening seems like it's too much, you can lower the opacity of this duplicate layer. Think of this as the control for the amount of sharpening, so try lowering the Opacity amount (at the top of the Layers panel) to 75% (for 75% of the sharpening), or 50% if that's still too much (as shown in the next step).

Step Four:

If you just need this level of intense sharpening over particular areas of your photo (like in this case, maybe over the building but not the sky), just press-andhold the Option (PC: Alt) key and click on the Add Layer Mask icon at the bottom of the Layers panel (shown circled here) to hide your sharpened layer behind a black mask. Get the Brush tool (B), from the Toolbar, and make sure your Foreground color is set to white. Then, from the Brush Picker in the Options Bar, choose a medium-sized, soft-edged brush and paint over just the parts of the image you want to be super-sharp (here, I painted over just the building, but not the steps—they already look a bit "crunchy"). Once you've painted over those areas, also try the Overlay and Soft Light blend modes to see which of the three you like best.

HDR Finishing Techniques (Vignetting, Sharpening & Soft Glow)

These are totally optional (but very popular) finishing moves for HDR images. I mentioned these effects earlier in this chapter when I applied them to our projects as finishing moves. But, I wanted to put them here separately so that if you wanted to just add one of these finishing techniques, you wouldn't have to go fishing through all those steps to find them.

Step One:

Once you've processed your bracketed photos in Merge to HDR Pro, go under the Filter menu and choose Camera Raw Filter (this is where we start our finishing moves by adding a dark edge vignette). There are actually two different places to apply vignettes in Camera Raw, but the one that pretty much everybody uses (because it looks the best) is Post Crop Vignetting (designed to be used after you've cropped the image, but you can apply it to an uncropped image, no problem). Click on the Effects icon (the third icon from the right) at the top of the Panel area. In the Post Crop Vignetting section, first make sure Highlight Priority is the selected Style (it's the only one that actually looks good), then drag the Amount slider to the left to darken the edges all the way around your image (as shown here, where I dragged to -18).

Step Two:

Click OK to open the image in Photoshop. Next, let's sharpen the living daylights out of it. You can use the High Pass sharpening technique we just did, or you can just Unsharp Mask the daylights out of it, using my favorite "sharpen the daylights out of it" setting, which is: Amount 90%, Radius 1.5, and Threshold 0. This is some serious sharpening, so don't apply this to photos of babies, or bunnies, or stuff you don't want to look like it's made of iron (kidding).

To get the soft glow finishing move that's so popular for HDR images, try this: press **Command-J (PC: Ctrl-J)** to duplicate your Background layer, then go under the Filter menu, under Blur, and choose **Gaussian Blur**. Enter 50 pixels for your blur Radius and click OK.

Step Four:

At the top of the Layers panel, lower the Opacity of this blurry layer to 70%. It still looks really blurry, but what gives this the right look is when you change the blend mode of this blurry layer from Normal to Soft Light. Now you get that soft glow across the image that takes the edge off the harsh HDR look. Again, all three of these finishing moves are optional, so don't think you have to apply them, but now at least if you do want to apply them, you know how to do it (and I usually do all three to my tone-mapped HDR images. If I'm going for the realistic HDR look, then I'll do the sharpening but I don't generally add the vignette or the blur to soften the look).

Photoshop Killer Tips

Zooming In Really Tight? There's a Pixel Grid to Help You Out

You won't see this neat little feature unless you zoom in to 600% magnification or more—it's a little pixel grid that appears that makes it visually easier to tell pixels apart when you're zoomed in crazy tight. It's on by default (give it a try—zoom in crazy tight and see), but if you want to turn it off, just go under the View menu, under Show, and choose **Pixel Grid**.

Duplicate Multiple Layers at Once Pressing Command-J (PC: Ctrl-J) is not only the fastest way to duplicate a layer, it is also the fastest way to duplicate multiple layers. Just go to the Layers panel, Command-click (PC: Ctrl-click) on the layers you want duplicated to select them, then use that same shortcut to duplicate all the selected layers.

Keeping Your Third-Party Plug-Ins from Loading into Photoshop

Before you launch Photoshop, pressand-hold the Shift key. A dialog will appear and, if you click the Yes button, it disables any third-party plug-ins. This can come in handy if you think you're having a problem in Photoshop caused by one. If you restart with them disabled and the problem goes away, you've probably found your culprit.

Create a New Document Just Like the Last One

There's a super-handy, yet little known, shortcut that lets you create a brand new document using the exact same specs (size, resolution, color mode, etc.) as the last one you made. Instead of choosing Command-N (PC: Ctrl-N) to bring up the New dialog, just press Command-Option-N (PC: Ctrl-Alt-N), and when the New dialog appears, all the specs for your last document will be entered for you.

Saving Time in HDR Pro

The more images you use to create your HDR images, the longer it takes HDR Pro to compile your final image, so this is a case where less is more. I usually use three images (as I explained at the beginning of this chapter), but an interesting tidbit I learned from one of the Photoshop product managers is that, for the best results, you need more darker photos than lighter ones. So, if you don't mind the extra wait, you're better off having just one image with a really bright exposure and four darker ones, than you are with an equal balance.

Editing the Lens Correction Grid

When you use the Lens Correction filter, the first thing you'll notice is that "annoying grid" isn't turned on by default like it used to be (by the way, the only reason it was annoying was because it was turned on by default). Now, not only is it off by default, but you can edit the size and color of the grid itself. When you turn on the Show Grid checkbox at the bottom of the Lens Correction dialog, a Size field and a color swatch become available to the right of the checkbox. Also, although there is a grid in the Lens Corrections panel of Camera Raw (press **V** to toggle it on/off), you can't change the size or color of that grid.

Renaming Multiple Layers Fast

Want to rename a bunch of layers? Just double-click directly on the first layer's name to highlight it, type in a new name, and then press the **Tab key** to jump to the next layer and its name field will be highlighted, ready to be renamed. The Tab key takes you to the next layer down; to jump back to a previous layer, press **Shift-Tab**.

Photoshop Killer Tips

Hide All Your Panels Fast

If you want to focus on your photo, and temporarily hide your Toolbox, Options Bar, and all your panels, just press the **Tab key**. Press it again to bring them all back.

Putting Your Drop Shadow Right Where You Want It

If you're adding a drop shadow behind your photo using a Drop Shadow layer style (choose **Drop Shadow** from the Add a Layer Style icon's pop-up menu), you don't have to mess with the Angle or Distance fields whatsoever. Instead, move your cursor outside the Layer Style

dialog—over into your image area—and just click-and-drag the shadow itself right where you want it.

Back in CS4, Adobe introduced this very cool little utility called "Kuler" which was designed to help you find, mix, match, and try out different color schemes, and it was so popular that it spawned its own online community, with users sharing and rating different sets of colors based on

themes. You can download the Kuler panel

by going under the Window menu and

choosing **Browse Extensions Online**. In the Kuler panel, you can browse some of the most popular color combos right

Need Help Finding the Right Colors?

within Photoshop. If you see a set of colors you like, double-click on it to see them as larger swatches in a panel. To make any of those color swatches your Foreground color, just double-click on it.

Getting Rid of Your Empty Layers Fast

In CS5, Adobe included a built-in script that will go through your Layers panel and remove any empty layers (layers with nothing on them) automatically (once you get a large multi-layered project going, you wind up with more of these than you'd think). To have Photoshop tidy things up for you, go under the File menu, under Scripts, and choose **Delete All Empty Layers**.

Removing Noise from Cell Phone Photos

Since Photoshop is a pro tool, most of us probably wouldn't even think of using Camera Raw's built-in Noise Reduction feature to remove the noise from our cell phone camera's photos, but...why not? Cell phone photos are notorious for color noise, which Camera Raw cleans up really well. Try it one time, and I'll bet you'll use it more than you ever dreamed (to open a cell phone photo in Camera Raw, just find it on your computer in Bridge, then Right-click on it and choose **Open in Camera Raw**).

Using the HUD Pop-Up Color Picker If you've ever thought, "There's got to be an easier way to pick colors than clicking on the Foreground color swatch every time," you're gonna love this: it's a popup color picker (Adobe calls it the HUD [Heads-Up Display], because you keep your eyes on the image, instead of looking over and down at the Foreground/Background color swatches). First, choose a Brush tool, then press Command-Option-Ctrl (PC: Alt-Shift) and click (PC: Rightclick) on your image. It brings up a simplified color picker where you can choose vour color (I find it easier to choose the hue first, from the bar on the right, then choose the tint and saturation of the color from the box on the left).

Chapter 7 Fixing Common Problems

Little Problems fixing common problems

The title for this chapter comes from the 2009 movie Little Problems (written and directed by Matt Pearson), but I could have just as easily gone with the 2008 short Little Problems (written and directed by Michael Lewen), but there was one big thing that made the choice easy. The first movie was about zombies. You just can't make a bad movie about zombies. It's a lock. Throw a couple of hapless teens (or in this case "an unlikely couple") into some desolate location with a couple hundred flesh-starved undead, and you've got gold, baby, gold! Now, has anyone ever wondered, even for a second, why every zombie in the rich and colorful history of zombies has an insatiable hunger for human flesh and only human flesh? Why can't there be zombies that have an insatiable hunger for broccoli? Then, in their bombed-out shell of a desolate vacant city, on every corner there would be other zombies selling broccoli the size of azalea bushes.

Anyway, it's just a little too coincidental that every zombie wants to eat you, but they don't want to eat something that might actually keep them alive, and is in ample and easily reproducible supply, like broccoli, or spring rolls, or chowder. Nope, it has to be human flesh, even though you know and I know (say it with me) it tastes like chicken (well, that's what I've been told, anyway). Another thing that drew me to the first Little Problems was the director's last name, seeing as all my books are published by subsidiaries of Pearson Education, a company who somehow chose to hire Ted Waitt as my editor, despite the fact that they were forewarned by the DCBGC (the Desolate City Broccoli Growers' Consortium) that Ted might not actually be the strict vegetarian he claimed to be in his resume. I probably shouldn't say anything bad about Ted, though. I don't want to bite the hand that feeds me.

When Your Subject Is in the Shadows

We all wind up shooting subjects that are backlit (where the light is behind your subject). That's because our eyes automatically adjust to the situation and we see the subject just fine in our viewfinder. The problem is our cameras aren't nearly as sophisticated as our eyes are, so you're almost guaranteed to get some shots where the subject is way too dark. Although I feel you get better results using Camera Raw's Exposure and Highlights sliders, the Shadows/Highlights adjustment does a fairly decent job, and there's a trick you can use to make the adjustment re-editable.

Step One:

Open a photo where your subject is in the shadows (it can be a person, or a building, or anything backlit). In this example, the light is behind our subject, so she's pretty much fully in the shadows. Ideally, we'd like to brighten her up to balance out the light in the photo. To do this, first go under the Filter menu and choose Convert for Smart Filters. This lets you apply the adjustment as if it was an adjustment layer (meaning you can reedit it later if you need to, or even delete the adjustment altogether). Even though the adjustment we're going to apply isn't found under the Filter menu, for some reason Adobe lets it act like it is a smart filter, so why not take advantage of it, eh? Now go under the Image menu, under Adjustments, and choose Shadows/Highlights.

Step Two:

If you're choosing Shadows/Highlights, you probably have a problem in the shadow areas, which is why, by default, it's set to open up (lighten) the shadow areas in your photo by 35%. However, in this case, our subject is so buried in the shadows that we'll have to open the shadows quite a bit. The problem with opening the shadows 50% or higher is your photos tend to look kinda "weird and milky" (as you can see here, where I've increased it to 65%, and now her face looks a bit strange).

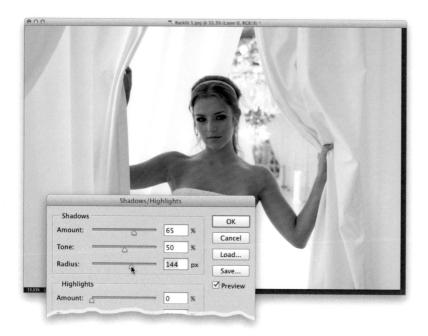

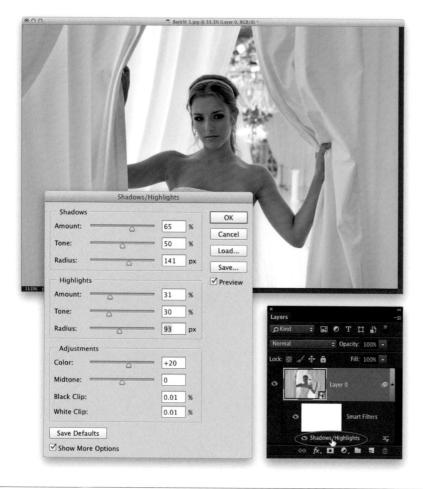

To get around that, turn on the Show More Options checkbox at the bottom of the dialog. This brings up an expanded version of the dialog (as shown here). The key to fixing this "weird and milky" look is to drag the Radius slider over to the right until it smooths out the effect and looks normal (here, I dragged it over to 144 pixels because that's where it looked most natural to me, but it really just depends on the photo. I would say that most of the time I set the Radius to around 125 to 175). By the way, the Radius amount determines how many pixels each adjustment affects, so to affect a wider range of pixels, you'd increase the amount, which is what we did here.

Step Four:

Now that the shadows are opened up (and look reasonably realistic), if you want, you can darken the highlights around her. In most cases, you'll only have to fix one or the other—the shadows or the highlights—but not both. For example, to darken the drapes a bit, go to the Highlights section and drag the Amount slider to the right (as seen here; I also increased the Radius slider quite a bit, as well). If you drag too far, you might start to see some banding in the drapes (where you start to see lines where the colors change, instead of a smooth transition between colors), so just keep an eye on the drapes as you drag. If later you need to tweak these settings, because you applied this as a smart filter, you can go to the Layers panel, double-click directly on the words "Shadows/Highlights" (as shown here), and the Shadows/Highlights dialog re-opens, with the settings you used previously. Just make any changes you want, then click OK.

(Continued)

Step Five:

The other cool thing about using Shadows/Highlights as a smart filter is that you get a layer mask with it. So if, as in this case, part of your image loses too much contrast when you make the Shadows adjustment, you can use the layer mask to hide the adjustment on that part of the photo. Here, we want to mask out the entire background, so click on that layer mask (below your image layer, next to the words "Smart Filters") to make it active. Then, get the Quick Selection tool (W) and paint over your subject until she is completely selected. If you select too much, Option-click (PC: Alt-click) on the area you want to remove from your selection. Now, press Command-Shift-I (PC: Ctrl-Shift-I) to Inverse your selection, then press Command-Delete (PC: Ctrl-Backspace) to fill the selection with black, hiding the adjustment from view.

TIP: Save a New Default

If you come up with some settings you like, click the Save As Defaults button in the bottom-left corner of the dialog, and now it will open with your settings.

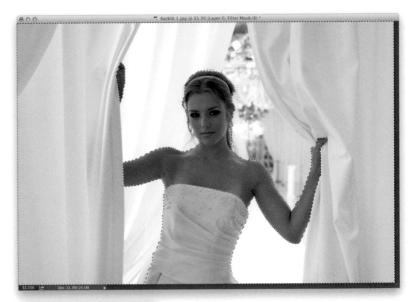

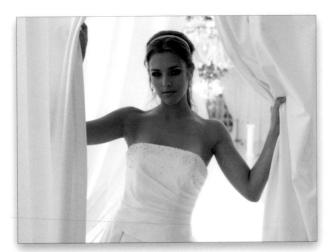

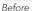

After (opening up the shadows and pulling back the highlights)

Nothing ruins an outdoor shot like a dull gray sky, but luckily, in many cases, you can save the shot by darkening the midtones a bit, and adding a blue tint or gradient to the sky. Here's how to do both:

Fixing Shots with a Dull Gray Sky

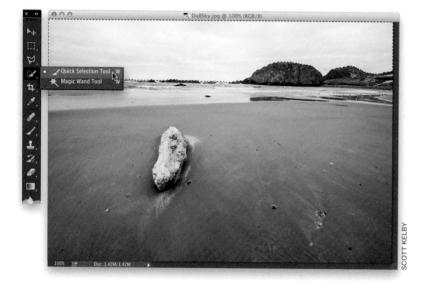

Step One:

Here's a shot where the sky is really blah. Not totally 100%, but close enough. Also, the clouds are a little dark, so even if you went into Camera Raw and lowered the exposure, those darkish clouds would look like rain clouds, and you'd have a whole different problem to deal with (an underexposed photo with the rocks in the shadows). So, this technique will work pretty well for this image. You'll start by making a selection of the sky and your first thought might be to use the Magic Wand tool. Now, if the sky was just a flat sky with no clouds, that would probably work out okay, but in this case (a sky with clouds), you're much better off using the Quick Selection tool (it'll select that sky in all of 5 seconds). So, get the Quick Selection tool (W) from the Toolbox, click it on the far-left side of the sky, then drag it over to the right side, and—BAM!—it's selected (as shown here). Note: If it selects too much, just Option-click (PC: Alt-click) on the area you want to remove.

(Continued)

Step Two:

When I make a selection like this, to make sure it didn't miss any little areas, I usually expand (grow) the selection outward by a pixel or two (that way, it kind of "digs-in" to the rocks a little and eliminates any little gaps that would be a giveaway you tweaked the sky). To do this, go under the Select menu, under Modify, and choose **Expand**. When the dialog appears, if it's a really high-resolution image, use 2 pixels. If it's a 6- or 8-megapixel image (or smaller), just use 1 pixel, then click OK (you probably won't see anything onscreen when you do this—you just have to trust that it actually expanded outward by a pixel or two).

Step Three:

To get a realistic color for the sky, we're going to open another photo that already has a nice sky color (you can download this same photo, and most of the key photos used in this book, at the web address listed in the introduction at the front of the book). Once you open the image, switch to the Eyedropper tool (I), and click once on the brightest blue area in the image (as shown here) to make that your Foreground color. Now, press the letter \boldsymbol{X} to swap your Foreground and Background colors, then click the Eyedropper on the darkest blue in the photo (higher in the sky), so that now your Foreground is a darker blue, and your Background is a lighter blue.

TIP: The Color Selector Ring

That ring that appears when you use the Eyedropper tool is there to help you see which color you're selecting. The outside ring is a neutral gray, which just helps to make sure you're seeing the right color without being influenced by other colors around it. The bottom half of the inside ring shows the old color, and the top half shows what your Foreground color would change to if you clicked right now.

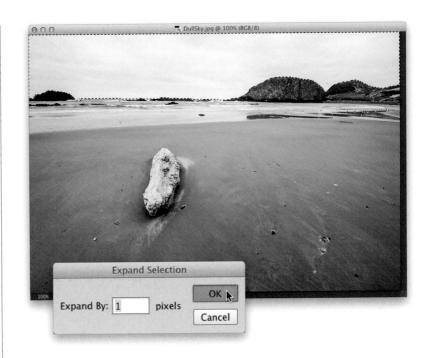

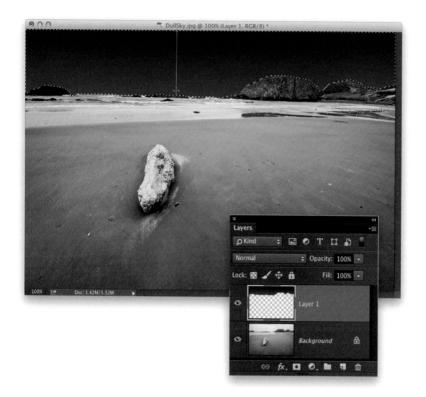

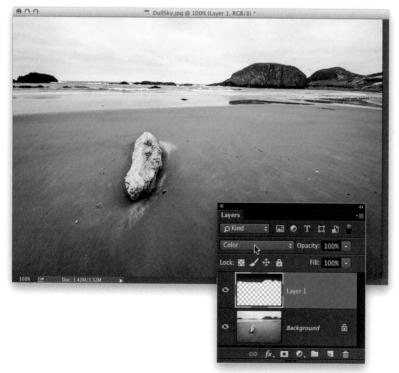

Step Four:

Go back to the original image, then go to the Layers panel and add a new, blank layer by clicking on the Create a New Layer icon at the bottom of the panel. Then, switch to the Gradient tool (G), and click-and-drag your gradient from the top of the photo down to the bottom of the sky (the light blue color should be at the bottom of the gradient). This fills the new layer with a gradient made up of your Foreground and Background colors (as seen here). For some images, you can leave this gradient as is (or maybe just lower the layer opacity a little to let it blend in), but I think it usually looks a little too fakey, which is why there are two more steps.

Step Five:

First, press Command-D (PC: Ctrl-D) to Deselect, then go to the Layers panel and change the layer's blend mode from Normal to Color (shown here), just to see how the color itself looks. In this case, it looks a bit too cyan and fakey, so we'll have to take it another step further (don't worry—it's easy), but at least we can see that we're in the ballpark (so to speak).

(Continued)

Step Six:

There are two layer blend modes that add contrast to our layer: Soft Light and Overlay. Let's try both of those. When you try Soft Light, you can see its effect is more subtle, and Overlay (shown here) is more contrasty (and in this case, that's what I'd go with, because it looks darker, but not at all over-the-top. If you want a really dramatic sky, try Color Burn, and then lower the layer's Opacity to around 50%). If you're not sure which one you want, just press Shift-+ (plus sign) to toggle through all the different blend modes until you find one you like. A before and after are shown below (it's subtle, but it's supposed to be).

After

In older versions of Photoshop, when we wanted to dodge and burn, we had to jump through a bunch of hoops (creating special layers, and using blend modes and such), because the Dodge and Burn tools were...well...let's just say they weren't the best (and that's being kind). Luckily, back in Photoshop CS5, Adobe updated these tools, which totally fixed the problem, and now it's safe to use the Dodge and Burn tools for lightening and darkening different parts of your image.

Using the Dodge and Burn Tools

Step One:

Before we dig into this, I just want to you let you know up front that I would normally do my dodging and burning inside Camera Raw using the Adjustment Brush (and do the lightening and darkening using only the Exposure slider). However, if you're already in Photoshop and don't want to go back to Camera Raw, then here's how you'd do it: In the photo shown here, our light is kind of out of balance. The thing I want people drawn to is the mossy rock in the foreground, but the brightest thing in the photo (the thing that draws your eye) is the sky and sunlit trees, which is where I don't want the viewer looking. In fact, almost the entire foreground is in shadow, so first, we're going to dodge (lighten) the rock and a little of the hillside. Then, we're going to burn (darken) the sunlit trees further up the hill and the sky. Basically, we're just going to rearrange how the light is falling on our photo. Now, I don't use the Dodge and Burn tools directly on the original photo. Instead, press Command-J (PC: Ctrl-J) to duplicate the Background layer. That way, if we don't like what we've done, we can lessen the effect (by lowering the layer's opacity) or undo it altogether by throwing the layer away.

(Continued)

Step Two:

Get the Dodge tool (O) from the Toolbox (as shown here), and begin painting over the area you want to lighten (in our case, we'll start by painting over the mossy rock in front—you can see the brush cursor near the front of it here). Keep holding the mouse button down as you paint, because the Dodge and Burn tools have a build-up effect—each time you release the mouse button and start painting again, the amount of Dodge (or Burn) builds up.

Step Three:

Release the mouse button, and paint over that same mossy rock area again, and you'll see how it gets another level brighter. Remember: While the mouse button is held down, you're painting one level of brightness. Release the mouse button, then click-and-paint over that area again, and you're painting over the original brightness with more brightness, and so on (it's kind of like polishing a silver platter—the more times you polish it, the brighter it gets). Now look at how much brighter the rock is here, compared with the original image in Step One. Next, let's work on the hill just above the rock.

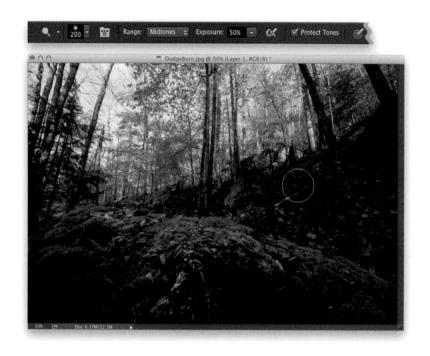

Step Four:

Start painting over the hillside to dodge (brighten) it, but keep the mouse button held down the whole time to paint just one level of brightness over it. Now, before we switch to burning on the sunlit trees and sky, take a look up in the Options Bar for this tool, and you can see that we've been dodging just the Midtones (and that's generally where I do my dodging and burning), but if you wanted the tool to just affect the highlight or shadow areas, you can choose that from that Range pop-up menu. Also, the 50% Exposure amount is fine for something like this, but if I were doing this on a portrait, I'd usually want something much more subtle, and I'd lower the amount to around 10%-15%.

Step Five:

Now, let's switch to burning. First, start by pressing Command-J (PC: Ctrl-J) to duplicate your top layer. So, at this point, you've got the original untouched image as your Background layer, the brightened Dodge Layer in the middle (I renamed it "Dodge Layer" just to make it easier to see), and a copy of the brightened layer on top, which is the one we're going to burn on (I named it "Burn Layer"). By keeping everything on separate layers, if you don't like the burning effect, you can reduce it by lowering the opacity, or delete it altogether and you won't lose the dodging you did on the layer below it. Now get the Burn tool (as shown here), and paint over the sky and bright trees. By darkening those areas, it takes the focus off of them, which helps lead the eye to the rock. (Whether you realize it or not, you're painting with light. Cool!)

Step Six:

Let's darken the sky a bit more by burning over it, again. Just remember—while you're painting, keep your mouse button held down the whole time, or part of your sky will be one shade darker, and then another part might be two shades darker (where the two areas overlap). One more thing: up in the Options Bar you'll see a checkbox for Protect Tones. That's the checkbox that helps to keep the color of what you're dodging and burning intact, so things just get brighter or darker, and not sunburned and color saturated. I leave this on all the time, even when I'm not dodging and burning portraits (which is when it's most useful). Below is a before/ after, and while I'm usually fairly subtle with my dodging and burning, here I took things a little farther than I normally would, just to show a clear example of the power of dodging and burning.

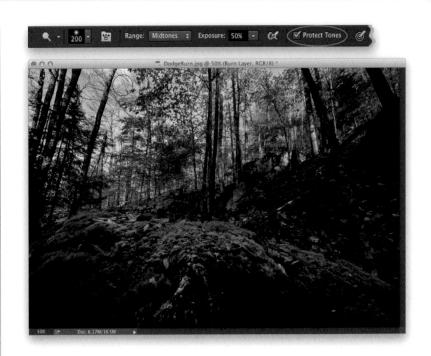

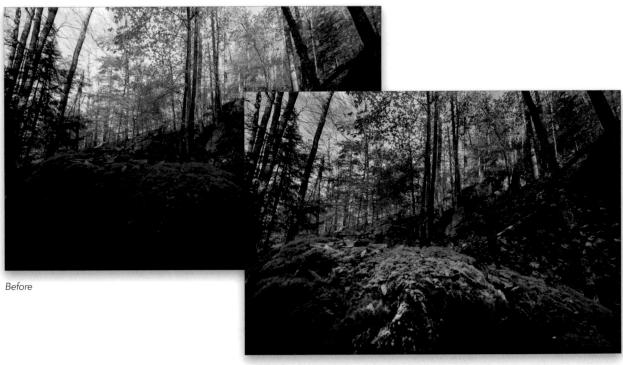

After

I get more requests for how to fix this problem than probably all the rest combined. The reason is it's so darn hard to fix. If you're lucky, you get to spend an hour or more desperately cloning. In many cases, you're just stuck with it. However, if you're smart, you'll invest an extra 30 seconds while shooting to take one shot with the glasses off (or ideally, one "glasses off" shot for each new pose). Do that, and Photoshop will make this fix absolutely simple. If this sounds like a pain, then you've never spent an hour desperately cloning away a reflection.

Fixing Reflections in Glasses

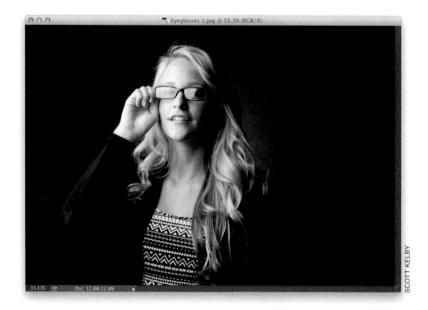

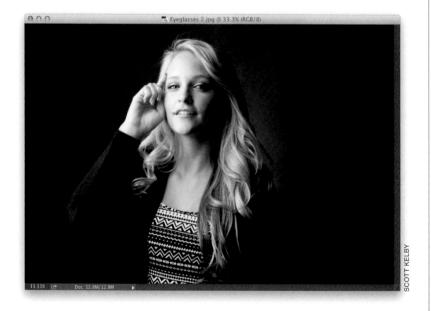

Step One:

Before we get into this, make sure you read the short intro up top here first, or you're going to wonder what's going on in Step Two. Okay, here's a photo of our subject with her glasses on, and you can see the reflection in them (pretty bad on the left side, not quite as bad on the right, but it definitely needs fixing). The ideal situation is to tell your subject that after you take the first shot, they need to freeze for just a moment while you (or a friend, assistant, etc.) walk over and remove their glasses (that way they don't change their pose, which they absolutely will if they take their own glasses off), then take a second shot. That's the ideal situation.

Step Two:

I could see right away that we were going to have a reflection in her glasses, so I told her after the first shot not to move her head, and had someone go over and remove her glasses, and then I took another shot (she did, though, raise her finger in this shot, but that's not a problem).

With both images open in Photoshop, get the Move tool (V), press-and-hold the Shift key, and then click-and-drag the "no glasses" photo on top of the "glasses" photo (as I did here). Now, if you planned ahead and took shots with and without the glasses (one right after the other), then you can take a shortcut and use Auto-Align Layers to perfectly match up the two shots. In the Layers panel, Command-click (PC: Ctrl-click) on each layer to select both (as shown here), then go under the Edit menu and choose Auto-Align Layers. Leave the Auto option selected and click OK, and in just a few seconds, they will be aligned right on the money. Now, if you did all of this "the right way" in the studio, then you can jump to the second part of Step Six. However, if the shots were taken handheld, and a few minutes apart, we wouldn't be able to use Auto-Align Layers (the subject may have moved too much). We'd have to do it manually (another reason why setting this up the right way in the studio really pays off). So, we'll take a look at what to do if this happens.

Step Four:

You need to be able to "see through" the top layer, so you can see her eyes on the bottom layer (that way, you can line them up). So, start by going to the Layers panel and lowering the Opacity of the top layer to around 50% or 60% (as shown here). Now, with the Move tool, position the eyes on the top layer as close as you can get to those on the bottom layer.

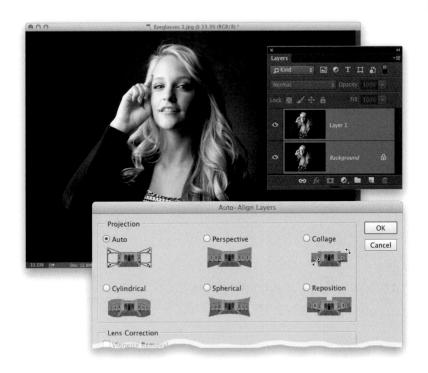

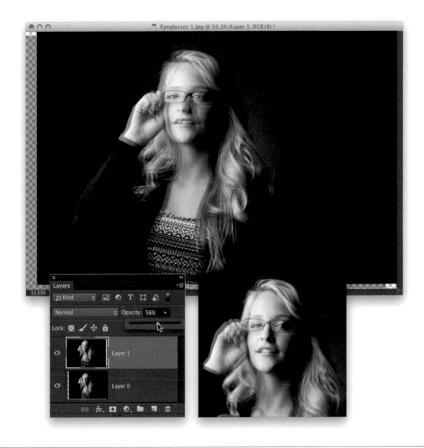

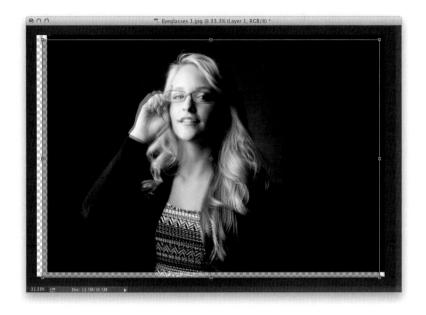

Step Five:

If your subject's position changed at all (maybe their head tilted or their shoulders moved), you might need to rotate the top photo, so the eyes match up better. So, press Command-T (PC: Ctrl-T) to bring up Free Transform, then zoom out (to shrink the size of your image window), and pull out the corners of the image window, so you see some of the dark gray canvas area around your image (as seen here). Now, when you move your cursor outside the Free Transform bounding box, it will change into a two-headed rounded arrow, so you can click-and-drag in a circular motion to rotate the top layer. (Note: You may need to move your cursor inside the bounding box to reposition the top layer, as well.)

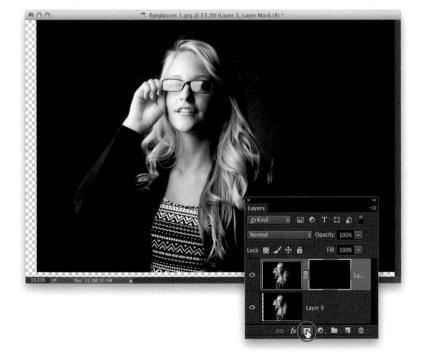

Step Six:

Once it looks pretty well lined up, press the **Return (PC: Enter) key** on your keyboard to lock in your rotation, then raise the Opacity of this top layer back to 100%. Now, all we really need from the image on the top layer is the area that appears inside her frames. So, press-and-hold the Option (PC: Alt) key and click on the Add Layer Mask icon at the bottom of the Layers panel to hide this rotated layer behind a black layer mask (as shown here).

Step Seven:

Now, with your Foreground color set to white, get the Brush tool **(B)**, choose a small, soft-edged brush from the Brush Picker up in the Options Bar, then simply start painting over the lens on the right, and it reveals the version of her eye without the glasses on (as seen here). What you're doing is revealing the top layer, but just where you want it.

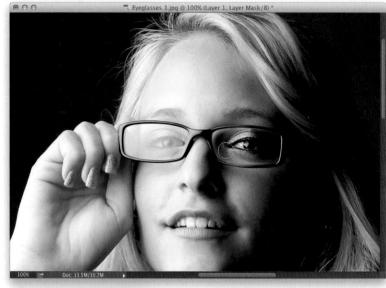

Step Eight:

Once the eye on the right is done, do the same thing for the eye on the left (you can also paint her finger back in). Make sure you use a small brush and be careful not to accidentally paint over any of the frames. If you do make a mistake, no biggie, just press X to switch your Foreground color to black and paint the frames back in. Now, remember, this whole process would be made a whole lot easier (you could skip Steps Four and Five altogether) if you remember, once you get a look you like in the studio, to have your subject freeze, remove their glasses, and take another shot. Then, Auto-Align Layers can do its thing and save you a lot of time and trouble. A before and after are shown on the next page.

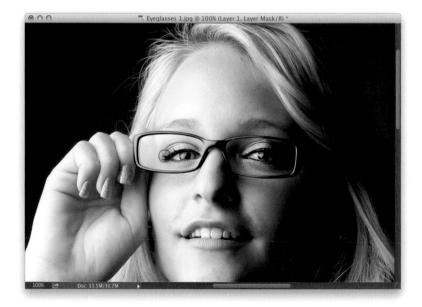

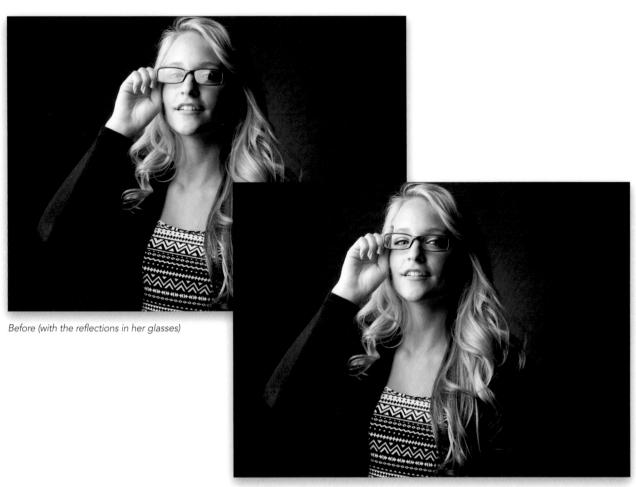

After (the reflections are gone)

Fixing Group Shots the Easy Way

Group shots are always a challenge because, without a doubt, somebody in the group will be totally hammered (at least, that's been the experience with my family. You know I'm kidding, right?). Okay, the real problem is that in group photos there's always one or more people who blinked at just the wrong time, or forgot to smile, or weren't looking at the camera, etc. Of course, you could just take their expression from another frame and combine it with this one, but that takes a lot of work. Well, at least it did before the Auto-Align Layers feature. This thing rocks!

Step One:

Here's a group shot where one of the subjects (the guy in the middle) isn't smiling.

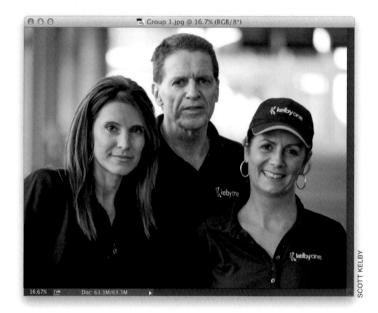

Step Two:

Of course, with group shots, you take as many shots as the group will endure, and, luckily, a few frames later, we have one where the guy looks great. But, we can't use this shot, because now the woman on the right is squinting. So, the idea here is to take the guy from this shot and combine him with the first photo to make one single group photo where they're all smiling and have their eyes open.

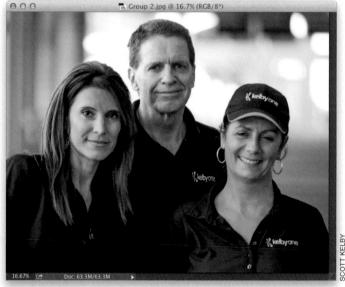

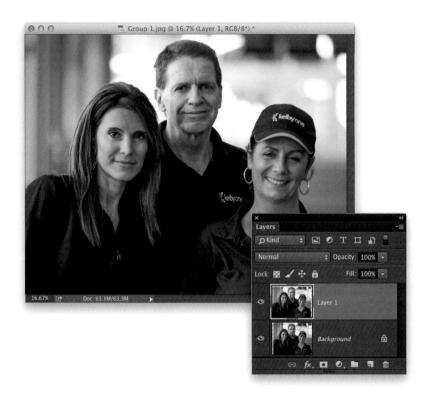

Start by opening both photos in Photoshop and dragging them into the same document: get the Move tool (V), pressand-hold the Shift key, and click-and-drag the photo where the guy looks good over on top of the other photo, where he's not smiling (it will appear as its own layer in the other document, as you can see in the Layers panel shown here).

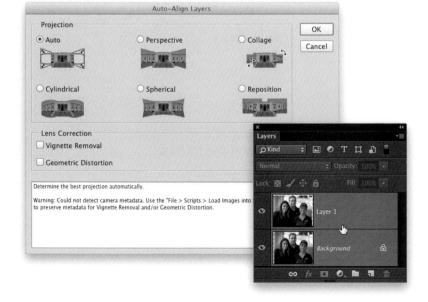

Step Four:

Usually, just pressing-and-holding the Shift key will help the photos line up pretty well (especially if the shots were taken with your camera on a tripod), but if you hand-held the shots, or if your subjects moved a bit, you'll need Photoshop to line them up precisely for you. You do this by going to the Layers panel, Command-clicking (PC: Ctrl-clicking) on both layers to select them (as shown here), then going under the Edit menu and choosing Auto-Align Layers. When the Auto-Align Layers dialog appears, leave Auto selected at the top, and then click OK to have Photoshop align the two layers for you (and it usually does a pretty darn amazing job, too!).

Step Five:

Now that they're aligned, click on the top layer in the Layers panel to make it the active layer. Press-and-hold the Option (PC: Alt) key and click on the Add Layer Mask icon at the bottom of the Layers panel to hide the top layer (with the guy smiling) behind a black layer mask. Now, get the Brush tool (B), choose a mediumsized, soft-edged brush from the Brush Picker in the Options Bar, and with your Foreground color set to white, paint over the guy's head. As you do, it reveals the good version of him where he's smiling (as shown here). Keep painting until his head, shirt, and basically as much as you need, look natural in the photo. When you're done, get the Crop tool (C) and crop the image down to size. The final is shown below.

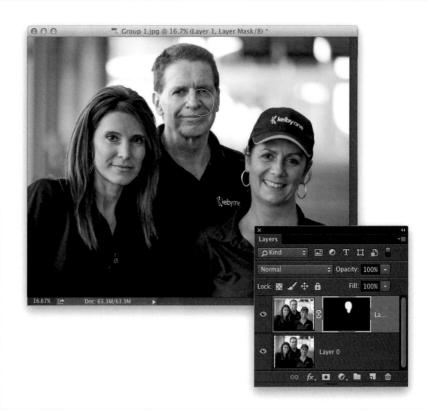

Before: The guy in the middle isn't smiling

Before: The woman on the right is squinting

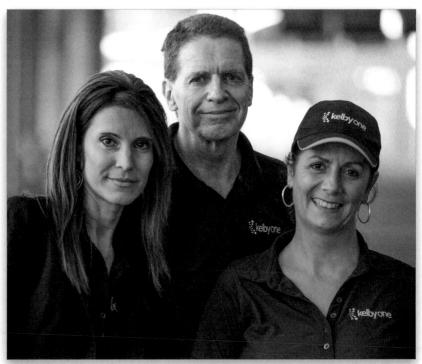

After: Parts of the two photos are combined to make one perfect group shot

I do a lot of portrait retouching (heck, I even wrote a bestselling book on the topic, but if you think I'm going to plug my *Professional Portrait Retouching Techniques* for *Photographers Using Photoshop* book here in this book, man are you right) Anyway, one feature on every retoucher's wish list was the ability to apply Liquify as a smart object, so we could edit or undo our Liquify retouches anytime. This is now available in the Creative Cloud version of Photoshop. What wasn't on our radar was the handy Smooth tool, which helps hide our Liquify retouches.

Liquify Is Now Re-Editable (and It Has a Handy Tool!)

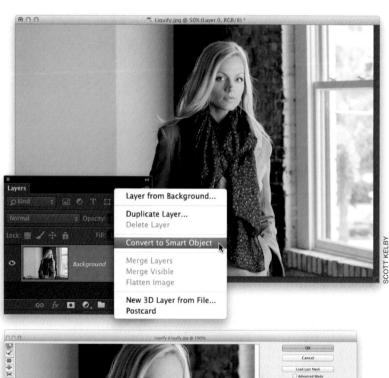

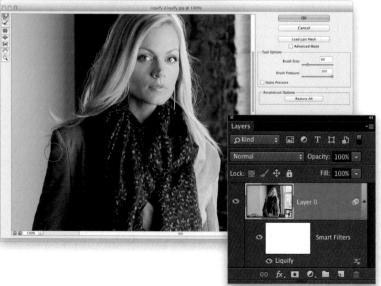

Step One:

To use Liquify as a smart object, start by converting your image layer into a smart object layer (either go under the Filter menu and choose **Convert for Smart Filters**, or go to the Layers panel, Rightclick on the Background layer, and choose **Convert to Smart Object**, as shown here).

Step Two:

Now, choose Liquify from the Filter menu and make any changes you want (here, we'll use the Forward Warp tool [W]—the first tool at the top of the Toolbox-to fix the indentation in our subject's coat just below her shoulder). Use a smaller brush to nudge that area outward until it looks nice and even (like you see here). Let's also nudge in her sleeve a little lower down, as well, and maybe nudge the indentation out on her other shoulder a little, too (so, we adjusted three areas in all). When you're done, click OK and that layer now appears as an editable smart filter layer with a layer mask attached (so, if you wanted to, you could hide any part of the Liquify edit you just made by painting over that area in black).

If you decide maybe you went a bit too far in Liquify, normally you'd have to start over from scratch. But, since you made this a smart object first, you can reopen the image with your retouches still "live," so you can edit them. To do this, just double-click directly on the word "Liquify" (shown circled in red here) directly below the smart filter layer in the Layers panel, and it reopens the layer in Liquify. Now all your edits are not only in place, they're editable. For example, if you want to undo just part of your last edit (let's say you wanted to undo the changes you made on the right side to her shoulder), you can just get the Reconstruct tool (R; the second tool from the top in the Toolbox) and paint over that area to return it to the original look while leaving the rest of your edits as-is.

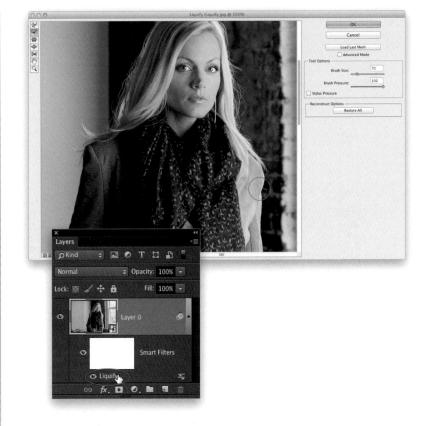

Step Four:

Okay, so that's the smart object part (easy enough, right?). Now let's look at the Smooth tool. To get to this tool, you have to turn on the Advanced Mode checkbox (near the top right of the dialog), which reveals more tools and controls. The Smooth tool (E) now appears in the Toolbox and is the third tool down. You'd generally use this tool if you see that an edit you made with one of the other tools looks rippled or obviously retouched. The Smooth tool actually works kind of like the Reconstruct tool, but instead of bringing the full original image back where you paint, it only brings back part of it. The first pass with the tool undoes "part" of your retouch; another pass undoes a little more. So, you can use it with a small brush for a more realistic retouch.

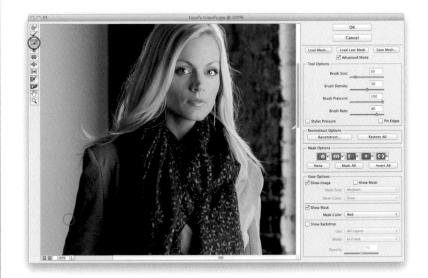

Most of the selecting jobs you'll ever have to do in Photoshop are pretty easy, and you can usually get away with using the Magic Wand, Lasso, or Pen tools for most jobs, but the one that has always kicked our butts is when we have to select hair. Over the years we've come up with all sorts of tricks, including the intricate Channels techniques I covered in my *The Photoshop Channels Book*, but all these techniques kind of went right out the window when Adobe supercharged the Quick Selection tool in Photoshop CS5 with the Refine Edge feature. This is, hands down, one of the most useful, and most powerful, tools in all of Photoshop.

Making Really Tricky Selections, Like Hair (and Some Cool Compositing Tricks, Too!)

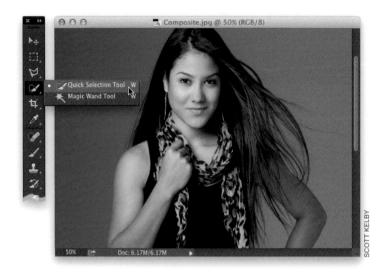

Step One:

Start by opening an image that has a challenging area to select (like our subject's hair here, which is being blown by a fan). Then, get the Quick Selection tool (**W**) from the Toolbox (as shown here).

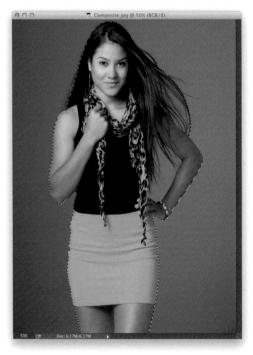

Step Two:

Here's how it works: you just take the tool and paint loosely over the areas you want to select, and it expands to select the area (kind of like a much smarter version of the Magic Wand tool, but using different technology). One thing I've learned about this tool is it actually seems to work best when you use it quickly—really zoom over your subject with the tool and it does a pretty decent job. Here, I selected the subject, and while you can see some problems with the selection (the area of gray between her arm on the right and her side). it's not that bad overall. If it selects too much, press-and-hold the Option (PC: Alt) key and paint over that accidentally selected area to remove it from your selection. Don't worry—it's not going to look perfect at this point.

Now, here's something else I've learned about the Quick Selection tool: while it's pretty good at selecting, it's not always as good at deselecting areas that you don't want selected (like that gray area between her arm and her side). When I deselected that area, it also deselected some of her hair and scarf, so I had to reselect those. If it isn't working, try switching to the Magic Wand tool (Shift-W), pressing-and-holding the Option (PC: Alt) key, and just clicking once in that area to instantly deselect it.

Step Four:

Okay, here comes a very important part of this stage of the process, and that is making sure that when you select her hair, you don't select any background area with it. In other words, don't let there be any hair selected with gray background showing through. In fact, I basically follow the rule that I don't get too close to the outside edges of my subject's hair unless an area is pretty flat (in other words, no flyaway, tough-to-select hair in that area). You can see what I mean in the close-up here, where I avoided the thinner edges of her hair (we'll let Photoshop select those hard parts-we'll just get close to the edge then stop). Also, you can see where I stopped before some areas where the hair is finer. Again, we'll let Photoshop grab those parts later, but for now we're most concerned with avoiding selecting areas where you can see gray background through her hair. If you accidentally select an area with gaps, then it's okay to, with the Quick Selection tool, press-and-hold the Option (PC: Alt) key, and paint over those gap areas to deselect them.

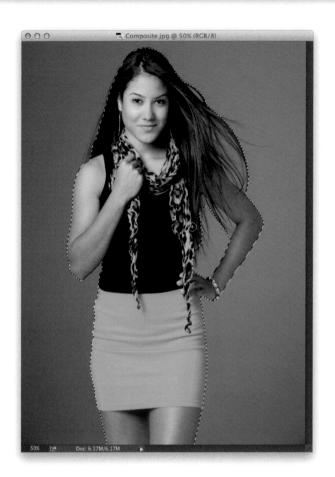

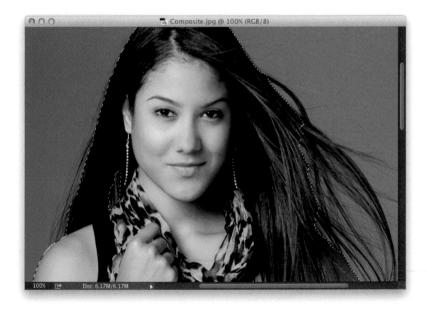

Step Five:

Once your selection looks pretty decent, it's time to unlock the real selection power (the Quick Selection tool is just the warmup act). Go up to the Options Bar and click on the Refine Edge button (shown circled here). This is where the magic happens. In the Refine Edge dialog, you have a number of choices for how you can view your selected image (including just the standard old marching ants), but just for now, as part of our learning process, go ahead and choose Black & White, from the View pop-up menu. This shows your selection as a standard layer mask. As you can see, the Quick Selection tool, by itself, isn't gettin' the job done (the edges are jaggy and harsh, and there's no wispy hair selected at all). That's okay, though, because we're just gettin' started.

Step Six:

Next, turn on the Smart Radius checkbox (you won't see anything happen yet, but turn it on anyway). Smart Radius is the edge technology that knows the difference between a soft edge and a hard edge, so it can make a mask that includes both. This checkbox is so important that I leave it on all the time (if you want it always on, as well, just turn it on and then turn on the Remember Settings checkbox at the bottom of the dialog). Now, again, just for learning purposes, drag the Radius slider all the way over the right (to 250), and all of her hair gets selected instantly (pretty amazing isn't it?). While it did a great job on her hair, there are parts of her (like her hand on her hip) that are being "overselected." Those areas will wind up being transparent, and you don't want that, so we always have to back it way down. But, I just wanted you to see the incredible math at work.

Step Seven:

Okay, let's drag that Radius slider back down until her hand on her hip looks more solid white. Here's how this works: We want our subject to be solid white and we want the background to be solid black. Anything that appears in gray will be semitransparent. That's okay if this happens in her hair in wispy areas, but it's not good on her arms or clothes or anything that's supposed to have a well-defined hard edge. Otherwise, we'd leave the Radius up at 250 and be done with it. But, there's more to most portraits than just hair, so we have to keep those other areas pretty much intact, too. Here, I rolled back the Radius to almost 60, but you might be able to bring it up a bit more, maybe to somewhere in the mid-60s. By the way, for simple selections, leave the Radius amount down low. When you have a tricky selection, like fine hair blowing in the wind, you'll have to increase it. So, just remember: trickier selections mean higher Radius amounts.

Step Eight:

Now, let's change the View to Overlay to see if there are any areas we missed. The parts that are selected appear in full-color, and the parts that aren't appear in red. If you see the background color showing through (in our case, gray), you've got a problem (and we do here, on the left side). You need to tell Photoshop exactly where the problem areas are, so it can better define those areas. You do that with the Refine Radius tool (E; shown circled here). It's active by default, so just take your cursor and simply paint over the areas where you see the background peeking through (as shown here), and it redefines those areas. This is what picks up that fine hair detail.

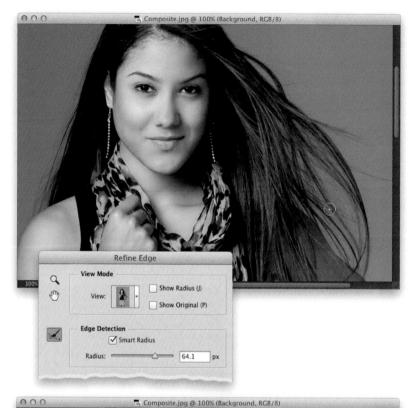

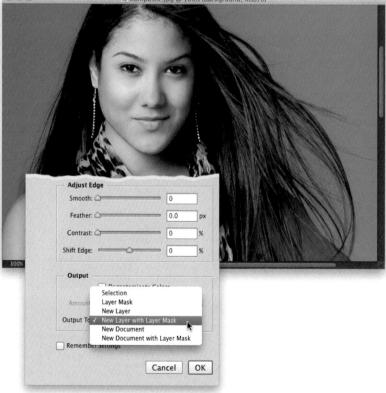

Step Nine:

As you look around her hair, if you see parts of it that are tinted red, those parts aren't selected. So, just paint a stroke or two over those areas (like I'm doing here). and they become full-color (letting you know they're added to your selection) as Photoshop refines those edge areas where you're painting. It'll look like it's painting in white sometimes, but when you're done, it just redefines the area and tells Photoshop that this area needs some work, and it "redoes" its thing. Here, I've gone over some areas that were tinted red on the left side of her hair, and on the right side, too, and you can see those areas are now appearing in color. I also increased the Radius amount a bit.

Step 10:

I recommend avoiding the Adjust Edge section sliders in the center of the dialog altogether, because you'll spend too much time fussing with them, trying to make them work. (I figure you want me to tell you when to avoid stuff, too.) Down at the bottom of the dialog, there's a Decontaminate Colors checkbox, which basically desaturates the edge pixels a bit. So, when you place this image on a different background, the edge color doesn't give you away. Just below that, you get to choose what the result of all this will be: will your selected subject be sent over to a new blank document, or just a new layer in this document, or a new layer with a layer mask already attached, etc.? I always choose to make a new layer with a layer mask in the same document. That way, I can just grab the Brush tool and fix any areas that might have dropped out, which we're probably going to have to do next, so choose New Layer with Layer Mask and click OK.

Step 11:

When you click OK, your image will now appear on a transparent layer (as seen here) and if you look in the Layers panel, you'll see a new layer with a layer mask attached (just what you asked for). You can also see it does a pretty amazing job. It won't get every little thin, wispy hair strand, but it gets most of the important ones. Also, I've got a trick or two coming up that will help a bit more, but first, let's do a quick check of that mask and finetune it just a bit before we put her over a different background (that's right, baby, we're doing some compositing!). Pressand-hold the Option (PC: Alt) key and click directly on that layer mask thumbnail in the Layers panel to see just the mask (you can see it in the next step).

Step 12:

Now, zoom in tight on her arm on the right, and you can see some areas that aren't solid white (which means these areas will be semi-transparent and that's not what you want for her arm). So, get the Brush tool (B) and, with your Foreground color set to white, choose a small, hard-edged brush from the Brush Picker in the Options Bar, and then paint right over those grayish areas, to make them solid white. You can see some areas on the side of her head here where her earring and scarf aren't selected that need a cleanup, as well. Next, press \boldsymbol{X} to switch your Foreground color to black to clean up any areas where the white has spilled over onto the black. That should be solid black in the background areas. For a little help cleaning up tricky areas, switch your Brush's blend Mode to Overlay. That way, when you're painting with white, it automatically avoids painting over the color black (and vice versa).

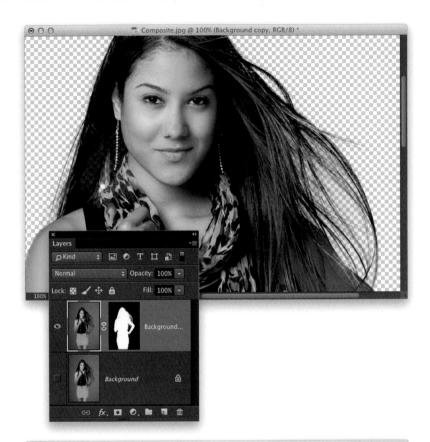

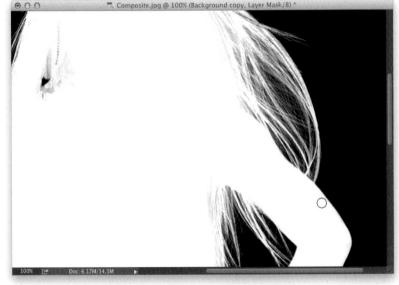

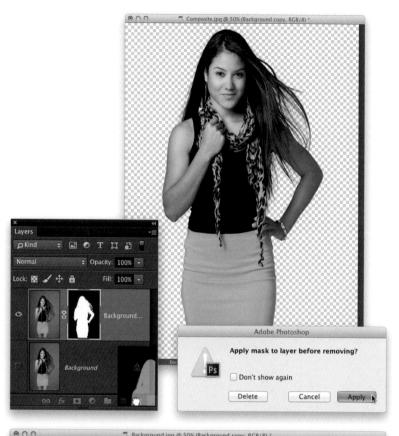

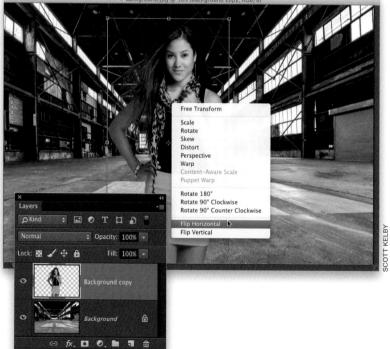

Step 13:

At this point, we're done with our mask, so you can apply it permanently to your image by clicking directly on the layer mask thumbnail (in the Layers panel) and dragging it onto the Trash icon at the bottom of the panel (as shown here) to delete it. When you do this, a warning dialog pops up asking if you want to "Apply mask to layer before removing?" You want to click Apply, and the masking you did is now applied to the layer (and the layer mask thumbnail is deleted). This just makes things a little easier from here on out.

Step 14:

Next, open the background image you want to use in your composite. Get the Move tool (V), then drag-and-drop your subject right onto this background image (as shown here). (Note: This is easier if you have the Application Frame turned off and can see at least part of both images on your screen. If you have it turned on, so you can't see both images at once. just click-and-drag the subject image up to the tab of the background image and hover there for a moment or two until it lets you drop the image on the background. If all else fails, copy-and-paste it onto this background; it will appear on its own layer.) Press Command-T (PC: Ctrl-T) to bring up Free Transform and resize her to fit better on the background (just press Command-0 [zero, PC: Ctrl-0] to get the control handles). While you're still in Free Transform, Right-click inside the bounding box, and choose Flip Horizontal (she looks better this way on this background). You can now press Return (PC: Enter) to lock in your transformation. Now, you see our next challenge here? Her color tone makes it look like she wasn't photographed in these surroundings (plus, she has a tiny white fringe around her outside edge, which is a dead giveaway that this is a composite).

Step 15:

First, let's get rid of that thin white fringe around her, then we'll deal with our color issue. To remove the fringe, go under the Layer menu, under Matting (it's at the very bottom of the menu), and choose **Defringe**. When the Defringe dialog appears (shown here), enter 1 (use 2 pixels for a higher-megapixel image), click OK, and that fringe is gone! (Photoshop basically replaces the outside edge pixels with a new set of pixels that is a combination of the background it's sitting on and your subject's edge, so the fringe goes away.)

Step 16:

Here's a trick I stumbled upon years ago when making composites (back when we used channels for stuff like this). This trick gives you more detail and brings back some of those lost wisps of hair by building up some pixels. It's going to sound really simple and it is. Just press Command-J (PC: Ctrl-J) to duplicate your layer (the one with your subject). That's it. Just duplicate your subject layer, and it has a "building up" effect around the edges of her. Suddenly, it looks more defined, and it fills in some of the weaker wispy areas. If for any reason it looks like too much, at the top of the Layers panel, just lower the Opacity of this duplicate layer until it looks right (here, I lowered it to 50% and it looks about right). Next, merge this duplicate layer with your original subject layer by pressing Command-E (PC: Ctrl-E). Okay, now to tackle the fact that the color of our subject doesn't match the surroundings she was supposedly shot in.

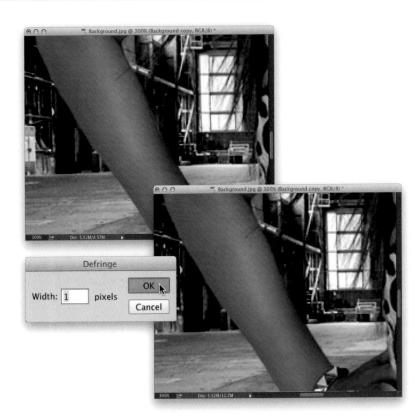

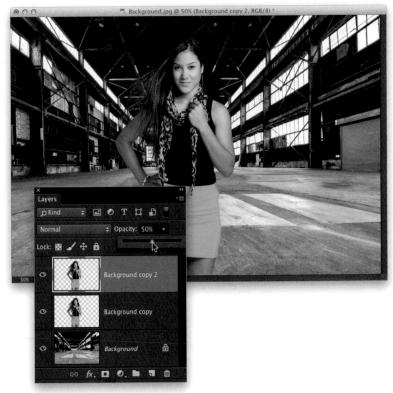

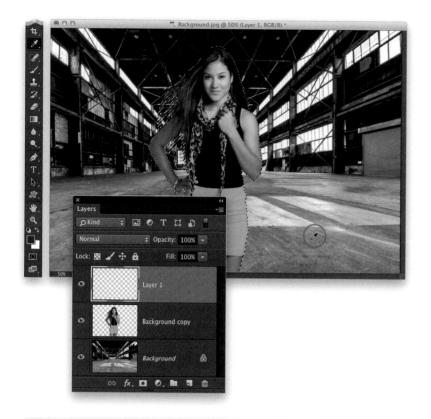

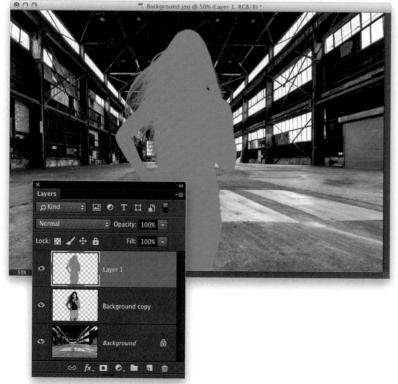

Step 17:

We need a selection around our subject layer again, so Command-click (PC: Ctrlclick) on your subject layer's thumbnail to load it as a selection. Once the selection is in place (as seen here), add a new blank layer by clicking on the Create a New Layer icon at the bottom of the Layers panel. Now, look at your image and ask yourself, "Which color really stands out to me in this background?" Here, I see brown, gray, and white, but the color that's really jumping out to me is the brownish gray in the floor. So, get the Eyedropper tool (I) from the Toolbox and click it once on an area of brownish gray in the photo to make that exact brownish gray your Foreground color (as shown here, where I'm clicking on the floor in the foreground).

Step 18:

Now, fill the selection (on your empty layer) with this brownish gray color by pressing **Option-Delete (PC: Alt-Backspace)**. Then, deselect by pressing **Command-D (PC: Ctrl-D)**.

Step 19:

To make this brownish gray area blend in: (1) change the layer's blend mode from Normal to Color (as shown here), so just the color shows through, instead of being solid. Then, (2) lower the Opacity to the point where you see the color image start to emerge, but it has enough of the brownish gray tint to it that it really looks like she was photographed there on location at least colorwise, anyway. For this image, I lowered the Opacity of the brownish gray layer to 30%, which ties the color of the two together (as seen in the final image below, where her overall color is more muted, like the background colors, but with a hint of that brownish gray). Now, press Command-E (PC: Ctrl-E) once more to merge this brownish gray layer with the subject's layer below it.

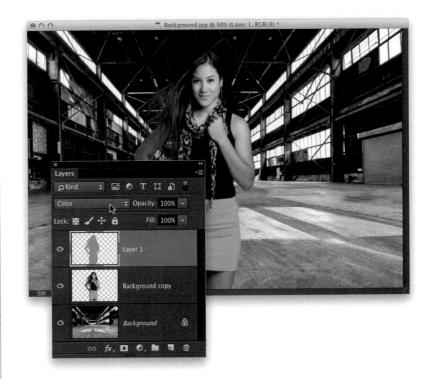

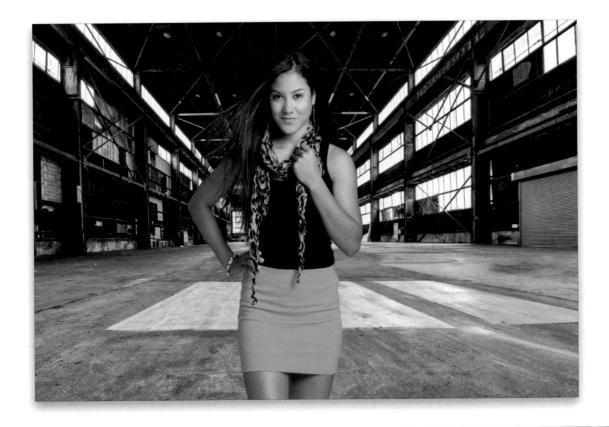

How's that one for a title? Well, that's the best explanation of what happens sometimes when you shoot really wide, and in Photoshop, there's a tool called Adaptive Wide Angle that was invented for these situations. However, there are three things you need to know about this filter: (1) you're not going to use it very often, (2) you're either going to have to crop pretty massively after using it or use Content-Aware Fill to fill in the gaps, and (3) it actually does a pretty darn good job when you do need it.

Fixing Really Messed Up Wide-Angle Shots

Step One:

Open the photo that has a serious lens issue you want to fix. I personally don't use smart filters a bunch, because once I apply a filter, I'm usually pretty much done with it. But, in this case, it's not a bad idea to first go under the Filter menu and choose Convert for Smart Filters, and then choose Adaptive Wide Angle from that same menu. The reason why this might come in handy is that, depending on the image, you may need to come back and tweak your existing filter settings (well, it's been the case for me anyway), and by making it a smart filter, you can apply the filter, and then reopen it with all the Constraint lines still in place, so you can tweak them (this will all make more sense in just a minute).

Step Two:

When the Adaptive Wide Angle dialog opens (shown here), it reads the lens data embedded into the photo by your camera (see the bottom-left corner of the dialog), and it tries to apply an Auto correction. Sometimes it does a pretty good job, but more often than not, it doesn't. Like in this case, you can see the stadium is still really bent, so we'll have to manually tell Photoshop where the image is bent, and it'll do the rest.

We start by using the Constraint tool (it's the default tool and the first one in the toolbar in the top left). Basically, you click at the base of the object you want straightened (like the press box on the right side here, which is bowing outward), and then as you move your cursor to the right, along the top of the press box, the agua line you're dragging literally bends (it does this automatically, because it knows the lens you used and what kind of problems you're dealing with). You get a zoomed-in closeup of where your cursor is currently located in the Detail preview on the right side of the dialog (as seen here), which is really handy for situations like this where you want the end of your line to be right along an edge. Note: If you mess up, you can delete a Constraint line by just pressingand-holding the Option (PC: Alt) key, clicking once on it, and it's gone.

Step Four:

Once you click your mouse near the end of the press box (like I did here), it straightens that press box. It also gives you a preview of the cropping work that you'll need to do pretty shortly (either that, or Content-Aware Fill, but you can see how it's having to warp the image around to pull this straightening trick off). Also, if part of the top of the press box still looks bent after adding the Constraint line, you can grab the end of the line near where the problem is and literally just drag it out longer. That will usually get rid of the problem, even if you have to drag it off the image area. If you do, you can move your image over in the preview window, so you can reach that end handle if you need to tweak it again, by switching to the Adaptive Wide Angle's own Move tool (it's the third tool down in the toolbar).

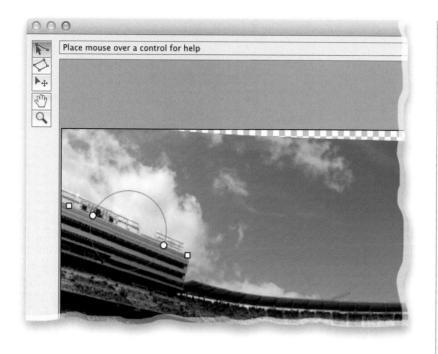

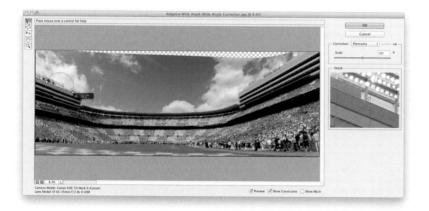

Step Five:

Let's go to the press box on the left side and do the same thing—click-and-drag the Constraint tool out over the roof, and when you release the mouse button, it straightens it. So, that's the basic plan: you take the Constraint tool and drag it over parts of your image that need to be straightened and it does its thing.

TIP: If Your Constraint Lines Don't Bend

If Photoshop recognizes your lens and has a profile for it, then the lines will bend automatically. But, if it doesn't, a warning dialog will appear telling you that no matching lens profile was found, and it's then up to you to make the bend manually. Just click the Constraint tool on one end of what you want to fix, then click it again on the other end to complete your straight line. Then, click on the center point within the circle and bend the line, so it fits.

Step Six:

Also, while we're here, when you lay down one of these Constraint lines, you'll see a round circle with two round handles appear with it. That lets you fine-tune the angle of that line after you've laid it down. So, if it's off a little (or a lot), you can grab one of those round handles and literally rotate the circle in a clockwise (or counterclockwise) motion to change the angle of the fix. As you do this, a little pop-up appears giving you a readout with the amount of rotation (in degrees, as seen here). Once you let go, it readjusts the fix based on how much you rotated.

Step Seven:

Go ahead and click OK to finish up our Adaptive Wide Angle fix. Now, remember, if you click OK and something doesn't look quite right, and you converted this image for smart filters before you opened the filter itself (see Step One), then you can go to the Layers panel and double-click directly on the words "Adaptive Wide Angle" (as shown here). This will reopen the Adaptive Wide Angle dialog with all your Constraint lines still in place, so you can tweak them, rather than starting over from scratch.

TIP: Straightening Rectangles

If you need to quickly fix something like a doorway or window (a rectangle), then use the Polygon Constraint tool (the second tool down in the toolbar), which works like the Polygonal Lasso tool—just trace around your rectangle and it straightens it.

TIP: Making a Curved Line Straight
Once you have a Constraint line in place,
if you decide you should have Shift-clicked
(to make the line straight) and didn't or
vice versa, just Right-click on the line and
a pop-up menu will appear where you can
choose the type of line you want to convert it to.

Step Eight:

So, after you click OK, you'll see you still have a little work to do. First, the image is a little crooked, so go under the Filter menu and choose **Camera Raw Filter**. Click on the Lens Corrections icon (the fourth icon from the right) at the top of the Panel area, and then, in the Manual tab, drag the Rotate slider to the left to straighten it out, and click OK.

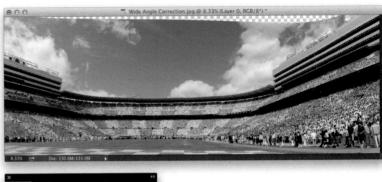

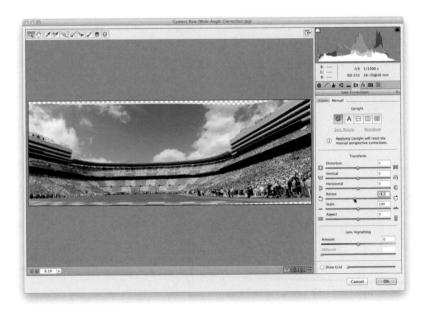

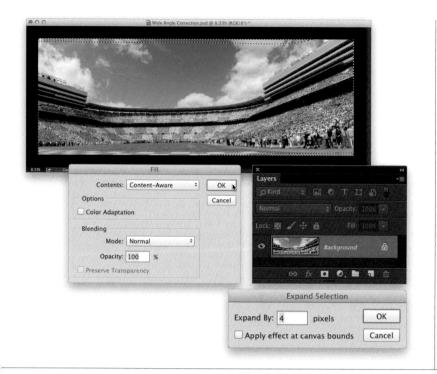

Step Nine:

Now, go to the Layers panel's flyout menu and choose Flatten Layers (you have to flatten that Smart Filter layer now to do this last step). Get the Magic Wand tool (press Shift-W until you have it) from the Toolbox, and click in all those white gaps at the top, bottom, and sides to select them (pressand-hold the Shift key to add to the selection). Go under the Select menu, under Modify, and choose **Expand**. Enter 4 pixels and click OK to expand your selected area by 4 pixels. Now, go under the Edit menu, choose Fill, and from the Use pop-up menu, choose Content-Aware Fill. Click OK to fill in those areas, and then press Command-D (PC: Ctrl-D) to Deselect. Below is a before/after.

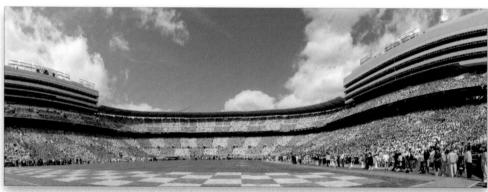

Before

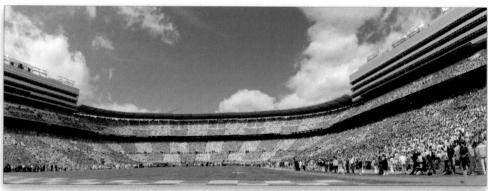

After

Saving Blurry Pictures Using the Shake Reduction Filter

If you have a shot you took handheld in low light (so the blurriness was caused by shooting with a slow shutter speed), or if your blurry shot came from a long lens, you may be in luck using a filter called Shake Reduction. It can greatly reduce the blur caused by shots where your camera moved a bit (it's not for shots where your subject is moving). This filter works best on images that don't have a lot of noise, have a pretty decent overall exposure, and where you didn't use flash. It doesn't work on every image, but when it does, it's pretty jaw-dropping.

Step One:

Here's a shot I took handheld in low light; it's a blurry mess, and this is exactly when you'd reach for the Shake Reduction filter (it's found under the Filter menu, under Sharpen). When the filter opens, it immediately starts analyzing the image, starting in the middle (where most blurring occurs) and searching outward from there. You'll see a little progress bar appear (as it's thinking) near the bottom of the small preview on the right side of the dialog (that preview is called the Detail Loupe; more on this in a moment). If you want to cancel the analyzing process, just click the little circular "No!" symbol at the end of the progress bar. Note: I've turned off the Preview checkbox here, so you could see the blur.

Step Two:

Once it's done doing the math, it shows you its automated blur correction (seen here), where I have to say, on this image, it did a pretty good job. It's not perfectly sharp and there is some ghosting, but the original was completely unusable. At least now, if I wanted to put it on Facebook or Twitter at web resolution, it would be totally passable, which I think is saying a lot. For most users, this is all you'll need to do: open the filter, let it do its thing, and you're done. However, if you're a "tweaker," then read on.

The filter automatically calculates what it thinks is the amount of camera shake based on how many pixels it thinks have moved, but if the auto method doesn't look good, it may be that it either needs to affect more or fewer pixels. That's what the Blur Trace Bounds slider is for. This slider controls how many pixels the filter affects (kind of like how the Tolerance slider for the Magic Wand tool determines how far out the tool selects). Dragging the slider to the left affects fewer pixels (so, if there's just a little blurring, it may need to affect fewer pixels) and dragging to the right affects more pixels. Its own estimation is pretty darn good but, again, you can override it (in this case, I only moved it a little). If you get ghosting (as we did here) or other artifacts, drag the Artifact Suppression slider to the right a bit (here, I dragged it to 45%).

Step Four:

On the right side of the filter dialog is that small preview called the Detail Loupe, which shows you a zoomed-in view of your image (you can change its level of magnification by clicking the zoom amount buttons right below it). If you press the letter **Q** on your keyboard, the Detail Loupe now floats, so you can reposition it anywhere you'd like (press Q again to re-dock it). If you click-and-hold inside the Detail Loupe, it gives you a quick "before" view of your image (before you removed the camera shake). When you release the button, it brings you back to the edited "after" image.

Step Five:

Luckily, there's more to the Detail Loupe than just that. Its power comes when you position it over an area you want analyzed. Let's open a different image and put this Detail Loupe to work (this is, as you can see, another blurry mess—a shot you'd delete for sure). This is the "before" image (I turned off the Preview checkbox, so you can see what it looks like before the filter is applied). Now, let's use the Detail Loupe to help us correct the blurriness.

Step Six:

Double-click on the spot within your image where you want that Detail Loupe to appear (it'll leave its home on the right side and jump to that spot in your image). Now, click the circular button in the bottom-left corner of the Loupe (as seen here) and it analyzes the area right under the Loupe. (Note: If you already had the Loupe floating, you don't need to double-click, a single click will do.) Look at how much better the image looks with the camera shake reduced. So, in this case, we doubleclicked on the area right in front, but what if there's more than one place where you want the emphasis on camera shake reduction placed? Well, luckily, you can have multiple Regions of Interest (that's what Adobe calls the areas being analyzed).

TIP: Manually Choosing Blur Direction

If you think the filter got the direction of the blur wrong, you can choose it manually using the Blur Direction tool (the second tool down in the Toolbox in the top left—it becomes active after you expand the Advanced section on the right). Just click-and-drag it in the direction of the blur, for the approximate length of the blur. Use the **Bracket keys** to nudge the length; add the **Command (PC: Ctrl) key** to nudge the Angle.

Step Seven:

To see how much area is inside the Blur Estimation Region, expand the Advanced section (on the right side of the dialog) by clicking on its right-facing triangle, and you'll now see a bounding box around the area that's being analyzed (press Q to re-dock the Detail Loupe). You can click directly in the center of that box to drag it to a new location to have it analyze that area instead. You can also click-and-drag the corners in/out to resize it.

TIP: Reducing Junk Sharpening Creates

Sharpening generally brings out noise (which is why Adobe says this filter works best on images that were not shot at a high ISO), but there are two sliders that can help: (1) the Smoothing slider tries to reduce grain in the image, and (2) the Artifact Suppression slider helps to get rid of spots and other junk that appear when you apply extreme sharpening like this. These are both applied before the standard noise reduction (see tip below).

Step Eight:

If you need to analyze more than one area, you can use the Blur Estimation tool (it's the first tool in the Toolbox) to drag out another Blur Estimation Region (as seen here). Now it will focus on those two areas when analyzing the image to reduce blur.

TIP: Auto Noise Reduction

By default, the Shake Reduction filter applies an Auto noise reduction to the source image, but if you don't think it did a great job, you can use the Source Noise pop-up menu to try one of the three different noise reduction amounts (Low, Medium, and High).

Stretching Stuff to Fit Using Content-Aware Scale

The first of the Content-Aware features we'll cover comes in handy when you need to resize just part of your image without totally trashing the main subject of it. This is great when you have to make your image fit into a document size that doesn't match the aspect ratio of a digital camera image (for example, like when you add a still image to a video slide show). That's when Content-Aware Scale rocks, because it's "aware" of the important part of the image, and so it only stretches the non-important parts (and if it's not quite sure, you can help it out). It's like an "intelligent" resizer.

Step One:

Here are the two documents we're going to work with. The first is our digital camera photo, and the second is a blank document that's more like the widescreen aspect ratio of video (in the New dialog, I chose Film & Video from the Preset popup menu and NTSC DV Widescreen from the Size popup menu).

Step Two:

Get the Move tool (V) and click-and-drag your photo into the widescreen document. To shrink your image down so it fits fully inside the document, press Command-T (PC: Ctrl-T) to bring up Free Transform (if you can't reach the Free Transform handles, press Command-0 [zero; PC: Ctrl-0], and the image window will expand enough so you can reach all the handles). Press-andhold the Shift key, click on a corner handle, and drag to resize your image. When you get it so it fits fully inside the document (as seen here), press the Return (PC: Enter) key to lock in your resizing. You can see the problem, here: to get it to fit, without cropping, leaves white gaps to the left and right of your image.

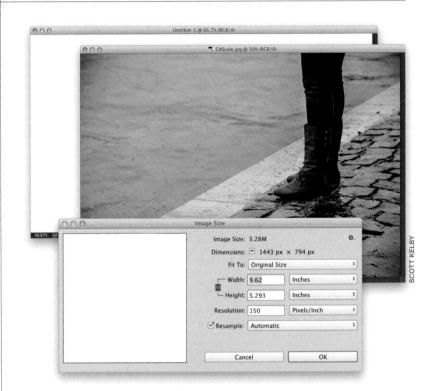

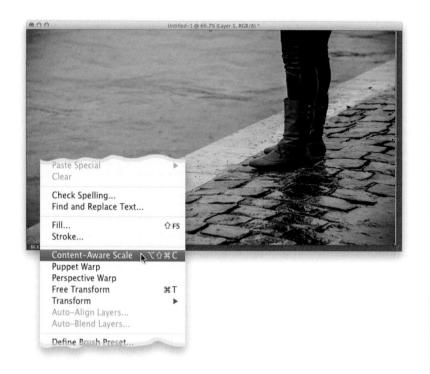

Now, you could just bring up Free Transform again, drag the left side handle over so it covers the gap on the left side, and then do the same thing to stretch the image over to the right side (as shown here), but that stretches our subject out and her legs are now thicker and distorted (take a look back at the image in Step Two and you'll see how much wider she looks here). This will not win you any fans (or repeat business), so don't hit the Return key to lock in your transformation. Instead, hit the **Esc key** to cancel your transformation. Then, go under the Edit menu and choose **Content-Aware Scale**.

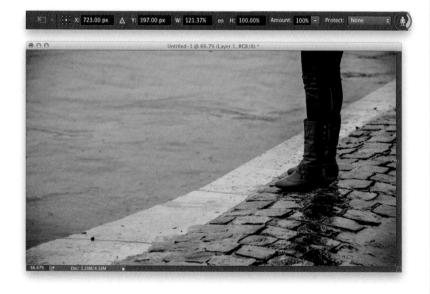

Step Four:

Choosing this brings up what looks just like the Free Transform handles (but these have "special powers"). Now, do the same thing you just did in Step Three—drag the left side handle over to cover the gap on the left, and then do the same thing on the right side (as shown here). It knows where your subject is (and that it's the most important part), so it only stretches the background (parts that can be scaled), and not her (which should not be scaled). It also expands the area it stretches in a very smart way, so the image doesn't look like it has been stretched. If you're using this on a different image, and it doesn't recognize that there's a person in your photo, click the Protect Skin Tones button up in the Options Bar (shown circled here), and that will alert Photoshop that there's a person in the image that it should avoid stretching. Of course, it can still get confused and miss that there's a person (or object) that you don't want stretched, which is why you'll want to know this next trick.

Step Five:

Before we go on to that, you'll want to know that you can also use this to shrink the width of the photo without distorting your subject (it'll slide her legs over, but it won't distort them, which is pretty amazing—maybe more amazing than the stretching). You do it the same way: just go into Content-Aware Scale and click-and-drag the side handles inward, and the scene just kind of collapses in around her legs, but they stay intact (as seen here). Notice how the edge of the walkway is a little distorted, but doesn't look bad and is easily fixed? Pretty amazing, eh? Okay, now on to how to protect your subject when Photoshop doesn't recognize which part of the photo is the important part.

Let's open up a different image (shown here) and drag it over into our main document (you can click-and-drag the layer for the previous image onto the Trash icon at the bottom of the Layers panel to get rid of it). Press Command-T (PC: Ctrl-T) to go into Free Transform again and resize the image to fit in the document. Then, let's go ahead and use Content-Aware Scale again to shrink it down, so you can see what happens when Photoshop, for whatever reason, doesn't recognize our subject (the dress forms and dresses). Grab the side handles and drag way in toward our subjects, and you can see it totally squishes them (as seen here at the bottom). Luckily, we can fix this easier than you'd think.

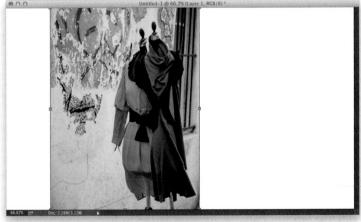

Destination			ОК
Document:	Untitled-1	•	
Channel:	New		Cancel
Name:			
Operation			
New Cha	nnel		
O Add to C	hannel		
Subtract	from Channel		
OIntersect	with Channel		

Step Seven:

The trick is simple: make a selection of the subject you want to protect (in our case, the dress forms and dresses), save that selection, then tell Photoshop you've saved it, and it then avoids that selected area like the plague. So, start by getting whichever selection tool you're most comfortable with from the Toolbox, and put a selection around your subject (here I used the Quick Selection tool, which if anything, is quick. It's not the most accurate, but that's okay for what we need to do here). Once your selection is in place, go under the Select menu and choose Save Selection. When the Save Selection dialog appears, just click OK, and now you can deselect by pressing Command-D (PC: Ctrl-D).

Step Eight:

Next, go under the Edit menu and choose Content-Aware Scale. All you have to do now is tell Photoshop that you have a saved selection (called an Alpha channel). To the left of the Protect Skin Tones button up in the Options Bar, you'll see a Protect pop-up menu. From that menu, choose **Alpha 1** (your saved selection), and now Content-Aware Scale knows exactly what not to stretch. So, grab the side handles, drag way in, and you'll notice that it keeps our subjects intact and squishes the background in around them instead.

Removing Stuff Using Content-Aware Fill

When people talk about "Photoshop magic," Content-Aware Fill is one of those things they're talking about. Even after using this feature for a couple of years now to get rid of distracting things in my images, it still amazes me more often than not with the incredible job it does. The fact that it's incredibly easy to use at the same time really makes it a powerful, and indispensable, tool for photographers.

Step One:

Here, we have a couple standing on the edge of some rocks with their shoes behind them, and it distracts from our subject (the lighthouse), so ideally we'd like the couple and their shoes out of the shot.

Expand Selection Sox. E2: 0 Doc. 5.98M/5.99M Expand By: 4 pixels

Cancel

CAFill.jpg @ 50% (RGB/8)

000

Step Two:

First, to have Content-Aware Fill remove the couple, just get the Lasso tool **(L)**, or whichever selection tool you're most comfortable with (like the Quick Selection tool, Pen tool—whatever), and draw a selection around them. Once your selection is in place, you can help Content-Aware Fill do its thing by expanding that selection outward by 4 or so pixels. So, go under the Select menu, under Modify, and choose **Expand**. When the Expand Selection dialog appears (shown here), enter 4 pixels, click OK, and your selection grows outward by that much.

Next, go under the Edit menu and choose Fill. When the Fill dialog appears, choose Content-Aware from the Use pop-up menu (as seen here). Now, just click OK, sit back, and prepare to be amazed (I know—it's freaky). Not only is the couple gone, but it also patched the ocean and waves pretty darn perfectly behind them (that's why it's called "Content-Aware" Fill. It's aware of what is around the object you're removing, and it does an intelligent filling in of what would normally just be a big white hole in your image). Go ahead and deselect by pressing Command-D (PC: Ctrl-D). Now, do the same with their shoes. The more I use it, the more it amazes me, but part of using this effectively is learning its weaknesses, and how to get around them when possible.

Step Four:

One area it didn't fill perfectly is a section of the waves where it left a line, so we'll have to fix that manually using the Clone Stamp tool. Get the Clone Stamp tool (S) from the Toolbox, Option-click (PC: Alt-click) to the left of the line and paint over the line to the right (as seen here at the top). Now, you will fall deeply in love with Content-Aware Fill if you can come to peace with the fact that it won't work perfectly every time. But, if it does 70% or 80% of the work for me (in removing something I don't want), that means I only have to do the other 20% (or maybe 3%, like in this case), and that makes it worth its weight in gold. If it does the entire job for me, and sometimes it surely does, then it's even better, right? Right. Also, it helps to know that the more random the background is behind the object you want to remove, the better job Content-Aware Fill generally does for you.

Step Five:

Content-Aware Fill is pretty amazing when it works, but like any other tool in Photoshop, it doesn't work 100% of the time on every single type of photo and every situation. When I use Content-Aware Fill, I usually wind up using the Spot Healing Brush along with it, because it has Content-Aware healing built in. The Patch tool (the Healing Brush's cousin that works better for removing large objects) also has Content-Aware capabilities now. Let's open another image (the shot here) and use all of these tools together to remove the person in the background, along with all the security rope, the sign opposite the person, and the sign on the right of the image.

Step Six:

A lot of times you don't have to do as accurate a selection as we just did when removing the couple in the previous project. For the person in the background, just zoom in and take the regular ol' Lasso tool (L), draw a loose selection around the person (as shown here), then go under the Edit menu and choose Fill. When the Fill dialog comes up, make sure Content-Aware is selected in the Use pop-up menu, then click OK, and press Command-D (PC: Ctrl-D) to Deselect (you'll see in the next step that the person is gone, and it did a great job of filling in the columns and glass door).

Adaptation: Sample All Layers CAFIII2 jpg @ 66.7% (RCB/S) ** CAFIII2 jpg @ 66.7% (RCB/S) **

Step Seven:

Take a look at where the person used to be. He's outtathere! And, I also removed the sign that was opposite him. Let's switch to the Spot Healing Brush tool (J) for the security rope on the left. You literally just make your brush size a little bigger than the rope, paint over it, and Photoshop uses the Content-Aware technology to remove it (when I release the mouse button, a second later that will be gone, too!). Note: The regular Healing Brush tool (the one where you have to choose the area to sample from by Optionclicking [PC: Alt-clicking]) does not have the Content-Aware technology. Only the Spot Healing Brush tool and the Patch tool have it (but you have to turn it on for the Patch tool—it's on by default with the Spot Healing Brush).

Step Eight:

Now, let's use the Patch tool (press Shift-J until you have it). You use it initially just like the Lasso tool: click-and-drag a loose selection around the object you want to remove (the sign on the right, here), then click your cursor inside that selected area and drag it to a nearby clean area (you'll see a preview inside the selected area of what your patch will look like). Then, when you release the mouse button, it snaps back and the sign is removed. I use the Patch tool for removing larger objects like this. If you want it to use the Content-Aware technology, in the Options Bar, choose Content-Aware from the Patch pop-up menu (as shown here). By the way, using the Content-Aware option won't always be better than the regular Patch tool healing—it just depends on the image. So, if you don't like the results of one, try the other. We're not done here yet, though.

Step Nine:

Here's the result of dragging the selection straight up and lining up the edge of the corner. When it snapped back, it did a great job (I liked the Normal setting better than Content-Aware, here). If it doesn't work, just press **Command-Z (PC: Ctrl-Z)** to Undo your patch, then Command-D (PC: Ctrl-D) to Deselect, and you can try Content-Aware Fill or the Spot Healing Brush instead.

Step 10:

Let's take care of one last thing. Switch back to the Spot Healing Brush (press **Shift-J** until you have it), then paint over the white patches on that column to the left (as shown here).

TIP: Fixing Bad Repairs

We were lucky in this photo, but in a lot of cases, the objects you want to remove are in close proximity to other objects you want to keep. Then, when you try to patch something, it doesn't patch your hole with background, it patches your hole with something in the foreground (imagine if, when we used Content-Aware Fill, it filled the person with the floor? It happens more often than you'd think). To get around that, put a selection around what you want to tell Photoshop is "off limits" for using as a patch, then save that as a selection (under the Select menu, choose Save Selection, then click OK). Now, it will avoid that area when choosing areas to pull fill from.

Step 11:

You can see here, the Spot Healing Brush and the Patch tool did a great job on the wall. In fact, the Spot Healing Brush worked so well that as soon as those white patches were gone, I took it and painted right over a couple light patches on the columns, and in two seconds they were gone—it filled them in almost perfectly, as if they were never there. Before and After images are shown below. (Note: When I was done, I noticed that the columns were bowing a bit, so I opened the image in Camera Raw and, in the Lens Corrections panel's Manual tab, I dragged the Distortion slider a little to the right to straighten them out.)

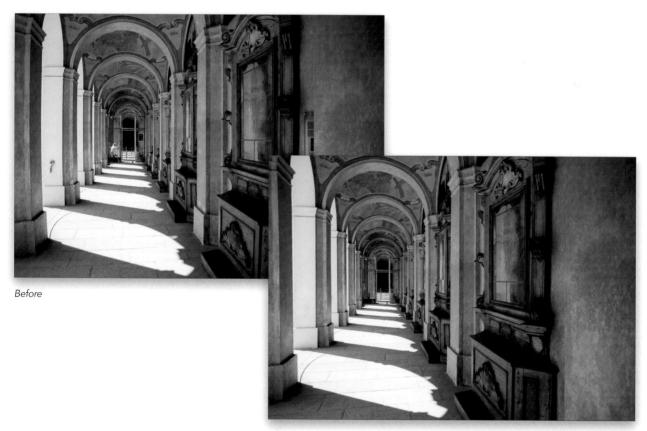

After

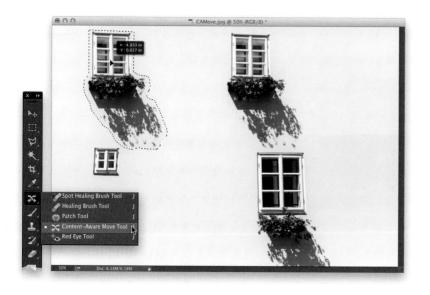

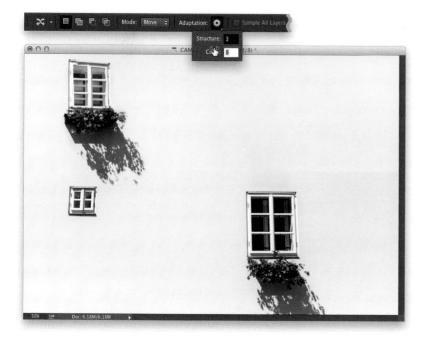

Next, go to the Toolbox, and get the Content-Aware Move tool (as shown here—it's nested in the same menu as the Healing Brush tool and Patch tool; or just press **Shift-J** until you have it). Now, click on your selected subjects and drag them over to the left side of the image (as shown here). The original of them will still be in the same position for a few seconds while Photoshop is freaking out (kidding. While Photoshop is doing its math).

Step Four:

When you release your mouse button, it's going to take a few moments for the magic to happen (depending on how large your file size is), but then you'll see that not only are your subjects moved, but the hole that would normally have been left behind is instead totally patched and filled (as shown here). However, don't deselect quite yet. Leave your selection in placeespecially if it didn't work well-because while it's still selected, you can change how Photoshop creates the background texture and color that blends with your move. You do this from the Adaptation pop-up menu up in the Options Bar. What's nice is, since your selection is still in place, you can choose a different option from that menu and it will re-render your move. So, all you have to do is try each one at different settings and choose the one that looks the best (again, I do this only if there's a problem). Also, the higher the number you choose, the more Photoshop uses of the actual real background to create the texture or color blending. This looks more realistic in some cases, but it can make the move look weird in others, so it's best to try both high and low numbers if it just doesn't look right. (Note: If needed, you can also switch to the Spot Healing Brush and clean up any stray areas it left behind.)

Photoshop Killer Tips

Using Shadows/Highlights Like an Adjustment Layer

Well, it's not technically an adjustment layer, but it acts and performs exactly like one. When you choose **Convert for Smart Filters** before choosing **Shadows/Highlights**, you get many of the same benefits as an adjustment layer, like being able to go back and adjust the settings later and having a layer mask. Also, if you double-click on the little adjustment sliders

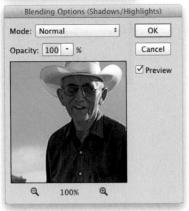

icon to the right of the name, it brings up a dialog where you can change the blend mode and opacity; you can click the Eye icon to turn the adjustment on/off; and finally, you can delete it anytime during your project.

Changing the Position of Your Lens Flare

When you use the Lens Flare filter (found under the Filter menu, under Render) it puts the flare in the center of your image, but you can actually choose the position for your flare center (which changes the look of your flare quite a bit) by just clicking-and-dragging the flare center within the filter's Preview window. By the way, a great way to apply this filter is to add a new layer, fill it with black, then run the filter, change its layer blend mode to Screen, and it will blend in with your image, so you can drag it wherever you'd like (if an edge shows, add a layer mask and paint over the edges in black with a huge, soft-edged brush).

Not Sure Which Blend Mode Is the Right One?

Then just press **Shift-+** to toggle through all the layer blend modes one-by-one, so you can quickly find out which one looks best to you.

How to Change the Order of the Brushes in the Brush Picker

Go under the Edit menu, under Presets, and choose **Preset Manager**. When the dialog opens, by default it's set to display all your brushes, so now all you have to do is click-and-drag them into the order you want them. When you've got everything in the order you want, click the Done button.

Photoshop Killer Tips

Changing the Color of Your Guides

Want to change the color of those guides you drag out from the rulers? Just pull out a guide, then double-click directly on it, and it brings up the Preferences dialog for Guides, Grid & Slices, where you can choose any color you'd like. You can also press Command-K (PC: Ctrl-K) and click on Guides, Grid & Slices on the left.

What That Fill Field Does

In the Layers panel, right below the Opacity field is a Fill field, which has had Photoshop users scratching their heads since it debuted several versions ago. It only kicks in when you have a layer style applied to a layer, like a drop shadow or bevel. If you have something on a layer and you apply a drop shadow to it, then lower the Opacity amount, the object and its shadow both fade away, right? But if you lower the Fill amount only, the object starts to fade away, but the drop shadow stays at 100% opacity.

The Hidden Shortcut for Flattening Your Layers

There technically isn't a keyboard shortcut for the Flatten command, but I use a standard shortcut for flattening my image all the time. It's **Command-Shift-E** (**PC: Ctrl-Shift-E**). That's actually the shortcut for Merge Visible, so it only works if you don't have any hidden layers, but I usually don't, so it usually works.

Customizing the HUD Pop-Up Color Picker

You can have a heads-up display color picker appear onscreen when you're using the Brush tool by pressing Command-Option-Control (PC: Alt-Shift) and clicking (PC: Right-clicking). And, did you know you also get to choose which type and size of HUD you want? Press Command-K (PC: Ctrl-K) to bring up Photoshop's preferences, click on General on the left, then up near the top of the General preferences is a HUD Color Picker pop-up menu for choosing your style and size.

Changing Brush Blend Modes on the Fly

If you want to change the blend mode for your current brush without traveling up to the Options Bar, just **Control-Shiftclick (PC: Shift-Right-click)** anywhere in your image, and a pop-up menu of Brush tool blend modes appears.

Creating Cast Shadows

To create a cast shadow (rather than a drop shadow), first apply a Drop Shadow layer style to your object (choose Drop Shadow from the Add a Layer Style icon's pop-up menu at the bottom of the Lavers panel, change your settings, and click OK). then go under the Laver menu, under Layer Style, and choose Create Layer. This puts the drop shadow on its own separate layer. Click on that new drop shadow layer, then press Command-T (PC: Ctrl-T) to bring up Free Transform. Now, press-andhold the Command (PC: Ctrl) key, grab the top center point, and drag down at a 45° angle to create a cast shadow (like your shadow is casting onto the floor).

Copying Layer Masks from One Layer to Another

If you've created a layer mask, and you want that same mask to appear on a different layer, press-and-hold the Option (PC: Alt) key and just drag-and-drop that mask onto the layer where you want it. It makes a copy, leaving the original intact. If you want to remove the mask from one layer and apply it to another, then don't hold the Option key and, instead, just click-and-drag the mask to the layer where you want it.

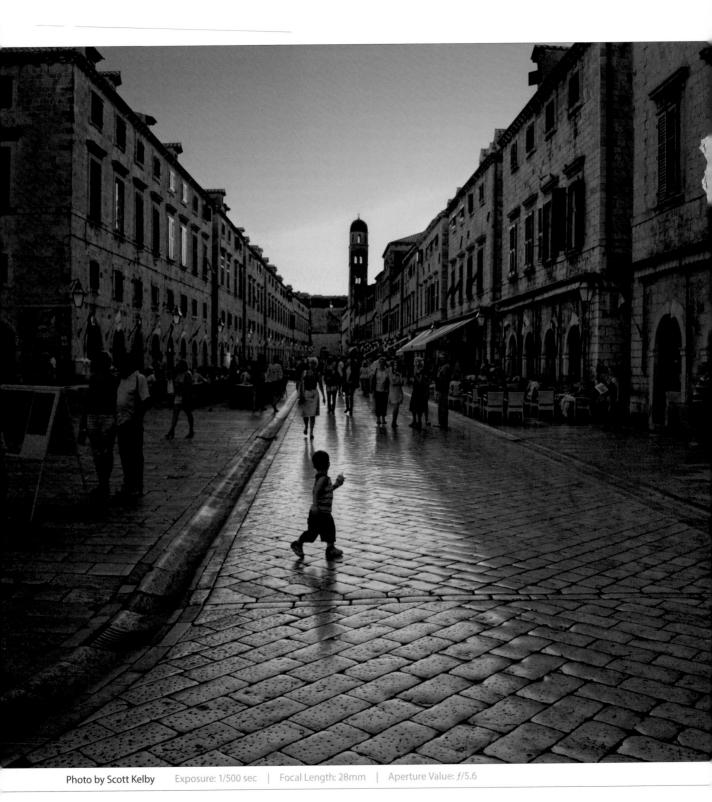

Side Effects special effects for photographers

The name of this chapter comes from the 2009 movie short Side Effects (it's less than 20 minutes long, which is probably why you can buy it for only \$1.99 in the iTunes Store. It's either that, or it's so cheap because of its lack of zombies). Anyway, here's how they describe Side Effects (say this in your best movie voice-over guy voice): "An ordinary guy becomes a human guinea pig in an experimental drug test and meets the girl of his dreams..." Sounds like a pretty typical everyday story. At least the human guinea pig in an experimental drug test part. Anyway, I looked at the movie poster, and the guys in the poster all have this creepylooking bluish/green color cast that makes them look kind of sickly, but then the female lead's photo looks fine, with regular-looking flesh tones, and that's when I realized why this guy thinks he's found the woman of his dreams. She doesn't have a creepy bluish/green color cast. I mean, think

about it. If all the girls around you had a serious white balance problem, and then all of sudden you meet a girl carrying around her own 18% gray card, and so she looks correctly color balanced in any lighting situation, wouldn't you fall in love with her, too? Exactly. I'll bet in the last 10 minutes of the movie, you find out that this guy actually starts an online business for people using dating sites like eHarmony, or Match.com, or HandsomeStalker.com, where he offers to remove bluish/green color casts from your profile photo for a price. Things are going pretty well for him for a while, but then in about the eighteenth minute,

the experimental drug wears off, and he finds himself trapped in a dank, dimly-lit room, forced to write non-sensical chapter intros late into the night, until his wife comes in and says "Honey, come to bed," but right then, he notices she has a bluish/green color cast, and....

Desaturated Skin Look

This is just about the hottest Photoshop portrait technique out there right now, and you see it popping up everywhere, from covers of magazines to CD covers, from print ads to Hollywood movie posters, and from editorial images to billboards. It seems right now everybody wants this effect (and you're about to be able to deliver it in roughly 60 seconds flat using the simplified method shown here!).

Step One:

Open the photo you want to apply this trendy desaturated portrait effect to. Duplicate the Background layer by pressing **Command-J (PC: Ctrl-J)**. Then duplicate this layer using the same shortcut (so you have three layers in all, which all look the same, as shown here).

Step Two:

In the Layers panel, click on the middle layer (Layer 1) to make it the active layer, then press Command-Shift-U (PC: Ctrl-Shift-U) to Desaturate and remove all the color from that layer. Now, lower the Opacity of this layer to 80%, so just a little color shows through. Of course, there's still a color photo on the top of the layer stack, so you won't see anything change onscreen (you'll still see your color photo), but if you look in the Layers panel, you'll see the thumbnail for the center layer is in black and white (as seen here).

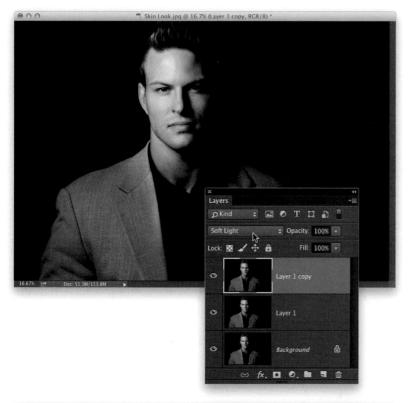

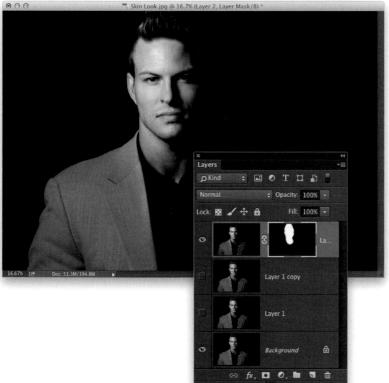

In the Layers panel, click on the top layer in the stack (Layer 1 copy), then switch its layer blend mode from Normal to **Soft Light** (as shown here), which brings the effect into play. Now, Soft Light brings a very nice, subtle version of the effect, but if you want something a bit edgier with even more contrast, try using Overlay mode instead. If the Overlay version is a bit too intense, try lowering the Opacity of the layer a bit until it looks good to you, but honestly, I usually just go with Soft Light myself.

Step Four:

Our last step is to limit the effect to just our subject's skin (of course, you can leave it over the entire image if it looks good, but normally I just use this as a skin effect. So, if it looks good to you as-is, you can skip this step). To limit it to just the skin, press Command-Option-Shift-E (PC: Ctrl-Alt-Shift-E) to create a merged layer on top of the layer stack (a merged layer is a new layer that looks like you flattened the image). You don't need the two layers below it any longer, so you can hide them from view by clicking on the Eye icon to the left of each layer's thumbnail (like I did here), or you can just delete them altogether. Now, press-and-hold the Option (PC: Alt) key and click on the Add Layer Mask icon at the bottom of the Layers panel to hide our desaturated layer behind a black mask. Press **D** to set your Foreground color to white, get the Brush tool (B), choose a medium-sized, soft-edged brush from the Brush Picker in the Options Bar, and just paint over his face, hair, and neck (or any visible skin) to complete the effect. If you think the effect is too intense, just lower the Opacity of this layer until it looks right to you. That's it!

High-Contrast Portrait Look

The super-high-contrast, desaturated look is incredibly popular right now, and while there are a number of plug-ins that can give you this look, I also wanted to include this version, which I learned from German retoucher Calvin Hollywood, who shared this technique during a stint as my special guest blogger at my daily blog (www.scottkelby.com). The great thing about his version is: (1) you can write an action for it and apply it with one click, and (2) you don't need to buy a third-party plug-in to get this look. My thanks to Calvin for sharing this technique with me, and now you.

Step One:

Open the image you want to apply a high-contrast look to. Let's start, right off the bat, by creating an action to record our steps, so when you're done, you can reapply this same look to other photos with just one click. Go to the Actions panel, and click on the Create New Action icon at the bottom of the panel. When the New Action dialog appears, name this "High-Contrast Look" and click the Record button. Now it's recording every move you make... every step you take, it'll be watching you (sorry, I just couldn't resist).

Step Two:

Make a copy of your Background layer by pressing **Command-J** (**PC: Ctrl-J**). Now, change the blend mode of this duplicate layer to **Vivid Light** (I know it doesn't look pretty now, but it'll get better in a few more moves).

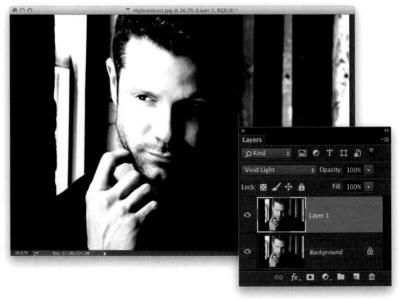

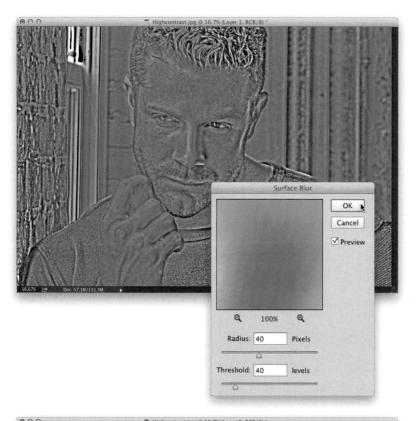

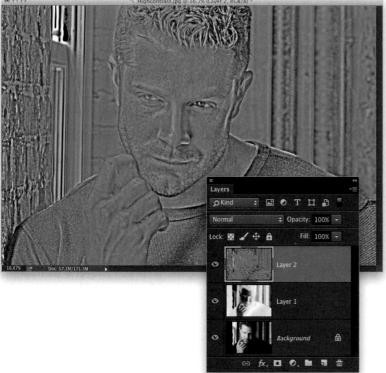

Now press **Command-I (PC: Ctrl-I)** to Invert the layer (it should look pretty gray at this point). Next, go under the Filter menu, under Blur, and choose **Surface Blur**. When the dialog appears, enter 40 for the Radius and 40 for the Threshold, and click OK (it takes a while for this particular filter to do its thing, so be patient. If you're running this on a 16-bit version of your photo, this wouldn't be a bad time to grab a cup of coffee. Maybe a sandwich, too).

Step Four:

We need to change the layer's blend mode again, but we can't change this one from Vivid Light or it will mess up the effect, so instead we're going to create a new layer, on top of the stack, that looks like a flattened version of the image. That way, we can change its blend mode to get a different look. This is called "creating a merged layer," and you get this layer by pressing Command-Option-Shift-E (PC: Ctrl-Alt-Shift-E).

Step Five:

Now that you have this new merged layer, you need to delete the middle layer (the one you ran the Surface Blur upon), so drag it onto the Trash icon at the bottom of the Layers panel. Next, we have to deal with all the funky neon colors on this layer, and we do that by simply removing all the color. Go under the Image menu, under Adjustments, and choose **Desaturate**, so the layer only looks gray. Then, change the blend mode of your merged layer (Layer 2) to Overlay, and now you can start to see the effect taking shape. Now, head back over to the Actions panel and click on the square Stop Recording icon at the bottom of the panel, because what we're going to do next is optional.

Step Six:

This high-contrast look looks great on a lot of stuff, but one area where it doesn't look that good (and makes your image look obviously post-processed) is when you apply this to blurry, out-of-focus backgrounds, like the one you see here. So, I would only apply it to our subject and not the background. Here's how: Option-click (PC: Alt-click) on the Add Layer Mask icon at the bottom of the Layers panel to hide the contrast layer behind a black mask (so the effect is hidden from view). With your Foreground color set to white, get the Brush tool (B), choose a medium-sized, soft-edged brush, and paint over just our subject to add the high-contract effect there.

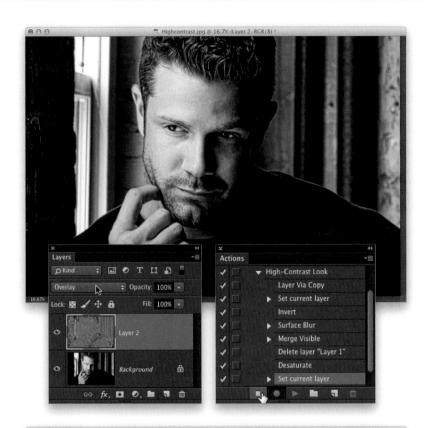

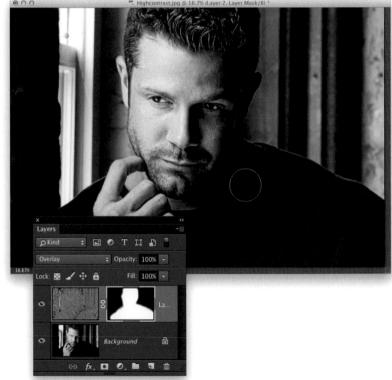

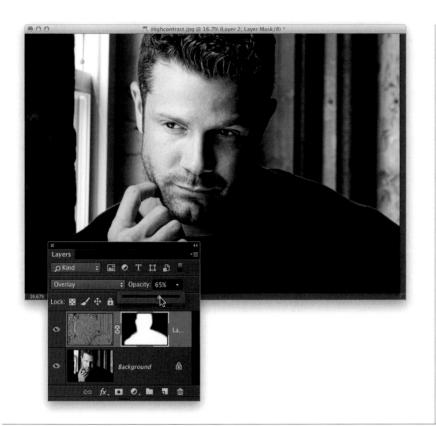

Step Seven:

Finally, go to the Layers panel and lower the Opacity of this layer until it looks more natural, as shown here at 65%. Now, you can flatten the layers and sharpen it using Unsharp Mask (see Chapter 9. Here, I used Amount: 120, Radius: 1, Threshold: 3) to finish off the effect. A before/after is shown below. Remember: you created an action for this, so now you can apply this effect to other images with just one click.

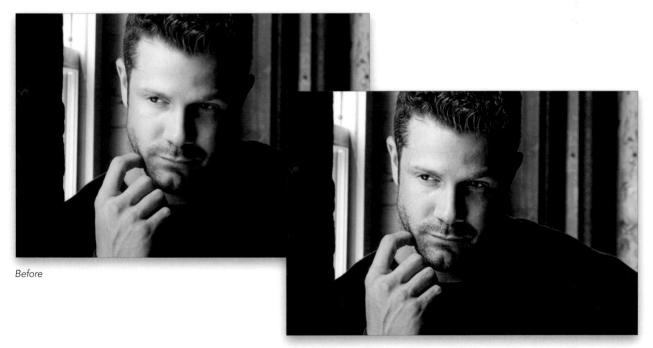

After

Dreamy Focus Effect for People and Landscapes

This is an effect I get asked about a lot, because I use it a lot. The particular thing I get asked is, "How do you get that look where your image looks sharp, but soft at the same time?" Well, it's actually really simple, but don't tell anybody it's this simple, because I'd prefer that people thought I had to pull off some serious Photoshop magic to make this happen. LOL!

Step One:

The sharpness of this effect comes from sharpening the image right up front, so I usually save this effect for when I'm about to save the file (in other words, I usually save the sharpening for the end, but in this case, there's another move that happens after the sharpening, so let's start with the sharpening first). Go under the Filter menu, under Sharpen, and choose **Unsharp Mask**. When the dialog appears, enter 120% for the Amount, set the Radius to 1.0, and set the Threshold to 3 for some nice punchy sharpening. Click OK.

Step Two:

Duplicate this sharpened layer by pressing **Command-J (PC: Ctrl-J)**.

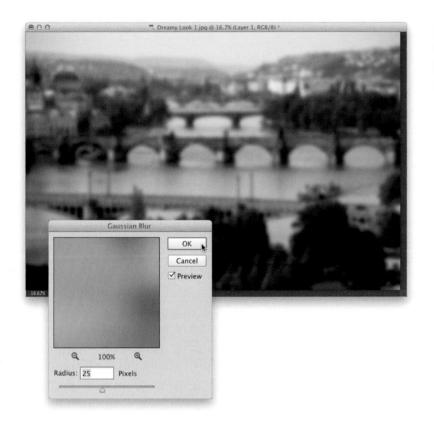

Now, go to the Filter menu, under Blur, and choose **Gaussian Blur**. When the filter dialog appears, enter 25 pixels for the Radius (you may have to go to 35 pixels or higher if you have a 24-megapixel or higher camera. Don't worry so much about the number, just make sure your image looks at least as blurry as this one does), and click OK.

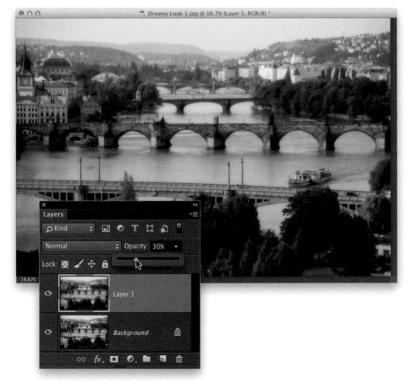

Step Four:

Finally, go to the Layers panel and change the Opacity amount of this blurred layer to 30% (as shown here), and that completes the effect. Now, I know what you're thinking, "Scott. Seriously. Is that all there is to it?" Yes, and that's why it's best we keep this just between us. ;-)

Panoramas Made Crazy Easy

I used to have an entire segment in my live Photoshop seminars where I'd show the seven things you needed to do with your camera to shoot a pano that Photoshop would merge seamlessly together. Then, Adobe improved the Photomerge feature so vastly that you now only need to do one simple thing: as you shoot, overlap each frame by around 20% (so if you're shooting in the desert, from left to right, the same rock would appear on the right edge of the first shot and the left edge of the next frame). That way, Photoshop sees how they get stitched together. Outside of that, you can now even hand-hold your shots and it will perfectly align your frames, too.

Step One:

Before you create your pano, you need to choose whether you want to edit it (stuff like exposure, highlights, and such) now, in Camera Raw, while the individual images are still in 16-bit RAW format, or once it's a single 8-bit pano. It's your call, but I recommend tweaking them now in Camera Raw before you make your pano, so you get the advantages of working with RAW-quality images (if they're JPEG images, it doesn't matter when you edit them—I'd just wait until they're a pano). So, if you shot in RAW, go ahead and Command-click (PC: Ctrl-click) to select all the pano images in Bridge (as seen here).

Step Two:

Now, press Command-R (PC: Ctrl-R) to open your selected images in Camera Raw (as seen here). Click the Select All button at the top of the filmstrip on the left to select all the images you just opened, so any changes you make are automatically applied to all the pano frames. Let's increase the Exposure (to +0.15) and Contrast (to +67), pull back the Highlights to -64 to bring back some dimension and detail in the sky, and bump the Shadows up to +63 to see more detail inside the archways. Set the white and black points by pressing-and-holding the Shift key and double-clicking on the Whites and Blacks slider knobs. Then, let's crank the Clarity to +60 to accentuate the texture, and the Vibrance to +27, so there's at least a little blue in this dreary gray sky. Don't click the Open Images button, just click Done.

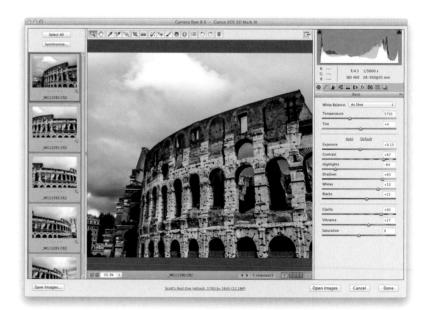

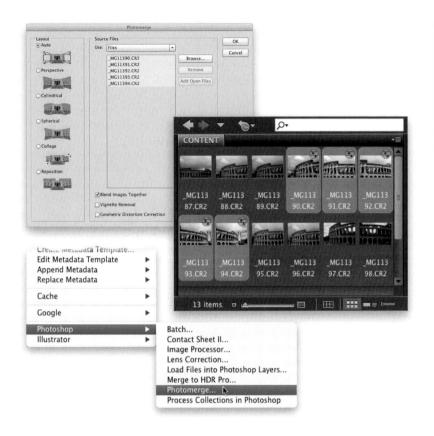

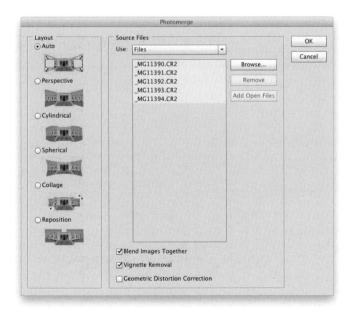

Back in Bridge, the thumbnails will update with the new look, and each thumbnail will have a little circular adjustment badge icon, letting you know they've been adjusted in Camera Raw. Make sure those images are still selected, then go under the Tools menu (up top), under Photoshop, and choose Photomerge (as shown here). If you skipped the Camera Raw stuff and just opened your JPEG photos directly in Photoshop, then go under the File menu, under Automate, and choose **Photomerge**. When you choose Photomerge, it brings up the dialog you see here, with the images you selected listed in the center column. (Note: If you opened JPEGs directly in Photoshop, the center column will be empty, so you'll click the Add Open Files button, here.)

Step Four:

In the Layout section on the left, make sure the Auto radio button is selected. At the bottom center of the dialog, make sure the Blend Images Together checkbox is turned on. Now, there are two other options you'll want to know about: (1) If you have lens vignetting (the edges of your images appear darkened), then turn on the Vignette Removal checkbox and, while it will take a little longer to render your pano, it will try to remove the vignetting (it does a pretty decent job). If you're using a Nikon, Sigma, or Canon fisheye lens to shoot your panos, turn on the Geometric Distortion Correction checkbox at the bottom to correct the fisheye distortion. By the way, don't use a fisheye to shoot your pano. Just sayin'. Secondly, I recommend skipping any lens correction stuff (like using Upright or any of the Lens Correction adjustments) until after your images have been combined into a pano. I've found sometimes it messes up your pano if you do it before you make the pano, so just do it later. Go ahead and click the OK button.

Step Five:

Here's the pano, stitched together in Photoshop and with the changes we made to it back in Camera Raw. If you look over in the Layers panel, you can see all the layers and layer masks that were created to perfectly stitch these five images into one seamless panorama. Let's go ahead and flatten those layers (we're not going to mess with them at all), by choosing Flatten Layers from the Layers panel's flyout menu. You can also see that to make this pano stitch together perfectly, Photomerge had to slightly warp, bend, and rearrange things in a way that almost always creates gaps in different parts of your image (you can see transparent areas—the gray-andwhite checkerboard—on all sides). We'll deal with those in just a minute, but just know that this is perfectly normal and will happen just about every single time you make a pano. (A brief note about those Layout choices [Perspective, Cylindrical, Spherical, Collage, and Reposition] in the Photomerge dialog: they all give you... well...funky looking panos. That's the best description I can give you, so I don't use them. Ever. But, that's just me.)

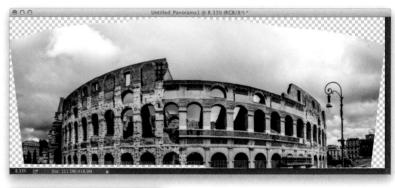

Step Six:

We'll have to crop the photo down to get the final look we want, but luckily that's an easy job. Get the Crop tool (C) from the Toolbar, which brings up a cropping border around your image (like you see here). Crop the ground and sides in fairly close, but don't worry about the sky too much (we'll deal with that next). Now, if on the empty sides of your pano there's something without a lot of intricate detail, like grass or desert or water, you don't have to crop as close because our next step works best with things that don't have lots of intricate detail, like the sky, or grass, or water, etc.

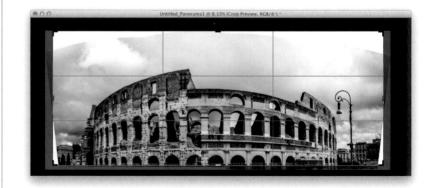

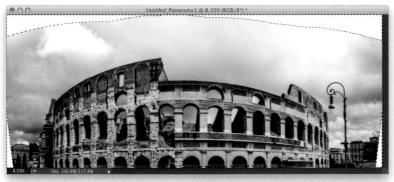

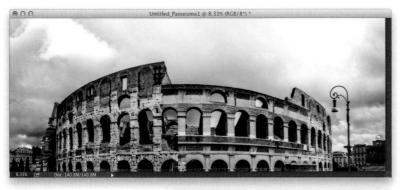

Step Seven:

Press Return (PC: Enter), and your pano is cropped down to size (as seen here), but you can see that we have gaps on the top, left, and right sides. So, get the Magic Wand tool from the Toolbox (press Shift-W until you have it) and click in the bottom-left white gap once, then pressand-hold the Shift key and click in the gap on the bottom right, and then click one more time anywhere in the top gap (holding the Shift key lets you add the other areas to your current left-corner selection). If the Magic Wand tool ends up selecting part of the sky when you click in the top gap, just press Command-Z (PC: Ctrl-Z) to Undo that selection, switch to the Quick Selection tool (Shift-W), pressand-hold the Shift key, and paint in the selection in the gap up top. Now, we're going to use Content-Aware Fill to fill in those gaps, but it works best if you give it some breathing room by expanding your selected areas by 4 pixels. To do that, go under the Select menu, under Modify, and choose **Expand**. Enter 4 pixels (as seen here) to grow your selection outward a bit, and click OK. Now our file is ready to let Content-Aware work its magic.

Step Eight:

Go under the Edit menu and choose **Fill**. When the dialog appears (shown here), from the Use pop-up menu at the top, choose **Content-Aware**, then click OK, sit back, and prepare to be amazed. Well, most of the time it's pretty darn amazing. Every once in a while, it's just way, way off and you have to undo it and go a different route. But, when it's fixing things like gaps in the sky, or in a desert floor, or anything that's kind of random by nature, it works wonders, and in an image like this, it does a really great job (as shown here). Press **Command-D (PC: Ctrl-D)** to Deselect.

Step Nine:

Remember when I said earlier that you should wait until later to apply any lens corrections to your images because sometimes it messes up the stitching pretty significantly? Sure you do. Well, anyway, that time is now. If you look at the image back in Step Eight, you can see that the Colosseum kind of bows out a little bit, so let's get rid of that distortion by go ing under the Filter menu and choosing Camera Raw Filter. When Camera Raw opens, go to the Lens Corrections panel, click on the Manual tab, then drag the Distortion slider to the right until the bowing goes away. I also noticed that the Colosseum itself seemed to be leaning outward a bit, so I dragged the Vertical slider to the left to -3, so the outside walls looked straight. When you're done, you can either crop in the edges (created by the lens correction) or use Content-Aware Fill again. If you need to do any other tweaks, just click on the Basic panel icon and make your tweaks there. Lastly, add an Unsharp Mask and you're done. The final is shown below.

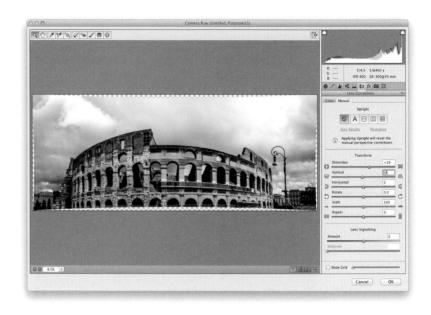

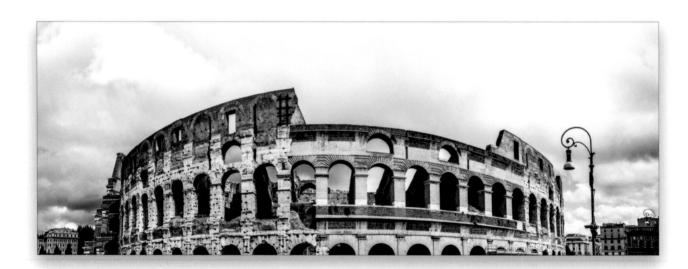

The Blur filter gives you a really easy way to create the miniaturization effect you see all over the web, where a photo is transformed to look like a tiny toy model (well, think of it more like an architectural model). Using this filter is easy if (this is a big if) you have the right type of photo. Ideally, you'd use one where you photographed from a high point of view, looking downward, and the higher you are, and the steeper the angle, the better it helps sell the idea that you're looking down on a scale model.

Tilt Shift Effect (Using the Blur Gallery)

Step One:

Open the image you want to apply the effect to (be sure to read the intro above to make sure you use the right type of image, or this effect will look pretty lame. Of course, as always, you can download the image I'm using here from the book's downloads page mentioned in the introduction). Now, go under the Filter menu, under Blur Gallery, and choose **Tilt-Shift** (as shown here).

Step Two:

When you use any of the filters in the Blur Gallery, it uses interactive, onscreen controls to work with your images. It places a round pin in the center of your image, and above and below that are two solid lines, and then two dotted lines. The solid lines show you the area that will remain in focus (the focus area), and the area between each solid line and dotted line is transition, where it fades from sharp to blurry. The wider the distance between the solid and dotted lines, the longer it takes to go from sharp (inside the solid line) to totally blurry (outside the dotted line). Note: To remove a pin, just click on it and hit the Delete (PC: Backspace) key on your keyboard.

You control the amount of blur by clicking on the gray part of the ring around the pin, and dragging around the ring. As you drag, the ring turns white to show you how far you've gone, and the actual amount of blur appears in a little popup display at the top of the ring (as seen here, where I dragged to 66). I totally dig adjusting the blur right on the image this way, but if it gets on your nerves, you can use the Blur slider in the Blur Tools panel that appears over on the right side of your workspace.

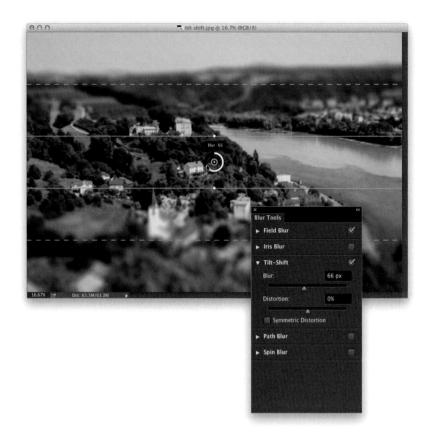

Step Four:

When you're going for this tiny models look, I think it looks better if you compress both of the focus areas—making the in-focus area smaller and the transition area smaller. Here's how: First, click on the pin and move it down and to the right (as seen here). Then, click directly on the top solid line and drag inward toward the round pin thingy in the middle (and yes, thingy is the official name given by the International Board of Unsure Naming, or the IBUN). Get it pretty close. Now, do the same thing with the bottom solid line, moving it up toward the round pin thingy. Next, drag the center of the top dotted line in closer to the top solid line, and then do the same to the bottom dotted line (as shown here).

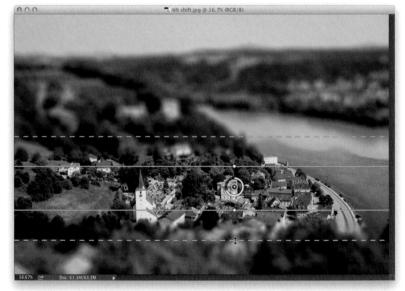

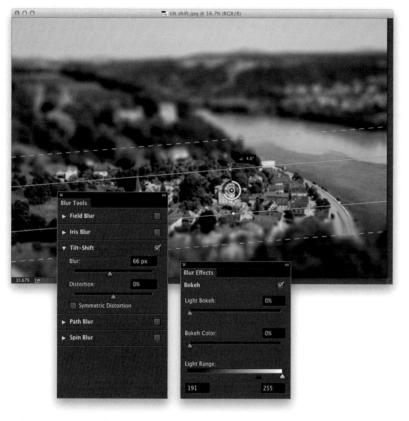

Step Five:

If you want to rotate your in-focus area (and blur, and the whole shebang), move your cursor over the white center dot on the solid line above the pin, and it will turn into a two-headed rotate arrow. Click-andhold on that white dot and rotate by dragging your cursor left/right. Easy peasy. There are a few more options you'll want to know about: The first is the Distortion slider over in the Blur Tools panel, under Tilt-Shift. This lets you change the shape of the blur. If you turn on the Symmetric Distortion checkbox, it makes your blur look really bad and distorted. I personally haven't come up with a reason why I'd ever turn this on, unless I was angry at my photo. Another set of controls is in the Blur Effects panel: The top one lets you increase the highlights in the blur area, which can be nice for some outdoor portraits, but it's a very sensitive slider—if you drag too far, it looks like someone dropped a highlights grenade into your image, so use it sparingly.

Step Six:

There are a few more controls up in the Options Bar: One is the Focus amount, and it's set at 100% (sharp focus) by default. The lower you set it, the more it makes the in-focus area blurry (I haven't found a use for this). Next is the Save Mask to Channels checkbox, which lets you save the area you've masked (using this tool) to a channel (in the Channels panel), in case you want to edit it later (to add noise to it, or remove all the color, etc.). If you reload that channel, the masked area becomes selected. Lastly, there's a High Quality checkbox, which gives you a better quality blur, but it takes longer to apply. Some handy shortcuts: press P to hide the blur (press it again to bring it back), and press-andhold H to hide your round pin thingy and all the lines from view. Click OK at the end of the Options Bar. Here's the final image with the Tilt-Shift effect applied.

Iris & Field Blur (or How to Fake the 85mm f/1.4 Look)

This is a really cool feature, because it lets you add a super-shallow depth-of-field effect to your image after the fact, and it lets you place the focus point, and the blur, right where you want it (but doesn't give you the miniature effect like the Tilt-Shift Blur does).

Step One:

Start by opening the photo you want to add a background blur to (like you shot it at a wide-open aperture, like f/1.4 or f/1.8). Now, go under the Filter menu, under Blur Gallery, and choose **Iris Blur** (as shown here). The area around the bride in this image is a little blurry, but we want to make it a lot blurrier, so she stands out even more.

Step Two:

When you choose Iris Blur, it adds an oval border to the center of your photo, as seen here, and you'll use this oval to determine how much of the image stays in focus, and which parts get blurry (the area in the center of the oval will be in focus and then it'll transition to blurry closer to the edge of the oval). Move your cursor anywhere inside the oval and a set of onscreen controls appear. At the center is a little round pin-click-anddrag directly on that to move the oval anywhere you'd like. The area inside the four larger white dots shows you the area that will remain in sharp focus (the focus area), and the area between those four dots and the solid oval-shaped border is the transition area, where it fades from infocus to blurry. If you click-and-drag the white dots in toward the center, it shrinks the area that's in focus, so it's a long, smooth transition to blurry on the edges. If you pull them outward, it widens the in-focus area and the transition is shorter and more abrupt.

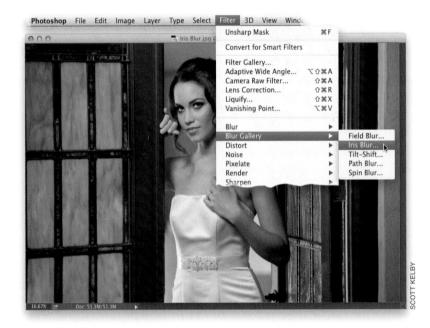

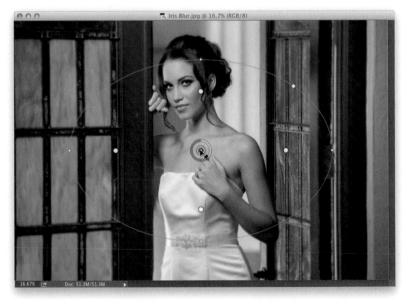

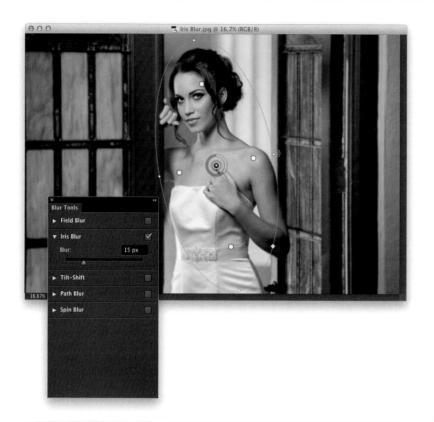

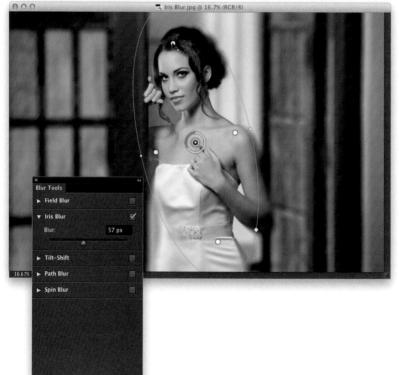

We want our focus squarely on the bride, so we're going to make our oval thinner (so it's closer to her body), and we're go ing to rotate it to the left so it matches her pose. To shrink in the sides of the oval, click on the small dot on either side of the oval and drag inward toward the bride. Now, take that same dot and drag upward a bit, and it rotates the oval (as shown here). To stretch the oval out longer, click on one of the top or bottom small dots on the oval and just drag it out. You can reshape or rotate the oval any time to fit whatever shape you need (within the constraints of an oval, of course). So, here we have our tall, thin oval positioned over our bride. By default, it applies a slight blur to everything outside this oval, but the default setting is so low you can barely even see it's there.

Step Four:

To increase the amount of blur, click on the gray part of the ring around the pin and drag to the left, and as you drag, it increases the amount of blur (I dragged to 57 px. Of course, you could always just use the Blur slider in the Blur Tools panel, on the right side of your workspace, but where's the fun in that?). Once I did that, I noticed that the top of her hair was still really blurry, and the oval wasn't exactly in the right spot, and it wasn't big enough. No worries, just click-and-drag the oval out taller (as seen here), click on the pin and drag the oval over to the left a bit, so it fits better over her, and lastly, clickand-drag one of the large white dots out toward the oval a bit (as shown here) to have more of her inside the oval in focus. Ahhh, that looks better.

Step Five:

If there are other areas you want in focus, just add more pins. All you have to do is click once anywhere outside the oval, and it creates a new oval with the same amount of blur as your original oval (that's handy!). So, for example, if you wanted her arm to be in focus, too, just click on it to add another oval (as seen here), then shrink it down to size and position it over her arm. Want more of her hair in focus? I added a small one up there, too (you can see a third pin there). So, how long did all those blur pins take to create? Just seconds. Each one takes one click to create and one or two clicks to position, so don't let all those dots on the bride throw you—this is easy stuff. One last thing: once you hit the Return (PC: Enter) key to apply your blur effect, you can control the amount of blur after the fact by immediately going under the Edit menu and choosing Fade Iris Blur. Lower the Opacity to around 70% and see how that looks (pretty sweet, right?). Below is a before/after, but we're going to move on to another blur filter now.

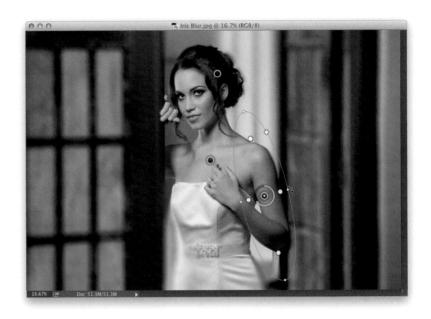

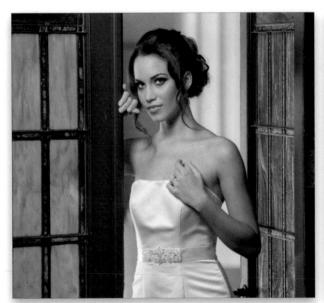

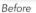

After

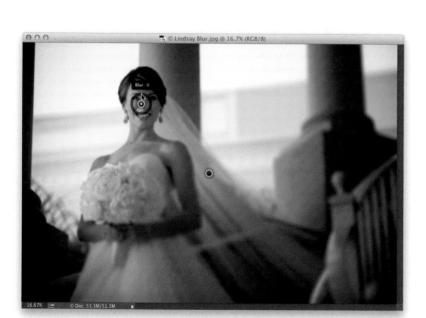

Step Six:

Okay, on to Field Blur. I use this to create gradient blurs (mostly because I can't figure out anything else to do with it that I can't do with the Iris Blur). Open a new image and choose **Field Blur** from the Filter menu, under Blur Gallery. It places a pin in the center of your photo (as seen here) that blurs your entire image. Ummm...yeah...that's helpful. To increase the amount of blur (as if), click on the gray part of the ring around the pin and drag to the left (just like you did with the Iris Blur). Well, it's a start. But the idea here is to add a second pin and make that have 0% blur.

Step Seven:

Click on the bride's face to add a second pin, then click on the gray part of the ring and drag around to the right until your blur is set to 0 (as seen here), and the area beneath that pin is now in focus. I know what you're thinking: this sure seems like just another version of the Iris Blur. I know it seems like that, but that's only because it kinda is. However, the next step will show you where it differs (well, at least somewhat).

Step Eight:

Press and hold the letter **M** and it shows you a preview of the mask created by these pins. The black area is completely in focus, the gray area (as it moves down) is partially in focus, and then the area in white is completely out of focus. So, from top to bottom, what you're seeing is the top in focus and then it graduates down to blurry. But, it won't look quite like what you see here, until you drag the top (focused) pin to the right a bit. As you drag, you'll see the mask change live, so getting it set up like this will take you all of 2 seconds. When you're done positioning the pin, let go of the M key.

Step Nine:

When you're done, click the OK button (up in the Options Bar) and the effect is applied. You can see how the top of the image is in focus, and by the time you get to the bouquet, it's already out of focus (I ended up moving the first [blurred] pin down a bit). Perhaps not the most amazing effect in Photoshop, but at least if you need it, now ya know.

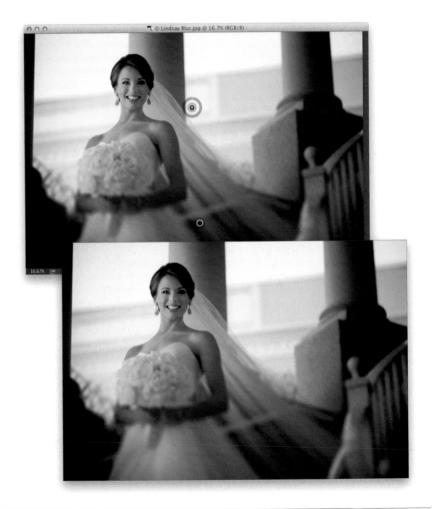

The Lighting Effects filter has been in Photoshop for as long as I can remember, which lets you know how long it has needed a serious makeover. Luckily, for us, it recently got one and it's better than ever. It's basically a filter that creates lighting right where you want it, with different styles of lighting, and to be able to do that, it has to darken the rest of your photo first, and then it lights the one (or more) areas you choose. The interface also uses some of the new onscreen interactivity that Adobe has been working with, so besides just being better, now it's just plain fun to use.

Creating Dramatic Lighting

Step One:

Open the image you want to add dramatic lighting to. In the image shown here, the lighting on our subject is pretty decent, but there's so much ambient (existing) light in the room that it's not very dramatic (I shot this with all natural light, and a bunch of it is bouncing up onto her gown from the gray-and-white marble floor). I always start by duplicating the Background layer (you'll see why in just a few steps), so press **Command-J** (**PC: Ctrl-J**).

Step Two:

Go under the Filter menu, under Render, and choose Lighting Effects. The Toolbox gets hidden (you don't need it), a new Lights panel appears on the right, the Properties panel shows the Lighting Effects controls, and we have new options in the Options Bar. Also, you can see that it has greatly darkened your entire image and put a spotlight in place (you're just seeing the default spotlight effect here, which is...well...kinda lame for the most part). Anyway, if all this looks kind of intimidating, I've got good news: you can choose to ignore almost all of it (you'll see why in the next step. By the way, I switched to the Application Frame window [under the Window menu] here for just a second, to easily show all of these things).

The reason we can ignore most of that scary-looking stuff is that there are builtin presets we can use—they're up top in the left side of the Options Bar. When you click-and-hold on the Presets pop-up menu, a list of predesigned lights (including multiple-light scenarios) appears (as seen here). For the dramatic lighting look, my favorite preset is Flashlight (it uses the Point style of light, which is a perfect circle of light, rather than the large, oval shape of the Spot Light style). When you chose Flashlight from the Presets menu, you get this soft, round spotlight. To position it where you want it, just click right in the center of it (the word "Move" will appear onscreen), and drag it where you want it. Here I dragged it over onto our subject's face, but it looks a little bright. So, move your cursor over the ring around the pin and the word "Intensity" will appear, showing the current amount of Intensity (brightness), ranging from 0 to 100. To lower the amount a bit, click-and-drag right on that ring in a counter-clockwise motion, and it lowers the brightness of the light (here, I dragged to 33).

Step Four:

You can control the size of your beam (Adobe calls it the "Scale") using the outermost ring (the outer green circle). Move your cursor right over it and it turns yellow and the word "Scale" appears onscreen along with the amount, from 0 to 100 (as seen here). Just drag inward/ outward to resize the beam. I have to tell you, this green ring is kind of finicky and it might take you moving your cursor over it a few times really slowly to finally get the yellow Scale ring to appear, so don't let it get you frustrated if it doesn't work the first time. These onscreen controls work pretty much the same for the rest of the lights, except for the Spotlight presets-for those, the outer-ring controls rotation, but you can click on the white dots to move it.

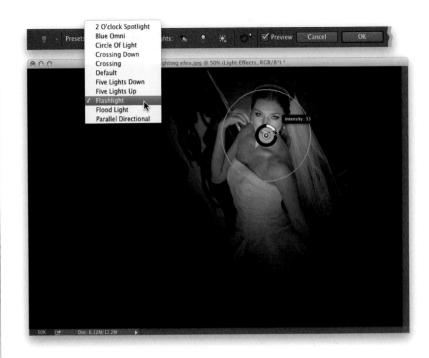

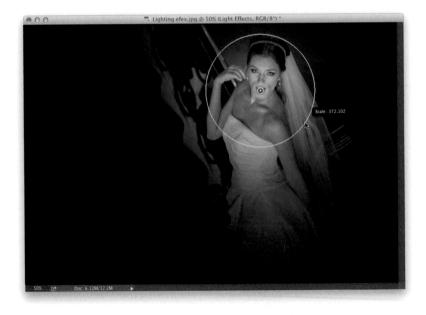

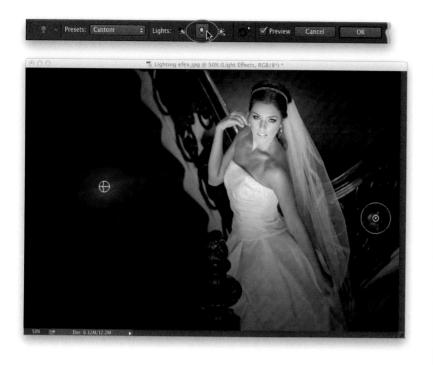

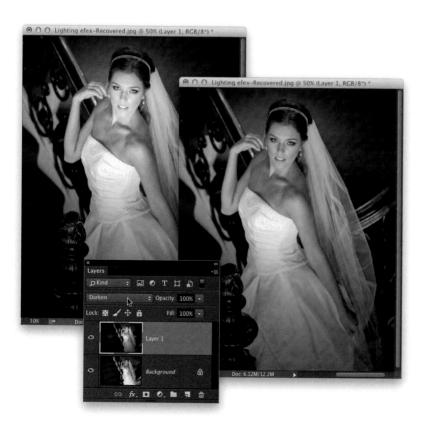

Step Five:

To add more lights, click on one of the three light styles up in the Options Bar. Here, we'll add a Point Light (shown circled here in red) and drag it over on the stairs on the left (they're just kind of lost there in the dark). Drag the Scale circle inward, until the size of the beam is very small (as seen here), and lower the Intensity quite a bit (I set it at around 25). Create another Point Light and do the same, but drag it onto the bannister on the far right. That's it, we just re-lit the image with three lights. Click the OK button in the Options Bar now (although we're going to come back and look at some other things in a minute).

TIP: Deleting Lights

To delete a light, click on it, then click on the Trash icon in the bottom-right corner of the Lights panel. It won't let you delete all the lights—it makes you leave one there (or your image would just be black).

Step Six:

If you look at the image here, on the left, you'll notice that the light on her face is pretty bright and direct, which is fine, but you can make it blend in a little better and look less harsh with just one click (that's why, at the beginning, we duplicated the Background layer—to apply what could be a final finishing move). To soften the light, in the Layers panel, change this laver's blend mode from Normal to Darken (as seen here), and it takes the "edge" off that main light and makes it softerlooking with a smoother blend, which could complete the effect (compare the left side here, now, with the right side set to Darken). One other thing: a benefit of having applied this effect on a layer is that you can control the overall amount of the effect after the fact. For example, if you think the background is too dark and too dramatic now, you can simply lower the Opacity of this layer and it lowers the intensity of the effect.

Step Seven:

Alhough I said you could pretty much ignore the panels on the right, just in case you're interested, we'll take look at them. Go back under the Filter menu, under Render, and choose Lighting Effects again (your lights will still be there, but they'll be brighter because it's applying the effect again). In the Lights panel, you'll see all your lights listed, kind of like layers. You can toggle them on/off here by clicking on the Eye icon to the left of each light. Also, if you want to change the style of light, click on it, then choose a new style from the pop-up menu in the Properties panel. Hey, there's one light we haven't really talked about because I've never found a use for it. It's called the Infinite Light, so go ahead and turn the other three off in the Lights panel and then create an Infinite light (click on the third Lights icon in the Options Bar). This light stays in the center of your image, like the sun—it doesn't move, so all you can do is change its direction (click-and-drag directly on the dot in the center, and you'll see the light icon near the edge of your image move; it's fun to see how it shows the light in 3D).

Step Eight:

Go ahead and click-and-drag the Infinite Light onto the Trash icon at the bottom of the Lights panel, because we don't really need it anymore, and turn your three Point Lights back on, because there are a few other controls in the Properties panel: (1) To change the color of your light, click on the Color swatch and choose a new color. (2) The Intensity slider is the same as the one you use right on the image itself. (3) The Hotspot slider controls the most intense center of the light when using the Spot Light. (4) The Colorize swatch controls the color cast of the darkened part of your photo (by default, it's flat). (5) The Exposure slider reminds me of the Highlights slider in Camera Raw, so if I use it at all, it's usually dragging it to the left to pull back highlights.

Step Nine:

There are a few more: (6) The Ambience slider controls the amount of darkening it applies to the rest of the image (that's what I did here, by dragging this to the right). (7) The Texture pop-up menu lets you accentuate the texture in your image with kind of an embossed look, on a per color basis. You control the amount using the Height slider. Try it and you'll see what I mean. I skipped over the two controls I use the least: the Gloss slider (which theoretically controls the amount of shine to the photo, but it seems to me like more of a contrast control), and the Metallic slider only seems to do anything when you have something metallic or reflective in your image, so if you do, dragging it to the right makes it more intense. A before/after is shown below (but, I turned off the two lights on the stairs and bannister—I just didn't like 'em—and increased the Intensity and Scale of the light on the bride).

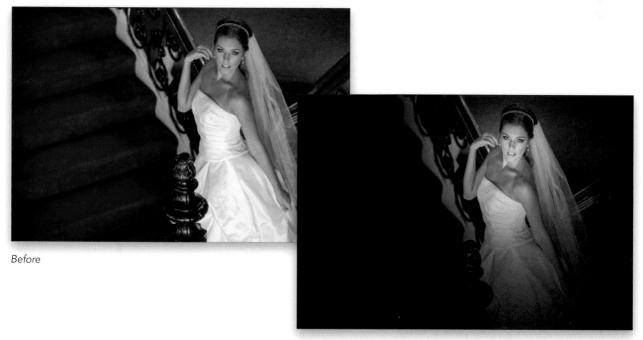

After

Photographic Toning Effects (from Sepias to Split Tones)

One of the most under-used adjustment layers has got to be the Gradient Map. For years, I've only used it for one thing—it makes a pretty mean black-and-white conversion in just one click (well, provided that your Foreground color is black and your Background color is white when you choose Gradient Map). Anyway, Adobe worked with photographer Steve Weinrebe to add 38 photo-toning and split-toning presets to the Gradient Map feature, making it an even better tool that nobody uses. I hope that changes today.

Step One:

Open the photo you want to apply a photo toning effect to. Then, go to the Layers panel and click on the Create New Adjustment Layer icon at the bottom of the panel, and choose **Gradient Map** from the pop-up menu (as shown here), or you can click on the last icon, on the bottom row, of the Adjustments panel.

Step Two:

As soon as you choose Gradient Map, it applies the default gradient, which as I said above, makes a pretty darn sweet one-click B&W image (as long as your Foreground and Background colors are set to black/white, respectively, before you choose Gradient Map). Okay, to be able to load the Photo Toning presets, you need to go to the Properties panel and click directly on the gradient itself (as shown here).

This brings up the Gradient Editor (seen here), and if you click on the little "gear" icon at the top-right corner of the Presets section, a pop-up menu appears. Choose Photographic Toning from this menu (as shown here). A dialog will appear asking if you want to replace the current default set of gradients with the ones you are loading. I chose OK, because (1) it's easier to work with them if they're not added to the existing set, and (2) you can always get back to the default gradients by simply choosing Reset Gradients from this same popup menu. Once they're loaded, now the fun begins, because all you have to do is click on any one of these gradients and it updates your image live, so you can just start clicking until you find one you like. Here's one called Sepia-Selenium 3 (it's the fourth one in the third row).

Step Four:

So, now you're pretty much windowshopping for the look you like—click a gradient, and if it's not the look you're looking for, click the next one. For example, here I chose Sepia-Cyan (perhaps not my first choice, but I did want to show you the variety of what's here). This one has more of a split-tone look, with a cyan color in the shadows and a yellowish color in the highlights. Make sure you try out some of the ones in the top row—there are some really useful duotone/sepia tone looks up there, and like most Adobe presets, the best, most-useful ones are near the beginning, and the farther they are down on the list, the less useful they are. One more cool thing: because these are adjustment layers, you can reduce the intensity of the effect by simply lowering the opacity of the adjustment layer (over in the Layers panel), and you can also change the layer blend mode (try Linear Burn on this shot) for even more looks.

Fashion Toning Using Photoshop's Color Lookup Adjustment Layer

You see color toning and film-look effects just about everywhere you look these days in fashion photography, and you can recreate this look using Photoshop's built-in Color Lookup tables (they instantly remap the colors in your image to create some pretty cool color effects, inspired by the lookup tables used in movie making and video). There aren't a lot of controls to play around with—most of these are pretty much "one-trick ponies," where you choose a look and you either like the effect or not—but what's nice is it's available as an adjustment layer, so you can control the amount of toning (or just tone the background using the built-in layer mask).

Step One:

Open the photo you want to apply a Color Lookup effect to. Then, go to the Layers panel, click on the Create New Adjustment Layer icon at the bottom of the panel, and choose Color Lookup from the pop-up menu (as shown here), or you can click on the last icon in the second row of the Adjustments panel. This opens the Color Lookup options in the Properties panel (shown here). There are three different sets of effects, and you make your choice from any of the three pop-up menus (you can only apply one at a time, but you can add multiple adjustment layers if you really feel you need to stack two).

Step Two:

Let's start with the top one: Click on the pop-up menu to the right of 3DLUT File, and you can see there's a long list of "toning looks." Everything from B&W to Traditional Film looks to split toning. Here, I chose Soft_Warming.look (I recommend you try them all out because, depending on the image, they can look very different). At this point: (1) if the effect seems too intense, you can lower the layer's Opacity; (2) you can change the layer's blend mode to control how this effect blends with the image on the layer below it; or (3) you can press Command-I (PC: Ctrl-I) to Invert the layer mask, which hides the effect behind a black layer mask, then take the Brush tool (B) and, with your Foreground color set to white, just paint the effect right where you want it to appear.

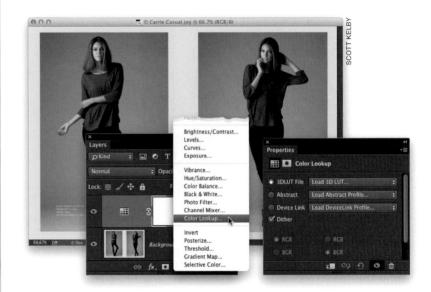

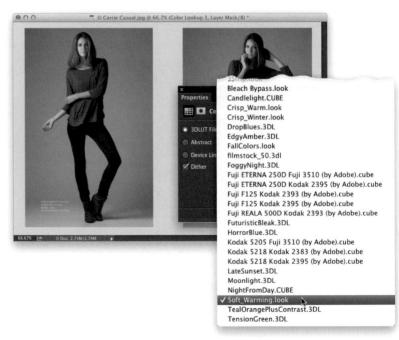

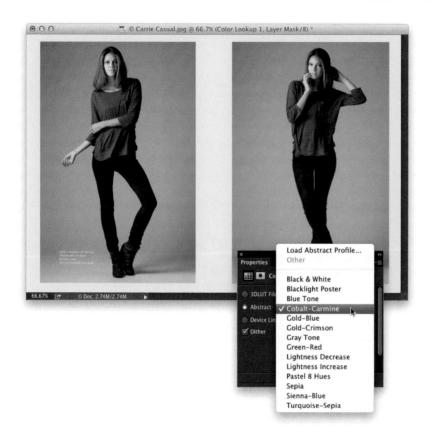

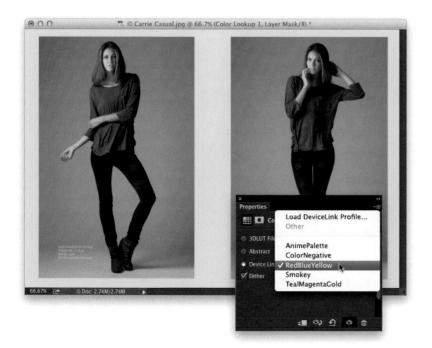

Now, let's go to the next set down in the Properties panel: Abstract, Click on the pop-up menu to its right to see all your choices. Here, I chose Cobalt-Carmine, which I think is another good choice for this image. Note: There are a few effects that have extra options. For example, from the 3DLUT File popup menu we used in Step Two, choose NightFromDay.CUBE and some new options appear at the bottom of the Properties panel. Since they're radio buttons, all you can do is choose one button on the left and one on the right, and as you click on them, they create variations of the look you chose. Also, there are a few handy buttons across the bottom of the Properties panel: The one I use the most is the Eve icon, which togales the Color Lookup adjustment layer on/off (and saves you a trip up to the Layers panel). If you click on the first icon from the left, it makes the effect only affect the layer directly below it (and not all the layers below it, like normal). The next icon over (the eye with an arrow) is a before/ after, which is pretty similar to turning the layer on/off with the Eye icon. The next icon (the curved arrow) just resets the entire panel to its defaults.

Step Four:

Let's try the last set, called "Device Link," and you can see its choices here (from the pop-up menu). I chose RedBlueYellow to get the look you see here. One last thing: If you choose the top choice in any of these pop-up menus, it opens an Open dialog, so you can load a profile. However, these aren't easy to find (I don't know anyone who has one outside of people working in movies), so just hit Cancel if that dialog appears (since most folks don't have these, it makes you wonder why it's not the last choice in each menu, right? Don't get me started).

Sculpting Using the Updated Liquify Filter

This is another filter Adobe updated back in Photoshop CS6, and although it's probably most often used in portrait retouching (I used it quite a lot in my portrait retouching techniques book), I did want you to know that: (a) it is much, much faster and more responsive now, because they handed the heavy lifting off to the Graphics Processing Unit (geek speak); and (b) they tweaked lots of little things to make it better and easier to use; plus (c) they added an incredibly helpful feature that lets you go back and pick up where you left off (very clever). So, here's a quick retoucharoo:

Step One:

Open the image you want to retouch (here, we have a nice headshot), then go under the Filter menu and choose Liquify (or press Command-Shift-X [PC: Ctrl-Shift-X]), which brings up the dialog you see here. There are two versions of this dialog: an Advanced Mode version, and the simplified version you see here, with just a few tools on the left, and just the Brush Size and Pressure settings on the right side. For most of what we wind up doing, the simplified version is pretty much all we need (we do most of our work using the Forward Warp tool—the top tool in the Toolbox), so turn off the Advanced Mode checkbox.

TIP: Visual Brush Resizing in Liquify If you want to quickly jump up to a much larger or down to a smaller brush size, on a Mac, press-and-hold **Option-Ctrl**, and **click-and-drag** your cursor to resize it onscreen. On a PC, press-and-hold the **Alt key**, and then **Right-click-and-drag**.

Step Two:

The Forward Warp tool moves your subject around like they were a thick liquid (like molasses), but the secrets to using it effectively are: (1) make your brush size the size of what you want to move, and (2) make subtle movements with it (just kind of nudge things around, and you'll get great results). So, take the tool, place the center crosshair just to the right of her cheek on the right, and nudge it over to the left to tuck it in a bit (as shown here).

Now, let's fix her hair on the right side, so it's more like the left side (keeping in mind our tip about making the brush size the size of what you want to move). Remember, just nudge it a bit, and as you move around that side of her hair, change the brush size to match the size of what you're trying to move. You can change the size of your brush using the Brush Size slider over on the right, but honestly, it's easier to use the keyboard shortcuts. The **Left Bracket key** makes the brush smaller; the **Right Bracket key** makes it larger (they're to the right of the letter "P" on your keyboard).

TIP: If You Mess Up, Try This
If you want to start over from scratch, click the Restore All button. If you want to just undo a step or two, you can use the same multiple undo shortcut you normally use in Photoshop: every time you press Command-Option-Z (PC: Ctrl-Alt-Z), it undoes another step.

Step Four:

Let's zoom in tight to adjust her top lip just a little bit. (By the way, Liquify uses the same keyboard shortcuts for zooming in/out that you normally use in Photoshop: Command-+ [plus sign; PC: Ctrl-+] will zoom you in, and Command-- [minus sign; PC: Ctrl--] will zoom you back out.) So, shrink your brush way down until it's the size of the bump on the top left of her lip and nudge it down just a tiny bit, so it matches the right side.

Step Five:

Now, let's zoom in tight on the left side of her hair. See those dents and bumps there? We're going to gently push out parts and push in the bumps, until it's all nice and smooth (although we'll try not to make it too perfect).

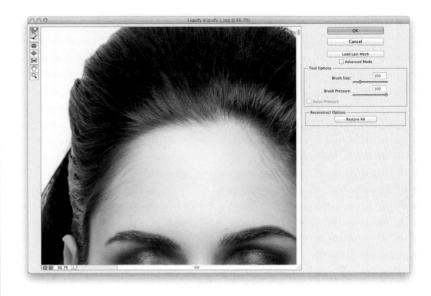

Step Six:

Okay, it's time to start pushing and pulling in those areas along her hair until it looks...well...like this. Now, turn the Advanced Mode checkbox back on, and those options appear on the right side of the dialog, and three extra tools are added to the Toolbox (as seen in the next step). The main feature of this Advanced Mode is the ability to freeze part of the image you don't want to move while you're moving areas right around it. For example, if we want to push in her left ear a bit, we run the risk of pushing in the side of her face at the same time. Luckily, you can freeze that side of her face and those frozen areas won't move no matter how far you tuck in that ear, like it's frozen.

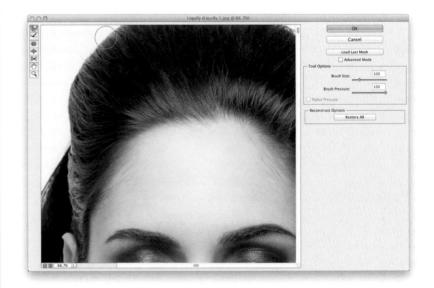

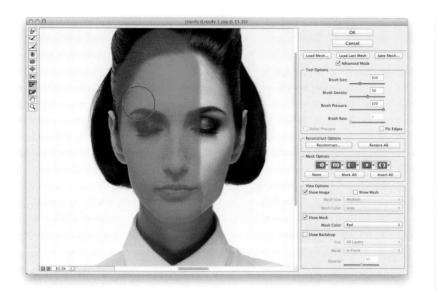

Step Seven:

Here, I painted with the Freeze Mask tool (**F**; it's the eighth tool down in the Toolbox) over her face, and as you paint it appears in a red tint (if you don't see the red mask area, in the View Options section on the right, turn on the Show Mask checkbox). To erase any area you accidentally painted over, switch to the Thaw Mask tool (**D**; it's the next tool down). Now, make you're adjustment, and when you're done, click OK, and your changes are applied. A before/after is shown below.

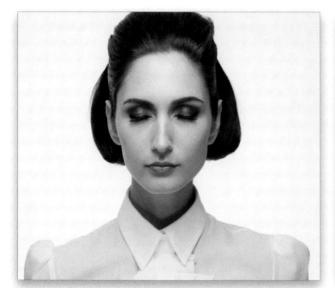

After

Lens Flare Look

This effect has come back into vogue in a big way (it was big years ago, then it went away, now it's back. The very definition of fashion, right?). Luckily, it's super-quick and easy (my favorite type of technique).

Step One:

Start by opening an image you want to add a Lens Flare effect to (as seen here). Create a new blank layer by clicking on the Create a New Layer icon at the bottom of the Layers panel.

Step Two:

Press **D** to set your Foreground color to black, then press **Option-Delete (PC: Alt-Backspace)** to fill this new layer with solid black. Now, go under the Filter menu, under Render, and choose **Lens Flare**, which brings up the dialog you see here. There are four different styles of lens flare, but the one I see most often is the first one (the 50–300mm Zoom). The Brightness slider controls...wait for it... wait for it...okay, obviously it controls the brightness of the lens flare (I left it set to 100%, here). Now, click OK to apply this Lens Flare effect to your black layer (as seen here).

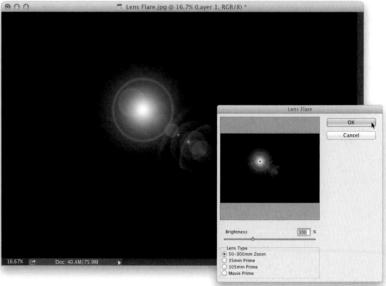

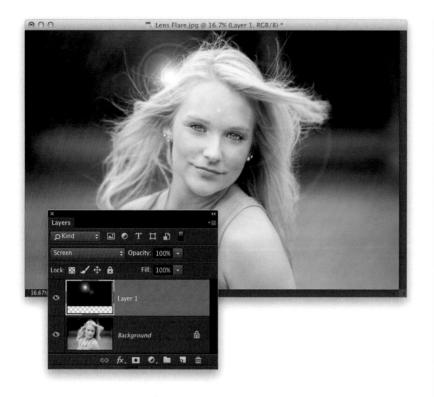

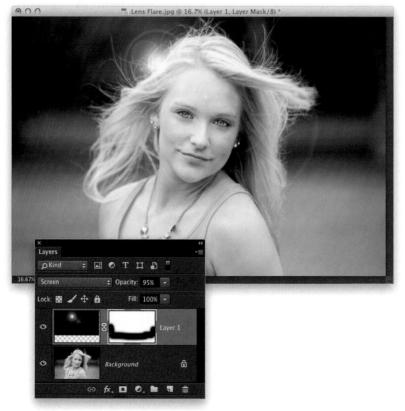

Of course, at this point, you've just got a lens flare on a black layer—we need to get it to blend in with our image. Easily done. Just go the Layers panel and change the layer blend from Normal to **Screen**. As soon as you do that—BAM!—the lens flare appears (as seen here), but it's going to appear in the center of your image. So, get the Move tool **(V)** from the Toolbox, click on the lens flare right on your image, and drag it where you want it (here, I dragged it to the left side of her head).

TIP: Changing the Position of the Lens Flare Rings

When the Lens Flare dialog is open, if you click on the little + (crosshair) in the center of the little preview window, you can drag it, and as you do, it changes the order and location of the lens flare rings.

Step Four:

When you move the Lens Flare layer like this, there is something you're probably going to run into, and that's a visible edge. Here's why: let's pretend we never added the lens flare and it was just a black layer. If we got the Move tool and dragged the black layer around, you'd see the edges of the black rectangle. So, after we add the lens flare and change the mode to Screen, while those edges aren't nearly as visible, there's a good chance they're there. So, click on the Add Layer Mask icon at the bottom of the Layers panel, and then press X to set your Foreground color to black. Get the Brush tool (B) from the Toolbox, choose a large, soft-edged brush from the Brush Picker up in the Options Bar, and then paint over those edge areas, so they blend in smoothly with the rest of the image. One last thing: if the effect seems too intense, you can just lower the Opacity of this layer until it looks right (here, I lowered it to 95%). Okey dokeythat's it.

Wet Streets and Cobblestones

This one is a quickie that lets you turn a dry cobblestone or asphalt street into a wet cobblestone or asphalt street. I showed this technique on a live webcast I did about travel photography editing techniques, and a month later people were still asking about it. So, I wanted to include it here in the book. What I love best is that it's quick, easy, and it usually works.

Step One:

You need to do this one in Camera Raw, but don't worry, even if you didn't shoot your image in RAW (this image is a JPEG I shot nine years ago), you can still use Camera Raw to edit the shot. With the image open in Photoshop, go under the Filter menu and choose Camera Raw Filter to open in the image in Camera Raw (as seen here). Go ahead and make any regular tweaks to the image while you're here in the Basic panel. Here, I increased the Exposure, and then Shift-clicked on the Whites and Blacks sliders to have Camera Raw automatically set the white and black points. I also increased the Vibrance a bit because the photo is just so gray. But the real question is: what's in the bag?

Step Two:

A baquette? Wine? A beret?

Click on the Adjustment Brush tool **(K)** up in the Toolbar and in the Adjustment Brush panel on the right, click on the + (plus sign) button to the right of Contrast. This zeros out all the other sliders and increases the Contrast amount by +25. Go ahead and drag that slider to +100. Now, drag the Clarity slider to +100, too. That's it—that's the recipe. Paint over the surface you want to appear wet (here, I'm painting to the right of the woman carrying a small cat in a bag. (Hey, it's possible.) As you paint, the area looks wet and appears to add reflections like an actual wet street.

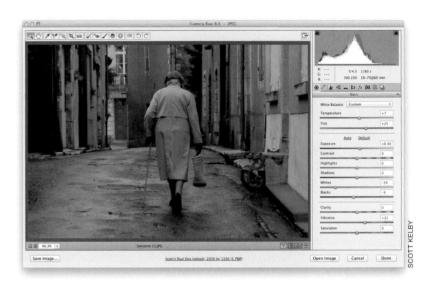

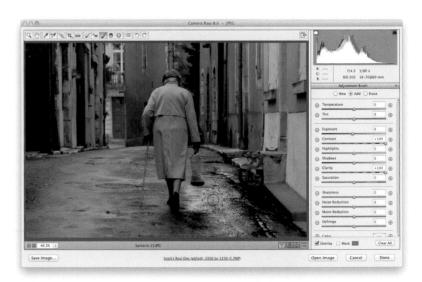

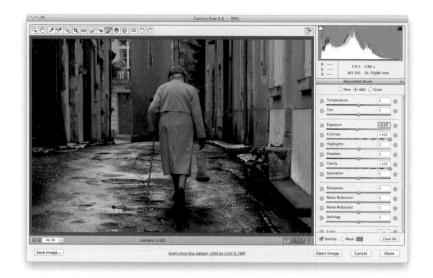

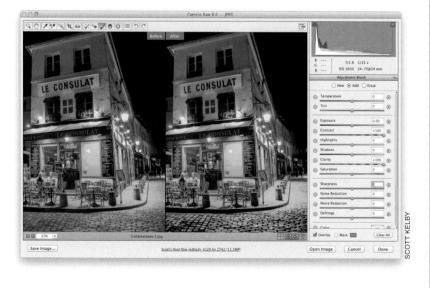

Don't forget to paint over the sidewalk and curb, as well. Also, if you paint over the street and it doesn't look "wet" enough, just click on the New radio button at the top of the Adjustment Brush panel and start painting over the same area, but start in a different part of the street (that way, you're stacking this second pass of the look over the first coat of "wet"). By the way, if for any reason the street looks too bright from applying that much Clarity, just lower the Exposure slider a little bit for each pin, so it looks to have about the same brightness overall. Once I was done painting the street here, the buildings looked too washed out, so I went back and added some more Contrast to the entire image.

Step Four:

This technique looks particularly great on cobblestone streets, and I did a before/after here in Camera Raw so you can see an example. Okay, that's it. Instant wet streets.

Photoshop Killer Tips

How to Open Multiple JPEGs or TIFFs in Camera Raw from Bridge

Opening multiple RAW photos from Bridge is easy—just select as many as you want, and then double-click on any one or Right-click and choose Default Application, under Open With. The problem is that doesn't work for JPEG or TIFF images. But, it's easy to open them inCamera Raw from Bridge, as well. Select multiple JPEG or TIFF images in Bridge, Right-click on any one, and just choose **Open in Camera Raw**.

Tip for Wacom Tablet Users

If you use a Wacom tablet for retouching, there are two buttons that keep you from having to jump to the Brushes panel when you need to control pressure-sensitive opacity or size. These two buttons appear in the Options Bar when you have a brush tool selected (they look like circles with a pen on them), and clicking them overrides the current settings in the Brushes panel,

so it saves you a trip to the Opacity or Size controls to turn those two on first.

If Photoshop Starts Acting Weird... ...or something doesn't work the way it always did, chances are that your preferences have become corrupt, which happens to just about everyone at one time or another, and replacing them with a new factory-fresh set of preferences will cure about 99% of the problems that you'll run into with Photoshop (and it's the very first thing Adobe's own tech support will tell you to fix), so it's totally worth doing. To rebuild your preferences, go ahead and guit Photoshop, then press-and-hold Command-Option-Shift (PC: Ctrl-Alt-Shift) and launch Photoshop (keep holding them down). A dialog will pop up asking if you want to Delete the Adobe Photoshop

Settings File. Click Yes, and chances are, your problems will be gone.

Creating a New Document with the Same Specs as Another Open Document

If you have an image already open, and you want to create a new blank document

with the exact same size, resolution, and color space, just press **Command-N (PC: Ctrl-N)** to bring up the New dialog, then from the Preset pop-up menu up top, choose the name of your already open document, and it takes all the specs from that document and fills in all the fields for you. All you have to do is click OK.

Retouching Tip for Liquify
If you're using the Liquify filter to do
some retouching on a portrait, you can
make sure you don't accidentally move
an area you don't want to affect by
freezing it, and there are freeze tools
in Liquify, but it's easier to just put a
selection around the area you want to

adjust first, then bring up the Liquify filter, and any area outside your selected area is automatically frozen. (You'll see a rectangle with your selection in it in the Preview area, and the areas outside your selection will be masked in red.)

Photoshop Killer Tips

Super-Fast Temporary Tool Switching

This is one Adobe introduced back in CS4. but few people knew it was there. They're called Spring Loaded Tools, and what they let you do is temporarily access any other tool while you're using your current tool. When you're done, Photoshop automatically switches back. Here's how it works: Let's say you have the Brush tool, but you need to put a Lasso selection around an area, so you don't paint outside of it. Just press-and-hold the L key (for the Lasso tool), and your Brush tool temporarily switches to the Lasso tool. Make your selection, then let go of the L key and you're back to the Brush tool. This is a huge time and trouble saver.

Designing for a Cell Phone or Tablet? Then you'll be happy to know that there are a bunch of built-in presets for the most

common sizes of mobile device screens. From the File menu, choose New, then choose **Mobile & Devices** from the Preset pop-up menu, and then choose the size you need from the Size pop-up menu.

Assigning More RAM to Photoshop
You can control how much of your computer's installed RAM actually gets set aside
just for Photoshop's use. You do this within
Photoshop itself, by pressing Command-K
(PC: Ctrl-K) to bring up Photoshop's Preferences, then click Performance in the list
on the left side of the dialog. Now you'll
see a bar graph with a slider that represents how much of your installed RAM is
set aside for Photoshop. Drag the slider to

the right to allocate more RAM for Photoshop (the changes don't take effect until you restart Photoshop).

Save Time When Saving

When you click on the Save Image button in the bottom left of the Camera Raw window, it brings up the Save Options dialog, but if you don't need to make any changes to your settings, you can skip this dialog altogether by pressing-

and-holding the Option (PC: Alt) key before clicking the Save Image button. Hey, every click you save, counts.

Shortcuts for Changing the Order of Layers

I use these a lot, because it saves a trip over to the Layers panel dozens of times a day. To move your current layer up one layer (in the stack of layers), press Command-] (Right Bracket key; PC: Ctrl-]) and of course to move down, you'd use the same shortcut with the Left Bracket key ([). To move the current layer all the way to the top, add the Shift key. Of course, you can't move anything below the locked Background layer.

Sharpen Your Teeth sharpening techniques

I had two really good song titles to choose from for this chapter: "Sharpen Your Teeth" by Ugly Casanova or "Sharpen Your Sticks" by The Bags. Is it just me, or at this point in time, have they totally run out of cool band names? Back when I was a kid (just a few years ago, mind you), band names made sense. There were The Beatles, and The Turtles, and The Animals, and The Monkees, and The Flesh Eating Mutant Zombies, and The Carnivorous Flesh Eating Vegetarians, and The Bulimic Fresh Salad Bar Restockers, and names that really made sense. But, "The Bags?" Unless this is a group whose members are made up of elderly women from Yonkers, I think it's totally misnamed. You see, when I was a kid, when a band was named The Turtles, its members looked and acted like turtles. That's what made it great (remember their hit single "Peeking Out of My Shell," or who could forget "Slowly Crossing a Busy Highway" or my favorite "I Got

Hit Crossing a Busy Highway"?). But today, you don't have to look ugly to be in a band named Ugly Casanova, and I think that's just wrong. It's a classic bait-and-switch. If I were in a band (and I am), I would name it something that reflects the real makeup of the group, and how we act. An ideal name for our band would be The Devastatingly Handsome Super Hunky Guys With Six-Pack Abs (though our fans would probably just call us TDHSHGWSPA for short). I could picture us playing at large 24-hour health clubs and Gold's Gyms, and other places where beautiful people (like ourselves) gather to high-five one another on being beautiful. Then, as we grew in popularity, we'd have to hire a manager. Before long he would sit us down and tell us that we're living a lie, and that TDHSHGWSPA is not really the right name for our band, and he'd propose something along the lines of Muscle Bound Studs Who Are Loose With Money or more likely, The Bags.

Sharpening Essentials

After you've tweaked your photo the way you want it, and right before you save it, you'll definitely want to sharpen it. I sharpen every photo, either to help bring back some of the original crispness that gets lost during the correction process, or to help fix a photo that's slightly out of focus. Either way, I haven't met a digital camera (or scanned) photo that I didn't think needed a little sharpening. Here's a basic technique for sharpening the entire photo:

Step One:

Open the photo you want to sharpen. Because Photoshop displays your photo differently at different magnifications, choosing the right magnification (also called the zoom amount) for sharpening is critical. Because today's digital cameras produce such large-sized files, it's now pretty much generally accepted that the proper magnification to view your photos during sharpening is 50%. If you look up in your image window's title bar, it displays the current percentage of zoom (shown circled here in red). The quickest way to get to a 50% magnification is to press Command-+ (plus sign; PC: Ctrl-+) or Command-- (minus sign; PC: Ctrl--) to zoom the magnification in or out.

Step Two:

Once you're viewing your photo at 50% size, go under the Filter menu, under Sharpen, and choose **Unsharp Mask**. (If you're familiar with traditional darkroom techniques, you probably recognize the term "unsharp mask" from when you would make a blurred copy of the original photo and an "unsharp" version to use as a mask to create a new photo whose edges appeared sharper.)

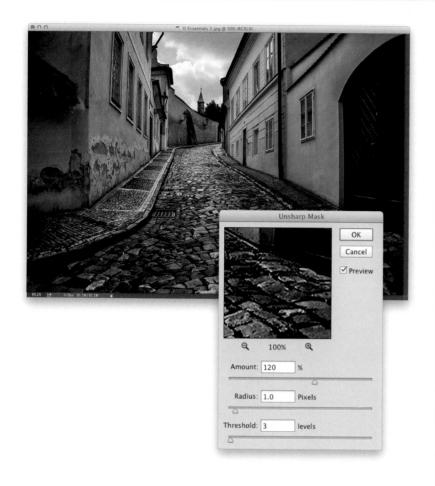

When the Unsharp Mask dialog appears, you'll see three sliders. The Amount slider determines the amount of sharpening applied to the photo; the Radius slider determines how many pixels out from the edge the sharpening will affect; and Threshold determines how different a pixel must be from the surrounding area before it's considered an edge pixel and sharpened by the filter (by the way, the Threshold slider works the opposite of what you might think—the lower the number, the more intense the sharpening effect). So what numbers do you enter? I'll give you some great starting points on the following pages, but for now, we'll just use these settings-Amount: 120%, Radius: 1, and Threshold: 3. Click OK and the sharpening is applied to the entire photo (see the After photo below).

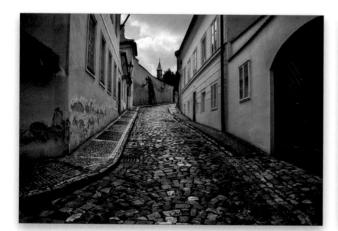

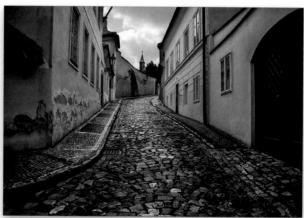

After

Soft subject sharpening:

Here are Unsharp Mask settings—Amount: 120%, Radius: 1, Threshold: 10—that work well for images where the subject is of a softer nature (e.g., flowers, puppies, people, rainbows, etc.). It's a subtle application of sharpening that is very well suited to these types of subjects.

Portrait sharpening:

If you're sharpening close-up portraits, try these settings—Amount: 75%, Radius: 2, Threshold: 3—which apply another form of subtle sharpening, but with enough punch to make eyes sparkle a little bit, and bring out highlights in your subject's hair.

TIP: Sharpening Women

If you need to apply a higher level of sharpening to a portrait of a woman, first go to the Channels panel and click on the Red channel (shown here) to make it the active channel (your image will appear in black and white). Now, apply your sharpening here, using a higher Amount, like 120%, Radius: 1, Threshold: 3, right to this Red channel. By doing this, it avoids sharpening most of the skin texture and instead just sharpens her eyes, eyebrows, lips, hair, and so on. Once it's applied, click on the RGB channel at the top of the Channels panel to return to the full-color image.

Moderate sharpening:

This is a moderate amount of sharpening that works nicely on everything from product shots, to photos of home interiors and exteriors, to landscapes (and in this case, some hats). These are my favorite settings when you need some nice snappy sharpening. Try applying these settings—Amount: 120%, Radius: 1, Threshold: 3—and see how you like it (my guess is you will). Take a look at how it added snap and detail to the bling around the hat and the edge of it.

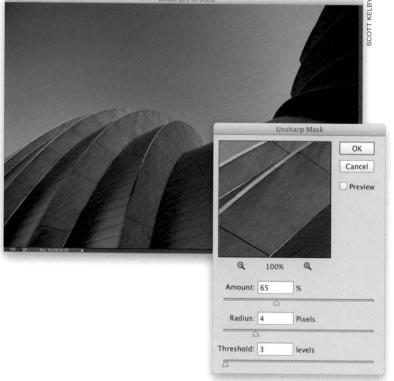

Maximum sharpening:

I use these settings—Amount: 65%, Radius: 4, Threshold: 3—in only two situations: (1) The photo is visibly out of focus and it needs a heavy application of sharpening to try to bring it back into focus. (2) The photo contains lots of well-defined edges (e.g., rocks, buildings, coins, cars, machinery, etc.). In this photo, the heavy amount of sharpening really brings out the detail in the edges of this building.

All-purpose sharpening:

These are probably my all-around favorite sharpening settings—Amount: 85%, Radius: 1, Threshold: 4—and I use these most of the time. It's not a "knock-you-over-the-head" type of sharpening—maybe that's why I like it. It's subtle enough that you can apply it twice if your photo doesn't seem sharp enough the first time you run it, but once will usually do the trick.

Web sharpening:

I use these settings—Amount: 200%, Radius: 0.3, Threshold: 0—for web graphics that look blurry. (When you drop the resolution from a high-res, 300-ppi photo down to 72 ppi for the web, the photo often gets a bit blurry and soft.) If the sharpening doesn't seem sharp enough, try increasing the Amount to 400%. I also use this same setting (Amount: 400%) on out-of-focus photos. It adds some noise, but I've seen it rescue photos that I would otherwise have thrown away.

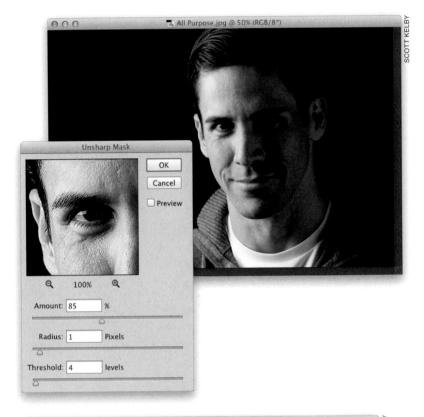

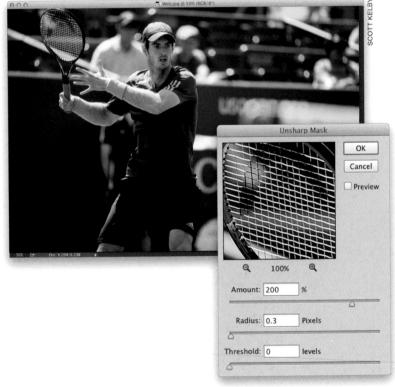

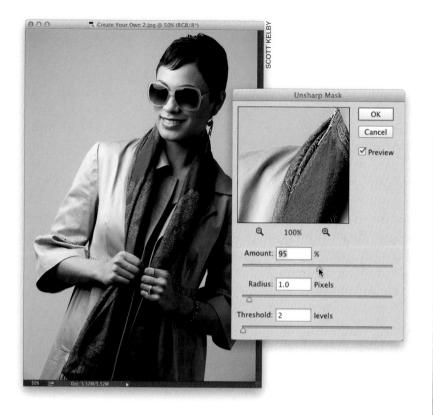

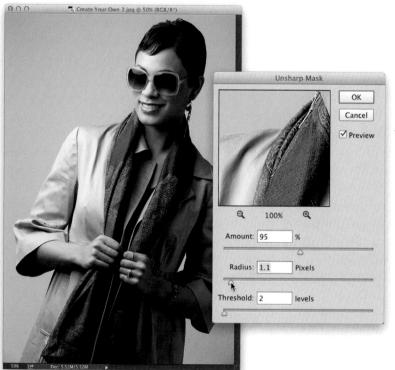

Coming up with your own settings: If you want to experiment and come up with your own custom blend of sharpening, I'll give you some typical ranges for each adjustment so you can find your own sharpening "sweet spot."

Amount

Typical ranges run anywhere from 50% to 150%. This isn't a hard-and-fast rule—just a typical range for adjusting the Amount, where going below 50% won't have enough effect, and going above 150% might get you into sharpening trouble (depending on how you set the Radius and Threshold). You're fairly safe staying under 150%. (In the example here, I reset my Radius and Threshold to 1 and 2, respectively.)

Radius

Most of the time, you'll use just 1 pixel, but you can go as high as (get ready) 2 pixels. You saw one setting I gave you earlier for extreme situations, where you can take the Radius as high as 4 pixels. I once heard a tale of a man in Cincinnati who used 5, but I'm not sure I believe it. (Incidentally, Adobe allows you to raise the Radius amount to [get this] 250! If you ask me, anyone caught using 250 as their Radius setting should be incarcerated for a period not to exceed one year and a penalty not to exceed \$2,500.)

Threshold

A pretty safe range for the Threshold setting is anywhere from 3 to around 20 (3 being the most intense, 20 being much more subtle. I know, shouldn't 3 be more subtle and 20 be more intense? Don't get me started). If you really need to increase the intensity of your sharpening, you can lower the Threshold to 0, but keep a good eye on what you're doing (watch for noise appearing in your photo).

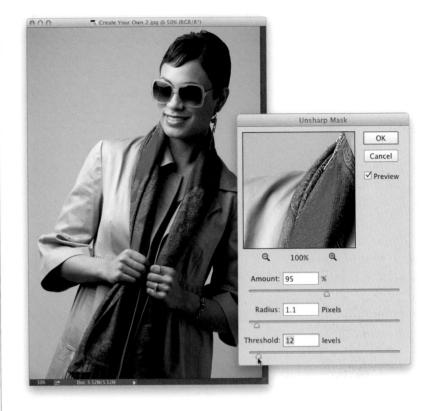

The Final Image

For the final sharpened image you see here, I used the Moderate sharpening settings I gave earlier (Amount: 120%, Radius: 1, Threshold: 3), and I used that tip I gave you after the Portrait sharpening settings for sharpening women, where I only applied this sharpening to the Red channel, so it avoided sharpening her skin texture too much (yet sharpened her hair, eyebrows, lips, clothing, etc.). If you're uncomfortable with creating your own custom Unsharp Mask settings, then start with this: pick a starting point (one of the set of settings I gave on the previous pages), and then just move the Amount slider and nothing else (so, don't touch the Radius and Threshold sliders). Try that for a while, and it won't be long before you'll find a situation where you ask yourself, "I wonder if lowering the Threshold would help?" and by then, you'll be perfectly comfortable with it.

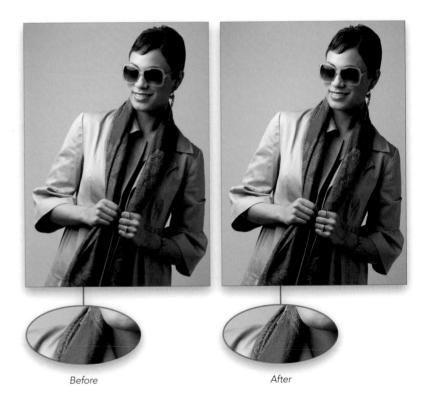

Back in Photoshop CS5, Adobe rewrote the underlying logic of the Sharpen tool—taking it from its previous role as a "noise generator/pixel destroyer" to what Adobe Product Manager Bryan O'Neil Hughes has called "...the most advanced sharpening in any of our products." Here's how it works:

The Most Advanced Sharpening in Photoshop

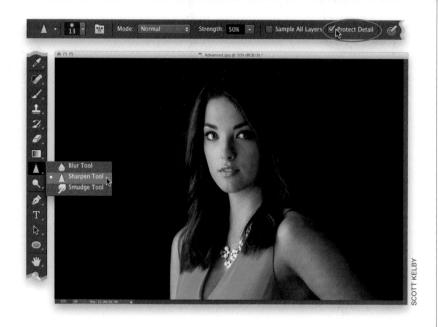

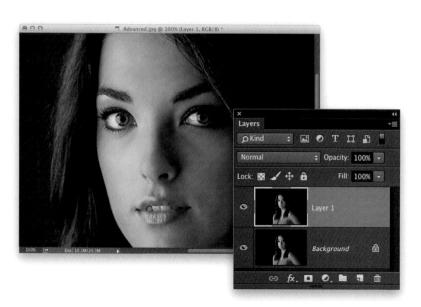

Step One:

Start by applying your regular sharpening to the overall image using Unsharp Mask or Smart Sharpen (more on this coming up next)—your choice. In this case, since this is a portrait of a woman, I'd apply this overall sharpening to just the Red channel (see the tip on page 290 in this chapter). Now, get the Sharpen tool from the Toolbox (it's found nested beneath the Blur tool, as seen here). Once you've got the tool, go up to the Options Bar and make sure the Protect Detail checkbox (shown circled here in red) is turned on (this is the checkbox that makes all the difference, as it turns on the advanced sharpening algorithm for this tool).

Step Two:

I recommend duplicating the Background layer at this point (by pressing Command-J [PC: Ctrl-J]) and applying this extra level of sharpening to this duplicate layer. That way, if you think the sharpening looks too intense, you can just lower the amount of it by lowering the opacity of this layer. I also usually zoom in (by pressing Command-+ [plus sign; PC: Ctrl-+]) on a detail area (like her eyes), so I can really see the effects of the sharpening clearly (another benefit of applying the sharpening to a duplicate layer is that you can quickly see a before/ after of all the sharpening by showing/ hiding the layer).

Now, choose a medium-sized, softedged brush from the Brush Picker in the Options Bar, and then simply take the Sharpen tool and paint over just the areas you want to appear sharp (this is really handy for portraits like this, because you can avoid areas you want to remain soft, like skin, but then super-sharpen areas you want to be really nice and crisp, like her irises and her necklace, like I'm doing here). Below is a before/after, after painting over other areas that you'd normally sharpen, like her eyes, eyebrows, eyelashes, and lips, while avoiding all areas of flesh tone. One more thing: This technique is definitely not just for portraits. The Sharpen tool does a great job on anything metal or chrome, and it's wonderful on jewelry, or anything that needs that extra level of sharpening.

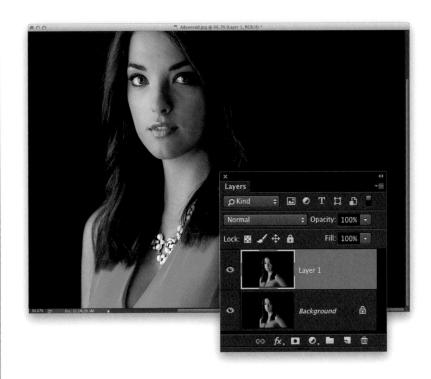

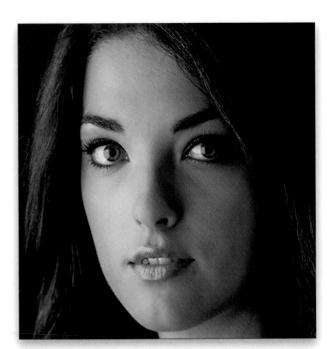

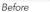

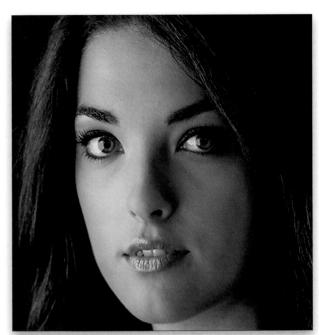

After

Smart Sharpen has been in Photoshop for a while now, but Adobe went back and updated both the math and the interface to make it the most powerful sharpening tool ever! Interface-wise, the window is now resizable (just drag a corner in/out) and they've streamlined the look, as well. But, it's what's "under the hood" that really makes it special, because now you can apply a higher level of sharpening without getting halos. There's also a new slider that allows you to sharpen without sharpening any noise that's already in the image.

Smarter Smart Sharpen

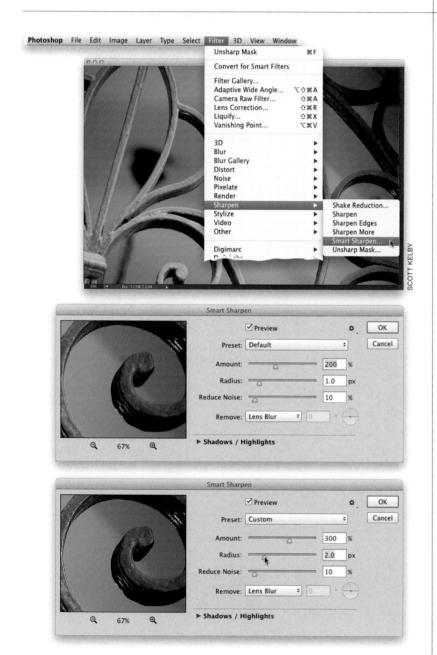

Step One:

Smart sharpening is in the same place it's always been: go under the Filter menu. under Sharpen, and choose Smart Sharpen (as shown here). This brings up the improved Smart Sharpen filter dialog, (which, as I mentioned above, is totally resizable). The controls are all in the same place as in the previous Smart Sharpen dialog, except for the addition of the Reduce Noise slider. The goal with this slider is not to decrease noise, it's to let you add a lot of sharpening without increasing the noise. So, after you apply your sharpening, you'll drag this slider to the right until the noise in the photo looks just about like it did before you sharpened the image.

Step Two:

One of the downsides of sharpening has always been that if you apply a lot of sharpening, the edges start to get "halos" around them, but Smart Sharpen's new algorithm lets you apply a higher amount of sharpening before halos start to appear. So, how do you know how far you can push the sharpening? Adobe recommends that you start by increasing the Amount slider to at least 300%, and then start dragging the Radius slider to the right until you start to see halos appear around the edges. When they appear, back the slider off by a little bit (until the halos go away).

Now you've got your Radius set correctly, so go back to the Amount slider and start dragging it to the right (above 300%) until the sharpening looks good to you (or haloing appears, but you'd have to crank it quite a bit before that happens). I think this new sharpening algorithm is dramatically better than in the previous Smart Sharpen, but if you'd like to use the old method (or just use it to compare), just press the letter L on your keyboard and it applies the legacy Smart Sharpen (the old version, before the new math). Press it again to return to the new Smart Sharpening. You can also choose Use Legacy from the settings pop-up menu at the top-right corner of the filter dialog.

Step Four:

In the previous version of Smart Sharpen, there was an Advanced radio button, and if you clicked on it, two other tabs would show up: one for reducing the amount of sharpening in the highlight areas (I never used that one), and one for reducing sharpening in the shadow areas (I occasionally used this one, but just on really noisy images—it allowed you to reduce or turn off sharpening in the shadow areas where noise is usually most visible—but now with the Reduce Noise slider, I'm not sure if I'll ever use it again). You can still access both of these features by clicking on the little right-facing triangle to the left of Shadows/ Highlights—just click on the triangle and the two sets of sliders appear (shown here).

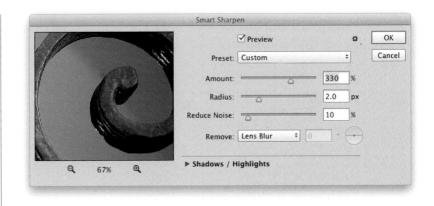

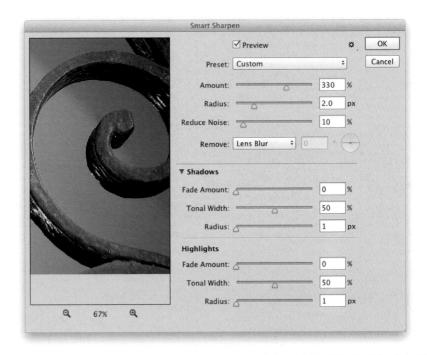

After

I don't normally include the same technique twice in the same book, but if you read the HDR chapter, I included High Pass sharpening there, too, because it has become kind of synonymous with HDR processing. Of course, what I'm concerned about is that you skipped over the HDR chapter altogether, and came here to the sharpening chapter, and you'd be wondering why the very popular High Pass sharpening technique (which creates extreme sharpening) wasn't included in the book. Well, it's so good, it is covered twice.:)

High Pass Sharpening

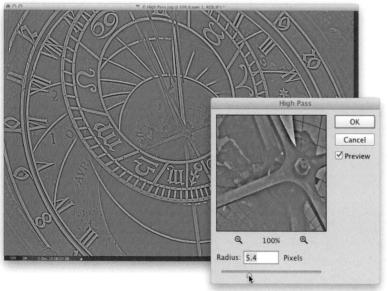

Step One:

Open a photo that needs some extreme sharpening, like this photo taken in Prague. Duplicate the Background layer, as shown here, by pressing **Command-J (PC: Ctrl-J)**.

Step Two:

Go under the Filter menu, under Other. and choose High Pass. You use this filter to accentuate the edges in the photo, and making those edges stand out can really give the impression of mega-sharpening. I start by dragging the Radius slider all the way to the left (everything turns gray onscreen), then I drag it over to the right. For non-HDR images, I don't drag it all that far—I just drag until I see the edges of objects in the photos appear clearly, and then I stop. The farther you drag, the more intense the sharpening will be, but if you drag too far, you start to get these huge glows and the effect starts to fall apart, so don't get carried away. Now, click OK to apply the sharpening.

In the Layers panel, change the layer blend mode of this layer from Normal to **Hard Light**. This removes the gray color from the layer, but leaves the edges accentuated, making the entire photo appear much sharper (as seen here). If the sharpening seems too intense, you can control the amount of the effect by lowering the layer's Opacity in the Layers panel, or try changing the blend mode to Overlay (which makes the sharpening less intense) or Soft Light (even more so).

Step Four:

If you want even more sharpening, duplicate the High Pass layer to double-up the sharpening. If that's too much, lower the Opacity of the top layer. One problem with High Pass sharpening is that you might get a glow along some edges. The trick to getting rid of that is to: (1) press Command-E (PC: Ctrl-E) to merge the two High Pass layers, (2) click the Add Layer Mask button at the bottom of the panel, (3) get the Brush tool (B), and with a small, soft-edged brush and your Foreground color set to black, (4) paint right along the edge, revealing the original, unsharpened edge with no glow.

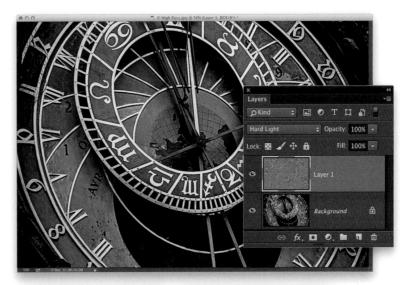

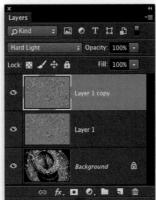

After

If you wind up doing all your edits from right within Camera Raw, and then you save straight to a JPEG or TIFF right from Camera Raw, as well (skipping the jump to Photoshop altogether), you'll still want to sharpen your image for how the image will be viewed (onscreen, in print, etc.). This is called "output sharpening" (the sharpening you do in Camera Raw's Detail panel is called "input sharpening," because it's designed to replace the sharpening that would have been done in your camera if you had shot in JPEG or TIFF mode).

Output Sharpening in Camera Raw

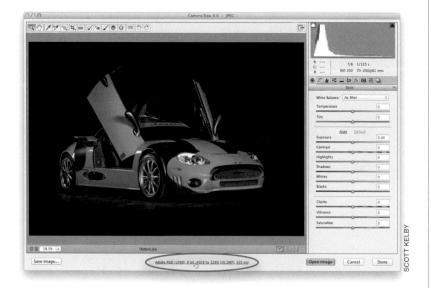

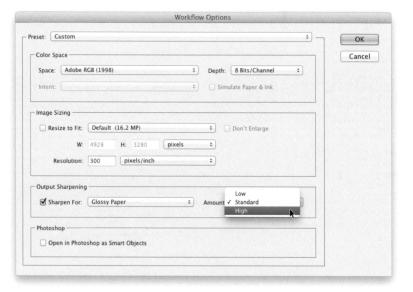

Step One:

Before we do this output sharpening, it's important to note that this sharpening only kicks in if you're going to save your image from right here within Camera Raw by clicking the Save Image button in the bottom-left corner of the Camera Raw window. If you click the Open Image or Done button, the output sharpening is not applied. Okay, now that you know, you find output sharpening by clicking on the line of text (which looks like a web link) below the Preview area (it's circled here in red).

Step Two:

First, turn on your Sharpen For checkbox in the Output Sharpening section, then choose how you want this image sharpened from the Sharpen For pop-up menu: Screen is for images you're going to post on the web, email to a client, or present in a slide show. If the image is going to be printed, choose whether you'll be printing to Glossy Paper or Matte Paper. Lastly, choose the amount of sharpening you want from the Amount pop-up menu. Camera Raw will do the math based on the image's resolution, your Sharpen For choice, and Amount choice (I never choose Low, by the way) to calculate the exact right amount of output sharpening. Note: When you click OK, the sharpening stays on from now on. To turn it off, turn off the Sharpen For checkbox.

Photoshop Killer Tips

Content-Aware Fill Tips

If you made a selection in an image and tried Content-Aware Fill on it, but you're not happy with the results, try one of these two tips: (1) Press Command-Z (PC: Ctrl-Z) to Undo the Fill, then try Content-Aware Fill again. It's somewhat random in choosing the area it samples to fill its area from, so simply trying it again might do the trick (this works more often than you might think). (2) Try to expand your selection a little bit. Once you've put a selection around what you want to remove, go under the Select menu, under Modify, and choose Expand, then try expanding your selection by 3 or 4 pixels, and try Content-Aware Fill again. It just might do the trick.

If One of Your Tools Starts Acting Weird...

...chances are something has changed in the options for that tool (up in the Options Bar) that may not be obvious by just looking at the Options Bar. In that case, you can reset the tool to its factory defaults by Right-clicking directly on the little downfacing arrow next to the tool's icon at the far-left side of the Options Bar, and a popup menu will appear where you can choose to reset your current tool, or all your tools.

Tip for When You're Zoomed In Tight

If you're zoomed in tight on a photo, there is nothing more frustrating than trying to move to a different part of the image using the scroll bars (they always seem to move

you way too far, and then eventually you just have to zoom back out and then zoom back in again). Instead, just press-and-hold the **Spacebar**, and it temporarily switches you to the Hand tool, so you can click-and-drag the image right where you want it. When you release the Spacebar, it returns you to the tool you were using.

Merge to HDR Pro Can Make Killer B&W Images

I know that when you say "HDR" most folks picture those surreal, super-vibrant images that you see all over the web, which is why you may not think of Merge to HDR Pro as a choice for creating blackand-white images, but it actually does a pretty amazing job (and although most of the built-in presets that come with Merge

to HDR Pro kinda stink, the Monochromatic (B&W) presets aren't half bad. Give this a try the next time you shoot a bracketed image.

Giving Your RAW Image to Someone Else (Along with Your Edits)

If you've edited a photo in Camera Raw, and you give the RAW file to a client, they won't see the edits you've made to the file, unless: (a) you include the separate XMP file along with your RAW file (it should be found right beside the RAW file in your image folder), or (2) you save the file in DNG format in the Format pop-up menu in Camera Raw's Save Options dialog (DNG is Adobe's open-source format for RAW images, and it embeds your edits in the DNG file).

Photoshop Killer Tips

Lock Multiple Layers at Once

If you want to lock more than one layer at a time, it's no sweat. Just Command-click (PC: Ctrl-click) to select as many layers as you want locked, and then click on the Lock icon at the top of the Layers panel.

This works the same when assigning Color labels—just select the layers you want to label, then Right-click on one of the layers, and choose the Color label you want to assign to the selected layers from the pop-up menu.

Making Selections Near the Edge of Your Document

When you're making a selection (with one of the Lasso tools), and you reach the edge of your document window, you don't have to release and start over—just press-and-

hold the **Spacebar**, and your Lasso tool temporarily switches to the Hand tool, so you can move over enough to complete your selection, then release the Spacebar and it switches you back to the Lasso tool, and (here's what's so cool) your selection-in-process has been frozen in place, so now you can pick right up where you were.

Keeping Your Camera Settings to Yourself

If you're posting an image on the web, or sending an image to a client, you might not want to have all your camera settings, and camera serial number, included in the image where anyone can view it (after all, does your client really need to know you

shot this at f/5.6 at 800 ISO?). So, to keep your camera settings to yourself, just press Command-A (PC: Ctrl-A) to select your entire image, then press Command-C (PC: Ctrl-C) to copy it into memory. Now, press Command-N (PC: Ctrl-N) and Photoshop will automatically create a new document that is the exact size, resolution, and color mode as the image you copied into memory. Next, press Command-V (PC: Ctrl-V) to paste your image into this new blank document. Then, press Command-E (PC: Ctrl-E) to flatten the image, and you can send this file anywhere without having your camera data in the file. However, I would go under the File menu and choose File Info, then click on Basic on the left, and I'd enter my copyright info in the copyright section.

Want to See Your Adjustment Layer Controls Larger?

If you add a Levels, or Hue/Saturation, or Curves (and so on) adjustment layer,

those controls appear in the Properties pan el at its default size. But, if you want more precision when working with those settings

in the panel, just click on the left side of the panel and drag it out to the left. As the panel gets larger, so do the adjustment's controls themselves.

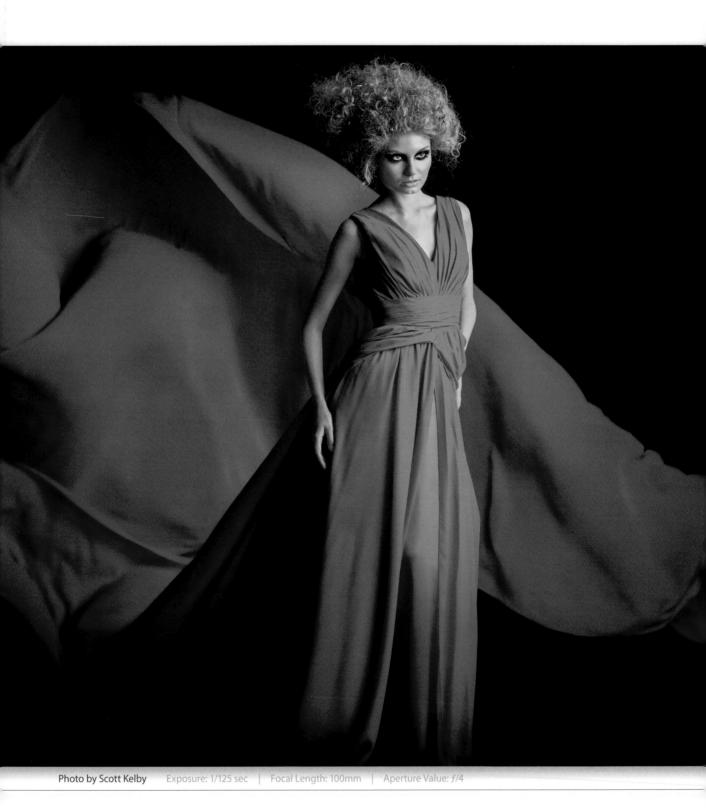

Chapter 10 Editing DSLR Video in Photoshop

Videodrome editing DSLR video in photoshop

The name of this chapter comes from the 1983 movie of the same name starring Debbie Harry, lead singer of the '80s band Blondie, in what I can only imagine was her film debut and simultaneous film career exit, since I never heard of Debbie Harry starring in any other movies. Now, in all honesty, I might be jumping the gun on this one, so in all fairness to Ms. Harry, I'm pausing this chapter intro right now to go and check the official online source for anything to do with movies, and that is, of course, www.homedepot .com (okay, not really, but I gotta tell ya, they had a pretty sweet deal on a DeWalt 18-Volt ½ in. Cordless Impact Wrench). Anyway, instead, I went and checked IMDb (the Internet Movie Database), and I have to tell you, I was pretty shocked to find out that Debbie Harry was actually listed as an actress in 53 movies and TV shows. 53! Digging a little deeper (not really), I learned that none of those were put together using Photoshop's built-in video capabilities, because prior to CS6, Photoshop barely had any serious

video editing capabilities. I mean, you could do a few things, but nothing like the complexity you see in Debbie Harry's 2011 (pre-CS6) movie short Pipe Dreams, where she played Iris, a young undocumented worker from Ecuador. (Oh, I can see where this is going. They never have their documentation, now, do they?) According to IMBb, the movie pretty much takes place in an aging smoking-pipe manufacturing plant. Geesh-not that tired old scenario again. I can probably tell you the ending already. Let me guess: she gets hooked on tobacco products and winds up hitchhiking to North Carolina, where she meets an aging nicotine salesman from Raleigh who convinces her to become a documented worker, and then the two open a small pet bakery/mobile spray-tanning business in Jacksonville, against the wishes of her controlling Canadian rebel-fighting parents and Kreshnik, her half-blind Albanian ex-fiancé and father of their illegitimate teacup schnauzer, Mr. Buttersticks. Tell me you didn't see that one coming, right?

Four Things to Know Now About Creating Video in Photoshop

Most of the photographers I talk to that have shot video with their DSLRs tell me they have a bunch of individual movie clips just sitting in a folder on their computer—they've never even created a movie with them. I ask why, and they say, "I don't have time to learn a video editing program." I get it. Neither do I, which is why I truly believe the video feature in Photoshop is a game changer. Now we can edit video in a program we already know, so we don't need to learn a new program, just one new feature. This is what we've always dreamed of: a photography program that lets us edit video, instead of making us photographers learn a video program. You're going to love this!

1 It Helps to Have Lots of RAM When it comes to video, more is more. Ideally, you'd have a minimum of 8 GB of RAM, but the more the merrier, because unlike still images, video has to "render" (which it does in RAM), and the more RAM you have, the faster you'll be able to preview clips without them being jumpy or jittery.

2 It's Ideal for Making Short Movies

Although you could certainly make a 30-minute movie in Photoshop, it's really best suited for shorter movies, like 5 to 10 minutes—the kind of videos wedding photographers might create, or promo videos for a photographer's website (maybe a behind-the-scenes of a shoot), or YouTube commercials, and stuff like that. If you need to make something longer and more complex, then you should make a number of short movies in Photoshop, and then combine all these shorter clips into one longer final version at the end. If you're thinking of using Photoshop to create a full-scale motion picture (i.e., Braveheart 2 or Spiderman 3), you should probably use a full-fledged video application like Premiere Pro.

Properties Levels Preset: Default RG8 Auto Auto Output Levels: 0 255

3 Pretty Much All of This Happens in Just One Panel

The Timeline panel is where we build our video, edit it, add more clips, add music, transitions, etc. Luckily, it's really pretty easy to learn because you don't have to learn a whole lot more than this one panel (I keep mine along the bottom of the screen). One Timeline feature you'll learn more about in just a few pages is the playhead. The playhead (it's that blue knob with the thin, red, vertical line) moves from left to right as your movie is playing to show you where you are in the movie. When the movie's not playing, if you want to see a particular video clip or a particular area of the movie, just drag the playhead to the spot in the movie where that thing appears and it shows it onscreen. This takes a little bit of getting used to (it'll catch you a few times where you're just sitting there wondering, "Why isn't it showing my clip." When that happens, just look to see where the playhead is—whatever it's over, that's what's being displayed). But, don't worry, you'll get it.

4 You Can Treat Video Clips Almost Like Stills and Use Nearly All of Photoshop's Regular Filters and Stuff

I think one of the best things about editing video in Photoshop is you get to use the same tools you're already familiar with from working on photos and just apply them to video. We're talking everything from Levels to Curves, to filters like Gaussian Blur and Unsharp Mask. You resize things using Free Transform, and you add type with the Type tools. Lots more on this soon, but here's the good news: once your video is in the Timeline in the order you want it, you already know how to do tons of cool stuff to your movie, because the rest is just Photoshop!

Opening Your Video Clips into Photoshop

You can open a video clip to start building your movie like it was any other file, so getting a clip to open in Photoshop is easy (especially since Photoshop supports all the most common movie file formats found in DSLRs), but this isn't about just opening a video clip in Photoshop to start your movie project. This is really about what to do after you've started your video project, because knowing what to do next (how to add more clips to your movie) can save you a lot of time and frustration. Later, you'll get to mix video and still (and have audio, as well), so learning this first is worth the guick read.

Step One:

Once your movie clips have been imported from your DSLR onto your computer, you can open these clips in Photoshop just like you would any other file—by going under the File menu and choosing Open, which is what I did here (go ahead and open a video clip. If you don't have one, you can download the ones I'm using here). When it opens, Photoshop knows it's a video file and it automatically opens the Timeline panel across the bottom (seen here), which is where we put our movie together. The length of the blue bar corresponds to how long the video is (in minutes and seconds). The longer the bar, the longer the video clip. You can change the size (magnification) of what's in the timeline by using the slider at the bottom of the panel.

Step Two:

If you want to add another video clip to play right after this clip, then you'd click on that little filmstrip icon to the right of Video Group 1 on the left side of the Timeline panel (it's shown circled here in red), and choose **Add Media**. In the Add Clips (PC: Open) dialog, navigate to the next video clip, select it, and click Open. This adds that video clip right after your first clip (the clips play in order, from left to right in the Timeline panel).

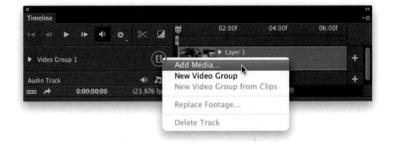

If you've got a bunch of clips you want to open at once, just click on the little filmstrip icon, choose Add Media, then in the Add Clips (PC: Open) dialog, Command-click (PC: Ctrl-click) on each clip to select all the clips you want to use and click Open.

Step Four:

This will open all the files in Photoshop with each on its own layer. Before I opened these clips, I renamed them in the order that I thought I might want them, so my clip's names are numbered (Clip 01.mov, Clip 02.mov, and so on). When they're opened, they open in order—Clip 01 is first, then Clip 02, and so on. Whichever clip is on the far left of the timeline (the bottom layer in the layer stack) will be the first clip that plays, whichever clips appears to the right of it plays next, etc.

Your Basic Controls for Working with Video

The panel where almost everything video-related happens is called the Timeline panel. Most video editors are based on this same idea, because it's a very visual way to put together a movie. You build your movie from left to right, just like you would a slide show, where the first thumbnail is the first slide, then the one to the right of that is the second, and so on. Same thing with video, except, of course, that the thumbnails are videos. Take two minutes now to learn the Timeline panel and its basic controls, and it'll make your video editing life a lot easier.

Step One:

You play, rewind, and fast-forward your video in Photoshop just like you would in any other video player (using the standard Rewind [Go to Previous Frame], Play, and Fast-Forward [Go to Next Frame] icons). However, there is a "rewind to the beginning" icon (it's actually the Go to First Frame icon) that you'll wind up using quite a bit (it's the first icon, just to the left of Rewind).

The Go to First Frame icon takes you back to the very beginning

Step Two:

Now, click on the down-facing arrow in the top right of the Timeline panel, and from the flyout menu, choose **Enable Timeline Shortcut Keys** to turn on your shortcuts for the panel. There's a great shortcut you can use to play your video: just hit the **Spacebar** on your keyboard. It starts (and then stops) your video. To jump to the beginning of the individual clip that is curently selected, press the **Up Arrow key** on your keyboard. To jump to the end of that clip, press the **Down Arrow key**.

TIP: Put Your Playhead at Any Spot To move your playhead to any spot you want it in the timeline, just click once up at the top of the timeline, right on where the seconds are listed, and your playhead immediately jumps to that spot.

Pressing the Up Arrow key jumps the playhead back to the beginning of the selected clip. The Down Arrow key jumps you to the end

By default, the start of the work area is the start of your movie

Drag the Start and End Work Area bars to change where your playhead starts and stops (so when you click Play, it will start 10 seconds into your movie, at the left bar, and stop 20 seconds in, at the right one)

To jump back 1 second in the timeline, press Shift-Up Arrow. To jump forward 1 second, press Shift-Down Arrow

If you know you want your movie to be a specific length, like maybe 30 or 60 seconds for a commercial, or 90 seconds for a promo movie, you can keep from having to scroll back and forth down your timeline by setting up your work area to display just that amount of time from the very beginning. You do that by dragging the little Set Start of Work Area bar at the beginning of the timeline or the Set End of Work Area bar at the end of the timeline to the length you want your movie. That way, when your playhead hits the end of your work area (after playing for 30 seconds), it stops (it doesn't just keep playing nothing). Also, if you want to work on just one part of a longer video, then you can drag the Set Start of Work Area bar to the beginning of that part, and then drag the Set End of Work Area bar to the end of that area. Now, when you click Play, it starts where you set the start of your work area and stops where you set the end.

Step Four:

There are some other shortcuts you might want to use once you really dig into this, but for now, I'd just concentrate on those ones I've given you here, because they're the ones you'll use every time you make a movie. Just in case you need them, though, here are a few more: To jump back one frame, press the **Left** Arrow key. Add the Shift key to jump back 10 frames. Use the **Right Arrow** key to jump forward one frame; add the Shift key to jump forward 10. To jump to the end of your timeline, press the **End key** on your keyboard. To jump back 1 second in time, press Shift-Up Arrow key. To jump forward 1 second, press Shift-Down Arrow key. Again, you may not ever use these, but at least you know they're there.

Step Five:

There are some other important things you'll want to know about the Timeline panel: One is that you can change the size of the thumbnails in the Timeline panel by dragging the size slider at the bottom of the panel (it's shown circled here in red). Dragging to the left makes the thumbnails smaller; dragging to the right makes them larger. The advantage of choosing a smaller thumbnail size is that you'll see more of your movie in the timeline without scrolling (of course, it helps if you have the eyes of a 14-year-old, because if you're any older, you're probably going to need bifocals).

TIP: Rearranging the Order of Clips

There are two ways to change the order of how your clips play: (1) you can dragand-drop the clips into the order you want right there in the timeline, or (2) you can change the order over in the Layers panel. They stack from bottom (being the first clip to play) to top, so just drag-and-drop the layers into the order you want the clips to play.

Step Six:

If you want to see a quick preview of any part of your video, you can just grab the playhead and, as you drag it right or left across your video, it plays a preview of the video that's below it (you don't hear any audio, you just see the video). This is called "scrubbing" in "Video Land" (they have a secret code name for everything). This is a huge time saver and you'll find yourself scrubbing over clips quite often.

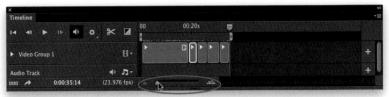

If you zoom out, you can fit the whole 35:14 movie in the timeline without having to scroll over to the right at all

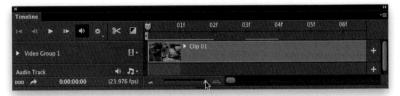

If you zoom way in, now you're just seeing the first 7 seconds of your movie. This is handy when you've got a lot going on (like a bunch of very short clips close together with transitions)

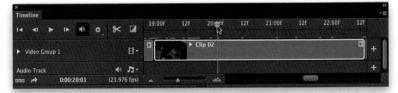

Here, I'm "scrubbing" across the second clip to see a preview of it, without clicking Play

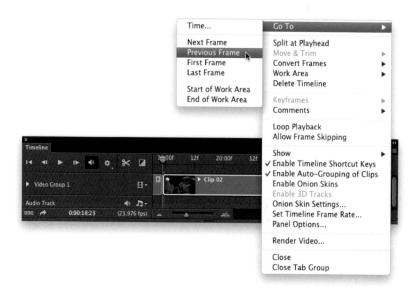

Step Seven:

You know that flyout menu at the topright corner of the Timeline panel? If you ever can't remember the shortcut to do something, you can most likely do it there. Also, by default, Photoshop uses its regular keyboard shortcuts for everything. For example, if you have the Move tool active, and you press the Up or Down Arrow key on your keyboard, it will move your clip up or down onscreen. However, if you turn on Enable Timeline Shortcut Keys, as we did in Step Two, then it uses the shortcuts I mentioned in that step. So, now the Up Arrow key jumps you to the beginning of the currently selected clip, and the Down Arrow key jumps you to the end of that clip.

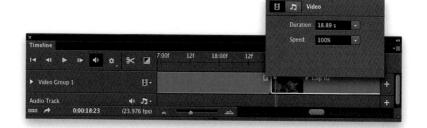

Step Eight:

There's a little right-facing triangle at the end of each video clip and clicking on it brings up a settings dialog with more options for that clip. For example, you can set the Duration in the Video settings here. So, if the clip needed to be 4 minutes exactly, you could set it to 4 minutes exactly by dragging the slider or simply entering 4 minutes in the Duration field. There's also a speed control here. If you click the music notes icon at the top, you'll get the Audio options for just this clip, including the overall volume for the clip's audio (or you can mute the audio), and you can set the audio Fade In and Fade Out points numerically.

Editing (Trimming) Your Clips

When we shoot digital photos, we wind up taking a lot of shots that nobody ever sees in our quest to find a "keeper." Same thing in video. We shoot a lot of footage where some parts at the beginning or end of our video (like us saying "Cut!" at the end of a clip) just need to be deleted. This cropping off of the beginning and/or end of our videos is called "trimming" (you trim off the parts that you don't want anyone to see), but we cover a bit more here than just this, so make sure you don't skip over it if you already know how to trim.

Step One:

In the Timeline panel, click on the Get Media icon and open Clip 01.mov and Clip 02.mov to start a new movie. Now, click the Play icon and you'll see that the first clip (the clip of the makeup table) has got a few starts and stops in it, so we need to trim away parts of the video we don't need. All you have to do is click-and-hold directly on the beginning of the clip in the timeline and a little trimming preview window will pop up (as seen here).

Step Two:

As you drag to the right (this is called "scrubbing" in video world), the preview starts and stops. It looks good right around the 2-second mark in the video, so keep dragging to the right until you get to that point. Now, just let go of your mouse button and it trims off everything before that. It shows the new start time of that clip as 2 seconds and 6 frames.

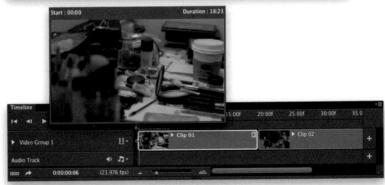

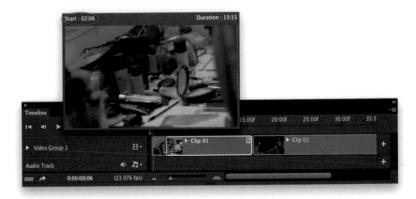

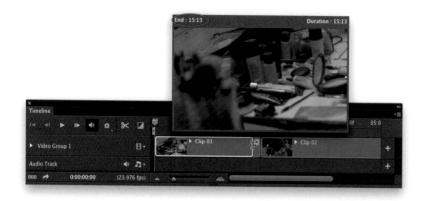

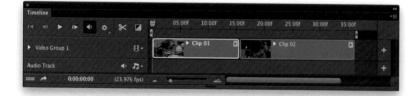

Next, let's do the same thing to the end of the clip and trim away some of the footage of the makeup table. Click-and-hold directly on the end of the clip (that preview window pops up again), and drag to the left while you keep an eye on that preview window. Keep dragging to about the 15:13 end mark (look up in the top-left corner of the preview window and it shows you the time in seconds and frames, so stop around 15 seconds and 13 frames, as shown here). You've now trimmed off a bit of the end, and your original 18-second video is down to about a 15-second clip overall.

Step Four:

Now, what about that second clip we added that appears immediately after the clip we just trimmed? Won't there be a big gap of nothing between the two clips? Nope. Photoshop automatically moves that clip over for you, so there are no gaps in your movie. Pretty sweet, eh? Here, you can see your two clips, which, even after trimming, are still back-to-back. If you look up at the top of the timeline, you'll see that the first clip is now only around 15 seconds of your movie, and the second clip starts immediately after it. Also, don't worry, even though you trimmed that video away, you can always bring it right back the same way you trimmed it—just click on either end and drag it out (so it's really more like it's hidden than trimmed, but again, in the world of video, its referred to as "trimming"). Okay, that's all there is to it.

Working with Audio and Background Music

There are three types of audio you'll wind up dealing with in your movies: (1) there's audio in the video you captured with your camera, and you get to decide whether your audience will hear that or not, (2) you can add a background music track behind your video, and (3) you can add additional audio tracks for things like narration or sound effects. Luckily, managing these is fairly easy.

Step One:

We'll pick up with the two clips we used in the previous trimming project. If you look in the Timeline panel, directly below your movie clips, you'll see an empty track right below it (and it says Audio Track to the left of it, below Video Group 1). That's where your audio (background music or narration tracks) goes. To add an audio track, click directly on the little music notes icon and, from the pop-up menu that appears, choose **Add Audio** (as shown here).

Step Two:

Find the audio track you want to use as your background music (Photoshop supports most common audio file formats, from AAC to MP3). You can go to the book's download page and download the track I used, which is a royaltyfree background music track from Triple Scoop Music (they have lots of great background music tracks you can buy and use in your projects. I actually have a Signature Series Music Collection on their site for landscape and travel photography. They were gracious enough to let me share this track with you to practice along with. I found it while browsing their site and it worked perfectly for this project. Be sure to take a look in the back of the book for a special deal from them). Anyway, once you select your audio file and click Open, it adds your background music to the timeline, where it appears in green so you know instantly it's audio (video clips appear in blue).

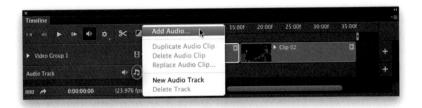

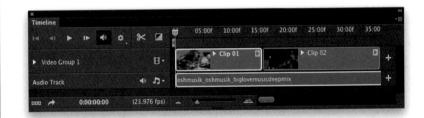

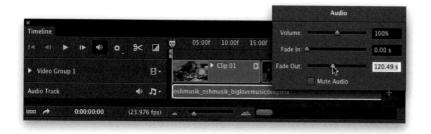

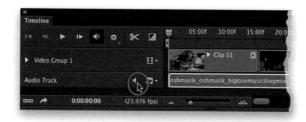

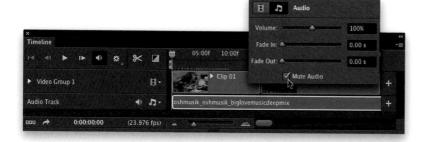

Click the Play icon (or just press the **Space**bar) to play our short video, and now the background music plays, as well. Makes a huge difference, doesn't it? At the end of this chapter, we're going to build a 2-minute demo video, so just like the video clip, trim the music down to around 2 minutes. Our music clip is 4 minutes 39 seconds long, so it's going to cut off really abruptly at the end of our video, unless we gently fade the music out. So, Right-click directly on your green audio track and an Audio settings dialog appears, where you can choose when you want the music to fade in (since we're starting at the beginning of the song, we don't need to fade in, but if we started later in the song, we would want it to) and fade out. Drag the Fade Out slider over to around the 120-second mark (as shown here) and click anywhere outside the dialog to close it. Now, play your movie again and, at the 120-second mark, your music will gently fade away.

TIP: Muting Your Background Music If you want to temporarily turn off your background music track, just click the little speaker icon (shown circled here) to the left of the music notes icon, and it mutes your background track.

Step Four:

When you played the video clip in Step Three, did you hear people talking in the background? That's our model and makeup artist talking while getting ready for the shoot. Of course, you don't want to hear that in this case—you just want to hear the background music—so you need to mute the audio on the video clip. Right-click on your first video clip and a settings dialog appears (seen here). Click on the music notes icon to see the Audio settings, then turn on the Mute Audio checkbox (as shown here), so you don't hear them talking while we were taping.

Step Five:

Besides your background music track, you can add a narration track (or a voiceover track), or even sound effects. To add another audio track, click on the music notes icon again (to the left of your existing music track), and choose New Audio Track (as shown here at top). This adds a blank audio track below your background music track, and it will be empty until you go back under that same pop-up menu and choose Add Audio, then find a narration or voice-over track to add. Here, I chose a voice-over track, and you'll see it appear in the new audio track right below the background track (seen here in the center). If you were to click the Play icon right now, our background music would start, but our voice-over would start immediately, as well. If you want your voice-over to start a little later (maybe after a few seconds of background music), just click-and-drag the voice-over clip to the right (don't try to trim it, you want to move the whole clip), until you get to the point in time you want it to start (at the bottom here, you can see I dragged it over so it will start around the 10-second mark).

Step Six:

If you are going to have a voice-over track, you'll probably want the volume of the music to lower once the talking starts (this is called "ducking" in the video world). To do that, click on the background music track, then click-anddrag your playhead over to a second or so before the point where your voiceover starts. Now, click on the Split at Playhead icon (it looks like a pair of scissors and is circled in red here) to split your background music into two sections. Then, Right-click on this second section and, in the Audio settings dialog, you can lower the Volume from 100% (full volume) to maybe 50% or 60% (as shown here).

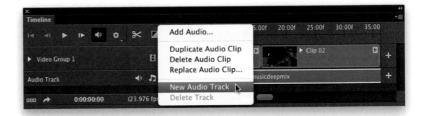

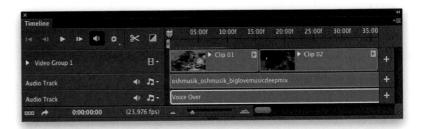

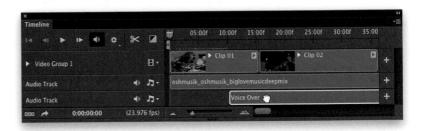

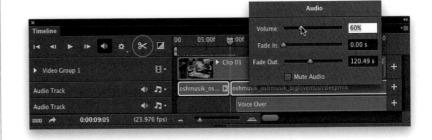

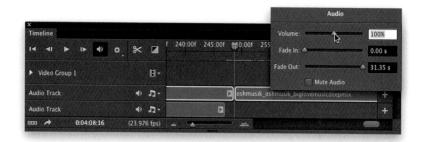

Step Seven:

Of course, at some point your voiceover will end, and you'll probably want the background music to return to full volume. You pretty much do the same thing. Just scroll down the timeline to the point where you can see your voiceover ends and move your playhead to a second or two after that point. Click on the track you want to split (your background music track), then click the Split at Playhead icon again to create a third section of your background music track. Right-click on this third section and set your volume back to 100% (as shown here).

Adding Transitions Between Clips and Fade Ins/Fade Outs

When you make a movie, you get to decide how your movie starts and ends. For example, at the end of the movie, does it just abruptly stop, or does it smoothly fade away to black? Same thing for the opening. Does it just start immediately when you click Play, or fade in from white or black? You also get to decide how your clips transition from clip to clip—a quick cut, or does it smoothly dissolve from one clip to the next? Of course, it depends on the type of movie you're creating, but adding these transitions can help give your movie a more polished look.

Step One:

Here are same two video clips again, and if you click the Play icon (or press the **Spacebar**), the first clip plays and then when it's done, the second clip plays immediately—it just cuts from one clip to the other. To add a nice fade between the two, click on the Transition icon (it looks like a square with a diagonal line), and the Drag To Apply dialog, with your transition choices, appears (seen here). The top one, Fade, doesn't work very well between two clips like this (it fades out at the end of the first clip, then fades in the second clip).

Step Two:

Instead, you'd probably choose a Cross Fade, which fades directly from one clip into the next (kind of like a dissolve in a slide show). To add a cross fade between your clips, first click on Cross Fade in the dialog, and then you get to choose how long you want this cross fade to take. The default choice is 1 second, but you can choose longer if you'd like by clicking on the Duration slider (I chose 2.15 seconds here). Now, just click-and-drag that cross fade down onto your timeline and position it between your two clips (as shown here), and then let go of your mouse button. It adds a little blue rectangle with two triangles (as seen in the next step) letting you know there's a transition added there. To remove a transition, click on that little rectangle and hit the Delete (PC: Backspace) key on your keyboard.

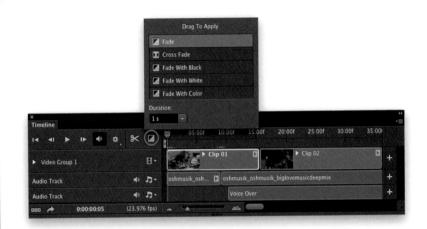

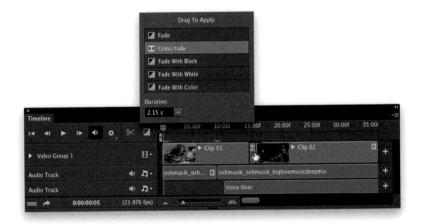

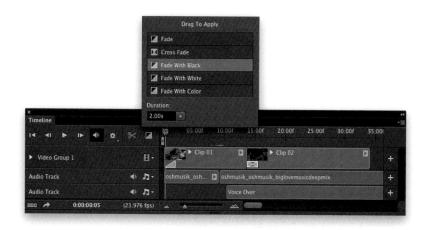

Duration

Cross Fade

Fade With Black

☑ Fade With White

Fade With Color

Color

Step Three:

Of the other choices here, I usually use Fade With Black, which is a great way to start your movie, because it starts with a black screen and then fades into your first video clip. However, the default 1-second duration always seems too short and abrupt to me (for the start of a video anyway), so I generally increase the duration to 2 seconds. To add this Fade With Black transition to the beginning of your movie, just click-and-drag it down to the beginning of your video clip and let go of the mouse button. It adds a little blue rectangle with a diagonal line letting you know there's a transition added there.

Tip: Editing Transitions

If you want to make any changes to a transition, just Right-click on it and you can make those changes in the Transition settings that pops up.

Step Four:

So, if you know what Fade With Black does, you can probably imagine what Fade With White does. If you choose Fade With Color, a little color swatch will appear in the bottom-right corner of the dialog (shown here at bottom right). Click on the color swatch and Photoshop's standard Color Picker appears for you to choose a solid color to fade to. At the end of your video, you're probably going to want to Fade With Black (dramatic ending, right?) and you do this the same way as adding any transition. Scroll down the timeline to the very end of your movie and then click the Transition icon to bring up the Drag To Apply dialog. Now, drag the Fade With Black transition and drop it on the end of your video clip. It adds a little "fade out" rectangle to let you know it's there. That's it.

Creating Lower Thirds (or Adding Logos)

If you're doing an interview as your movie, it's pretty common to have the person's name appear in the bottom third of the frame, usually within a rectangle or graphic bar of some kind (called a "lower third" in video world). The trick is to have the background behind your graphic bar appear transparent, so it doesn't cover your video with a solid white background. They're easy to create in Photoshop and then take directly over to your timeline. Plus, the same technique we use for lower thirds, you can use for bringing logos or other graphics into your timeline.

Step One:

Start by creating a regular ol' new document in Photoshop (go under the File menu and choose **New**). You want to make this pretty close to the dimensions of the movie you're creating, so from the Preset pop-up menu, choose **Film & Video**, and then choose a Size that is closest to the size of what you're editing (in this case, we're editing 1080p HD video, so I choose the HDV 1080p/29.97 preset, as seen here), then click OK to create a new blank Photoshop document.

Step Two:

Go to the Layers panel, click on the Create a New Layer icon to create a new blank layer, then get the Rectangular Marquee tool (M) and drag out a long, thin horizontal selection, like the one you see here (this will be our simple lower third shape). Press **D** to set your Foreground color to black, and then fill your selected area with black by pressing Option-Delete (PC: Alt-Backspace). Press Command-D (PC: Ctrl-D) to Deselect. Now, click on the Add a Layer Style icon at the bottom of the Layers panel, and choose Stroke from the popup menu. In the Layer Style dialog, click on the Color swatch and choose a green color from the Color Picker, set the Size to around 8 px, and click OK.

Now, we can't just save the file at this point, because we have a solid white Background layer, and that's exactly how this file would appear in our timeline—as a big white box with a black bar on it. So, what you need to do is simply drag your Background layer onto the Trash icon at the bottom of the Layers panel. Now, you just have that black bar all by itself with a transparent background (as seen in the image window and the Layers panel on the right), which is exactly what we want in our video (so just the bar sits over our video).

Step Four:

Arrange the two windows (your black bar and video clip windows), so you can see them both onscreen at the same time (if you're using Application Frame, try going under the Window menu, under Arrange, and choosing Tile All Vertically), get the Move tool (V), click on the black bar layer, and then just drag-and-drop it right onto your video. Now, you'll see the black bar with a transparent background in your Layers panel (which is exactly what we want), but it's not in the place where we want it. By default, it adds it at the end of the video clip, like it was another clip or still (it appears in purple, though, because it's a still. You may need to clickand-drag its thumbnail out a little in the timeline to see more of it). We need it to appear "over" the video clip.

Step Five:

What we need to do is get that black bar outside our Video Group 1, so it can appear over our video clip (not after it). To do this, click-and-drag the black bar layer straight up to the very top of the layer stack in the Layers panel—right outside Video Group 1. The trick to making this work is to move it up top until you see a thin white horizontal line appear. That's your cue to let go of the mouse button, and then it appears outside the group (as seen in the Layers panel here). Here's the "Gotcha!" You still can't see your black bar. That's because, although it's now on its own graphics track in the Timeline panel (above your video), it starts after the end of your clip. So, click on the black bar in the timeline, and drag it to the left to where you want it to appear over the video (as shown here at the bottom). Now (finally), you can see your black bar. Switch to the Move tool to reposition your bar wherever you'd like it (I had to center it and move it down a little).

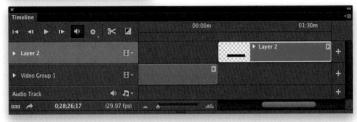

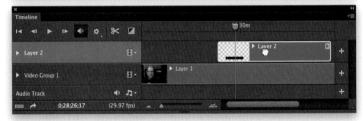

Step Six:

If you want your lower third to fade in, click on the Transition icon (shown circled here in red), and in the Drag To Apply dialog, click on Fade, choose a nice long Duration (like around 1½ seconds), and then click-and-drag the Fade transition and drop it on the beginning of your black bar in the timeline (as shown here). Now when the playhead reaches your black bar, it will fade it in over 1½ seconds. We're almost done.

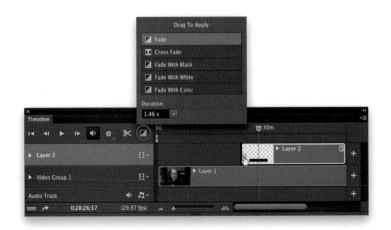

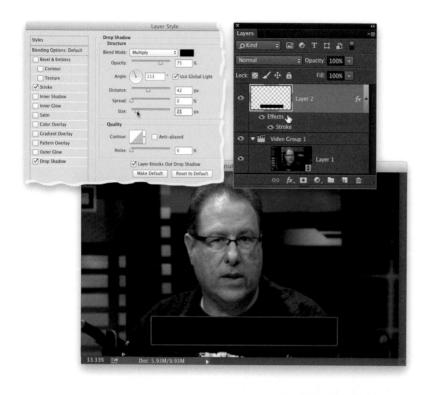

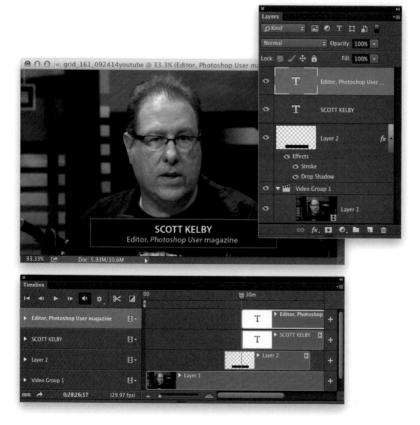

Step Seven:

You can add layer styles to your project, as well. In this case, let's add a Drop Shadow layer style to our black bar (so it casts a shadow back onto our video, which helps add depth and adds to the impression that our bar is "floating above" our video). To do this, make sure your playhead is over the black bar in the timeline, so you can see it onscreen, then double-click on Effects beneath the black bar layer's thumbnail in the Layers panel (as shown here). When the dialog comes up, click on Drop Shadow on the left. You can change the softness of the shadow by dragging the Size slider to the right (as shown here), and you can also change the position of the shadow by moving your cursor outside the dialog—right onto your image itself—and just dragging it where you want it (it's a little hard to see here on the dark background, but will be visible on a lighter one). When you're done, click OK, and now you've created extra depth.

Step Eight:

Now let's finish off our Lower Third project. Get the Type tool (T), click right on your lower third in your image window, and simply enter your text (as shown here, where I added some text in the font Myriad Pro Semibold and Myriad Pro Semibold Italic). You can switch to the Move tool and reposition this text just like you would with a text layer on a photo. Once again, take a look at the stacking order over in the Layers panel: the Type layers are on top, which means the type appears over the black bar, then you see the black bar next (it's over the video), and then the video clip itself. By the way, we didn't have to drag the Type layers up to the top, since we were already working outside Video Group 1. Finally, like I mentioned in the intro, you can use this same technique to add logos or other graphics to your video.

Applying Photoshop Filters and Adjustments

This is one of my favorite features: the ability to apply Photoshop adjustments (everything from Curves to Levels and a whole lot more) and regular Photoshop filters. What's really cool is that it pretty much lets you treat these video clips like they are still images, and the effects and edits you apply can be applied to the entire video clip you're working on—not just one frame. There are just a few little things you need to know so it works the way you want it to.

Step One:

Go ahead and close that last project, and let's start a new one (just so we don't get totally sick of seeing one video clip again and again). Open the file named, "Clip21.mov." Of course, if it needs some trimming, you can do that now if you'd like, but when you're done, go to the Layers panel, click on the Create New Adjustment Layer icon, and from the pop-up menu, you can choose any of the regular adjustment layers we'd use for digital photos (in this case, just choose Black & White, as shown here).

Step Two:

When you choose this, your video clip instantly becomes black and white (as seen here), and if you look in the Properties panel, you'll see all the regular Black & White sliders (I'm not a big fan of this adjustment layer for doing black-and-white conversions for photos, but just for this example, I don't think it'll hurt anybody). ;-) One thing to note: look in the Layers panel—it automatically groups this adjustment layer with just this one video clip. That's really helpful, because we just want to affect only this clip (not all our clips).

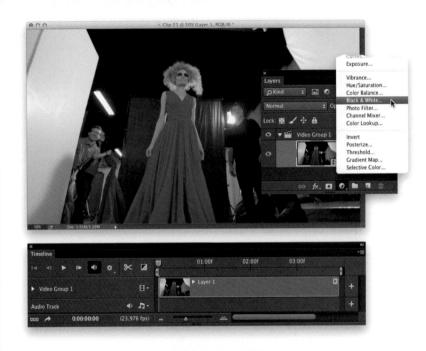

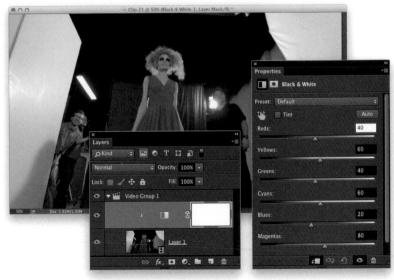

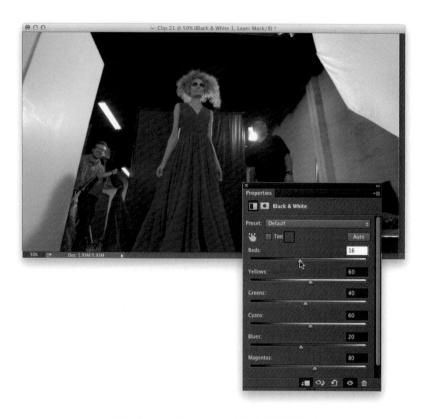

Here's something to keep in mind: these adjustment layers aren't just "one-click video effects"; you added a regular Photoshop adjustment layer. So, now think like you would if you were adjusting a digital camera photo, and do the same type of things (like, here, I lowered the amount of red to darken her dress, just like I would on a still, but it's applied to the entire clip. This is what is so darn powerful about having video in Photoshop like this. We can take the stuff we already know in Photoshop and apply it to video without having to learn a whole new program. That, I love!

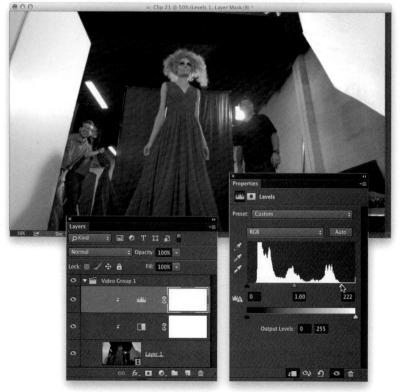

Step Four:

To further illustrate this, let's add another adjustment layer. Click on the Create New Adjustment Layer icon again, but this time choose Levels. In this case, the clip looks kind of flat, so we want to add contrast. Choose Increase Contrast 2 from the Preset pop-up menu in the Properties panel, and then click-and-drag the Highlights slider (the triangle on the far-right side under the histogram) to the left a bit to increase the highlights a little more. Notice that it's automatically grouped with your video clip, as well. Seriously, this is pretty darn amazing that we can treat moving video just like it was a still photo (can you tell I am just so digging this?). Okay, now let's take it up a notch.

Step Five:

Go to the Layers panel and delete those two adjustment layers, because now we're going to look at how to apply Photoshop filters to your video. First, go up under the Filter menu, under Sharpen, and choose Unsharp Mask. When the dialog appears, we're going to add some really heavy sharpening-try Amount: 135, Radius: 1.5, and Threshold: 3, and click OK. Now, click the Play icon to see how your video clip looks all sharpened. You're probably wondering why you could see the sharpening onscreen for a moment, but then as soon as it started playing, the sharpening was gone. That's because you can't just apply a filter directly to a clip—it will only apply it to the first frame (which is why you saw it for a split-second, and then it was gone). You have to do one extra step, so the filter is applied to the entire clip.

Step Six:

Press Command-Option-Z (PC: Ctrl-Alt-Z) until the sharpening is removed from that first frame. Now, to apply a filter to the entire clip at once, you'll need to first convert this clip into a smart object layer. Go under the Filter menu and choose Convert for Smart Filters (as shown here), and a little tiny page icon will appear in the bottom-right corner of your clip's thumbnail in the Layers panel, letting you know it's now a smart object. Then, go back to the Unsharp Mask filter, apply those same settings, and click OK. (Note: Applying a smart filter turns your video clip's bar purple in the timeline, as if it were a still image.) Now when you click the Play icon, the sharpening appears throughout the entire clip. But, there's a decent chance on that play-

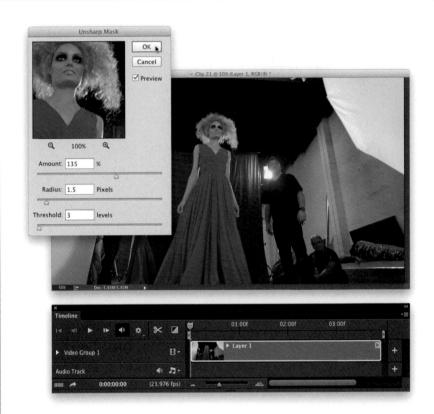

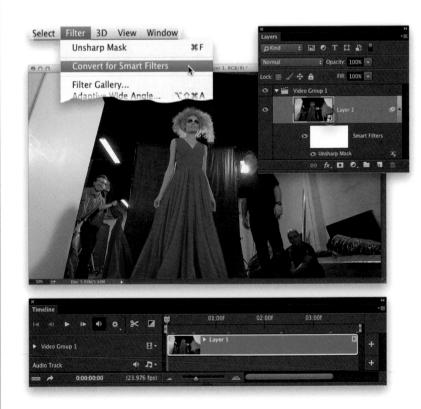

back you ran into a problem.

Step Seven:

So, chances are somewhat likely that when you played that clip it either was a bit jittery, or it played for a few seconds and then the playhead literally stopped. That's because the clip hadn't fully rendered a preview yet (this is a phenomenon video people deal with all the time, but as photographers we're like, "Huh?" because we're used to everything happening in real time). When you apply an effect like a filter, it takes some time (and a lot of your computer's RAM) to apply that sharpening to 24 frames every second. So, how do you know if your video has rendered and will play without being choppy? You'll see a thin, solid green bar directly above your video clip in the Timeline panel (as shown here at the bottom). If, instead, you see a broken green line, or just some green dots (as shown here at the top), that means it hasn't fully rendered, so your preview will be choppy at best. Now, on to the fix.

Step Eight:

I learned this fix from my buddy Richard Harrington (author of the book, Photoshop for Video, by Peachpit Press), and it works great. First, turn off the master audio (click that little icon that looks like a speaker, shown circled here in red) and then play the clip one time through. For whatever reason, that forces the preview to build, and with the audio turned off, you'll actually see the thin green solid bar appear as your playhead moves through the clip. Note: I noticed that if I applied a filter that does some serious math, like Liquify, I had to let it run through more than once with the audio off before the preview would fully render. Just a heads up on that.

Titles and Working with Text

There are two ways to work with text in your video project: one is to create your text in a separate Photoshop document (as if you were creating a slide for a slide show), and then bring that into your project, or you can just add your text directly into your video project, and here you'll learn both (and a couple of tips along the way).

Step One:

The nice thing about adding text to your videos in Photoshop is that you get to use all the regular type controls. But, before we start adding type to our video, if you're primarily going to do title slides (an opening slide or a closing slide), you might want to consider just building those separately in Photoshop and then dragging them into your video timeline. To do that, go under the File menu, choose New, and then from the Preset pop-up menu, choose Film & Video. That gives you a bunch of preset video sizes in the Size pop-up menu. Choose the one that matches the video you're going to be working with (in my case, it was HDTV 1080p/29.97). This creates a new document, which you can treat just like a photo (add backgrounds, text, and so on).

Step Two:

If you want to use a photo as your background, just open the photo and, using the Move tool (V), click-and-drag it onto your HD-sized document. Then, press Command-T (PC: Ctrl-T) to bring up Free Transform. Press-and-hold the Shift key to keep things proportional, and click-anddrag a corner point to resize your photo so it fits (as best it can) within this widescreen document. Now, get the Type tool (T), click on your image, and type in your text (it's best to keep your text away from the edges. The area inside is safe for putting text without it clipping off if you were to broadcast this video on television. Hey, it could happen).

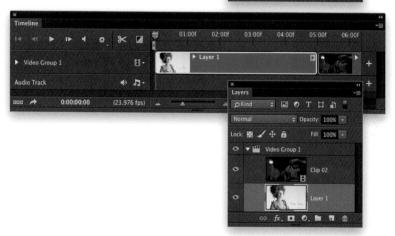

Once you've created your title slide the way you want it, go ahead and flatten the file (click on the down-facing arrow in the top right of the Layers panel, and choose Flatten Image), and then it's decision time. You can either: (a) save the file, and then, in the Timeline panel, click on the filmstrip icon and choose Add Media to add this slide to your timeline, or (b) drag-and-drop it right onto your timeline. To drag-and-drop it, you'll need to be able to see both your slide document and your video document, so if you can't, go under the Window menu, under Arrange, and choose Tile All Vertically to put both windows side-by-side.

Step Four:

Then, get the Move tool again, press-andhold the Shift key (so everything lines up perfectly), click on your flattened title slide (it's the window on the bottom in the previous step), and drag that image over onto your video clip (you should see a faint outline of your document as you drag. If you don't see it, hold the cursor down a little longer on the slide before you drag). Because you held the Shift key, the title slide fits perfectly onscreen (otherwise, you'd have to reposition it to fit onscreen afterward). This adds your title slide to your timeline, after the video clip (as seen here at top). To make it appear as the opening slide instead, just go to the Layers panel, click on that layer (the top layer), and drag it below your video clip layer (as seen at bottom here). Now, your title slide is the first thing in your timeline and will appear first when you play your movie.

Step Five:

Besides creating your title slides separately in Photoshop, you can add text over any still or video clip in your movie. However, if you just get the Type tool and, with your video layer active in the Layers panel, click on your video and start typing, it assumes you want to add this text to the end of your movie (here, I typed the word "Elegance," and it added a Type frame to the end of my movie, as seen in the timeline). What we actually want is for this text to appear on top of (over) our video clip, rather than after it. We're going to fix that in just a moment, but before we do, take a look at the Layers panel and notice that our title slide is at the bottom (which makes it play first), then our movie clip is right above that (meaning it plays second), and then our Type layer is above that, meaning it plays after the movie clip. Okay, now we can go fix it.

Step Six:

If your layers are all in the same Video Group (like a layer group when you're working on still images), each layer plays one after another. However, if you want something to appear over part of your video track, you have to move it outside that Video Group, so it's on its own separate track. So, go to the Layers panel, click-and-drag that Type layer up toward the top of the layer stack (above Video Group 1), and you'll see a white horizontal line appear. When you see that, let go of the mouse button, and your layer moves outside the group, and above it (as seen here), and your type now appears in its own track above your main video track in the Timeline panel. Now, click on that Type clip in the timeline, and drag it to the left, so it appears over the video clip, and now you can see the type appear over your video (as seen here).

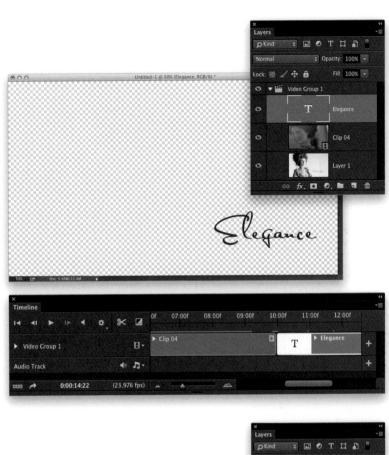

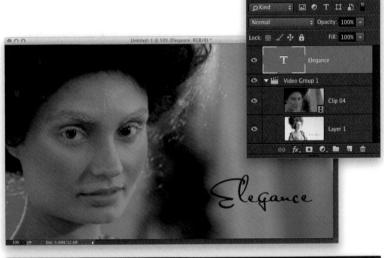

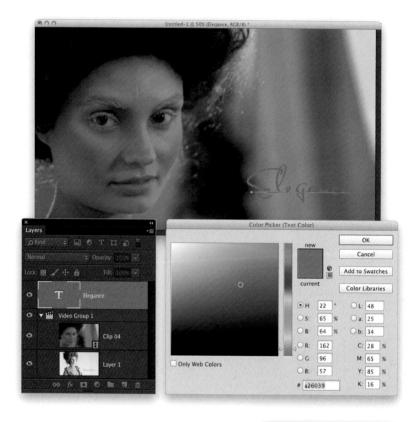

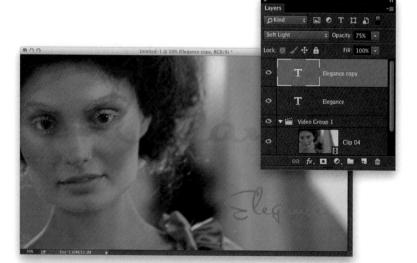

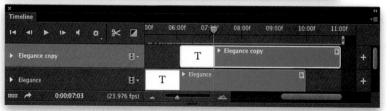

Step Seven:

Before we move on, one thing to keep in mind is if you're not seeing your text (but you can see that it's at the top of the Layers panel, outside your group). that's probably because you need to move your playhead over the part of your movie where the text appears. Okay, now that your text is in place, you can move it anywhere you want over the video by simply dragging it with the Move tool. If you want to change the color of your text, you'd do it the same way you do any other time: double-click directly on the little "T" thumbnail in the Layers panel (that's a shortcut to select all the text on the layer), then go to the Options Bar and click on the color swatch, which brings up the Color Picker, where you choose a new color and click OK. Besides the controls in the Options Bar, other Type controls are found in the Character panel (go under the Window menu and choose Character).

Step Eight:

While we're here, let's try a few more type techniques. Press Command-J (PC: Ctrl-J) to duplicate your Type layer. Press Command-T (PC: Ctrl-T) to bring up Free Transform, press-and-hold the Shift key, grab a corner point, and drag the text on this duplicate layer out so it fills the entire image area from side to side (as seen here), then position it near the top of the video. Because you can pretty much do the same stuff to a video that you can do to a still image, you can do things like changing the blend mode of the Type layer (go ahead and change it to **Soft Light**, so it blends in with the video), and lowering the layer's Opacity (lower it to 75%, as seen here). Lastly, drag this Type clip a little further to the right in the timeline, so the smaller word "Elegance" appears first, then the larger one. Note: How this effect looks will depend on the video clip. This just gives you an idea of what you can do.

Step Nine:

If you want the larger type to fade in (rather than just appearing abruptly), Click on the Transition icon, and in the Drag To Apply dialog (seen here), click on Fade, and then drag-and-drop it right at the beginning of your duplicate Type clip (as shown here), and now it will smoothly fade in. Okay, you ready to take it up a notch? Let's do some type animation.

Step 10:

In the Layers panel, click on the smaller Type layer, then go to the Timeline panel and click on the little right-facing arrow to the left of the word "Elegance" on the far left to reveal the animation controls (shown here). Move your playhead just past the beginning of where your type appears, then click on the Enable Keyframe Animation control to the left of Text Warp (as shown here) and it adds a diamond icon to your timeline (shown circled here in red), which marks the spot at which your text warp animation will start. Now, drag your playhead over to where you want it to stop and just leave it there for now. Double-click on your Type layer's thumbnail in the Layers panel to select your text, then go up to the Options Bar, and click on the Create Warped Text icon (also shown circled here). When the Warp Text dialog appears, choose any Style you like (I chose Arc), change the Bend amount (I chose +26), and click OK. Go back to the Timeline panel, and you'll see that a diamond icon was added to mark the end of your animation (as shown here at the bottom), and you're done. Now when you click the Play icon, your text will be regular text when it first appears, and then it will animate a bending move into an arc.

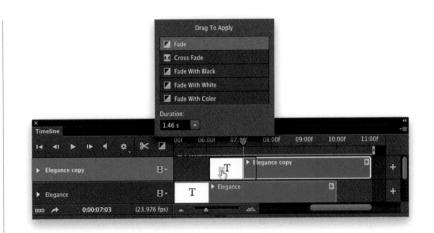

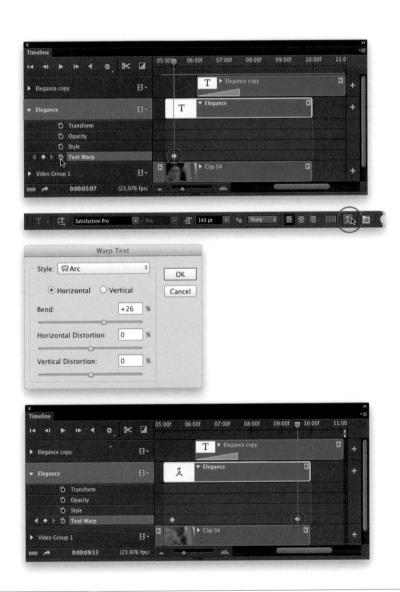

Besides adding the standard stuff in the Adjustments panel, we can also add overlays and different texture effects using layer blend modes, just like we would to a still image in Photoshop, but as always, there are a few little things to know about how these are handled when adding them over video.

Using Blend Modes to Create "Looks"

H.

. 17.

Step One:

Open the video you want to apply a blend mode look to. I downloaded a rose pattern texture for this from iStock (they've got loads of these—just search for "wedding textures." The pattern we're using here, which you can see in the next step, in high resolution, costs \$15). Now, go under the File menu and choose **Place Embedded** (this will let us open the pattern and scale it to the size we want it).

Step Two:

Navigate to the pattern file, click on it, and then click Place. When your illustration appears, it will appear as a box with a big X in it. Press-and-hold the Shift key, grab one of the corner points, and resize it so it fills the entire image area, then press the Return (PC: Enter) key to lock in your resizing. You're probably wondering why you're seeing the pattern appear in the Layers panel, but you don't see it in your image window, right? That's because, by default, it adds the new file to the end of your video. To change that, go to the Layers panel, click on the pattern layer, and drag it out of Video Group 1, up to the very top of the layer stack, and then release the mouse button. This puts the pattern on its own track in the Timeline panel, but now you'll need to click on it there and slide it over to the left, until it's directly above your video clip, and now you'll be able to see it.

Now, change the blend mode of this layer to Soft Light, and you can see how, by just changing the blend mode, the pattern is now blending with our bride video. This blend mode works for this particular clip and texture, but of course it depends on the clip and the texture which blend mode you should use. To try out different blend modes to see which one looks best to you, press Shift-+ (plus sign), and each time you press that, it toggles over to another blend mode. Just stop at the one you think looks best. For this combination, I think we should lower the Opacity of this layer to around 60% to help it blend a bit better.

Step Four:

Even though the blend looks nice, the texture is totally covering her face, and that's generally not what we're going for. So, we're going to fix this pretty easily by: (1) Adding a layer mask to this texture layer by clicking on the Add Layer Mask icon at the bottom of the Layers panel (it's the third icon from the left. Then, (2) get the Brush tool (B) from the Toolbar, choose a really large, soft-edged brush from the Brush Picker up in the Options Bar-make the brush size a bit larger than her head—and set your Foreground color to black (press D, then X). Finally, (3) just click once or twice right over her face. It cuts a hole in that texture, but the hole has soft edges because you chose a soft-edged brush, so the whole thing blends beautifully.

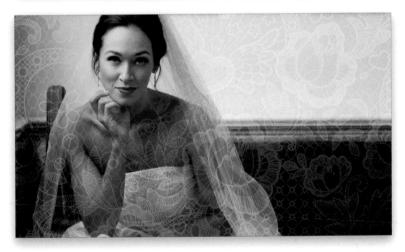

Before you jump into this start-to-finish project, you really need to have already read the rest of this chapter first, because I'm not going to re-explain in-depth stuff you've already learned earlier. I'm just going to tell you what to do, so you get the flow of a full project by taking what you've learned in this chapter and putting it to use. So, if you've read the rest of this chapter, go to the downloads page, download these same video clips and photos, as we're going to create a behind-the-scenes promo video for our studio using footage and finals from a recent fashion shoot (very popular these days on photographers' websites).

Our Start-to-Finish Project

Step One:

Let's get our clips into Photoshop: in the Timeline panel, click on the filmstrip icon and choose **Add Media** to open the Add Clips (PC: Open) dialog, and go to the folder with our video clips (download these from this book's companion webpage mentioned in the book's introduction). Select them all and click Open. Your clips will each appear on their own layer in the Layers panel, and one after the other in the timeline. Our behind-the-scenes movie is going to run about 2½ minutes long, so move your Set End of Work Area bar to around the 90-second mark if you want (see page 310 for more on your work area).

Step Two:

If you clicked on the Play icon right now, you'd have a movie—each clip would play one right after the other until you got to the end. It would be kind of an abrupt movie, though, because there's no fade in or out, but only hard cuts between each clip, there's no background music, etc. So, while it wouldn't be a very polished movie, it would be a movie. Let's start polishing. Start by trimming the first clip, Clip 01 (the clip of the makeup table). It has a few starts and stops in it, so just trim it to what you think is the best part of the clip (see page 314 for more on trimming). We've got about 26 clips here, so I'm not going to make you trim them all. I pretrimmed the rest because I want you to get through this project pretty quickly, but of course when you do your own projects, you'll probably trim most clips a little.

If you play the movie from the start, it seems to me like the second and third clips are in the wrong order (she's in makeup, then they're working on her hair, then she's back in makeup?). It seems like the makeup clips should be together, so the third clip should come before the second clip. You can drag-and-drop the clips right in the timeline (just click on the third clip and drag-and-drop it before the second clip), or go to the Layers panel and click-and-drag Clip 03 down in the stack, so it's the second layer from the bottom (as seen here). Now our video starts with Clip 01 (makeup), then Clip 03 (more makeup), then Clip 02 (hair), and the rest are in numerical order.

Step Four:

We haven't added any photos in yet (just video clips), but before you start dragging photos in, don't forget that our document is in an HD widescreen video size, and proportionally our photos aren't going to appear at the ideal size for photographs. So, in Photoshop, I create a new blank document that is the same size as my HD video. In this case, that's 1920 pixels wide by 1080 pixels deep at a resolution of 72 (as seen here below), and then I fill the background with black (with the Foreground color set to black, press Option-Delete [PC: Alt-Delete]). I open my photo in Photoshop, press Command-A (PC: Ctrl-A) to select the entire image, then I copy-and-paste it into that new document. Once it's there, I press Command-T (PC: Ctrl-T) and use Free Transform to resize the image (and, in this case, rotate it a bit, too!). When it's done, I flatten the layers, save it as a JPEG, and now it's ready to add to my movie at the right size.

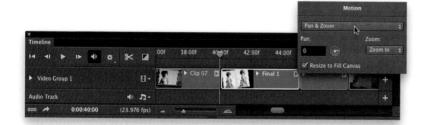

Step Five:

To add this photo to your video, click on the little filmstrip icon in the Timeline panel and choose Add Media, again. Find that photo on your computer and click Open to add it to the end of your timeline. Now, if it were me (and it is), I would have this photo appear right after Clip 07—where you see the image on my laptop. That way, the next thing you see is the final image. Again, you could just click-and-drag that photo from the end of the timeline until it's right after Clip 07, but when you have lots of clips like this, it goes really slow. It's faster to click-anddrag it right in the Layers panel—right down in the layer stack, so it appears above Clip 07. Note: The thumbnails for photos appear in purple in your timeline, so it's easy to see which is which.

Step Six:

Go ahead and drag your playhead over to Clip 07, and then click the Play icon (or just press the Spacebar) to see how your photo looks in the context of your movie. If you're thinking it looks kinda "still" after all those moving clips, I agree. Luckily, Photoshop lets you add a little motion to your photo, so it looks better when surrounded by moving video clips. Go to your photo in the timeline (look for the purple thumbnail) and click on the little triangle in the top-right corner to bring up the Motion options. Choose Pan & **Zoom** from the pop-up menu (as seen here), and now when your photo appears in the movie, it will slowly pan, and zoom in slowly, as well. This little bit of motion makes a huge difference. Move your playhead back to Clip 07, then click on the Play icon and watch how much better it looks now when your photo appears in your movie.

Step Seven:

to add to the video. I'd put the second one (Final 2.jpg) after Clip 17, and then the third (Final 3.jpg) after Clip 26 (don't forget to add motion to both—pan & zoom!). I'd also add your logo screen at the beginning and end of the promo video (I put my logo in white on a black background in Photoshop at the same dimensions as the video and saved it as a JPEG). Go ahead and open the logo screen, then press Command-J [PC: Ctrl-J] to duplicate the layer for the second one, then drag them so they're the first clip (before Clip 01) and the last clip (after Clip 26). Let's make one more slide in Photoshop: the fashion model's name on a white background using the font Futura Light. Save it as a JPEG, then open it, and put it right after your opening logo slide, before Clip 01. Don't forget to trim the ends of these clips in the timeline, so they're only about 2½ seconds long each. Here, you can see my opening logo clip and the clip with the model's name at the beginning of the movie now.

There are two more final photos we want

Step Eight:

So we've got a bunch of video clips, and we've added our final photos, logo slides, and model's name slide, but the transition between each is still an abrupt cut from one to the next. Let's add a little polish by putting a smooth blend (called a "Cross Fade" transition) between the clips. Click on the Go to First Frame icon to move your playhead to the beginning of your movie, then click on the Transition icon at the top of the timeline to bring up the transition options. Click on Cross Fade and then choose a short duration (like 0.75 of a second). Click-and-hold right on the little Cross Fade icon, and then dragand-drop it right over the spot where the first and second clips meet in the timeline. With your playhead back at the beginning of the movie, click the Play icon to see how much better this looks. Ahh, that's better!

* 17

(23.976 fps

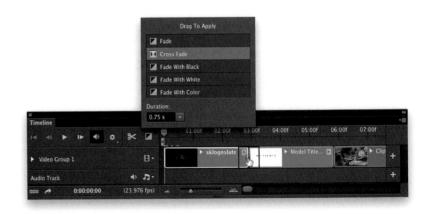

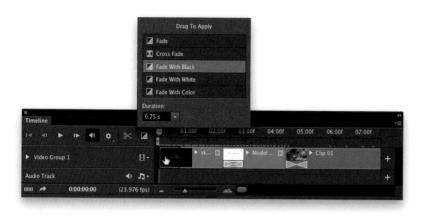

Step Nine:

Now that you know how easy it is to add transitions (technically, you learned this earlier in this chapter, right?), go ahead and drop Cross Fade transitions between each clip and any photos and slides (Note: To change the length of any Cross Fade once it has been applied to a clip, Rightclick on it and options pop up where you can change the duration.) Now everything will gently cross dissolve from one to the next, but your movie still starts and ends abruptly—with a hard cut. I prefer to gently fade in from black at the beginning, and fade out to black at the end. To do this, click on the Transition icon and, from the options, click on the Fade With Black icon and drag it onto the front of the logo slide at the beginning. Scroll to the end of your movie and do the same thing, but drag-and-drop that little icon onto the end of the logo clip thumbnail. Now, at the end, it will "Fade to black...."

Step 10:

Rewind your movie to the beginning, click the Play icon, and give it a look. It should be around 21/2 minutes long. It probably looks good, but sounds bad, right? It needs a background music track to hold it all together (that makes such a huge difference). I used a track from TripleScoopMusic.com (a popular source for photographers to buy royalty-free music that doesn't sound royalty freeit's seriously good!) called, "BigLoveMusic (Deep Mix)" by Oshmusik (I was able to provide the track for you to use to practice with, thanks to the folks at Triple Scoop Music. You can find it on the book's companion webpage mentioned in the book's introduction), but you can choose a different track if you'd like. To import music, click on the little music notes icon in the Timeline panel and choose Add Audio. Find your audio clip and, when you click Open, it adds it on a track below your video track in the timeline and it appears in green (as seen here).

Step 11:

Before you hit Play, I can tell you that the song is longer than our video (it's around 4 minutes, 39 seconds). So, scroll all the way to the right to the end of the green audio track, click on its right edge (just like you were trimming a video clip), and drag it to the left until it reaches the end of your video (just about the 2½-minute mark). Okay, scroll back to the beginning of the timeline, then hit Play to see and hear your movie again. Quite a huge difference now, right? (Note: If you want to wait a moment before the music starts, just click-and-drag the green audio clip to the right to where you want it to start.)

Step 12:

You probably noticed that while your ending logo slide faded out nicely, the background audio clip didn't—it just ended abruptly like someone lifted the needle off the record (what's a record? Ask your parents). Anyway, we want the audio to fade out during the final logo screen just like the video fades out (you can have it fade out anywhere you like, but that seems like a logical place). So, click in the time ruler, at the top of the timeline, right between where the Final 3.jpg image ends and the logo slide at the end of the movie starts to move the playhead there. Click on the green audio track (so just it is selected), then click on the Split at Playhead icon (the scissors) on the left side of the timeline (shown circled above in red). This splits the audio track into two clips at that point (although they still play as one). Click on the smaller audio clip on the right to select just that part, then click on the right-facing triangle at the top-right corner of the thumbnail to bring up the Audio options (seen here). Drag the Fade Out slider all the way to right, so by the end of the clip, the audio will have totally faded out. Now, play those last few clips and both the audio and video fade out like they should.

When you click the Split at Playhead icon, it splits the audio clip at that spot

The Fade Out slider lets you pick when you want the audio to be totally faded-out

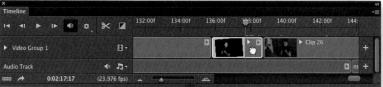

Step 13:

You probably noticed another problem: you still hear any audio your camera's mic picked up when you made these video clips. That's usually great, but in our case we just want to hear the background music, not the audio from the clips. So, what you have to do is click on each individual clip, then click on the right-facing triangle at the top-right corner of the thumbnail to bring up the Video options. Click on the Audio icon (the music notes) and then turn on the Mute Audio checkbox to silence the audio embedded in that video track. Yes, you have to do this to each track one-at-a-time. I know. Ugh.

Step 14:

Hey, is it too late to make a change to the order of the clips? Nope. We can change away, and that's good because once I watched it from start to finish, it seems like that last final image should come before Clip 26, not after it. We can change that, but there is something weird you might run into, so let's do it and that way we can cover it here. Go ahead and click-and-drag the Final 3.jpg image in front of Clip 26 in the timeline. When you do this, it removes the Cross Fade transitions for these particular clips (and the ones they were next to, as well), so you'll have to drag-and-drop them into place again. That's not the problem, though (see the next step).

Step 15:

What I've found is when you do that, it sometimes messes up the length of all the other Cross Fade transitions (making them much longer in duration). So, keep an eye out for this, and if it happens, you'll have to go back to each one, Right-click directly on the transition attached to the clip, and from the pop-up menu, change your duration back to what it was. Maybe it's a bug—I dunno—but that's what I've had to do numerous times. Well, at least ya know, just in case, right? Okay, give your project a good look to make sure there are no more tweaks, adjustments, or other edits because we're about to wrap this puppy up!

Step 16:

Okay, now it's time to save our project as a movie (so we can share it, email it, put in on YouTube, a phone, etc.). (Note: I'm going to show you a couple more optional things you can do to your video when we're done here, but you can certainly finish up here, if you'd like.) Click on the Render Video icon at the bottomleft corner of the Timeline panel (shown circled in red) to bring up the Render Video (export) dialog (shown here). Give your video a name, choose where you want to save it, and then from the Preset pop-up menu, choose the format you want for your video (in our case, we'll be sending our video to YouTube, so I'm choosing the YouTube HD 720p 29.97 preset). This puts all the right settings in for the best size and playback on YouTube. Well, except for one minor (kinda major) issue (see the next step).

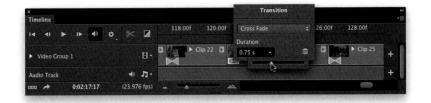

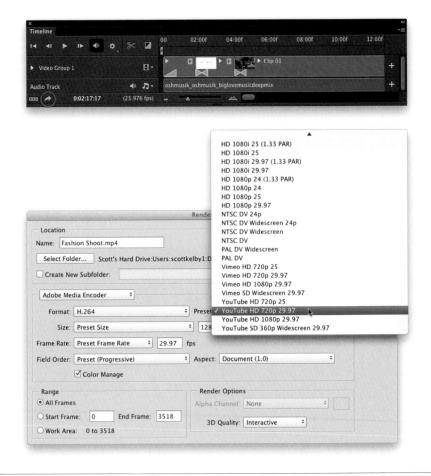

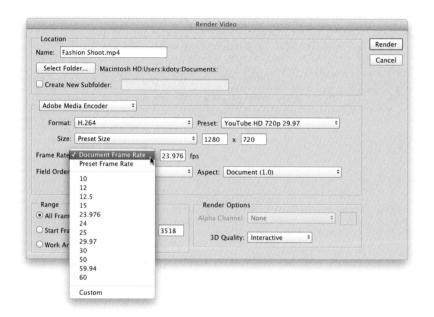

Step 17:

Now, your YouTube preset is choosing a Preset Frame Rate of 29.97 fps for your video, but we're not certain that's what your camera shot. So, to keep from having jittery or jumpy video playback on You-Tube, instead choose **Document Frame** Rate from the Frame Rate pop-up menu (as shown here), and it will input the actual frame rate your camera shot in that field. Now you can click the Render button and in about 5 (errrr...10?) minutes, your video is exported and ready for upload (of course, play it once to make sure everything came out the way you wanted, and that you can hear the audio track and that it looks right).

How to Create Scrolling Credits

If you want to add movie-style scrolling credits (credits that scroll from bottom to top) to the end of your video, you can create those right in Photoshop, and it's so amazingly easy. Takes all of about a minute (not counting how long it takes you to type everybody's name in, of course).

Step One:

Go to the Layers panel and click on the Create a New Layer icon at the bottom of the panel. This adds this new blank layer as a clip to the end of your timeline (how convenient-right where we'd want it, right?). Fill this layer with black (press D, then Option-Delete [PC: Alt-Backspace]). Then, get the Horizontal Type tool (T) from the Toolbox and, with you Foreground color set to white, click onscreen, start typing the first couple letters, and it adds this transparent Type layer to the end of our timeline (after the empty black-filled layer). But, we want this to appear over our black layer, not after it. To have it do that, go to the Layers panel, click directly on the Type layer, and drag it up to the top of the layer stack until it's all by itself outside of the Video Group. Once you do that, look in the timeline, and you'll see it now appears in a separate track above your video track. Click-and-drag it to the left, so it's over your black background and now you can see better as you type in your credits (I used the fonts Futura Light and Futura Extra Bold).

Step Two:

Next, move your playhead to the point where you want your scrolling credits to start (as seen here). Press-and-hold the Shift key, get the Move tool (V) from the Toolbox, click on your type onscreen, and drag straight downward until your text is literally completely off the bottom of the screen (as seen here—see the position of my Move tool?).

Step Three:

Over on the left side of the timeline, click on the little right-facing triangle to the left of the type to reveal another set of controls (seen here—they're Tranform, Opacity, Style, and Text Warp). Click directly on the little stopwatch icon to the left of Transform, and it adds a little gold diamond to your timeline at that point where your playhead is. That's the point in time where your scrolling will begin. Now, drag the playhead to where you want your scrolling credits to end (in this case, I dragged it to the end of the black frame, as seen here). Press-and-hold the Shift key (you have to hold Shift to keep everything perfectly aligned) and, using the Move tool, drag your hidden text at the bottom of your image area all the way past the top of your image area (as seen here—check out the position of my Move tool). When you release your mouse button, another little diamond will appear at the point on the timeline where your playhead is now.

Step Four:

There really is no step four—you're done. Grab the playhead and drag it back to the left, and you'll see the scrolling start as you drag (as seen here). So...ummm... that's pretty much it. You've got scrolling credits at the end of your movie now. Pretty sweet, eh?

How to Apply One Effect to Your Entire Movie at Once

Earlier, we looked at how to apply an effect to one individual video clip, like picking one clip and making it black and white, but what if you want your entire movie to be in black and white? Do you have to apply a black-and-white effect to every clip, one by one? Thankfully, no. It's easier to do than you'd think, and it's not just for black and white, either—you can use this trick with any adjustment layer, so think Color Filters, Curves, Gradients, Hue/Saturation, Color Balance, or even a Solid Color adjustment layer (but I would change the blend mode to Soft Light and maybe lower the opacity a bit on that one).

Step One:

down to the bottom of the layer stack, and click on the first clip in your movie (Clip 01, here). Then, click on the Create New Adjustment layer icon at the bottom of the Layers panel and choose **Black & White** from the pop-up menu. This makes just that one clip black and white (as seen on the left). But, here's how to apply it to multiple clips (or your entire movie): in the Layers panel, click-and-drag that Black & White adjustment layer up and out of the Video Group, so it's all by itself above the group (as seen here at right).

Start by going to the Layers panel, scroll

Step Two:

If you look in the timeline, that adjustment layer appears there on a new track above your movie in the timeline, and the length of that effect is the same length as your movie. If you need to trim it, like off your title slide, just click on the left edge of the thumbnail and drag to the right. Do the same thing to the end, if you need to.

Contact Sheet II Brought Two More Friends Along

In Photoshop CS6, Adobe brought back the Contact Sheet II automation (see the bonus Print chapter on the book's companion website, mentioned in the book's introduction), but they also brought back two more built-in automations that users have missed since they were removed back in CS4. We have PDF Presentation and Layer Comps to PDF back, as well (they're found under the File menu, under Automate and Scripts, respectively).

Changing Your Brush's Size, Hardness, and Even Opacity on the Fly If you press-and-hold **Option-Ctrl (PC:**

Alt) and click (PC: Right-click) your brush anywhere within your image, it brings up a preview of your currently selected brush tip (as shown here), with a little heads-up display showing you the current size, hardness amount, and brush opacity. Now you can drag straight upward to make it softer or down to make it harder. Drag left to make the brush size smaller; right to make it larger. That's cool, but now here's the trick: you can change one setting so that, instead of softness/hardness, dragging up/down changes the brush opacity. To

do that, press Command-K (PC: Ctrl-K) to bring up Photoshop's Preferences, and then in the General preferences, turn off the checkbox for Vary Round Brush Hardness Based on HUD Vertical Movement. Now when you drag up/down, it changes the brush opacity instead.

Applying a Layer Style to More Than One Layer at a Time

Put your layers in a group by Commandclicking (PC: Ctrl-clicking) on each one in the Layers panel to select them, and choosing **New Group from Layers** from

Photoshop Killer Tips

the panel's flyout menu. Now you can apply your group style (a drop shadow, for example) directly to that group, and it automatically applies that layer style to every layer in that group (and it doesn't matter how many layers you put inside that group—it adds it to all of them instantly). You can also add more than one layer style, if you like: just click on the group, then double-click on the fx icon to the right of the group name to re-open the dialog, and choose a layer style in the list on the left (let's say Outer Glow, for example) and it adds that style, along with the Drop Shadow you added earlier.

If You Work with a Lot of Layers, You're Going to Want to Learn This! If you've created a big multi-layer file, you're going to have a long scrolling list of layers, and sometimes finding the layer you're looking for gets really timeconsuming. Luckily, there's a filter bar at the top of the Layers panel. On the left side of this bar is a search pop-up menu, which changes your choices to the right of it. It's set to Kind by default, which gives you icons, and if you click on those icons, it filters to just show you particular kinds of layers. For example, if you click on the "T" icon, it hides all the other layers but your Type layers. I don't mean it hides them from view on your image, I mean now you only see Type layers in the Layers panel (every other kind of layer is hidden). There are filters to just show pixel layers (regular old image layers), just adjustment layers, just shape layers, or just smart object layers, and all it takes is one click on any of these to quickly see just those types of layers. You can also search for layers by Name (a text field appears, so

Photoshop Killer Tips

you can type in a name to search for), or by Effect (a pop-up menu of layer styles appears), or which blend mode you used, or a specific attribute, or assigned color. It's really pretty slick, and blindingly fast. When you're done (and you want to turn the filtering off), click on the little toggle switch on the far right of the filter bar.

Not Sure Which Method to Choose for Resizing? Let Photoshop Choose

If having to choose which interpolation method to use when resizing made your head hurt (and it did for a lot of folks), then you'll be happy to see the new default is Automatic, which means Photoshop will automatically choose the best one for what you want to do.

A Faster Way to Resize

If you find yourself doing a lot of resizing of objects or selections, you'll be pressing **Command-T (PC: Ctrl-T)** a lot to bring up Free Transform, but there's a faster way: Click on the Move tool **(V)**, and then up

in the Options Bar, turn on the checkbox for Show Transform Controls. This leaves the Free Transform handles visible all the time, around any selection or object on a layer, so all you have to do is grab a corner point and drag (of course, pressand-hold the Shift key to keep things resizing proportionally).

New Maximum Brush Size

Back in CS5, the maximum size you could make any brush was 2,500 pixels, which seems like a lot until you have all these new DSLRs that are over 30 megapixels, and all of sudden, your biggest brush isn't big enough. That's why you'll be happy to know, not only can you make your brush sizes more than 2,500 pixels, you can go all the way 5,000 pixels. Yeah, baby!

New Power for the Eyedropper

If you've added an adjustment layer above an image, and you use the Eyedropper tool to sample a color from that image, of course the color it picks is going to be based on how the adjustment layer is affecting that image, right? Right. However, you can make the Eyedropper tool ig-

nore the effect of any adjustment layer and, instead, sample from your image layers. You do this by choosing **All Layers No Adjustments** from the Sample pop-up menu in the Options Bar.

A Trick for Selecting Skin Tones

If you have skin tones that needs adjusting (maybe your subject's skin tone looks too red, but the rest of the photo looks good, which is more common than you might think), then you'll want to know this little trick in Photoshop: if you go to under the Select menu and choose **Color Range**, and then from the Select pop-up menu at the top of the dialog, choose **Skin Tones**, it looks for

Photoshop Killer Tips

flesh tones and selects them. If you're just trying to select skin tones in your subject's face, then turn on the Detect Faces checkbox to refine it even further. Then, drag the Fuzziness slider (kind of like the Tolerance amount in the Magic Wand tool) down to 1 and see what that looks like. If you need to raise the amount to select more skin, drag it to the right.

Saving Your Work Automatically Photoshop is an amazingly stable program (it hardly ever crashes for me, well...unless I'm in front of an audience, then it senses fear), but if for some reason it does crash (hey, it happens), you're not out of luck if you haven't saved the document you're working on in a while because there's an Auto Save feature that saves your document automatically at whatever amount of time you choose.

You do this by going under the Photoshop (PC: Edit) menu, under Preferences, and choosing **File Handling**. At the bottom of the File Saving Options section, you'll see the Automatically Save Recovery Information Every checkbox and a pop-up menu set to 10 Minutes by default (so, the most you can lose at any time is 10 minutes worth of work). But, if you can't bear to lose even that, you can choose 5 Minutes, or go the other way and increase the amount of time before it saves (for the brave at heart).

Want to Get Rid of All Your Hidden Layers Before You Save Your File?
Go to the Layers panel, and from the search pop-up menu at the top left of the filter bar at the top of the panel, choose Attribute, and then, from the pop-up menu that appears to the right, choose Not Visible. Now it displays any layers you're not using (since they're hidden). Select them all and hit the Delete (PC:

Backspace) key, and they're gone. Not only does this make your Layers panel shorter (fewer layers to scroll through), but it also makes your file size smaller by getting rid of layers you're not using.

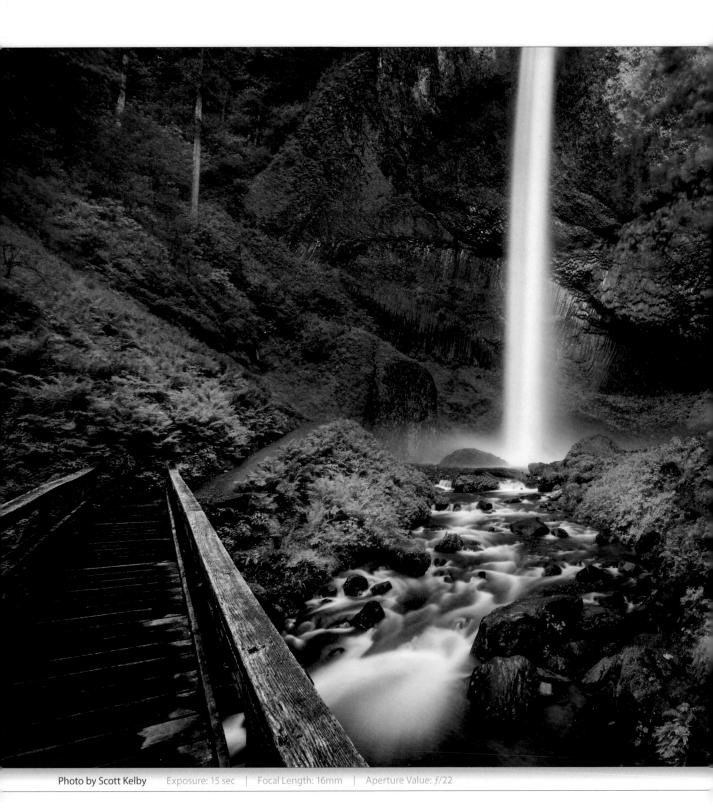

Chapter 11 My Step-by-Step Workflow

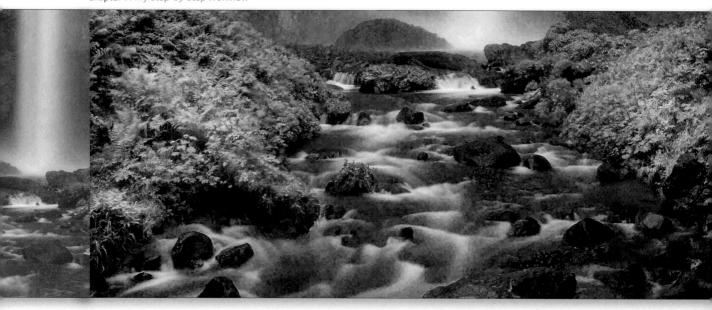

Workflow my step-by-step workflow

I'm about to let you behind the curtain and into the world of my own personal workflow. Not my Photoshop workflow, mind you, but the workflow I use to find the names for titles of chapter intros (it would be more useful to write a chapter on my Photoshop CC workflow, though. Maybe I'll do that after this page). Anyway, this has been a highly guarded, super-secretive process, shrouded in mystery and ensconced in velvet, but today, for you, I'm revealing it for the first time ever. So, here's what I do: First, I choose which word I want to search for (so, for a chapter on color correction, I can search for either color or correction), then I type my first choice into Apple's iTunes Store, because it shows movies, TV shows, and music. For the word "color," you get about a bazillion matches (especially songs), but depending on the word you choose, it might not return any results at all, in which case, I go to IMDb (Internet Movie Database; www

.imdb.com) and type in the word there. So, for this chapter, I figured I'd type in the word "work" and I'd get lots of results (like "Workin' for a Livin'" by Huey Lewis & The News, for example), but on a lark, I typed in "workflow" and sonof-a-gun if one result didn't come up: the two-song album "Workflow" by Ricky Ambilotti. In the world of psychotic chapter intro writers, this is as good as it gets. Now, you're probably thinking, "Wow, that's a surprisingly easy process," and to some extent it is, but there is something I didn't tell you that makes this process much, much harder. I never learned to read. I know that sounds kind of weird coming from someone who writes books for a living, but sadly, it's true. When I was in grade school, I skipped the reading class, because back then I was much more interested in hacking into the WOPR using my 300-baud dial-up modem and playing chess with Dr. Falken.

My Photoshop CC Photography Workflow

I've been asked many times, "What is your Photoshop photography workflow?" (What should I do first? What comes next? Etc.) So, I thought I would add this chapter here in the back of the book to bring it all together. This chapter isn't about learning new techniques (you've already learned all the things you'll need for your workflow), it's about seeing the whole process, from start to finish, in order. Every photographer has a different workflow that works for them, and I hope that sharing mine helps you build a workflow that works for you and your style of work.

Step One:

For the past few years, most of the new photography features Adobe has added to Photoshop have actually been added in Camera Raw (after all, it's a part of Photoshop that is dedicated strictly to photography), and like most photographers today, most of my workflow takes place right within Camera Raw (even if I didn't shoot in RAW format). Here, I'm going to take you through my start-to-finish workflow on a landscape photo of a waterfall (taken out in Portland, Oregon). I'm opening it here from Bridge in Camera Raw by just Right-clicking on it and choosing Open in Camera Raw. (You can download this same image and follow right along—the web address for the book's companion webpage is in the book's introduction up front.)

Step Two:

Here's the original RAW image open in Camera Raw. The first thing I do at this point is figure out what's wrong with the photo, and the question I ask myself is simple: "What do I wish were different?" Here, I wish the overall image was brighter (it looks a bit underexposed). The image kind of looks "flat," so I'd like to fix that, and I'd like more detail overall, but especially in the shadow areas along the right side of the image. I wish the image was more colorful (it sure was when I was standing there), and of course, I wish the entire image was sharper. So, now I have my list of tweaks I'll need to do to get this image where I'd like it to be.

Step Three:

Normally, I start by adjusting the white balance (see page 8), but in this case, I'm okay with the overall color temperature (don't get me wrong, I'm going to pump up the color in just a moment, but as far as it being too warm or too cool, or just totally wrong, I'm okay with that part for this particular photo. That's pretty common for shots taken outdoors, where white balance usually isn't a big issue). I usually do my edits in the Basic panel from top to bottom (that way I don't miss anything), and that means starting with fixing the overall exposure (the overall brightness or darkness of the photo; see page 12). Dragging the Exposure slider to the right makes the whole image brighter, and in this case, dragging to around +90 looks about right to me (there's no official "right" number. This is a call you have to make by looking at the photo, not the numbers—stop dragging to the right when it looks good to you personally).

Step Four:

This next tweak is probably the most important of them all, and the single slider that I believe will have the most impact on your photo (although it's probably the slider that gets talked about the least). It's the Contrast slider. The reason this photo, and millions upon millions of other photos, looks flat just like it is, is simply because the image doesn't have enough contrast. This is particularly true when you shoot in RAW format, because shooting in RAW turns your camera's contrast boost (the one it applies to JPEG images automatically) off, and without that contrast boost, your image looks kinda flat. So, don't be shy with the Contrast slider, especially on landscape, cityscape, travel, automotive, or anything with lots of detail—crank that contrast up! (Here I dragged it over to +65, which is where I felt like it looked good for this particular image.)

(Continued)

Step Five:

Once we increased the Exposure (making the photo brighter) and the contrast (making the brighter areas brighter and the darker areas darker), the waterfall almost seems to have a white "glow" to it. To reduce these powerful highlights, just drag the Highlights slider to the left. By the way, I rarely ever have to increase the highlights by dragging this slider to the right—95 times out of a 100 (or more), I'm dragging to the left to reduce the amount of the highlights. Now, for the particular photo you might be working on, how will you know if the highlights need to be pulled back? You don't always know. That's why you have to give it a quick try and see if it makes your image look better or worse. If it looks bad, then just doubleclick on the slider knob to reset it to zerono harm done. Here, I dragged it to the left to -58 and it gave more definition to the waterfall and removed the glowing.

Step Six:

I mentioned back when I was asking "What do I wish were different in this photo?" that the shadow areas along the right side of the photo seem too dark, and if things get too dark, you don't see any detail (and there's lots of detail there that should be seen. After all, those plants and such are just in the shade—they're not in a dark cave, right?). So, this is an easy fix. When something's lost in the shadows, just open up those shadow areas by dragging the Shadows slider to the right until it looks good to you (in this case, I dragged it all the way over to +95, and it looks much better). Note: Sometimes dragging this far might make things look a little flat, so it's possible after opening up the shadows a bunch like that, you might have to increase the Contrast amount some more, so it doesn't look too washed out. Also, if you have any high ISO noise in the photo, opening the shadows up too much tends to make the noise more visible. Not always, but just so ya know.

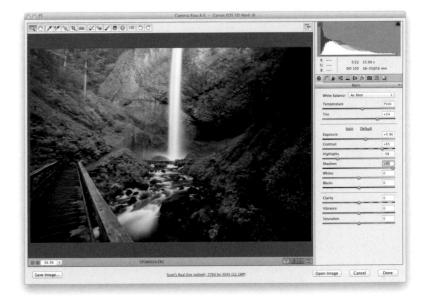

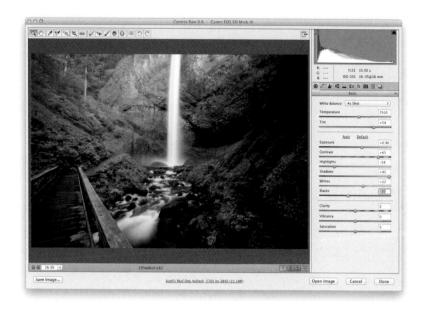

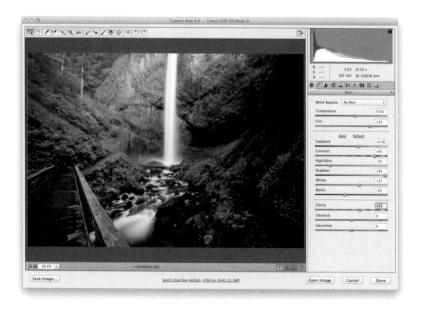

Step Seven:

Next, I set the white and black points to ensure that I'm capturing the maximum range that I can out of this image (but, of course, I try to do this without clipping the highlights. If they start to clip, then I either lower the Whites amount or drag the Highlights slider to the left to offset it). However, I don't do this manually— I actually let Camera Raw figure out where the white and black points are for me using a hidden little keyboard shortcut (see page 17). If you press-and-hold the Shift key, then double-click directly on the little Whites slider knob, it sets the white point for you. Do the same with the Blacks slider, and you're done. Now, depending on the image, sometimes you'll Shift-double-click either the Whites or the Blacks slider and it won't move at all. That's okay, because that means it's already set where it should be, so don't let that throw you.

Step Eight:

If I'm working on an image with lots of detail or texture (and landscape photos usually have both), I generally want to enhance and bring out that detail and texture, and to do that I drag the Clarity slider to the right (see page 20). Again, there is no "right" amount to drag itit just depends on the picture and how crisp and detailed you want the photo to look. If you drag it way over to the right, your image may start to look a bit like an HDR image, so keep an eye on how far you drag (unless you like the HDR look, then in that case, you may as well crank the Shadows and Contrast sliders way up and go all-in on the look. Otherwise, just don't drag it too far). Here, I dragged it to the right to +23.

(Continued)

Step Nine:

Making the image more colorful might be the easiest thing you do to this image, because there's one slider that does it all just drag the Vibrance slider to the right until it looks good to you. This is another slider you might want to go "easy" on, because if you drag too far, it starts to look really overly colorful and the image will start to look majorly tweaked, so try not to get too crazy with it (unless you work for a circus, then all bets are off). In this case, I increased the Vibrance amount to +11. I'm generally in that +10 to +15 range. Occasionally more, but not that often.

Step 10:

Take a look back at the image above in Step Nine, and in particular look at the area at the top of waterfall. That whole area across the top just looks too bright for the rest of the image, and because it's bright, our eyes are drawn up there, when we probably want them on the bottom of the waterfall and the rocks in the foreground. We can't lower the Exposure any more, or the whole photo will be underexposed, so we're going to add a neutral density gradient filter effect in Camera Raw (out on location, I'd do this by putting a glass filter in front of my lens that graduates from a dark gray down to transparent. That way, it darkens the top of the image, but leaves the foreground alone). Click on the Graduated Filter tool (G) in the toolbar up top. When the panel appears, click twice on the - (minus sign) button to the left of the Exposure slider to lower the amount and reset all the other sliders to zero, then press-and-hold the Shift key, and click-and-drag from the top of the image to around the bottom third of the waterfall. It darkens the top of the image, then fades away. For more on how to use the Gradient Filter tool, see page 91.

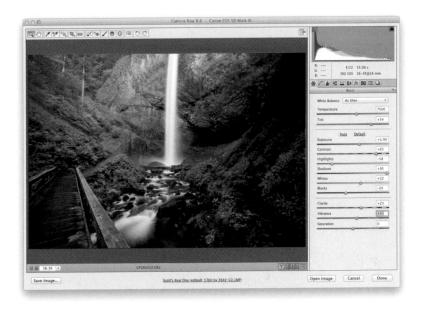

Step 11:

Okay, that certainly helped, but now look back at the image in Step 10—the rocks and trees to the left of the waterfall are still too bright and are drawing the eye, so we'll have to fix that. Get the Adjustment Brush (K) from the toolbar, then click on the - (minus sign) button to the left of the Exposure slider to reset the other sliders to zero, and then set the amount to -1.00. Now, take that brush and paint over those rocks on the left side of the waterfall and over those trees and shrubs to the left of it, as well, to darken those areas (called "burning," as in "dodging and burning." See page 82). Once you've painted over them, you can still change how dark or light that area is by simply dragging the Exposure slider. As long as the edit pin for that adjustment is active (it's green with a black circle inside; as seen here), you can change the exposure. If it's not active, just click on it to make it active.

Step 12:

Next, let's do some selective dodging (brightening) over some specific areas. Mainly, what we're going to do is brighten the highlight areas in the plants on the right side, the rocks right in the foreground, and maybe some of the plants on the left. So, first, click on the New radio button at the top of the Adjustment Brush panel (so Camera Raw knows to leave the burning we just did in place, and start something completely new). Then, drag the Exposure slider over to the right to +1.00. Increase the size of your brush to a medium size (use the Size slider at the bottom of the panel), and then just click with it once or twice over areas in the image that already have some highlights (as seen here). Now those areas look like little beams of light are peeking through the trees and falling on them. I would usually be a little more subtle with it, but I wanted you to be able to see the effect clearly.

(Continued)

Step 13:

Now that I'm looking at the image, that bridge looks a bit dry (well, for all that water being around and all), so why don't we use that "wet cobblestone" trick from the Special Effects chapter (see page 282), here? Click on the New radio button, again, at the top of the panel, then click the + (plus sign) button to the right of the Contrast slider to zero out the other sliders, and drag that Contrast slider to +100. Drag the Clarity slider to +100, as well, and then paint over the bridge to make it look wetter. It doesn't look as good as the cobblestones did, but it's not too bad either.

Step 14:

Go ahead and click on the OK button to open the image in Photoshop. Really, all I do at this point is add some sharpening, so go under the Filter menu, under Sharpen, and choose Unsharp Mask. For an image like this, I use a reasonably punchy amount of sharpening, like Amount 120%, Radius 1.0, and Threshold 3. If you want even punchier sharpening, try Amount 90%, Radius 1.5, and Threshold 0. That'll get 'er done! Other things I might consider doing in Photoshop would be cloning darker wood slats over those areas of the bridge that still look dry (as shown in the inset, here, where I'm using the Clone Stamp tool [S] to sample the darker part of the wooden slats, and then I'm cloning those over the dry spots). Also, there are a few little specks and spots you could choose to get rid of on the rocks, once again, using the Clone Stamp tool or the Healing Brush (your call). But, outside of that, this is pretty much what I do to most photos, which isn't all that much, but I think it has a pretty visible effect for creating a final image.

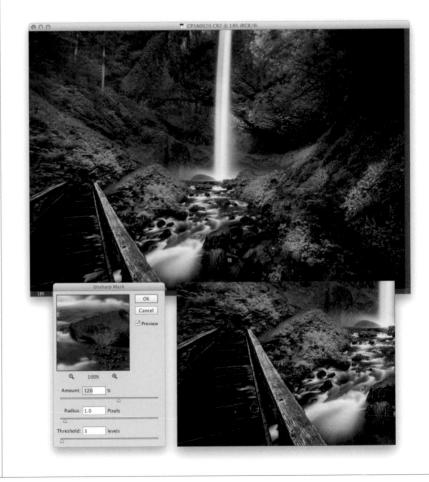

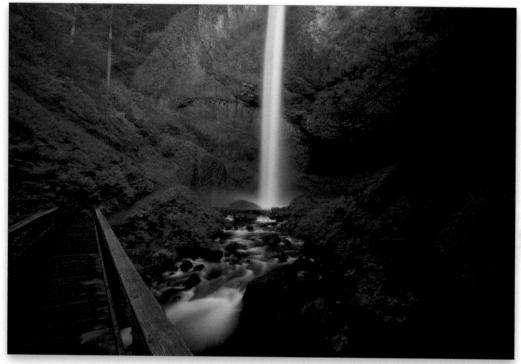

Before

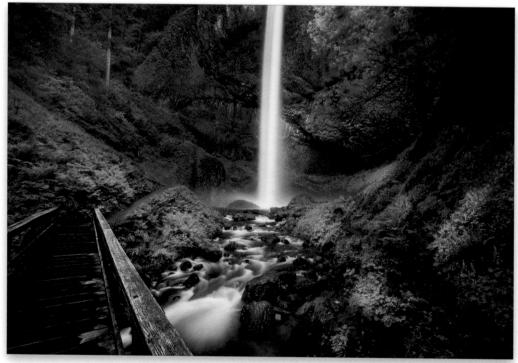

After

Index

8-bit mode, 76, 142, 169 16-bit mode, 76, 142 18% gray card, 11 32-bit HDR images, 168–169 50% magnification, 288 100% view, 35, 48

Α

about this book, xiv-xvii actions conditional, 138-140 high-contrast look, 248-251 Actions panel, 138, 248 Adaptation pop-up menu, 241 Adaptive Wide Angle filter, 221–224 Add Audio option, 316, 318, 341 Add Clips dialog, 309 Add Layer Mask icon, 40 Add Media option, 308, 331, 337 Adjust Edge sliders, 215 Adjustment Brush, 82 Auto Mask feature, 83, 84, 94 brush cursor display, 103 Clear All button, 104 color swatch additions, 104 contrast increased with, 90, 148 deleting adjustments made with, 83 dodging and burning with, 82-87, 359 doubling effects applied with, 102 drawing straight lines with, 103 Erase mode for, 86 hiding edit pins for, 104 killer tips about, 103-104 Mask checkbox, 84, 104 painting white balance with, 100 reducing shadow noise with, 101 resizing the brush, 89, 93, 104 retouching portraits with, 21, 89-90 selective color applied with, 93-94 softening skin with, 89 wet street effect with, 282-283 adjustment layers Black & White, 146, 326, 348 Color Lookup, 274-275

Curves, 35 enlarging controls for, 303 Gradient Map, 150, 151, 153, 272-273 ignoring with Eyedropper tool, 350 layer masks and, 242 Levels, 35, 151, 327 Shadows/Highlights, 242 video projects and, 326-327, 348 Adjustments panel, 150, 151, 157, 272, 274 Adobe Bridge. See Bridge Adobe Photoshop. See Photoshop CC Adobe Photoshop Lightroom, 35 Adobe Premiere Pro. 306 Adobe RGB color space, 75 Adobe Standard profile, 5 aligning layers, 176, 202, 207 all-purpose sharpening, 292 Alpha channels, 233 Ambience slider, 271 Amount slider Shadows/Highlights dialog, 191 Sharpening controls, 49 Smart Sharpen filter, 297, 298 Unsharp Mask dialog, 289, 293 Vignetting controls, 60, 61, 63 animation, video text, 334 Aperture Priority mode, 165 Application Frame, 217, 323 Arrow keys, 310, 311 Artifact Suppression slider, 227, 229 As Shot white balance, 8, 10 aspect ratio, 28 Audio settings dialog, 317, 318 audio tracks for video, 316-319 background music, 316-317, 341-343 narration or voice-over, 318-319 Auto button, Camera Raw, 17-19, 35, 78 Auto Mask feature, 83, 84, 94 Auto Save feature, 351 Auto Tone adjustments, 17 Auto-Align Layers function, 176, 202, 207 auto-correcting photos, 17-19 Automate options, 140

В

Background layer, 141 background music, 316–317

backgrounds	Blur Direction tool, 228
blur effects for, 262–266	Blur Effects panel, 261
compositing selections and, 217–220	Blur Estimation tool, 229
backlit subjects, 15, 190–192	Blur filter
Balance slider, 155	Field Blur, 265–266
barrel distortion, 172	Iris Blur, 262–264
Batch dialog, 140	Tilt-Shift Blur, 259–261
	Blur Gallery, 259, 262, 265
batch processing, 140	Blur slider, 260
before/after previews, 32–33	Blur Tools panel, 260, 261, 263
Bicubic sampling methods, 129	Blur Trace Bounds slider, 227
bit depth, 76	bonus features
Black & White adjustment layer, 146, 326, 348	
Black & White view, Refine Edge dialog, 213	Adobe Bridge chapters, xvi
black-and-white conversions, 146–160	Curves chapter, xvii
Camera Raw method for, 146–149	Print chapter, 127
contrast added to, 147–148, 151	sample image files, xiv
duotone effects and, 156	Bracket keys ([])
Merge to HDR Pro for, 302	blur length adjustments using, 228
painting with B&W, 93–94	reordering layers using, 285
photo toning effects and, 272–273	resizing brushes using, 89, 93, 277
quadtone effects and, 157–158	scrolling through layers using, 103
Silver Efex Pro 2 plug-in for, 160	bracketed exposures, 165
split-toning effects and, 154–155	Bridge
three-click method for, 150–153	Camera Raw version in, 4
Blacks slider, 16, 19, 147, 357	online bonus chapters on, xvi
blemish removal, 69, 88	opening JPEGs and TIFFs from, 2, 284
Blend If sliders, 141	Brightness slider, 280
	brush cursor, 103, 198
blend modes	Brush Picker, 242
Color, 195, 220	Brush tool
Color Burn, 196	changing blend modes for, 243
Darken, 269	eyeglass reflections and, 204
Hard Light, 183, 300	group shot fixes and, 208
keyboard shortcuts for, 34	
Overlay, 151, 183, 196, 216, 247, 250	HDR images and, 181, 183
pop-up menu for, 243	HUD color picker and, 187, 243
Screen, 242, 281	opacity settings for, 349
Soft Light, 151, 183, 185, 196, 247, 333, 336	selection cleanup and, 216
toggling through, 196, 242, 336	sharpening techniques and, 183, 300
video project, 335–336	special effects and, 247, 281
Vivid Light, 248	texture overlays and, 336
blended HDR images, 174–177	brushes
blur	new maximum size for, 350
adding to backgrounds, 262–266	resizing, 89, 93, 104, 142, 276, 277, 349
Blur Gallery effects, 259–266	softness/hardness setting, 142, 349
Gaussian Blur effect, 185, 253	burning and dodging. See dodging and burning
painting in Camera Raw, 103	
reducing with Shake Reduction, 226–229	
Surface Blur effect, 249	
Juliaco Biai Giloco, E	

Preview area in, 34, 35 Radial Filter tool, 95–99 calibration, camera, 71 rating photos in, 35 Camera Calibration panel, 71 Shadows slider, 14-15, 148, 178, 356 Camera Landscape profile, 6 sharpening photos in, 47-51, 301 camera profiles, 5-6 skipping the window for, 34 Camera Raw, 2-35, 38-79, 82-104 Snapshots panel, 103 Adjustment Brush, 82-87, 89, 93, 100, 102, 103 special effects using, 93-99, 282-283 Auto corrections, 17-19, 35, 78 Spot Removal tool, 35, 68-69, 70 B&W conversions in, 146-149 straightening photos in, 31 before/after previews in, 32-33 Temperature slider, 9-10 Blacks slider, 16, 19, 147, 357 Tint slider, 9-10 Bridge version of, 4 Tone Curve panel, 22-27, 148 calibrating for cameras, 71 Vibrance slider, 43, 358 camera profiles used in, 5-6 Visualize Spots feature, 70 Camera Raw Filter option, 7 White Balance settings, 8-11 chromatic aberration fixes in, 58-59 Whites slider, 16, 19, 147, 357 Clarity slider, 20-21, 148, 178, 357 Workflow Options dialog, 75-77 clipping warning, 13-14 See also RAW images color profile assignments, 79 Camera Raw Filter, 7 color range adjustments, 66-67 camera shake fixes, 226-229 contrast adjustments, 22-27 Camera Standard profile, 5-6 Contrast slider, 13, 147, 178, 355, 360 cameras. See digital cameras cropping photos in, 28-30, 141-142 Canon cameras, 5, 6, 164 Default button, 17, 34 canvas deleting photos in, 34 adding around images, 112 DNG conversion in, 64-65 rotating for tablets, 78 dodging and burning in, 82-87, 359 capture sharpening, 47 double-processing in, 38-43 cast shadows, 243 edge vignetting and, 60-63 cell phones editing multiple photos in, 44-46 designing for, 285 Exposure slider, 12, 99, 355, 359 Full Screen mode, 35, 78 photo noise reduction, 187 Channel pop-up menu, 26, 27 Graduated Filter tool, 91-92, 358 channels HDR image processing in, 178-179 adjusting individual, 26-27 Highlights slider, 14, 148, 178, 356 keyboard shortcuts for, 141 histogram in, 79 Channels panel, 290 JPEG and TIFF images in, 2-3, 4, 44 Character panel, 333 killer tips about, 34-35, 78-79, 103-104 chromatic aberration, 58-59 lens correction features, 52-57, 58-59, 60 Clarity slider localized corrections in, 82 Adjustment Brush, 86, 89, 101, 102, 282 Noise Reduction feature, 72-74, 78, 187 Camera Raw Basic panel, 20-21, 148, 178, 357 opening photos in, 2-3, 284 Classic mode options, 109 panorama adjustments in, 254-255 Clear All button, 104 perspective fixes in, 54-57 Clear Crop option, 29 photography workflow, 354-361 clipping warnings, 13-14 portrait retouching in, 88-90 Clone Stamp tool, 235, 360 Preferences dialog, 17, 48, 65 Presets panel, 23, 159

color	Constraint lines, 221, 222–224
changing for guides, 243	Constraint tool, 222, 223
composite photo, 219–220	Contact Sheet II automation, 349
converting to B&W, 146–160	Content-Aware Fill
	distracting object removal, 234–239
filling selections with, 219	off-limit item selections, 238
lighting effects and, 270	panorama adjustments, 257
range adjustments in Camera Raw, 66–67	tips for using, 302
sampling with Eyedropper, 194, 219	wide-angle photo fixes, 225
selective, 93–94	
setting to none, 103	Content-Aware Move, 240–241
text/title, 333	Content-Aware Scale
Color blend mode, 195, 220	resizing parts of images, 135–137
Color Burn blend mode, 196	stretching/shrinking parts of images, 230–233
color cast, 26, 71, 270	contrast
color channels	black-and-white conversions and, 147–148, 151
adjusting individual, 26–27	Curves for adjusting, 22–27
keyboard shortcuts for, 141	HDR image creation and, 171
color correction	high-contrast portrait look, 248–251
online chapter about, xvii	increasing midtone, 20–21
RGB curves for, 26–27	Levels for adjusting, 327
Color Detail slider, 73	TAT for targeting, 25
Color Lookup adjustment layer, 274–275	Contrast slider
color noise reduction, 72-73, 74	Adjustment Brush, 90, 282
Color Picker	Camera Raw Basic panel, 13, 147, 178, 355, 360
Adjustment Brush, 103, 104	Merge to HDR Pro dialog, 171
B&W conversions and, 152	Radial Filter tool, 96
Fade with Color transition and, 321	Convert for Smart Filters option, 190, 209, 221, 242,
Graduated Filter tool, 91	328
HUD pop-up version of, 187, 243	Convert to Grayscale checkbox, 146, 154, 156
keyboard shortcut assignment, 142	Convert to Smart Object option, 209
text/title color and, 333	copyright information, 127, 303
video graphic bar and, 322	Create Warped Text icon, 334
Color Priority vignetting, 63	Crop indicator icon, 30
color profiles, 79	Crop Shield, 110
Color Range dialog, 350–351	Crop tool (Camera Raw), 28–30
Color slider, 72–73	Crop tool (Photoshop), 108–117
Color Smoothness slider, 74	Auto-Align function and, 176
	cropping border, 108
color space configuration, 75	Delete Cropped Pixels option, 113
color swatches, 104, 270	HDR image creation and, 173
color warning triangles, 14	Lights Out cropping option, 110
Colorize swatch, 270	Original Ratio option, 112
composite images, 217–220	Rule of Thirds overlay grid, 108
color adjustments, 219–220	size and resolution options, 114–115
detail enhancement, 218	standard size options, 110
fringe removal, 218	
conditional actions, 138–140	Straighten tool, 130–131
constrained cropping, 28	tool presets, 116–117

cropping photos, 108–117	deleting
aspect ratio and, 28	adjustments, 83
Camera Raw option for, 28–30, 141–142	cropped pixels, 113
and canceling crops, 111	empty layers, 187
canvas area added for, 112	hidden layers, 351
creating custom tools for, 116–117	layer masks, 217
flipping the orientation for, 111	lights, 269
histogram accuracy by, 79	photos, 34
lens distortion fixes and, 56, 173	presets, 120
Lights Out mode for, 110	See also removing
overview of process for, 108–113	Density slider, 87
panorama creation and, 256–257	Desaturate command, 246, 250
preset sizes for, 110	desaturated portrait effect, 246–247
resolution setting for, 114, 115	Deselect command, 195, 219, 225, 233
rotating and, 109	Detail icon, 47, 72
rule of thirds and, 35, 108	Detail Loupe, 226, 227–228, 229
sizing/resizing and, 114–115	Detail panel, 51
straightening and, 31, 130–131, 134	Detail slider
vignetting and, 62–63	Camera Raw, 50
wide-angle shots, 221, 222	Merge to HDR Pro dialog, 167
Cross, Dave, 142	Detect Faces checkbox, 351
Cross Fade transitions, 320, 340–341, 343–344	digital cameras
cross-processing effect, 27	calibrating Camera Raw for, 71
curved line straightening, 224	camera profiles for, 5
Curves	HDR setup for, 164–165
Auto adjustment button, 35	hiding info from, 303
color corrections using, xvii, 26–27	lens profiles for, 52–53
contrast adjustments using, 22–27	reducing shake from, 226–229
HDR Pro dialog box, 167	resizing photos from, 121–123
online chapter about, xvii	white balance settings, 8, 100
RGB channel fixes using, 26–27	digital photography workflow, 354–361
saving as presets, 23, 27	distortion fixes
TAT used with, 25	Geometric Distortion Correction checkbox, 255
Curves adjustment layer, 35	Lens Corrections panel, 54–57, 172
Custom crop option, 29	Distortion slider
	Blur Tools panel, 261
D	Lens Corrections panel, 56, 172, 239, 258
dark circle removal, 68–69	distracting object removal, 234–239
Darken blend mode, 269	DNG (Digital Negative) format
Darks slider, 24	converting RAW files to, 64-65, 302
Decontaminate Colors checkbox, 215	setting preferences for, 65
Default button, Camera Raw, 17, 34	DNG Profile Editor utility, 6
Defringe dialog, 218	Document Frame Rate option, 345
Defringe sliders, 59	documents
Delete key, 29, 34	duplicating specs for creating, 186, 284
50.000 Roy, 27, 54	presets for creating, 119–120
	Dodge and Burn tools, 197–200

dodging and burning	Expand Selection dialog, 194
in Camera Raw, 82–87, 359	Content-Aware Fill and, 225, 234, 257, 302
in Photoshop CC, 197–200	Content-Aware Move and, 240
double-processing images, 38–43	exposure adjustments
downloadable images, xiv	Adjustment Brush, 85, 86, 89
downsizing photos, 132–133	black-and-white conversions and, 147
Drag to Apply dialog, 320, 321, 324, 334	Camera Raw Basic panel, 12–16
	workflow example of, 355–357
dragging-and-dropping	Exposure slider
photos from Bridge, 161	Adjustment Brush, 85, 86, 89, 101, 283
size/resolution issues with, 134	Camera Raw Basic panel, 12, 99, 355, 359
title slides into videos, 331	Graduated Filter tool, 91, 92
dramatic lighting effect, 267–271	Lighting Effects filter, 270
drawing straight lines, 103	Merge to HDR Pro dialog, 167, 169, 171
dreamy focus effect, 252–253	Radial Filter tool, 95, 96, 97, 98
drop shadows, 187, 243, 325	Eye icon, 103, 176, 247, 270, 275
dull gray skies, 193–196	Eye (CON, 103, 170, 247, 270, 273
duotone effects, 156, 158	eye retouching, 89–90, 161
Duotone Options dialog, 158	Eyedropper tool
duplicating layers, 186, 197, 199, 218, 246	channel adjustments and, 26
Duration options	ignoring adjustments using, 350
video clip, 313	ring appearing around, 194
video transition, 320, 321, 324	sampling colors with, 194, 219, 350
	eyeglass reflections, 201–205
E	
	F
Edge Glow sliders, 166	Fade In/Out options
Edge Smoothness feature, 170, 174, 180	for audio, 317, 342
edge vignetting, 60–63	for video transitions, 320–321, 324
adding, 61–63	Fade Iris Blur option, 264
HDR image, 184	Fade with Black transition, 321, 341
post-crop, 63, 184	fashion photography, 274–275
Radial Filter for, 95–99	Feather slider
removing, 60, 255	Adjustment Brush, 87
edit pins, 104	The second secon
editing	Radial Filter tool, 98
JPEGs and TIFFs in Camera Raw, 4	Vignetting controls, 63
multiple photos, 44–46	Field Blur effect, 265–266
transitions in movies, 321	File Handling options, 351
video clips, 314–315, 337	File Info dialog, 303
effects. See special effects	Fill dialog
emailed photos, 79	Content-Aware Fill, 225, 235, 236, 257
Embed Fast Load Data checkbox, 65	tips for displaying, 161
empty layers, 187	Fill field, Layers panel, 243
Enable Keyframe Animation control, 334	Film & Video preset, 322, 330
Enable Lens Profile Corrections checkbox, 52, 60	filmstrip, 3, 30, 34, 35, 44
Erase mode, Adjustment Brush, 86	filters
Esc key, 29, 31, 111	Adaptive Wide Angle, 221–224
EXIF data, 5, 53, 60, 71	Camera Raw, 7
	Field Blur, 265–266

Gaussian blur, 185, 253
High Pass, 182, 299
Iris Blur, 262–264
Lens Correction, 52, 186
Lens Flare, 242, 280–281
Lighting Effects, 267–271
Liquify, 209–210, 276–279
Radial, 95–99
Reduce Noise, 78
Shake Reduction, 226–229
smart, 190, 192, 221
Smart Sharpen, 297–298
Surface Blur, 249
Tilt-Shift Blur, 259–261
Unsharp Mask, 252, 288–294, 328, 360
video feature and, 328–329
finding specific photos, 79
fixing problem photos, 190–241
backlit subjects, 190–192
composite images for, 217–220
Content-Aware features for, 230–241
distracting object removal, 234–239
dodging and burning for, 197–200
dull gray skies, 193–196
eyeglass reflections, 201–205
group shot fixes, 206–208
Liquify filter for, 209–210
making tricky selections, 211–216
moving stuff naturally for, 240–241
Shake Reduction filter for, 226–229
stretching/shrinking parts of images, 230–233
wide-angle shots, 221–225
Flashlight preset, 268
Flatten button, 157
Flatten Image command, 42, 331
flattening layers, 42, 157, 225, 243, 256
Flip Horizontal option, 217
Flow slider, 87
Focus option, 261
Forward Warp tool, 209, 276
Frame Rate pop-up menu, 345
Free Transform
creating cast shadows with, 243
Flip Horizontal option, 217
reaching the handles of, 133, 230
resizing photos with, 133, 135, 217, 230, 338, 350
rotating layers with, 203
Show Transform Controls option, 350
video titles/text and, 330, 333

Freeze Mask tool, 279 fringe removal, 218 Full Upright option, 56 full-screen view, 35, 78 Fuzziness slider, 351

G

Gamma slider, 167 gang scanning images, 134 Gaussian Blur filter, 185, 253 Geometric Distortion Correction checkbox, 255 ghosting problems, 180-181 glasses, fixing reflections in, 201-205 Gloss slider, 271 Go to First Frame icon, 310 Google Nik Collection, 160 Gradient Editor dialog, 151, 152, 273 gradient effects neutral density, 91, 358 photographic toning, 273 sky adjustments, 91-92, 195 Gradient Map adjustment layer, 150, 151, 153, 272-273 Gradient tool, 195 Graduated Filter tool, 91-92, 358 graphic bar, 322-325 gray card, 11 gray skies, 193-196 grayscale conversions. See black-and-white conversions Grayscale mode, 150, 157 grids Lens Corrections panel, 142, 186 rule-of-thirds, 35, 108 group shot fixes, 206-208 groups layer, 349 video, 332 guides, preferences for, 243

Н

hair selections, 211–216 halos around images, 297 Hand tool, 302, 303 Hard Light blend mode, 183, 300 hardness of brushes, 142, 349 Harrington, Richard, 329

HDR images, 163–185	HSL/Grayscale panel, 66–67, 146, 154, 156
32-bit, 168–169	HUD pop-up Color picker, 187, 243
blended, 174–177	Hue/Saturation adjustments
Brush tool and, 181, 183	duotone effects and, 156
camera setup for, 164–165	split-toning effects and, 154–155
Edge Smoothness feature, 170, 174, 180	Hughes, Bryan O'Neil, 295
finishing techniques for, 184–185	
Gaussian Blur added to, 185	1
ghosting problems in, 180–181	
High Pass sharpening for, 182–183	image downloads, xiv
Merge to HDR Pro dialog for, 166–167	Image Processor dialog, 126–127
presets for creating, 166, 170–171	Image Size dialog, 121–123, 124–125, 128–129, 132
processing in Camera Raw, 178–179	Infinite Light style, 270
realistic look for, 168–169	input sharpening, 301
sharpening techniques for, 182–183, 184	Intensity slider, 270
single-image technique for, 178–179	Inverse command, 192
time saving tip for creating, 186	Invert command, 249, 274
tone-mapped look for, 170–173	Iris Blur effect, 262–264
vignettes applied to, 184	iStockPhoto, 335
HDR Pro feature. See Merge to HDR Pro dialog	
Healing Brush tool, 34, 237, 360	J
Height slider, 271	JPEG files
hiding	
edit pins, 104	editing in Camera Raw, 4, 9
panels, 187	opening in Camera Raw, 2–3, 44, 284
High Dynamic Range images. See HDR images	saving 16-bit images as, 142
High Pass filter, 182, 299	
High Pass sharpening	K
HDR images and, 182–183	kelbyone.com website, xiv, xvi
steps for applying, 299–300	keyboard shortcuts
	blend mode, 34
High Structure preset, 160 high-contrast portrait look, 248–251	brush size, 89, 93
Highlight Priority vignetting, 63, 184	channel, 141
	Color Picker, 142
highlights adjusting in photos, 14, 191	Full Screen mode, 35
clipping warning for, 13–14	layer functions, 243, 285
split-toning effects and, 154–155	Radial Filter tool, 96
· · · · · · · · · · · · · · · · · · ·	video controls, 310, 311, 313
Highlights slider Adjustment Brush, 101	zooming in/out, 32, 277, 288
Camera Raw Basic panel, 14, 148, 178, 356	keyframe animation, 334
Merge to HDR Pro dialog, 167, 171, 174	Kost, Julieanne, 141
	Kuler utility, 187
Tone Curve panel, 24, 25	real activity, 107
histogram, 79	
History panel, 103	L
Hollywood, Calvin, 248 Horizontal Type tool, 346	Lasso tool, 136, 234, 236
hot spot removal, 34–35	layer blend modes. See blend modes
Hotspot slider, 270	Layer Comps to PDF script, 349
Hotspot slider, 270	

adjustment layers and, 242
copying between layers, 243
creating from transparencies, 141
fixing photo problems using, 203-204, 208
HDR processing with, 177, 181, 183
permanently applying, 217
sharpening using, 183
smart filters and, 192
texture overlays and, 336
∟ayer Style dialog, 322
ayer styles
applying to multiple layers, 349
Drop Shadow, 187, 325
setting defaults for, 141
Stroke, 322
ayers
aligning, 176, 202, 207
deleting empty, 187
duplicating, 186, 197, 199, 218, 246
filter bar for showing/hiding, 349
flattening, 42, 157, 225, 243, 256
grouping, 349
inverting, 249
locking multiple, 303
merged, 247, 249
opacity settings for, 202
removing hidden, 351
renaming multiple, 186
reordering, 285
rotating, 203
scaling photos on, 133
scrolling through, 103
searching for, 349–350
video files on, 309, 337
viewing/hiding, 103, 176, 349
See also adjustment layers
ayers panel
Attribute options, 351
Eye icon, 103, 176
Fill field, 243
Left/Right Arrow keys, 311
Lens Correction filter, 52, 186
Lens Corrections icon, 52, 60, 172
ens Corrections panel
alignment grid, 142
chromatic aberration fixes, 58–59 edge vignetting adjustments, 60–63
eage vidiletting adjustments, nu-n.3

laver masks

panorama adjustments, 258 perspective fixes, 54-57, 239 profile-based fixes, 52-53 Upright feature, 54-57 lens flare effect, 280-281 Lens Flare filter, 242, 280-281 lens problems Camera Raw fixes for, 52-57, 58-59, 60 wide-angle photos and, 221-225 lens profiles, 52-53 Levels adjustment layer, 35, 151, 327 lighting, dramatic, 267-271 Lighting Effects filter, 267-271 Lightroom, Photoshop, 35 Lights Out cropping mode, 110 Lights panel, 267, 270 Lights slider, 24 Linear curve, 23 Liquify filter, 276-279 Advanced Mode options, 278-279 brush resizing methods, 276, 277 Forward Warp tool, 276-277 Freeze and Thaw Mask tools, 279 retouching tip using, 284 smart objects and, 209-210 Local Adaptation HDR mode, 166 localized corrections, 82 locking layers, 303 logos, adding to video, 340 lossy compression, 65 Loupe, Detail, 226, 227-228, 229 lower third options, 322-325 Luminance Contrast slider, 73 Luminance Detail slider, 73 luminance noise reduction, 73 Luminance slider, 73

Μ

Magic Wand tool, 193, 212, 225, 257 Mask checkbox, Adjustment Brush, 84, 104 Masking slider, 50, 51 Match Color dialog, 143 Matting options, 218 maximum sharpening, 291 Medium Contrast curve, 22

Merge to HDR Pro dialog 32-bit mode, 168–169 Advanced sliders, 167, 174 B&W image creation in, 302 Edge Glow section, 166 Edge Smoothness checkbox, 170, 174, 180 presets in, 166, 170–171 quick tour of, 166–167 Remove Ghosts checkbox, 166, 180–181 tip on saving time in, 186 Tone and Detail section, 167 See also HDR images Merge Visible command, 243 merged layers, 247, 249 Metallic slider, 271 Midpoint slider, 60, 61, 63 midtone contrast adjustments, 20–21 miniaturization effect, 259–261 Mobile & Devices preset, 285 moderate sharpening, 291 Motion dialog, 339 Move tool composite images and, 217 cropped photos and, 30, 113, 115 group shot adjustments and, 207 lens flare effect and, 281 video text and, 330, 331, 333, 346, 347 See also Content-Aware Move movies. See video music for video, 316–317, 341–343 Mute Audio checkbox, 317, 343 muting background music, 317	New Smart Object via Copy option Nik Collection, 160 Nikon cameras, 5, 6, 164 noise reduction, 72–74, 78, 101, 12 Noise Reduction slider, 101 numerical field settings, 143 O one-click presets, 159 OnOne Software, 128 Opacity settings B&W conversions and, 153 blurred layers and, 253 Brush tool and, 349 Color Lookup effect and, 274 composite images and, 220 cropping process and, 110 HDR images and, 177 multiple layers and, 202, 218 scrubby sliders for, 143 sharpening techniques and, 183,
	special effects and, 247, 251 spot removal and, 35 video title/text, 333 wrinkle removal and, 68 Open dialog, 3 Open Image button, 4, 29 Open Object button, 38–39 output sharpening, 301 Overlay blend mode, 151, 183, 19 Overlay view, Refine Edge dialog,
N naming/renaming	P Paint Overlay vignetting, 63
multiple layers 186	painting

multiple layers, 186 video projects, 344 narration for video, 318-319 negative clarity, 21, 89 Nelson, Felix, xvii neutral density gradient effects, 91, 358 neutral gray card, 11 New Action dialog, 138, 248 New dialog, 115, 119, 186, 284, 322 New Document Preset dialog, 120 New Preset dialog, 23, 159

New Smart Object via Copy option, 39 24, 187, 229

295, 300 6, 216, 247, 250 214

B&W effect, 93-94 noise reduction, 101 sharpness, 296 straight lines, 103 white balance, 100 Pan & Zoom option, 339 panels temporarily hiding, 187 workspace layout for, 143 See also specific panels

panoramas, 254–258	poster-sized prints, 128–129
Camera Raw adjustments for, 254–255	preferences
Content-Aware Fill for, 257	Bridge, 4
cropping to size, 256–257	Camera Raw, 17, 48, 65
lens corrections for, 258	rebuilding in Photoshop, 284
Photomerge for creating, 255–256	Premiere Pro, 306
vignette removal for, 255	Preserve Cropped Pixels option, 30
Parametric curve, 24–25	Preserve Details (enlargement) option, 124
Paste in Place command, 161	Preset Manager dialog, 117, 242
Patch tool, 236, 237	presets
Path Bar, Bridge, 3	B&W conversion, 160
patterns/textures, 335–336	cropping, 110, 114, 116–117
PDF Presentation automation, 349	Curves, 23, 27
Pen tool, 142	deleting, 120
Perfect Resize plug-in, 128	document, 119–120
perspective fixes, 54–57, 172	duotone, 158, 159
photo toning effects, 272–273	Film & Video, 322, 330
photography workflow, 354–361	HDR image, 166, 170–171
Photomerge feature, 255–256	Levels, 327
Photoshop CC	lighting effect, 268
photography workflow, 354–361	Mobile & Devices, 285
preference replacement, 284	one-click, 159
RAM allocation, 285	Photographic Toning, 273
Sync Settings, 118	tool, 116–117
UI appearance options, 78–79	video format, 344–345
Photoshop for Video (Harrington), 329	white balance, 9
"Photoshop Killer Tips" sections, xvii	workflow, 77
Photoshop Lightroom, 35	Presets panel, 23, 159
Pixel Grid option, 186	Preview area, Camera Raw, 34, 35
Place Embedded command, 335	Preview Preferences dialog, 33
Play icon, 314, 317, 320, 339	previews
playhead, 307, 310	before/after, 32–33
plug-ins	video, 312, 329
disabling third-party, 186	printing
Perfect Resize plug-in, 128	bonus chapter on, 127
Silver Efex Pro 2 plug-in, 160	poster-sized prints, 128–129
Point curve, 22–23, 26	resolution settings for, 122
Point Lights, 269	sharpening images for, 301
Polygon Constraint tool, 224	profiles
portraits	camera, 5–6
desaturated, 246–247	color, 79
high-contrast, 248–251	lens, 52–53
retouching, 68–69, 88–90, 284	Protect Details checkbox, 295
sculpting, 276–279	Protect Skin Tones button, 231
sharpening, 290	Protect Tones checkbox, 200
post-crop vignettes 63 184	

Q	white balance adjustments, 8–11
quadtone effects, 157–158	workflow settings, 75–77
Quick Selection tool, 40, 192, 193, 211–213, 233	See also Camera Raw
Quick solded on tool, to, they are a sequence	realistic-looking HDR images, 168–169
5	Reconstruct tool, 210
R	recording actions, 138–140
Radial Filter tool, 95–99	rectangle straightening, 224
Radius slider	Rectangular Marquee tool, 322
Edge Glow feature, 166	Recycle Bin icon, 79
High Pass filter dialog, 182, 299	Red channel sharpening, 290, 295
Refine Edge dialog, 213–214	Red Eye tool, 161
Refine Mask dialog, 42	red-eye removal, 161
Shadows/Highlights dialog, 191	Reduce Noise filter, 78
Sharpening controls, 49	Reduce Noise slider, 124, 297, 298
Smart Sharpen filter, 297	Refine Edge dialog, 213–215
Unsharp Mask dialog, 289, 293	Refine Mask dialog, 42
RAM	Refine Radius tool, 214
assigning to Photoshop, 285	reflections, eyeglass, 201–205
video feature and, 306	Regions of Interest, 228
rating photos, 35	Remember Settings checkbox, 213
RAW images	Remove Ghosts checkbox, 166, 180–181
auto-correcting, 17–19	removing
camera calibration for, 71	chromatic aberration, 59
camera profiles for, 5–6	distracting objects, 234–239
chromatic aberration fix, 58–59	edge vignetting, 60, 255
Clarity applied to, 20–21	eyeglass reflections, 201–205
color profile assignments, 79	fringe in composites, 218
color range adjustments, 66–67	red-eye problems, 161
contrast adjustments, 22–27	spots and specks, 70
converting to DNG format, 64–65, 302	See also deleting
cropping, 28–30	renaming. See naming/renaming
double-processing, 38–43	Render Video dialog, 344, 345
edge vignetting in, 60–63	rendering bar for video, 329
editing multiple, 44–46	Resample checkbox, 122, 123, 124, 128, 132
exposure adjustments, 12–16	Reset Gradients option, 273
giving to clients, 302	Resize to Fit checkbox, 76, 127
gradient effects, 91–92	resizing. See sizing/resizing
histogram for, 79	resolution
lens corrections, 52–57	Crop tool field for, 114, 115
noise reduction, 72–74	image size and, 119–125, 132, 134
opening in Camera Raw, 2, 3, 284	print, 122
panorama adjustments as, 254	web, 121
retouching, 88–90	Restore All button, 277
saving as DNGs, 64–65	retouching portraits
sharpening, 47–51	Camera Raw techniques for, 68–69, 88–90
spot removal, 70	Photoshop Liquify filter for, 276–279, 284
straightening, 31	RGB curve adjustments, 26–27
3.	

Rotate View tool, 78	selections
rotating	deselecting, 212, 233
canvas, 78	edge-of-document, 303
crops, 109	expanding, 194, 225
layers, 203	filling with color, 219
photos, 78	inversing, 192
views, 78	Liquify filter, 284
Roundness slider, 63	
rule-of-thirds cropping, 35, 108	making tricky, 211–216
rulers	saving, 136, 233, 238
	skin tone, 350–351
displaying, 121	viewing, 213, 214
unit-of-measure changes, 143	selective color, 93–94
Run Action checkbox, 127	sepia-tone images, 156, 273
	Set Additional Crop Options icon, 109, 110
S	Set Start/End of Work Area bar, 311
sampling colors in photos, 194, 219	Set White Point Preview histogram, 168
Saturation slider	shadows
	adjusting in photos, 14–15, 190–192
Adjustment Brush, 85, 93, 103	creating cast, 243
Merge to HDR Pro dialog, 167	drop, 187, 243, 325
Save As Defaults button, 192	duotones and, 156
Save Image button, 64, 285, 301	noise reduction and, 78, 101
Save Mask to Channels checkbox, 261	split-toning effects and, 154–155
Save Options dialog, 64, 285, 302	Shadows slider
Save Selection dialog, 233	Adjustment Brush, 101
saving	Camera Raw Basic panel, 14–15, 148, 178, 356
16-bit photos to JPEG, 142	Merge to HDR Pro dialog, 167, 171, 174
Auto Save feature for, 351	Radial Filter tool, 98
automated resizing and, 126–127	Tone Curve panel, 24
Camera Raw defaults, 47	Shadows/Highlights adjustment layer, 242
RAW files as DNGs, 64–65	Shadows/Highlights dialog, 190–192
selections, 136, 233, 238	Shake Reduction filter, 226–229
video projects, 344	Sharpen tool, 295–296
scaling	Sharpening sliders, 49–51
content-aware, 135–137, 230–233	sharpening sliders, 47–37 sharpening techniques, 288–301
lighting effects, 268, 269	Camera Raw and, 47–51, 301
photos on layers, 133	
See also sizing/resizing	Channels panel and, 290
Scott5 HDR Pro preset, 170–171, 174	dreamy focus effect, 252
Screen blend mode, 242, 281	essentials of, 288–294
scrolling credits, 346–347	HDR images and, 182–183
scrubbing video clips, 312, 314	High Pass sharpening, 182–183, 299–300
scrubby sliders, 143	noise reduction and, 229
sculpting portraits, 276–279	Opacity settings and, 183, 295, 300
S-curves, 27	output sharpening, 301
Select All button, 30, 45, 46	portrait sharpening, 290
Select Rated button, 79	print sharpening, 301
solder nated button, 77	sample settings, 289–294

Liquify filter used as, 209-210 sharpening techniques (continued) opening images as, 39, 41, 76 Shake Reduction filter, 226–229 Sharpen tool and, 295-296 page icon indicating, 39 setting preferences for, 161 Smart Sharpen filter, 297-298 video clip conversion into, 328 soft subjects and, 290 Smart Radius checkbox, 42, 213 video and, 328 Smart Sharpen filter, 297–298 web graphics and, 292 Smooth tool, 210 workflow example of, 360 Sharpness slider, Adjustment Brush, 89 Smoothing slider, 229 snapshots, 103 Shift Edge slider, 42 Snapshots panel, 103 shortcuts. See keyboard shortcuts soft glow finishing, 185 Show Cropped Area checkbox, 110 Soft Light blend mode, 151, 183, 185, 196, Show Grid checkbox, 186 247, 333, 336 Show Mask checkbox, 279 soft spotlight effect, 60-61 Show Overlay option, 35 soft subject sharpening, 290 Show Transform Controls checkbox, 350 softening skin, 21, 89 side-by-side previews, 32 softness of brushes, 142, 349 Silver Efex Pro 2 plug-in, 160 Sony cameras, 164 single-image HDR look, 178–179 Source Noise pop-up menu, 229 sizing/resizing Spacebar automated saving and, 126-127 brushes, 89, 93, 104, 142, 276, 277, 349 Hand tool accessed with, 302, 303 playing video with, 317, 320, 339 conditional actions for, 138-140 special effects, 246-283 cropping and, 114-115 Camera Raw used for, 93-99, 282-283 default setting for, 350 Color Lookup effects, 274–275 digital camera photos, 121–123 desaturated skin look, 246-247 downsizing process and, 132-133 dramatic lighting effect, 267-271 dragging photos and, 134 dreamy focus effect, 252-253 Free Transform used for, 133, 135, 217, Field Blur effect, 265-266 230, 338, 350 high-contrast portrait look, 248-251 interpolation method for, 350 Iris Blur effect, 262-264 parts of images, 135-137, 230-233 lens flare effect, 280-281 photos on layers, 133 panorama creation, 254–258 poster-sized prints, 128-129 photo toning effects, 272-273 Preview area, 35 sculpting with Liquify filter, 276-279 RAW images, 76 selective color, 93-94 resolution and, 119-125, 132, 134 tilt shift effect, 259-261 thumbnails, 312 video projects and, 348 tip for speeding up, 350 wet street effect, 282–283, 360 upsizing process and, 124-125 Split at Playhead icon, 318, 319, 342 skin softening, 21, 89 split-screen previews, 33 skin tone selections, 350-351 split-toning effects, 154-155 sky adjustments, 91-92, 193-196 Spot Healing Brush, 236, 237, 238-239 smart filters, 190, 192, 221, 328 Spot Removal tool, 35, 68-69, 70, 88 smart objects spot/speck finding feature, 70 creating new via copy, 39 Spring Loaded Tools, 285 double-processing images using, 39-40 dragged-and-dropped images as, 161 sRGB color space, 75, 79

star ratings, 35, 79	TIFF files
straight lines, 103	editing in Camera Raw, 4, 9
Straighten tool	opening in Camera Raw, 2–3, 44, 284
Camera Raw, 31	Tile All Vertically option, 323, 331
Photoshop, 130–131	tilt shift effect, 259–261
straightening	Timeline panel, 307, 308, 310–313, 339
automated cropping and, 134	Tint slider
Camera Raw tool for, 31	Adjustment Brush, 85
curved lines, 224	Camera Raw Basic panel, 9–10
lens perspective problems, 54–57	titles/text for videos, 330–334, 340, 346
Photoshop tool for, 130–131	tonal corrections, 17
rectangles, 224	Tone Curve panel, 22–27, 148
streets, wet look for, 282–283	tone-mapped HDR look, 170–173
Strength slider, 166, 174	Tool Presets panel, 116–117
stretching parts of images, 230–233	tools
Stroke layer style, 143, 322	fast switching between, 285
Strong Contrast curve, 22, 148	resetting to defaults, 302
Surface Blur filter, 249	See also specific tools
Symmetric Distortion checkbox, 261	Transition icon, 320, 324, 334, 340, 341
Sync Settings, 118	transitions, video
Synchronize dialog, 45	adding, 320–321, 340–341
synchronizing edits, 45–46	editing, 321, 344
	Trash icon, 79
Т	tricky selections, 211–216
	trimming video clips, 314–315, 337
Tab key, 187	Triple Scoop Music, 316, 341
tablets, designing for, 285	tritone effects, 157
Tabs feature, 141, 143	type
Targeted Adjustment tool (TAT), 25	scrolling, 346–347
color range adjustments using, 66–67	video project, 325, 330–334, 340, 346
contrast adjustments using, 25	warp animation, 334
Temperature slider	Type tool, 325, 330, 332
Adjustment Brush, 100	7) - 101., 020, 000, 002
Camera Raw Basic panel, 9–10	11
text	U
scrolling, 346–347	UI appearance options, 78–79
video project, 325, 330–334, 340, 346	Undo command, 17, 238, 277, 302
warp animation, 334	Unsharp Mask filter
Texture pop-up menu, 271	dreamy focus effect and, 252
textures/patterns, 335–336	essentials of using, 288–294
Thaw Mask tool, 279	HDR image sharpening and, 184
third-party plug-ins, 186	sample settings, 289–294
three-click B&W conversion, 150–153	video projects and, 328
Threshold slider, 289, 294	workflow example using, 360
thumbnails	See also sharpening techniques
layer mask, 217	unwanted object removal, 234–239
resizing, 312	Up/Down Arrow keys, 310
Timeline panel, 312, 339	Upright feature, 54–57

Use Classic Mode checkbox, 109 Use Legacy option, 298 user interface options, 78-79 V Versace, Vincent, 129 Vertical Upright option, 55 Vibrance slider Camera Raw Basic panel, 43, 358 Merge to HDR Pro dialog, 167 video, 306-348 adjustment layers in, 326-327, 348 audio options for, 316-319, 341-343 basic controls for, 310-313 blend modes used in, 335-336 effects applied to, 348 file format presets for, 344-345 filters used in, 328-329 graphic bar creation, 322-325 important points about, 306-307 keyboard shortcuts, 310, 311, 313 motion effects added to, 339 music added to, 316-317, 341-343 narration or voice-over for, 318-319 opening in Photoshop, 308-309 ordering clips for, 312, 338, 343 photos added to, 338–339 previewing, 312, 329 project workflow, 337-345 rendering bar for, 329 saving as movies, 344-345 scrolling credits for, 346-347 texture overlays in, 335–336 Timeline panel, 307, 308, 310–313 title and text options, 330-334, 340, 346 transitions for, 320-321, 340-341, 343-344 trimming, 314-315, 337 Video Groups, 332 viewing

upsizing images, 124-125

vignette effects
adding, 61–63
HDR image, 184
post-crop, 63, 184
Radial Filter for, 95–99
removing, 60, 255
Vignetting slider, 60
visual brush resizing, 276
Visualize Spots feature, 70
Vivid Light blend mode, 248
voice-over for video, 318–319
Volume slider, 318

W

Wacom tablets, 78, 284 warning triangles, 14 Warp Text dialog, 334 web-based book resources, xiv, xvi websites color space for, 79 image resolution for, 121 sharpening photos for, 292, 301 Weinrebe, Steve, 272 wet street effect, 282-283, 360 White, Terry, 156 White Balance adjustments Auto function for, 19 Camera Raw options for, 8–11, 19 gray card used for, 11 Match Color dialog for, 143 painting with white balance, 100 White Balance pop-up menu, 11 White Balance tool, 10-11 Whites slider, 16, 19, 147, 357 wide-angle photo fixes, 221-225 Workflow Options dialog, 75-77, 79 Workflow presets, 77 workflow process for photography projects, 354-361 for video projects, 337-345 workspaces, 143 wrinkle removal, 68

before/after previews, 32-33

full-screen images, 35 selections, 213, 214

XMP files, 65, 302

Υ

YouTube video presets, 344–345

Ζ

zoom pop-up menu, 79 Zoom tool, 20 chromatic aberration and, 58 click-and-drag option, 161 red-eye removal and, 161 sharpening and, 35, 48 zooming in/out, 32, 277, 288

"Triple Scoop Music is the real deal!"

—Scott Kelby

Triple Scoop Music is the acclaimed music licensing service loved by creative professionals.

Find the perfect song or soundtrack for your next project at www.TripleScoopMusic.com

Use the discount code Kelby333 to save 10% on your purchase!

www.TripleScoopMusic.com

kelbyone

Start your training now at **kelbyone.com**

CAMERA RAW WHITE BALANCE CARD

From Scott Kelby's The Adobe® Photoshop® CC Book for Digital Photographers (2014 Release)